THE
EMPIRE
OF THE
EAGLE

An *illustrated* natural
history

Mike Unwin and David Tipling

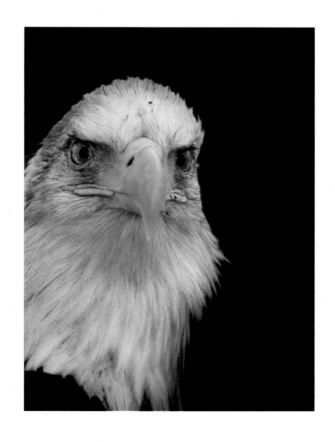

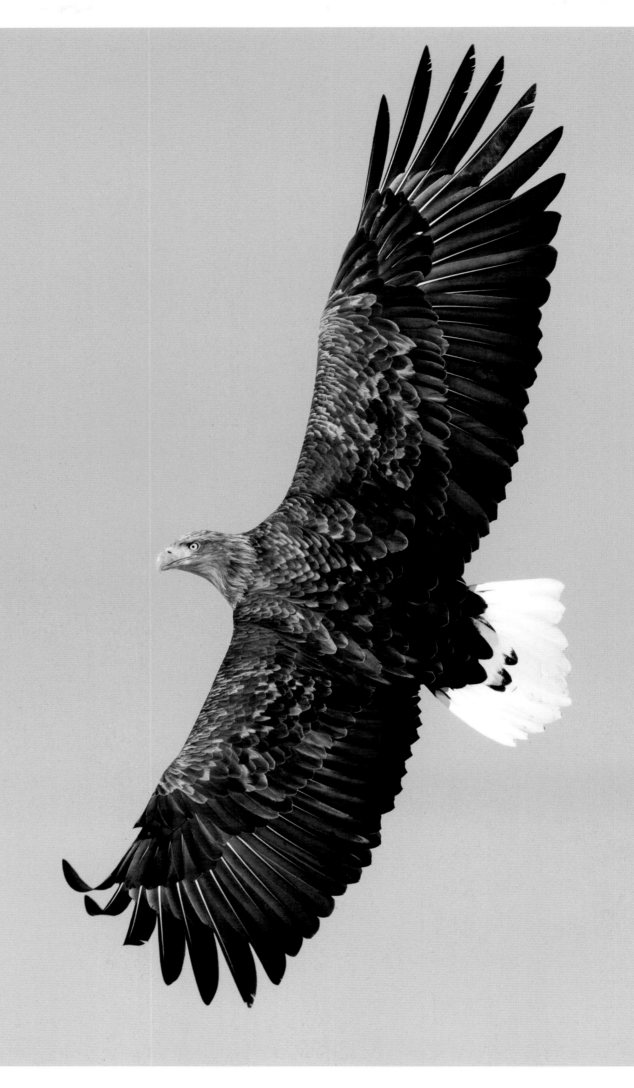

THE
EMPIRE
OF THE
EAGLE

An *illustrated* natural history

Mike Unwin and David Tipling

Yale UNIVERSITY PRESS

New Haven and London

Page 1: Bald Eagle
Page 2: White-tailed Sea-eagle
Pages 4–5: Spanish Imperial Eagle
Pages 6–7: Kazakh eagle hunters, Mongolia
Page 8: Crested Serpent-eagle
Pages 10–11: Tawny Eagle with black-backed jackals
Pages 278–279: African Fish-eagle on cliff at Victoria Falls

Published in association with
Yale University Press
P.O. Box 209040
New Haven, CT 06520-9040
yalebooks.com

This book was designed and produced by
White Lion Publishing
The Old Brewery
6 Blundell Street
London N7 9BH

Senior Editors Carol King and Hannah Phillips
Senior Designer Isabel Eeles
Editor Liz Jones
Production Manager Rohana Yusof
Editorial Director Ruth Patrick
Publisher Philip Cooper

Colour reproduction by Bright Arts
Printed in China by RR Donnelley

ISBN 978-0-300-23289-9 (hardcover : alk. paper)
Library of Congress Control Number: 2018939538

10 9 8 7 6 5 4 3 2 1

MIX
Paper from
responsible sources
FSC® C101537
www.fsc.org

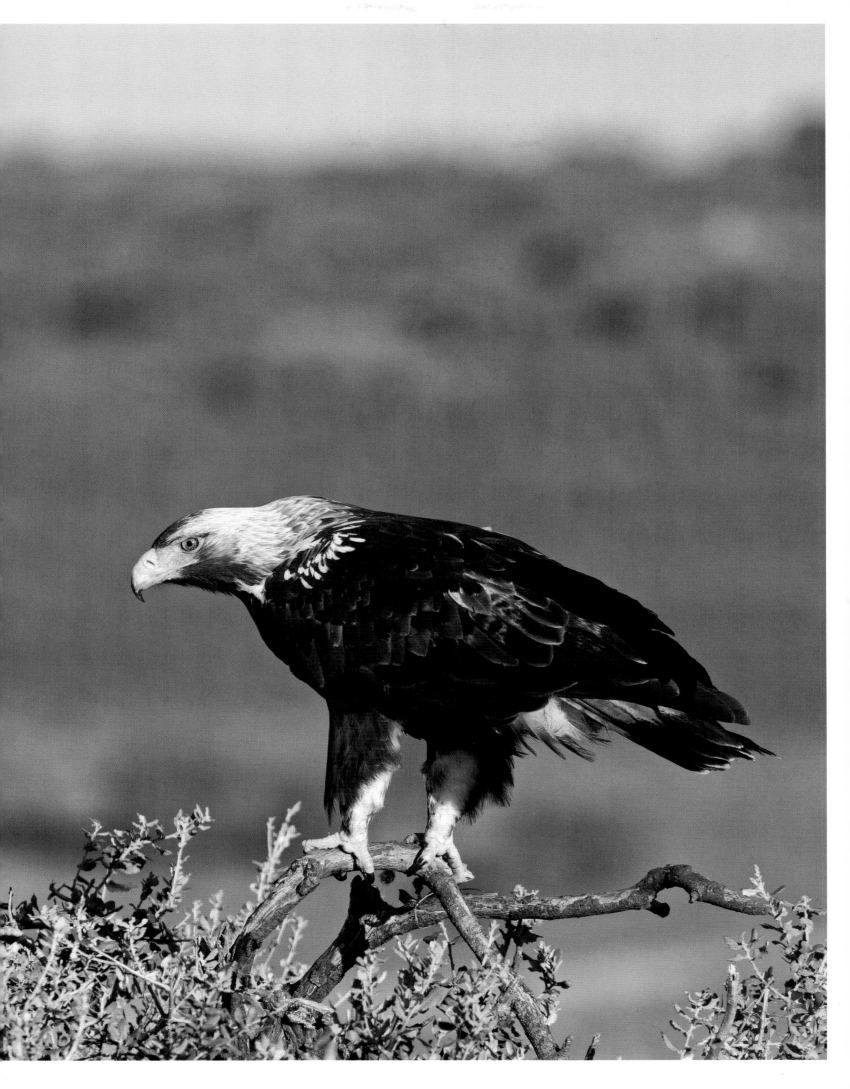

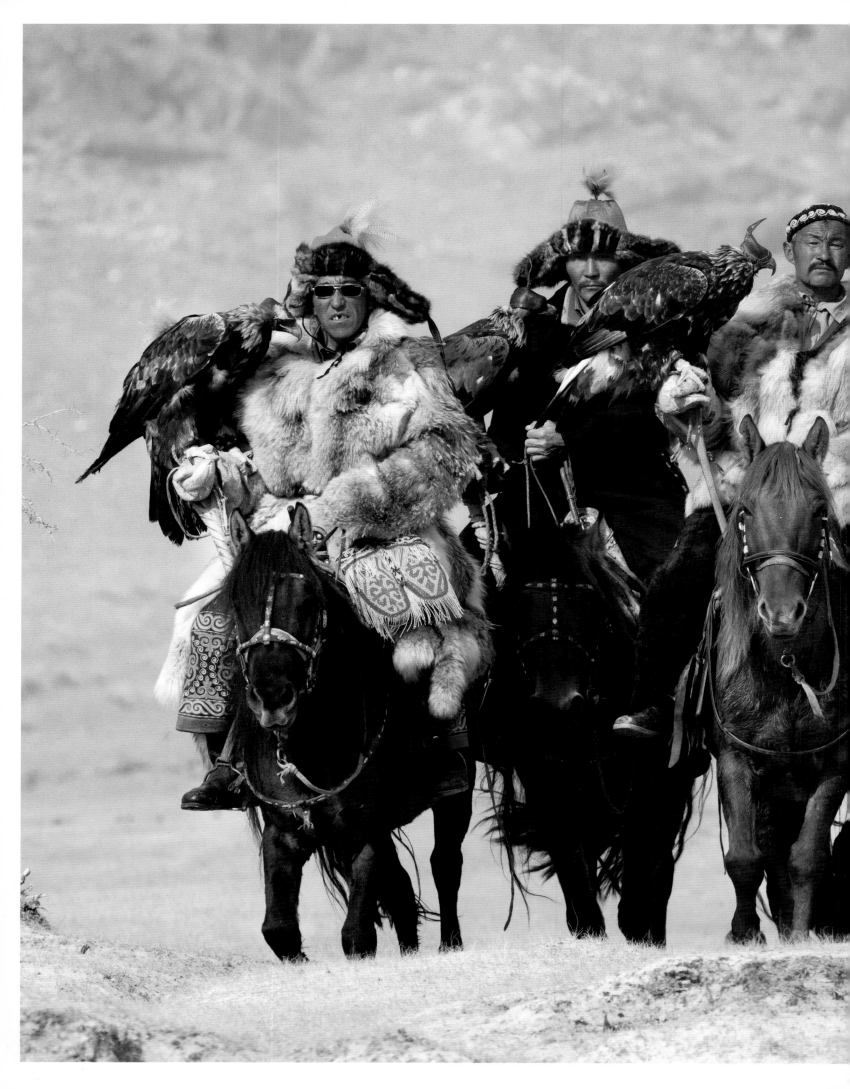

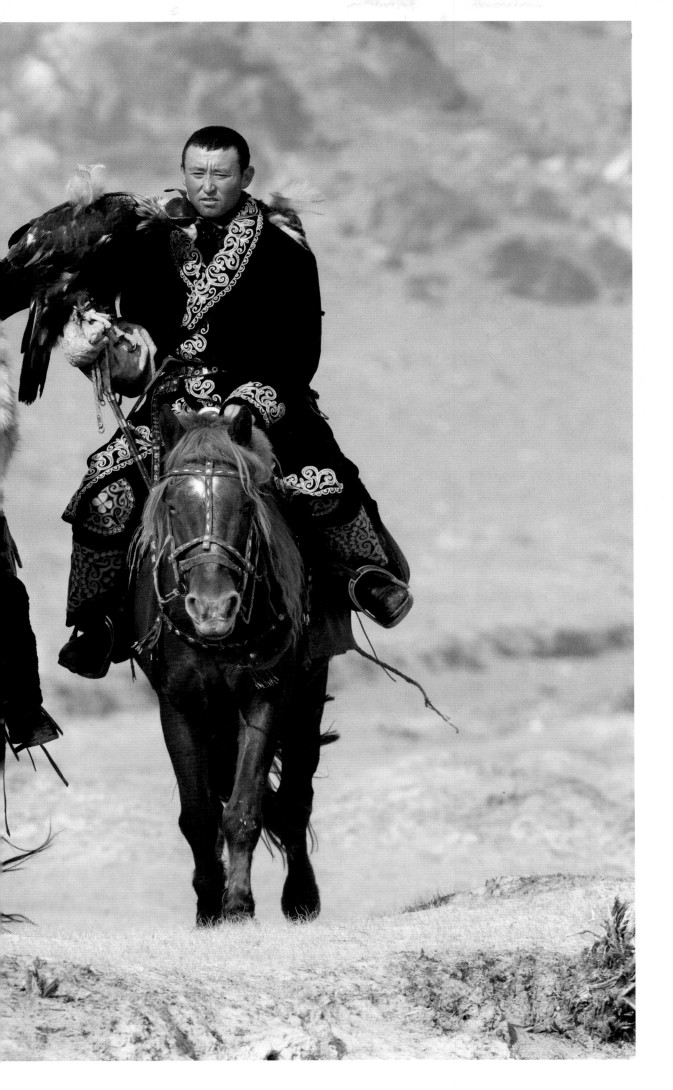

CONTENTS

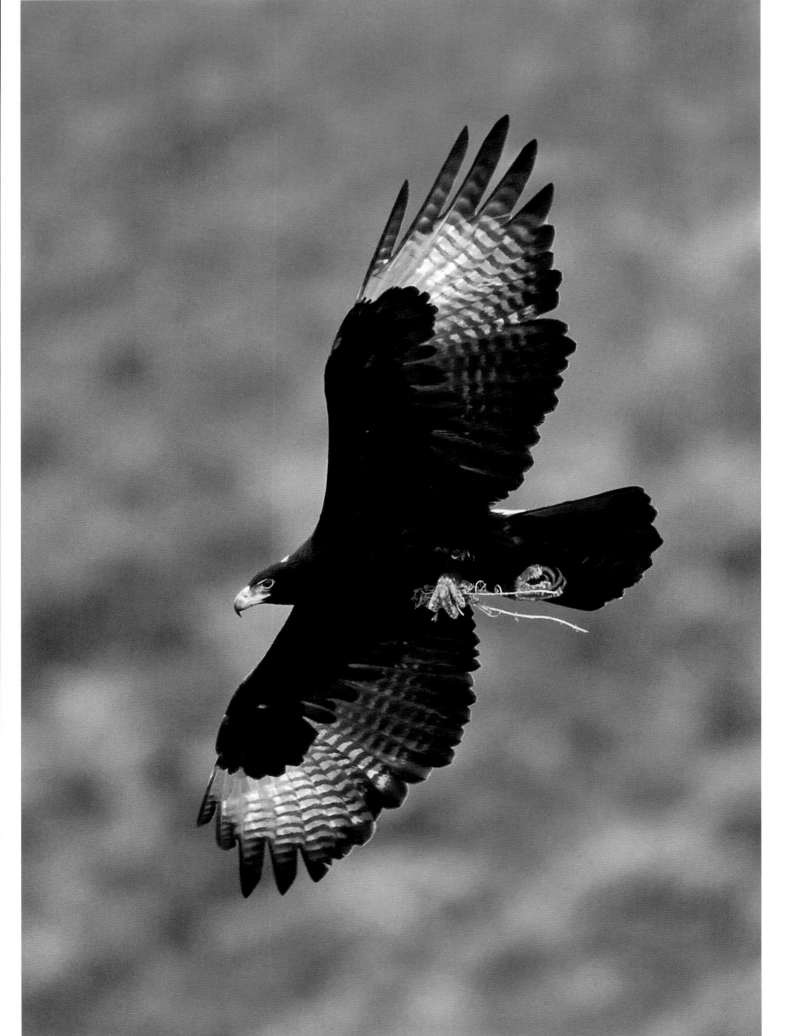

INTRODUCTION

My first eagle was a Golden. I was seven years old, enjoying a summer family holiday in the Scottish Highlands. My father spotted the bird cresting a ridge high above our picnic site. A mobbing common buzzard, just half its size, provided instant scale. Unfazed by its tormentor, the eagle continued its long, gliding trajectory, as though on an invisible zip line to the horizon, leaving the common buzzard circling aimlessly over our heads.

I was hooked. As a fledgling birdwatcher, common buzzards were exciting enough, but a "goldie" was as glamorous as a Siberian tiger or *Tyrannosaurus rex*. Admittedly, that first sighting was little more than a distant silhouette. But somehow that enhanced the mystique. I have since been lucky enough to see many eagles in many places, from Harpy Eagles in a Panama rain forest to Steller's Sea-eagles soaring across Kamchatka's smoking skyline, and each new sighting still quickens the pulse. It's that sense of being in the presence of a top-of-the-heap predator: an animal that holds life and death in its unflinching gaze and can exit our world with just one beat of its wings.

Of course, I'm not the first to feel this way. Few wild creatures have made more of an impression on the human imagination than eagles, elevated by their hunting prowess and flying skills to emblems of freedom and power worldwide. In our awe, however, we have often imbued them with human qualities, from courage to cruelty, that have no place in their evolutionary makeup. And in so doing, we have often courted misunderstanding. Eagles, sadly, have provoked hostility for as long as they have inspired reverence. Like all apex predators, they are persecuted for the menace they are thought to pose to livestock and livelihoods. Their position at the top of their respective food chains' also leaves them first to suffer as habitats degrade and disappear. Today, many species are under threat.

This book is a photographic celebration of all the world's eagles. It aims to illustrate their sheer variety, showing how almost every corner of the world is home to one species or another, and to open a window on their intriguing lives.

The chapters are organized by habitat, grouping the birds loosely by shared environment rather than by taxonomy or geographical distribution. The text aims to demystify a little: while acknowledging what inspires us about eagles, it explains how these qualities arise from simple adaptations for survival. Inevitably, some species proved easier to document than others—even finding an image for such little-known birds as the Papuan Eagle (p. 210) proved a serious challenge—but, to offer a complete picture, this book tries to represent every species. Mindful of the threats eagles face, it also spells out each one's current conservation status—from Least Concern to Critically Endangered—as listed by BirdLife International. It is my hope that, in celebrating the many wonders of these birds, this book will make a contribution toward securing their place in our world for generations to come.

What is an eagle?

The earliest eagles appeared some 35 million years ago. Feeding mainly on fish, these early birds were forerunners of today's sea-eagles. The group has since diversified prolifically, evolving to exploit the planet's ever-changing ecological niches. In the process, many species have come and gone. Haast's Eagle (*Harpagornis moorei*), which inhabited New Zealand's South Island, was one of the most recent to disappear. This 33-pound (15 kg) giant preyed on moas, huge flightless birds many times its own weight, and died out around 1400, when the Maori people finished off its food supply.

Today's eagles belong to the Accipitridae family, which embraces hawks, kites, harriers, common buzzards, Old World vultures, and most other modern raptors. Scientists recognize up to seventy-one species, spread across twenty-three genera. The precise number depends on which taxonomic authority is followed, as ongoing molecular research leads to the "splitting" of some species and the shifting of others between genera. The sixty-eight species described here are those recognized by BirdLife International at the time of going to print. But,

OPPOSITE The Verreaux's Eagle is a large African species that embodies, in its size, power, and mastery of flight, all the qualities associated with these impressive birds of prey.

whatever the number, you need not be a scientist to appreciate the diversity. These birds range in size from the pigeon-sized Pygmy Eagle (p. 216) to the immense Steller's Sea-eagle (p. 230). They occur on every continent except Antarctica and have embraced a spectrum of habitats, from grasslands and deserts to mountains, wetlands, tropical forests, and oceanic islands.

Taxonomy aside, eagles can be loosely divided by appearance and behavior into four basic groups. Booted eagles make up the largest, with some ten genera—including *Aquila*, of which the Golden Eagle is a member. They range widely in size, but all have legs feathered to the toes, hence "booted." Sea-eagles are large eagles with broad, vulture-like wings and unfeathered legs. They inhabit wetland habitats, where they feed on aquatic prey and carrion, and include such well-known species as the Bald Eagle (p. 246). Snake-eagles are small to medium-sized eagles of Africa and southern Asia, specially adapted to hunting reptiles. Forest eagles comprise several unrelated genera that share similar adaptations for hunting among trees, including relatively short wings, and include such formidable predators as the massive Harpy Eagle (p. 164), plus various hawk-eagles in South America and southern Asia, known for their dashing pursuit of birds.

NATURAL-BORN KILLERS

Eagles, let's face it, are killers. It's how they survive. Some are big enough to target small antelope; others have evolved for a more specialized menu, such as snakes or fish. Hunting techniques reflects habitat. In open country, eagles may soar great distances, scanning from on high, or quarter the ground slowly to ambush prey. In forest habitats, they pursue a sit-and-wait approach, scanning from a strategic perch and then dropping down on prey or dashing out to grab it in flight.

Many species are highly versatile. The Golden Eagle, for example, uses up to seven hunting techniques, including "riding" larger mammals such as small deer until they collapse, and dropping tortoises from on high to smash their shells. Tawny Eagles, highly capable predators, will also scavenge alongside vultures at a carcass or snap up termites from a breeding swarm. Indeed, many eagles turn to carrion, where available. And some, notably sea-eagles, are adept kleptoparasites—pirates that harass other hunters for their catch.

In many ecosystems, eagles are among the most powerful of all predators, occupying an ecological role on par with that of large mammalian carnivores. Indeed, in some environments, eagles are the most powerful of all predators: Harpy Eagles, for

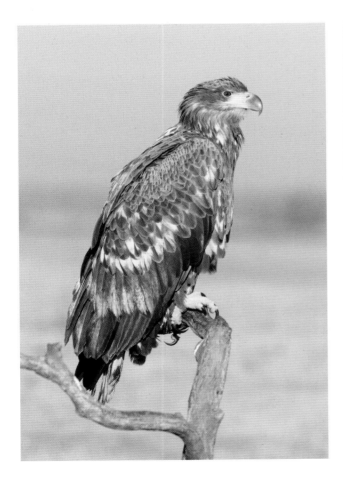

ABOVE Eagles, such as the White-tailed Eagle (left), belong to the Accipitridae family along with most other diurnal birds of prey, including the common buzzard (right). All share a similar hooked bill and sharp talons.

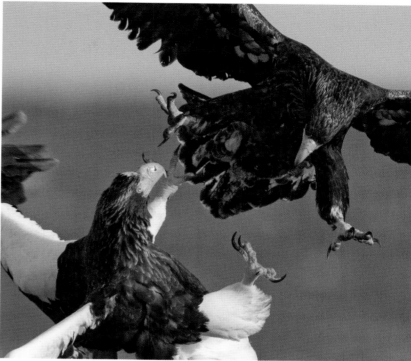

example, occupy the equivalent niche in South America's rain forest canopy to that of jaguars on the forest floor. The basic laws of ecology dictate that apex predators can never be numerous or the food pyramid would become top-heavy and break down. Thus, while some species are widespread, eagle numbers are always necessarily lower than those of most other birds.

Perhaps the ultimate expression of our respect for eagles is the fear that we ourselves might fall victim. Giant eagles carrying people off have appeared in myth since ancient times, and the idea has spawned numerous fantastical "true stories." A few large eagles are capable, in principle, of killing a small human infant, but we are not a prey species to which they are adapted, and most such stories can be dismissed as lurid fantasy. Africa's Crowned Eagle (p. 144), however, may be one exception: there are credible records of human remains found in nests and even fossils of prehistoric hominids that appear to have been predated by this fearsome bird.

FIT FOR PURPOSE

One glance at an eagle's talons, and you know it's a predator. A Harpy Eagle's huge feet are equipped with claws longer than a grizzly bear's. These lethal digits can exert a crushing force of 440 pounds per square inch (309,350 kgf/m²): more acute than the jaws of a pit bull terrier. They perform multiple tasks: killing prey outright, by crushing its skull or piercing its vital organs; securing a hold on the struggling victim; pinning down the carcass while plucking or dismembering it; and clinging on

tight as the prey is carried away. The talons are also formidable weapons, enabling the bird to strike vicious blows when battling others over a carcass or defending itself against an assailant.

Eagles have a proportionally larger bill than all other raptors except the very biggest vultures. This fearsome appendage serves not so much for killing prey as for butchering the carcass: plucking and tearing with the hooked tip, and gouging with the blade-like edges, an eagle can extract every last scrap of meat. It is made of keratin, the same substance of which fingernails are formed, and keeps growing throughout an eagle's lifetime in order to counter wear and tear.

"Eagle-eyed" is no empty phrase. The eyesight of these birds is among the strongest in the animal kingdom—some four to eight times stronger than ours, and able to spot a rabbit from 1.8 miles (3 km). Like all predators, its eyes are set on the front of the head, allowing the depth perception required for an accurate strike. The large pupils maximize the light that reaches the retina, where the unusually light-sensitive fovea allows exceptional resolution, clarity, and color vision, enabling an eagle to spot camouflaged prey from afar. The bird's penetrating expression comes from its prominent brow ridge, which protects the eyes from the claws of struggling prey. A transparent third eyelid, the nictitating membrane, sweeps like a windscreen wiper across the eye to keep it clean.

Eagles are wonderful flyers, able to soar high, glide vast distances, and plunge at terrifying speed on their quarry. Their low "wing-loading"—the ratio of mass to wing surface

TOP LEFT A Crowned Eagle clutches a vervet monkey it has captured. This African forest species is a specialist predator of primates.

TOP RIGHT Two Steller's Sea-eagles fight over a carcass, revealing both their impressive talons and surprising aerial agility for birds of such great size.

area—maximizes their ability to gain lift from thermals and updrafts. By soaring on outstretched wings, an eagle can gain height without flapping, and by folding them back and closing the slots between the tapered primaries, it can enter a long horizontal glide. A Golden Eagle has been known to accelerate this glide into a controlled dive of over 155 mph (250 km/h). Forest eagles have broader, shorter wings than open-country species, giving them quicker acceleration and increased agility.

Eagles are not known for colorful plumage. Most species sport some combination of black, brown, gray, and rufous—often streaked, spotted, or barred—which offers basic camouflage when at the nest or approaching prey. A few are more boldly colored. The *Haliaeetus* sea-eagles have snow-white heads and/or tails, which provide conspicuous territorial advertising and, as the birds prey largely on fish, does not alert their prey. Like all birds, eagles renew their plumage annually. For their first few years, until they reach breeding maturity, the color and pattern of this plumage changes with each molt. Immature birds are thus easily distinguished from adults. Immature Golden Eagles, for example, differ from their parents by having white patches on their wings and tail. The extent of this white decreases with each molt until, by year six or seven, they have acquired their complete all-brown adult plumage.

THE CYCLE OF LIFE

Most eagle species are monogamous and form life-long pairs, retaining the same territory and nest sites for years. Females are generally larger than males—notably among the larger *Aquila* eagles, in which a female may weigh 40 percent more than her mate. In spring, a pair consolidates its pair bonds with spectacular aerial courtship displays, which may include undulating "sky dances" from the male, and choreographed duets in which the pair lock talons and tumble from the sky, separating only metres above the ground. Eagles are also at their most vocal at this time. For such powerful birds, many have surprisingly feeble voices. *Haliaeetus* sea-eagles are an exception, however, with several species—notably the African Fish-eagle (p. 254)—celebrated for their ringing calls.

An eagle's territory varies in size. In remote mountainous terrain, where prey is scarce, it may be enormous—as much as 77 square miles (200 km²) for a pair of Golden Eagles. In areas of plentiful prey, it may be much less. Within its home range, each pair defends a smaller breeding territory, where it sites its nests—typically platforms of sticks, wedged in the fork of a tall tree and lined with leaves. Many nests are enormous: the Bald Eagle has built the largest recorded stick nest of any bird, measuring more than 20 feet (6 m) deep. Some species may also use a cliff ledge or reappropriate the old nest of another bird.

A female eagle typically lays a clutch of one to two eggs, sometimes more. She is largely responsible for incubation, while the male does most of the hunting. Once the hatchlings have grown strong enough, both parents hunt together in order to provision their voracious brood. Though many eagles lay two or more eggs, few produce more than one infant a season. This

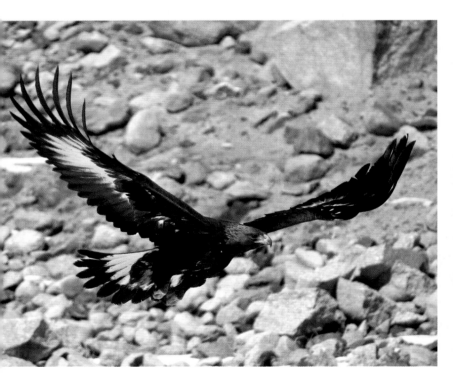

ABOVE The white patches on the wings and tail of this Golden Eagle reveal that it is an immature bird in its second or third year.

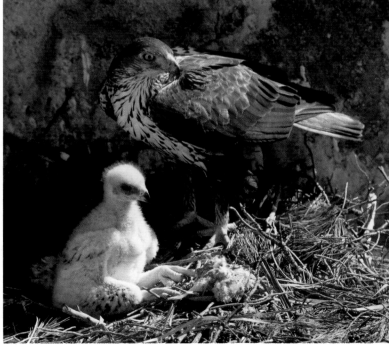

ABOVE A Bonelli's Eagle attends to its single chick, the only one of the clutch to survive. Like other Aquila species, this eagle habitually practises siblicide.

is often due to siblicide—the killing of the smaller chick by its older, larger sibling. This practice is common across several genera (though not all: it is rare, for example, in sea-eagles), and comes down to size and timing. An eagle's eggs hatch two or three days apart. The first hatchling bullies, attacks, and starves its smaller sibling, which, with the parents doing nothing to intervene, soon perishes. Though it may seem wasteful, this brutal practice does make evolutionary sense. For breeding success, a pair of eagles need raise only one chick. With food unreliable and new hatchlings vulnerable, a second chick serves as backup. But once the first starts growing healthily, the second is no longer needed. Indeed, its demise may save the parents some hard work down the line.

Growing up is a slow process in eagles. In some species, a chick takes over three months to fledge, after which it remains in its parents' care, receiving food and honing its hunting skills; for many months more—up to eighteen months in extreme cases, such as the Crowned Eagle (p. 144). Such exhausting dedication to parenting means that some species breed only once every two or even three years, a slow productivity rate that proves problematic for populations in decline. The first two or three years after leaving its parents' care represent the most hazardous period of an eagle's life. At this time, immature birds wander widely in search of food and territory. If they survive, however, many go on to live long lives. Some species may last thirty years or more in the wild, and even longer in captivity.

Most eagles are largely solitary. They seldom flock, other than when—in certain species—gathering at local sources of abundant food: for example, Bald Eagles and Steller's Sea-eagles at spawning salmon grounds. A number of northern species are migratory, heading south in winter to warmer climes when food becomes scarce on their breeding range. During migration, they may become more gregarious, especially when passing through migration bottlenecks such as the Strait of Gibraltar. Tropical species, assured of a reliable year-round supply of food, are more sedentary.

Icon and inspiration

If one animal warrants the cliché "iconic," it is surely the eagle. From earliest recorded history, the idealized qualities of these birds—power, pride, courage, freedom, and so on—have elevated them to emblems, working their way into everything from religious ceremonies to pop music. The Golden Eagle, for example, is the national bird of Albania, Egypt, Afghanistan, Germany, and Mexico. Other eagles afforded a similar honor include the Javan Hawk-eagle (Indonesia), the Harpy Eagle (Panama), the Philippine Eagle (The Philippines), the Spanish Imperial Eagle (Spain), the Bald Eagle (United States), and the African Fish-eagle (Zambia).

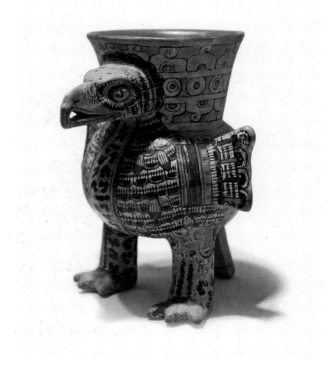

TOP RIGHT A sculptured wall relief (865–860 BCE) from the Temple of Ninurta, at Nimrud, the Assyrian capital of northern Iraq, depicts an eagle-headed protective spirit.

ABOVE A ceramic eagle vessel from eastern Nahua in Mexico, dating from the thirteenth to early sixteenth century.

INTRODUCTION

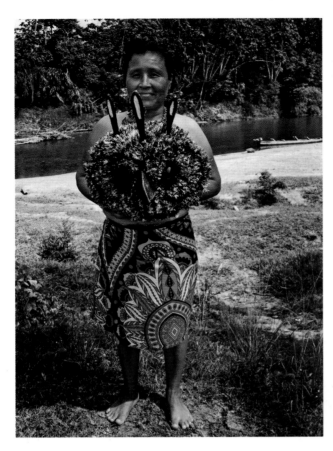

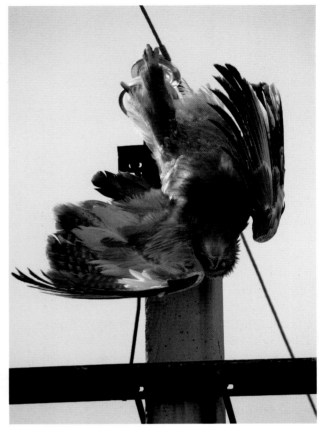

Leaders throughout history, from the ancient Egyptians to the Ottomans, have drawn on the eagle's association with power. Most significant was the Holy Roman Empire (27 BCE–395CE), whose legions swept across Europe bearing the *Aquila* as their standard. The honor of carrying the eagle went to an *aquilifer*, or eagle-bearer, and a lost standard meant disgrace and disaster. Others to have harnessed the eagle to similar ends include Charlemagne, Saladin, Napoleon, the U.S. Army, and, most notoriously (don't blame the eagle), the Nazis.

Eagles have also played a spiritual role in many cultures, often interceding between humankind and deities. In ancient Greece, an eagle was the totem of Zeus, who took the bird's form when swooping down to carry off Ganymede to Mount Olympus; in ancient Norse mythology, an eagle sat on top of Yggdrasil, the giant tree of life that ran through the universe. In Celtic mythology, the eagle was hailed as an oracle, foretelling an army's fortunes in battle (a high soaring eagle meant victory). In the Anglican tradition, an eagle commonly appears carved into a pulpit, its spread wings symbolizing the spread of Christianity around the world. In Hindu lore, the eagle figure Garuda is the mount of the god Vishnu, while in Japanese myth, the eagle takes the form of the Tengu, a half-bird/half-human monster that acts as protector of the mountains.

Nowhere has the eagle enjoyed greater spiritual significance than among the native peoples of North America, where many tribes, including the Apache, Cherokee, and Navajo, revered this bird as sacred, celebrating its powers in rituals. Eagle feathers were bestowed upon warriors who had proved their bravery in battle; the spectacular headdresses worn by senior warriors required the feathers of at least five eagles. Today, eagles are still held sacred in Native American communities, and the custom of awarding feathers has extended to such contemporary rituals as high-school graduation. Under the 1978 American Indian Religious Freedom Act, legally certified Native Americans may still acquire a license to obtain eagle feathers for spiritual reasons.

Western culture has celebrated eagles in numerous other forms. We have driven in eagle cars (the Chrysler Corporation's Eagle Talon), flown in eagle aircraft (the Cessna 421 Golden Eagle), hit "eagles" in golf, and watched eagles play American football (Philadelphia Eagles). We have seen Richard Burton in *Where Eagles Dare* (1968) and Robert Redford in *Legal Eagles* (1986), and have sung along to anything by The Eagles. But there is surely no finer poetic expression of our fascination than "The Eagle" (1851) by Alfred, Lord Tennyson, whose opening line, "He clasps the crag with crooked hands," has become the textbook example of alliteration for schoolchildren everywhere.

Our admiration for eagles has also seen us attempt to harness their powers to our own ends. Falconry, the hunting of live prey using trained raptors, has its origins in Central Asia some 4,000 years ago. In medieval Europe it was popular among the nobility, with King Harold of England depicted in the Bayeux Tapestry carrying a hawk on his wrist, and only fell into decline in the nineteenth century with the advent of firearms.

ABOVE LEFT An Embera woman from Nuevo Vigia village in the Darién, Panama, displays a traditional Harpy Eagle mask made from palm fiber.

ABOVE RIGHT An electrocuted Steppe Eagle hangs dead from a power line.

In falconry's strict hierarchy of raptors, eagles have always held top spot. The size and aggression of the largest species make them hard to train. In the Tien Shan mountains of southern Kazakhstan and western Mongolia, however, a dedicated band of hunters have perfected the art of hunting with Golden Eagles. Known as *berkutchy* in Kazakh, this ancient sport takes place among the Kazakh and Kyrgyz people and involves a lifetime's dedication, with bonds between hunter and bird lasting more than twenty years. Today, some 250 eagle hunters remain, each having inherited the tradition from their father.

EAGLES UNDER THREAT

Despite our admiration for eagles, we have not made their lives easy. In some parts of the world they continue to suffer persecution, shot or poisoned in retaliation for alleged predation on livestock, or even hunted for sport. Even more serious is the damage we have done to their environments: deforestation, commercial agriculture, and pollution have all robbed eagles of the habitats they need for breeding and hunting, while insecticides and other toxins have often poisoned the birds themselves—for example, the advent of DDT in the 1950s and 1960s wiped out the Bald Eagle across much of the United States. More recent hazards include manmade obstacles such as wind turbines, which in some areas take a heavy toll on dispersing young eagles. Low population densities leave eagles highly vulnerable to environmental threats, and—having low reproduction rates—such populations are slow to recover. It is thus unsurprising that many species are under threat. Today, the International Union for Conservation of Nature (IUCN) lists three as Critically Endangered, nine as Endangered, and another twenty-three as Near-threatened or Vulnerable.

Conservationists are on the case. BirdLife international and its partner organizations around the world are working to protect eagles, whether through increased protection for their habitats or lobbying and education to prevent their persecution. Proactive measures include reintroduction of eagles to their former homes—such as that of White-tailed Eagles (p. 238) to Scotland. Meanwhile, eagles bring pleasure to many people: from conservationists, who know that these birds are vital indicator species of a healthy environment, to birders, who race around the globe ticking off as many species as they can. And then there are those who simply love the wild, for whom that soaring silhouette over a ridge or proud stance atop a treetop represents all that is most stirring about the natural world.

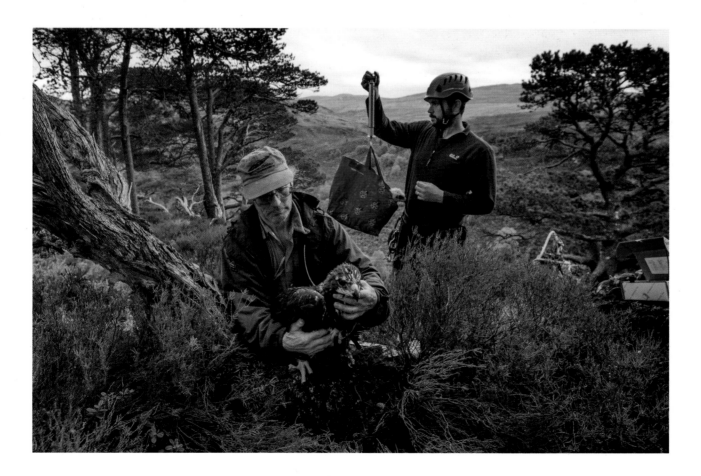

ABOVE Researchers weigh Golden Eagle chicks during a survey of Scotland's Golden Eagle population in 2015.

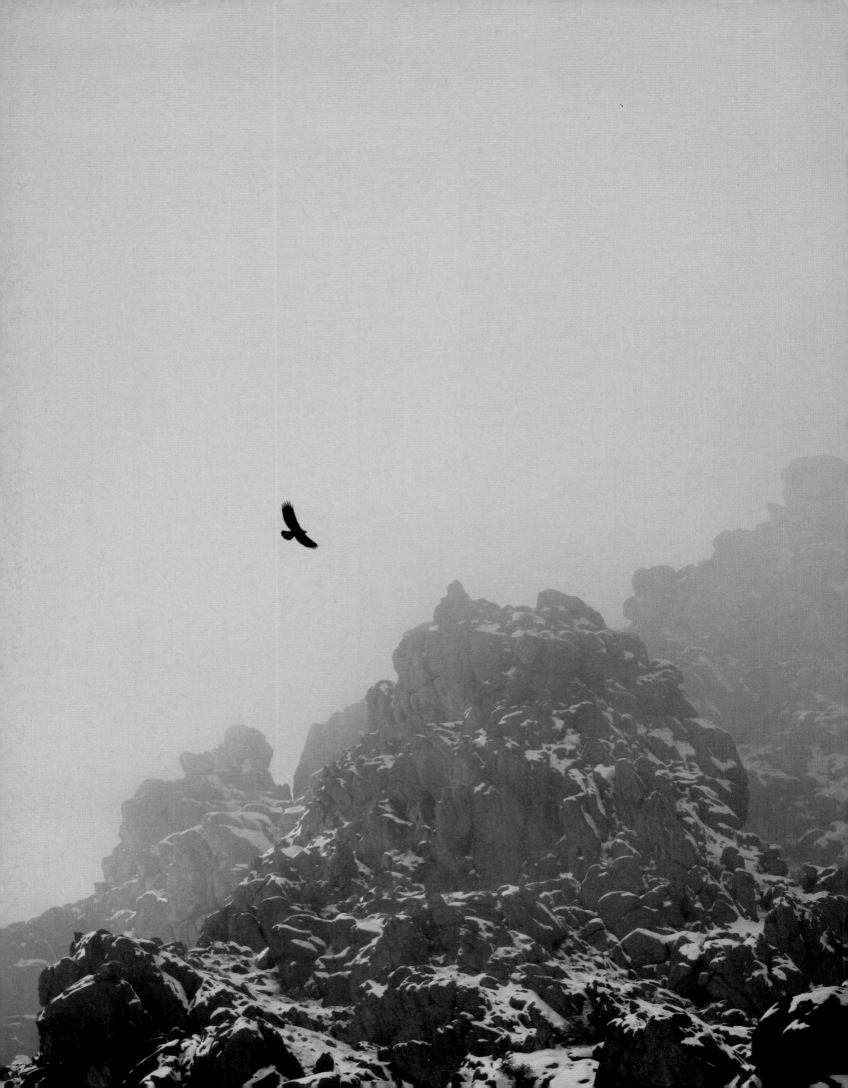

01 | HUNTERS OF THE UPLANDS

THE TITLE OF THE CLASSIC World War II movie *Where Eagles Dare* (1968) perfectly encapsulates the popular idea of an eagle's home: namely a rocky mountaintop, out of reach of all but the most adventurous (in this case, Richard Burton and Clint Eastwood doing battle with Nazis in the Bavarian Alps). It is an image celebrated in the eagle of Alfred, Lord Tennyson's famous poem, which "clasps the crag with crooked hands" and "watches from his mountain walls." In our mind, eagles and mountains go together. We see these birds as inhabiting a world above and beyond our comfort zone.

This concept owes much to one species: the Golden Eagle. It is the world's most widespread eagle, and across many large tracts of the Northern Hemisphere it is pretty much the only eagle, and so has received a disproportionate amount of attention. Golden Eagles live in mountains, or at least in high-altitude uplands. Even those in lowland regions are confined largely to steep, rocky terrain. The typical view is from far below, while one soars along a distant ridge high above.

On a global scale, however, this is not typical eagle terrain or behavior. Although the easy, soaring flight of these large raptors may seem tailor-made for the mountains, relatively few of the world's sixty-eight eagle species occur predominantly at high altitudes. And with good reason: life in the mountains is hard—especially when it comes to finding food. The harsh climate, together with associated factors such as thin soils and extreme topography, makes for a reduced biodiversity, with the number of species falling the higher you climb. There is far less prey available to eagles in the highlands than in lowland habitats such as forests and grassland. Finding enough food to survive means combing vast areas—often fruitlessly. And when winter closes in, the food supply dwindles even further, obliging many species to migrate to the lowlands.

Mountain eagles are thus specialists, reliant largely on a small selection of prey species. The Golden Eagle, for example, subsists in many regions on mountain hares, alpine marmots, and ptarmigans—all hardy animals specially adapted to life at altitude. Africa's closely related Verreaux's Eagle, which always occurs in rocky terrain if not always at high altitude, feeds almost entirely on the rock hyrax—a marmot-sized mammal that lives on cliffs, rock faces, and boulders.

While prey may be scarce, the open terrain and reduced vegetation mean it is often visible from afar—and the mountain updrafts allow eagles to rise to great heights with minimum effort and to scan over a vast distance. The birds have developed hunting techniques that suit the terrain: they soar along ridges, searching for prey on both sides, then drop unseen upon their target from high above; or quarter low over the ground, hugging its contours and using dips and ridges to ambush prey that flushes from beneath them.

And when it comes to breeding, mountains tend to reduce an eagle's competition—both from other species and from other individuals of its own. Nests are typically spaced far apart. The terrain also offers highly secure nest sites in the form of cliff ledges or trees growing on steep slopes. Some species, such as Bonelli's Eagle, may breed in mountainous terrain but descend to nearby lowlands for hunting.

There are also mountains in the tropics, of course. Though generally free of snow, except for the very highest, they are nonetheless exposed environments, subject to low temperatures, high winds, and heavy rainfall that restrict plant growth and create specialized habitats such as cloud forest. A number of eagles have adapted to these conditions. In tropical Asia, the Kinabalu Serpent-eagle and Mountain Hawk-eagle are both highland versions of closely related lowland species that have moved uphill, as it were, to establish niches of their own. In South America, the Mountain Solitary Eagle and Black-and-chestnut Eagle occupy similar roles.

Mountains pose challenges for the birdwatcher. The going is tough, the weather unpredictable, and the birds few and far between. But for those prepared to venture where eagles dare, the reward can be the stirring sight of these magnificent predators high over the most dramatic of backdrops.

OPPOSITE A Golden Eagle soaring high over the mountains of Ladakh, in the Indian Himalayas, embodies the popular image of all eagles.

GOLDEN EAGLE

AQUILA CHRYSAETOS

APPEARANCE
Very large and powerfully built; dark brown, with sandy/golden nape and gray patches on wings and tail; legs and base of bill bright yellow; immature eagles have white patches on primaries and tail; in soaring flight, spreads wings in shallow "V" with primary tips splayed; when gliding or diving, wings swept back.

SIZE
length 26–40 in. (66–102 cm) weight male 5.5–8.9 lb (2.5–4 kg),

female 7.2–14 lb (3.25–6.35 kg) wingspan 5 ft 11 in.–7 ft 8 in. (1.8–2.3 m)

DISTRIBUTION
Across northern hemisphere: in Europe, from Scotland, Spain, and the Alps to the Balkans and Scandinavia; in Asia, across Russia and China to Japan, Turkey, the Caucasus, and the Himalayas; also in the Middle East and North Africa; in North America, from Mexico through the western United States and across Canada.

STATUS
Least Concern

FOR PEOPLE IN MANY PARTS OF THE WORLD, the Golden Eagle is the definitive bird of prey. Deeply embedded in Western culture, it was the "standard" under which the Roman legions marched, "The Eagle" of Tennyson's celebrated poem, and today is enshrined as the national emblem of Albania, Germany, Austria, Mexico, and Kazakhstan.

This celebrity derives from the bird's impressive appearance and its predatory prowess. A formidable hunter, it may stoop at speeds of more than 150 miles per hour (240 kph) and kill animals as large as adult roe deer, using talons the length of a tiger's claws and a grip eight times more powerful than a human hand.

The Golden Eagle's hunting skills are nowhere more revered than in the Tien Shan mountains of Central Asia, where a small community of dedicated "eagle hunters" fly the birds to capture foxes and other prey in a unique and ancient practice, known in Kazakh as *berkutchy*. Elsewhere, however, it is less popular: farmers in many regions have long blamed Golden Eagles for taking lambs and other livestock, and the raptor has suffered centuries of persecution as a result.

To scientists, the Golden Eagle is the largest in the *Aquila* genus of "booted" eagles. On average, it is the seventh-heaviest eagle worldwide, with the fifth-largest wingspan. Size varies

between the sexes—females are 20 to 30 percent bigger than males—and across geographical regions. Appearance also varies a little by region, but adults everywhere are largely dark brown, with a paler nape that flashes gold in sunlight (hence the name) and gray areas on the wings and tail. They also have bright yellow legs and a yellow cere. Immature eagles have striking white patches on wings and tail, which shrink as they mature. By their fifth year, they are all brown, like adults.

In the field, a Golden Eagle's shape is more distinctive than its coloration—especially in flight, when its long neck protrudes farther than in the smaller eagles and common buzzards with which it might be confused, and its tail is longer than that of similar-sized sea-eagles. The massive wings form a distinctive shallow "V" when soaring, with the primaries splayed like fingers. When gliding or swooping they are swept back, with the fingers closed. A perched Golden Eagle radiates power, with prominent "shoulders" (the folded wrist joint) and a deep chest. It also reveals shaggy "pants" and tarsi (lower legs) feathered right to the toes—the latter feature distinguishing all *Aquila* eagles from *Haliaeetus* sea-eagles (see Chapter Five).

This is one of the most widely distributed of all raptors, ranging across the Northern Hemisphere. In Europe, it inhabits upland regions from the Scottish Highlands and Iberian Peninsula to Turkey and Scandinavia. In Asia, it ranges across Russia and China to Japan, the Caucasus, the Himalayas, and the central steppes. It also occurs in the Middle East and North Africa, with its southernmost breeding limit being the Bale Mountains of Ethiopia. North America has the largest population, however, ranging from central Mexico up through the western United States and across Canada. Scientists recognize six separate subspecies, which differ by size and plumage. The nominate race is the European one, *A. c. chrysaetos*. Others include the slightly smaller Iberian race *A. c. homeyeri* and the North American race *A. c. canadensis*, which is the most numerous. The largest is the Himalayan race, *A .c. daphanea*, while the smallest and darkest is the Japanese *A. c. japonica*.

OPPOSITE The Golden Eagle derives its name from the color of its long nape feathers.

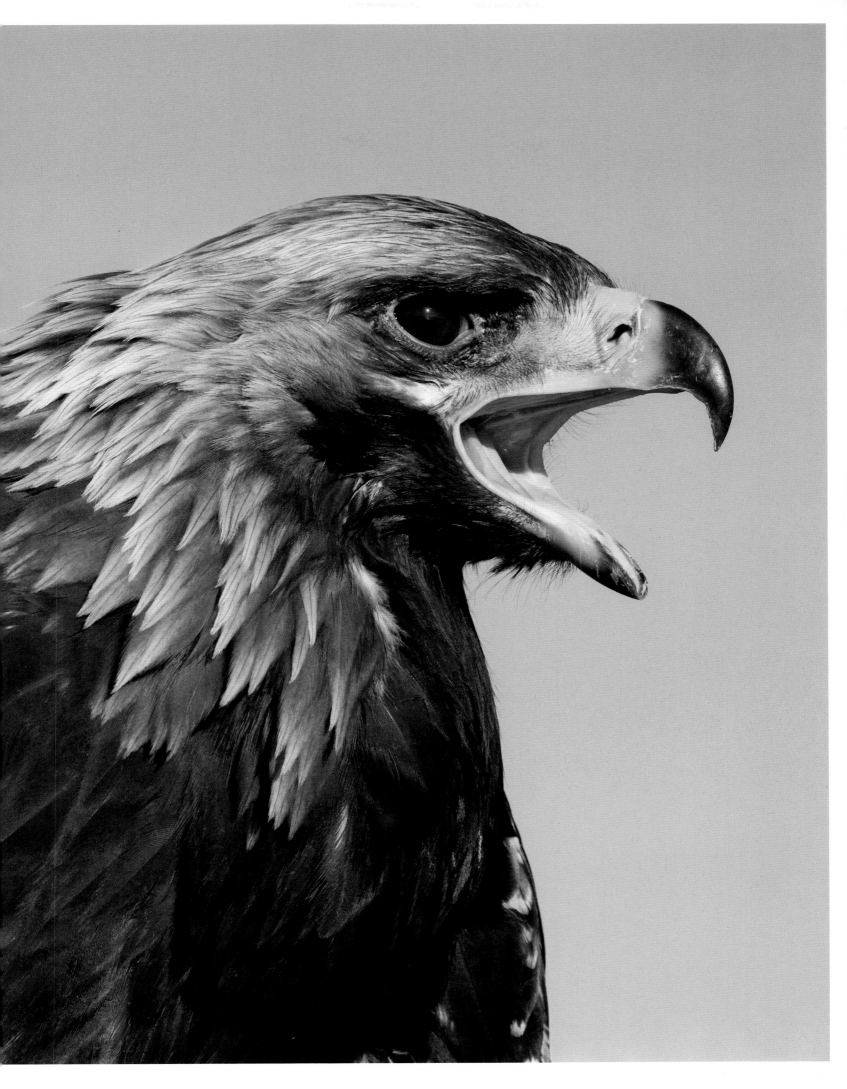

HUNTERS OF THE UPLANDS

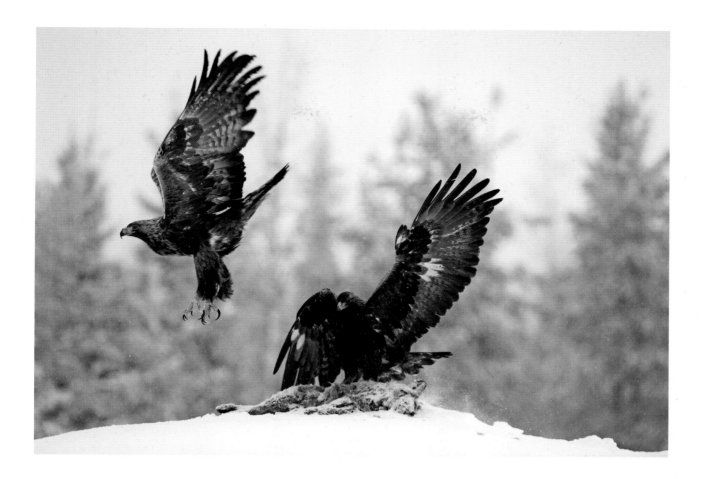

Wherever it occurs, the Golden Eagle requires large, undisturbed tracts of open country, generally with cliffs or escarpments for nesting. Although often associated with mountains—and recorded at 19,700 feet (6,000 m) in the Himalayas—high altitude is not a prerequisite, and it will also frequent semidesert, prairie, and steppe. Though it avoids dense forest, it occurs on the fringes of the taiga in Russia and Scandinavia, and the dry oak woodlands of Mexico and California. Populations in some northern regions are migratory but elsewhere it stays put, if resources allow. Immatures travel the farthest, when dispersing from their natal range.

This eagle is one of the most powerful and versatile of all avian hunters. Scientists have recorded more than 400 species in its diet worldwide, ranging from tiny songbirds to large mammals more than ten times its weight. Typical prey comprises small-to medium-sized, ground-dwelling animals of around 2.5 to 5 pounds (1−2 kg), with hares, marmots, and grouse all being staples in regions where they occur. Hunting technique varies, from a long attacking glide—the eagle first spotting its prey while soaring at great height—to quartering low over the contours of a hillside and snatching prey flushed into the open. When attacking a large mammal, it may latch on with its talons and "ride" the unfortunate victim to collapse. Predation on livestock is rare: eagles caught feeding on sheep carcasses have generally found the animal dead. These birds may be great hunters but they are also consummate scavengers.

Golden eagles need a lot of space to breed, with a range of up to 77 square miles (200 km²) occupied by a single pair. In spring, males perform spectacular "sky dance" display flights, to repel rivals and attract females—the latter often joining them in the air. Pairs usually mate for life. They build a stick nest—generally on a cliff or large tree. This structure grows larger each year and may exceed 8 feet (2.5 m) in width. In spring the female lays two eggs (occasionally three). These hatch after forty-one to forty-five days, with the parents sharing incubation duties. The older chick is generally the stronger and will bully its weaker sibling, often to death. Chicks fledge after roughly seventy-five days but stay with their parents for another three months as they learn to fly. Within a year, they disperse.

Life is tough for young Golden Eagles, and many do not survive their first two years. Those that reach maturity will start breeding at about five years and may pass thirty in the wild. Natural predation is rare, but humans pose numerous threats, from deliberate persecution (by gamekeepers, farmers, and egg collectors) to the more insidious perils of pesticides and habitat destruction. Wind turbines also take a toll. Today, the Golden Eagle is classed as Least Concern by the IUCN, with an estimated 60,000 to 100,000 breeding pairs worldwide. However, populations in many regions have declined steeply since the Industrial Revolution, and continue to. In the United Kingdom, this is an Amber List species, meaning its population is low but stable, with an estimated 420 breeding pairs.

ABOVE During winter, Golden Eagles may gather to feed on carrion.

OPPOSITE Golden Eagles build eyries on cliffs and raise a single chick.

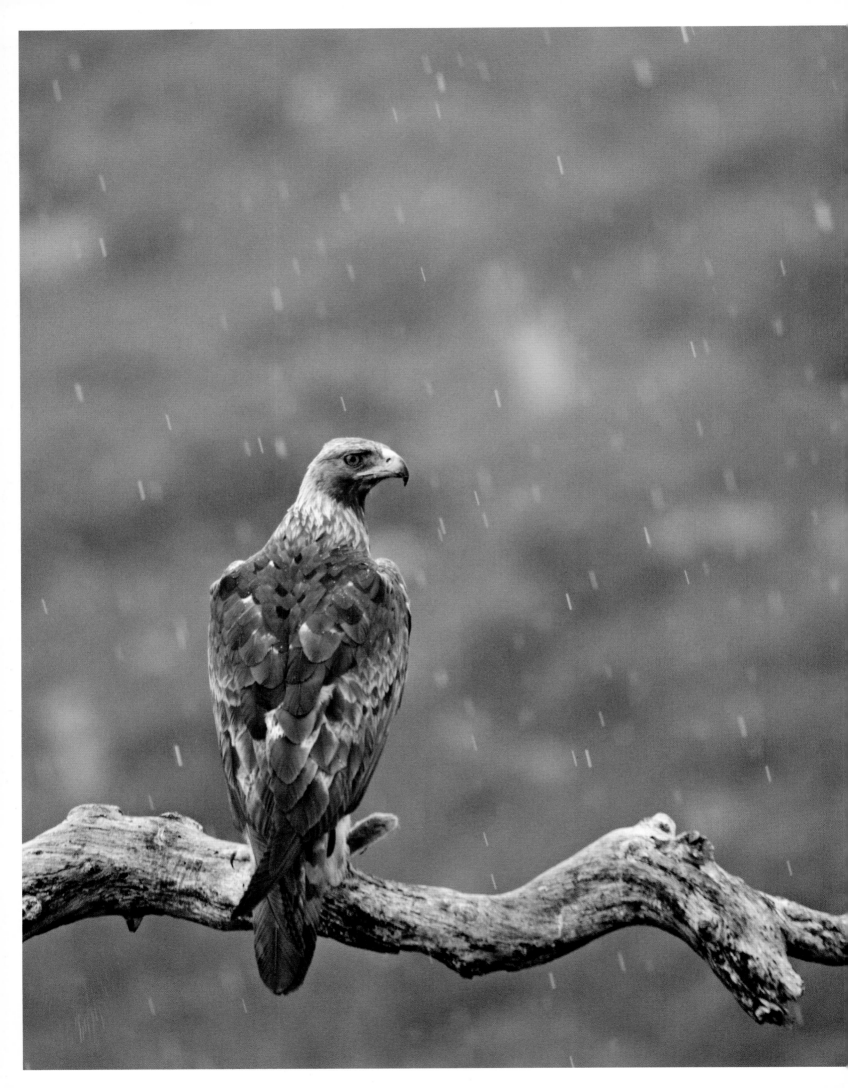

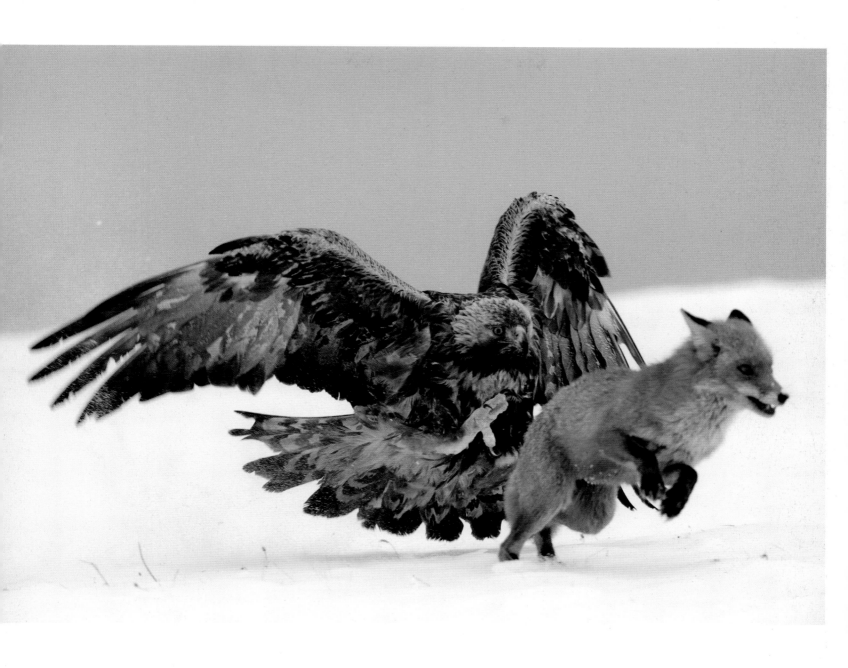

ABOVE A Golden Eagle drives a scavenging red fox away from a carcass. On occasion, this powerful raptor may also prey upon its rival predator.

OPPOSITE A Golden Eagle sits out a blizzard. This species endures some of the most extreme climatic conditions of any eagle, and is adept at finding food where few other raptors can.

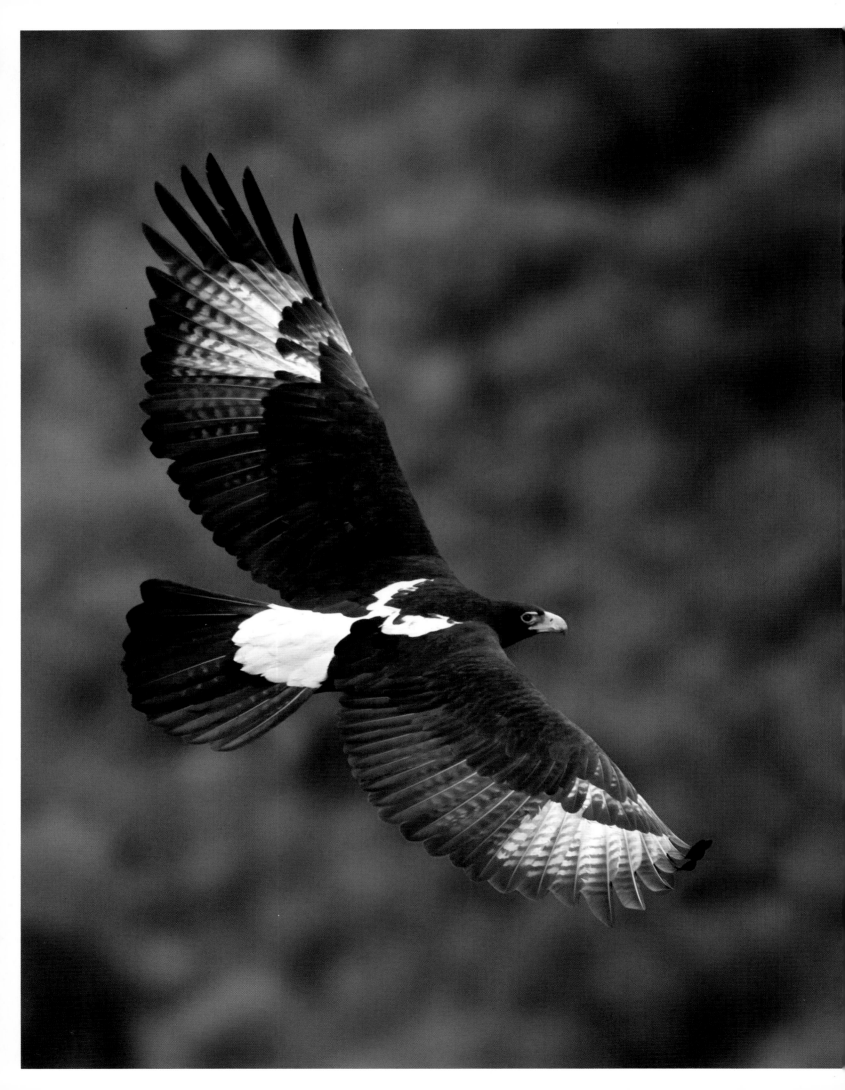

VERREAUX'S EAGLE

AQUILA VERREAUXII

APPEARANCE
Big and powerful; adults jet-black, with white rump and white "V" on back; bright yellow cere, eye-ring, and eyebrows; pale primary "windows" visible in flight; immatures brown with golden crown, cream pants, and rufous nape and mantle; flight profile shows wing shape with bulging secondaries and narrow wing-base; soars with wings in shallow "V."

SIZE
length 30–38 in. (75–96 cm)

weight males 6.6–9.3 lb (3–4.2 kg), females 6.8–15.4 lb (3.1–7 kg) wingspan 5 ft 11 in.–7 ft 7 in. (1.81–2.3 m)

DISTRIBUTION
Africa—mostly southern and eastern, from the Bale Mountains (Ethiopia) to the Cape of Good Hope (South Africa); also localized populations in West Africa and the Arabian Peninsula; confined to rocky habitats.

STATUS
Least Concern

IT'S EARLY MORNING ON AN African hillside. As rock hyraxes emerge from their granite hideaways to catch the first rays of the sun, a familiar shadow sweeps across the slope, and the hyraxes dash for cover. They re-emerge to watch their nemesis disappear. But too soon. A second eagle, the mate of the first, angles in from behind, massive talons outstretched.

Few raptors are more dependent on one prey item than is the Verreaux's Eagle. In many areas, this big eagle preys on little else: studies from the Matobo Hills in Zimbabwe show that these furry, rock-dwelling African mammals—which resemble guinea pigs but, bizarrely, are related to elephants—make up more than 95 percent of the bird's diet there. Such extreme specialization ensures that the lives of these two animals are closely intertwined. The eagle seldom occurs anywhere without a population of rock hyraxes.

This eagle is one of the world's most distinctive. In size and shape it is very similar to the Golden Eagle (p. 22), with a stout bill, long neck, and long, feathered legs. Indeed, it is one of the three largest eagles in Africa and the seventh or eighth heaviest in the world. In coloration, however, adults are unique among eagles. Their plumage is predominantly jet-black, and offset by bold white markings on the back, rump, and primaries— especially conspicuous in flight—and bright face markings.

The flight silhouette is also unique, with the narrow wing-base and broad secondary feathers creating a marked bulge in the wing. Immatures are dark brown with a patterning of golden, cream, and ginger. By five years of age, they have the smart black-and-white livery of their parents.

The Verreaux's Eagle was first described in 1830, commemorating the French naturalist Jules Verreaux, who visited southern Africa in the early nineteenth century. Scientists have since found that its similarity with the Golden Eagle is no coincidence. The two species are very closely related and, together with the Australian Wedge-tailed Eagle, vie for position as the largest of the *Aquila* booted eagles.

Thanks to the Matobo Hills studies—ongoing since the late 1950s—we know a great deal about the biology of this species; in particular, its dependency on the rock hyrax. In areas of lower hyrax density, it may turn to other mammals, from hares to monkeys, and once small antelope. A Verreaux's Eagle was even seen to kill a 33-pound (15 kg) young mountain reedbuck. Large birds, such as guinea fowl and francolin, sometimes also make the menu. Hunting is generally in a low-level quartering flight, with the eagle hugging the contours of cliffs or hillsides before dropping on the unwary victim. Pairs sometimes hunt cooperatively, with one bird flying past to distract the prey while its partner strikes from behind. Huge talons, larger and much more powerful than a human hand, quickly despatch the victim. The foot pad is about 20 percent bigger than a Golden Eagle's—a feature that is thought to be an adaptation for gripping the broad backs of hyraxes.

Although numerous predators, from pythons to leopards, target hyraxes, the Verreaux's Eagle faces little competition from other raptors. Conflicts between Verreaux's and Martial Eagles have been recorded, including one case in which the former stole a rock hyrax kill from the latter. The Bale Mountains of Ethiopia is the only place where the territories of Verreaux's and Golden Eagles regularly overlap—with the latter proving dominant in any conflict.

OPPOSITE A Verreaux's Eagle in flight is unmistakable, with its bold coloration, and the diagnostic bulge to the trailing edges of its wings.

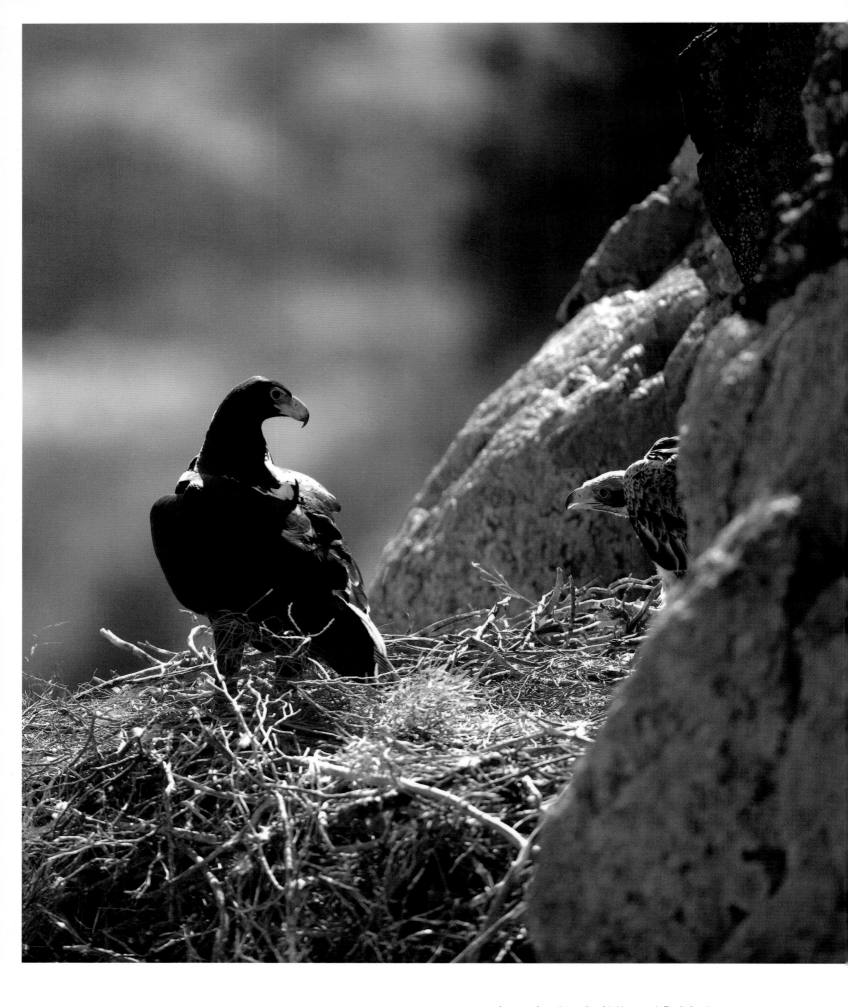

ABOVE At more than six weeks, this Verreaux's Eagle has its immature plumage, but may remain in the nest with its parents for another month.

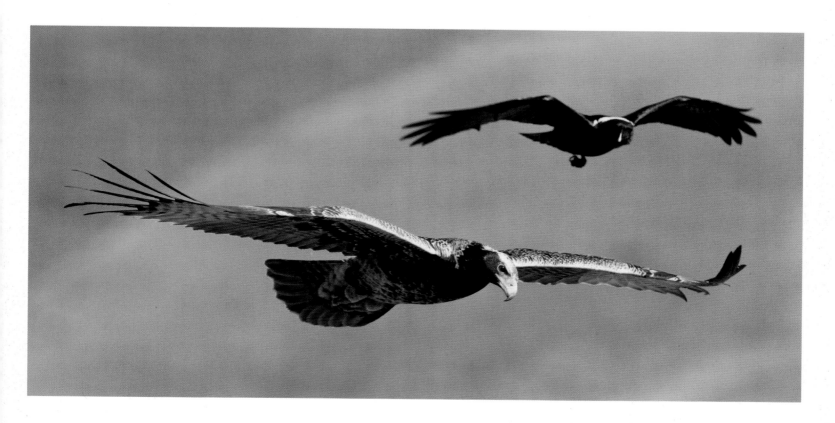

A pair of Verreaux's Eagles establishes a home range of 2.3 to 25 square miles (6–65 km²), its size varying with the local abundance of prey. Both male and female display over their territory throughout the year—to cement their pair bond and repel any other pairs or individuals that might covet their patch. The male's spectacular performance involves a high, undulating flight with long, steep dives, sometimes also incorporating rolls and somersaults. When a pair displays together, one bird may roll over and present claws in flight—or the male may fly behind the female with wings curved exaggeratedly upward.

The pair generally build their nests on cliffs, in a crevice or cave, or on an open ledge. These structures tend to be more broad than deep, measuring up to 71 inches (1.8 m) across, and are easily detected by the white droppings on the rocks below. Both adults help defend the nest from predators, sometimes even dropping sticks on intruders such as baboons. Females usually lay two eggs (one to three is known), at three-day intervals. Incubation lasts forty-three to forty-seven days, with the female doing most of the work and the male bringing food to her.

The Verreaux's Eagle, in common with other *Aquila* eagles, is an obligate cainist: in more than 90 percent of observed nests, the older, stronger chick has killed its younger sibling, either by starvation or direct attack. For the survivor, the first adult feathers appear at about thirty-four days, and by sixty days

full immature plumage has grown. Fledging takes ninety to ninety-nine days, substantially longer than in the Golden Eagle. Toward the end of this process, the female stops roosting with her chicks and instead perches with the male a short distance away. Family parties may stay together for up to six months after fledging. The young then disperse, but the adults remain on their home range for the rest of their lives.

Verreaux's Eagles occur across much of southern and eastern Africa, and very locally in West Africa and the southern Arabian Peninsula. There are notable populations in Ethiopia, Kenya, Tanzania, Malawi, Zimbabwe, Namibia, and South Africa. Favored habitat ranges from high mountains—up to 13,000 feet (4,000 m) in Ethiopia—to desert escarpments and eroded granite inselbergs (known in Africa as "kopjes") in savanna environments. In short, anywhere with rock hyraxes and rocks. They avoid human activity and development, although for many years a pair or two have nested in the Walter Sisulu Botanical Gardens, one of the most popular recreational areas in Johannesburg.

The IUCN classes the Verreaux's Eagle as Least Concern, with a population estimated in the tens of thousands. This species seldom eats carrion so, unlike many African raptors, is not seriously threatened by poisoned carcasses left out by farmers for scavengers such as jackals. However, it remains vulnerable to the loss or development of its habitat—in particular, any activities that reduce the population of its rock hyrax prey.

ABOVE A White-necked Raven harasses an immature Verreaux's Eagle in South Africa's Drakensberg Mountains.

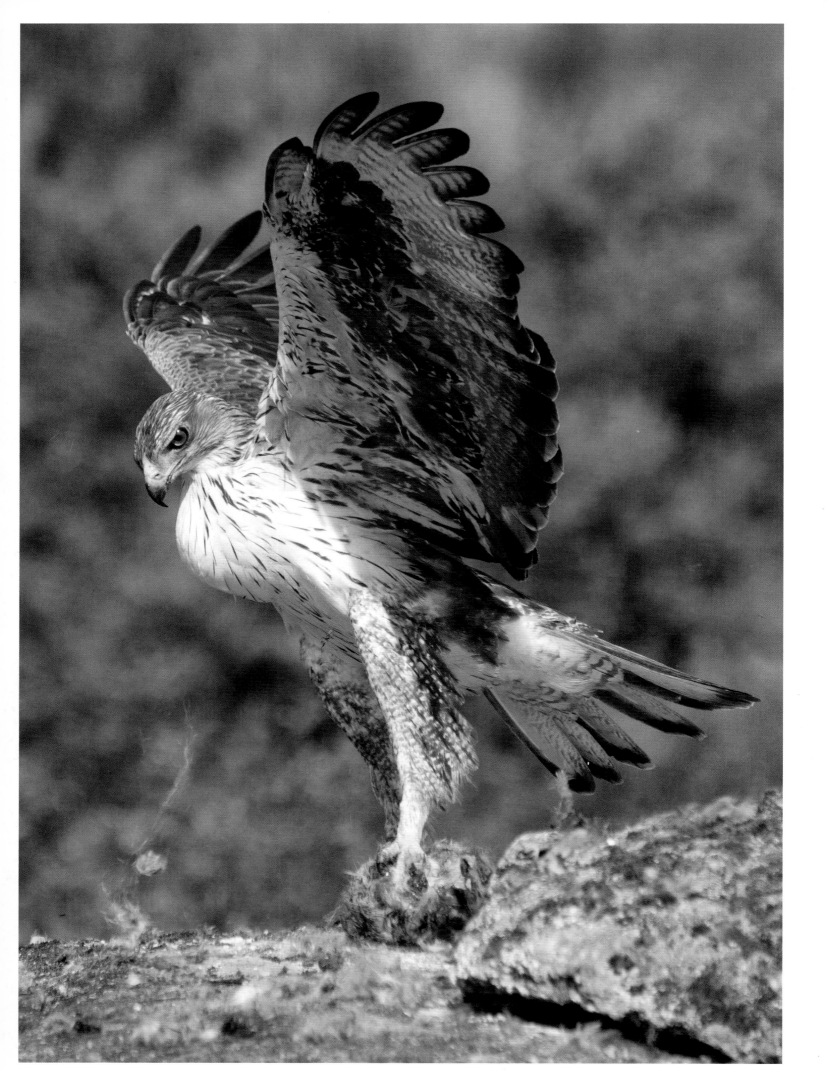

BONELLI'S EAGLE

AQUILA FASCIATA

APPEARANCE
Medium to large; brown upperparts with white patch on back; white underparts, finely streaked in black; pale underwings, with dark band along line of coverts and broad black terminal band to tail; feet and eyes yellow; immatures deep buff below, with no terminal band on tail.

SIZE
length 25–28 in. (65–72 cm)
weight 3.5–5.5 lb (1.6–2.5 kg)

wingspan male 59–63 in. (150–160 cm), female 65–71 in. (165–180 cm)

DISTRIBUTION
From the Mediterranean (southern Europe and North Africa) to eastern China, with scattered populations in Iran, the Arabian Peninsula, and the Indian subcontinent; separate subspecies on Lesser Sunda Islands (Indonesia.)

STATUS
Least Concern

THIS POWERFUL EAGLE IS less known than many *Aquila* species. It is neither as big nor as striking as a Golden Eagle, and in Europe its retiring behavior and declining numbers make it a rare sighting for the birdwatcher. Nonetheless, it is a formidable predator, and certainly looms large in the lives of the rabbits and other small game that share its Mediterranean home.

First described by Italian zoologist Franco Andrea Bonelli (1784–1830) in 1815, and later named in his honor by his French counterpart Louis Vieillot (1748–1830), the Bonelli's Eagle sits midway in size between a Golden Eagle and a common buzzard. Adults have largely brown upperparts, and white underparts streaked in black. In flight, they show a dark band along the underwing coverts and a broad black terminal band to the tail. The feet and eyes are yellow. Immatures are buff-brown.

The Bonelli's Eagle has a complex taxonomic history. Once thought conspecific with the African Hawk Eagle, the species was subsequently "split" from its relative. In 2005, based on new molecular data, the two species were reclassified—moved together from the *Hieraaetus* genus of hawk eagles to the *Aquila* genus of booted eagles. Today, scientists recognize two subspecies: the nominate race *A. f. fasciata*, which ranges from the Mediterranean across the Middle East and South Asia as far as China; and a smaller race *A. f. renschi*, which occurs only on Indonesia's Lesser Sunda Islands.

This is a shy species that generally frequents hilly and mountainous terrain, hunting over the scrubby slopes and in nearby woodland. Prey comprises mammals such as rabbits and birds such as pigeons and partridges, though may also extend to reptiles and large insects. Typically, the eagle spots its victim from the cover of a large tree then swoops down to capture it on the ground, although it may sometimes stoop from on high, or quarter hillsides like a Golden Eagle.

Breeding starts at around three years. Like many eagles in temperate regions, a pair builds up to six nests, switching between them from one year to the next. These are made of sticks and located either on a cliff ledge or in the crown of a large tree. In Spain, some are even built on electrical towers. Nests expand over years, reaching 6 feet (1.8 m) deep and 6 feet 7 inches (2 m) across. In Europe, breeding starts early, with the female typically laying two eggs from February onward. The chicks hatch after thirty-seven to forty days and fledge after a further fifty-five to seventy days. The chicks reach maturity at about three-and-a-half years. Pairs form life-long bonds; a lifespan of thirty-two years has been recorded in the wild.

Bonelli's Eagle has a large range and is not thought threatened globally. In Europe, however, it is endangered, with a declining population of just over 1,000 pairs. A large factor in the species' decline is adult mortality: many birds—up to 50 percent of those recorded in Spain—are killed in collisions with power lines; others are shot by hunters, who resent the eagle's predation on their own target species. The loss of habitat is a serious threat to breeding success, as is lack of food: rabbits have succumbed to disease and declined heavily around much of the Mediterranean. Today, there is a protection plan for Bonelli's Eagles in Europe, incorporating such measures as enforcing hunting regulations, protecting breeding sites from disturbance, and modifying power lines. Over the longer term, conservationists aim to encourage the bird to recolonize former haunts, including the Tramuntana mountains in Mallorca, where 2015 saw the first chick successfully raised.

OPPOSITE A Bonelli's Eagle takes flight with the remains of a rabbit it has captured.

ABOVE A hunting Bonelli's Eagle folds back its wings to accelerate into the dive, and swings its talons forward at the last moment.

RIGHT A female Bonelli's Eagle at her nest in Maharashtra, India. She has brought fresh green leaves to provide a soft lining for her two eggs.

OVERLEAF A Bonelli's Eagle in Spain scans the surrounding hillsides for rabbits.

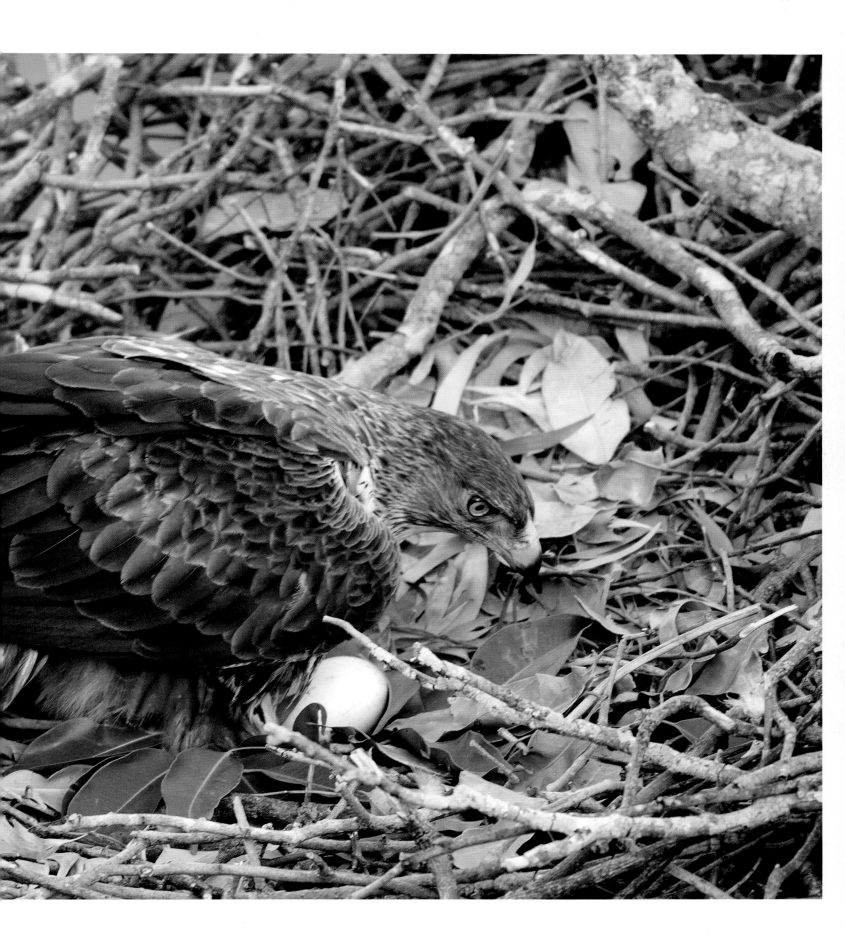

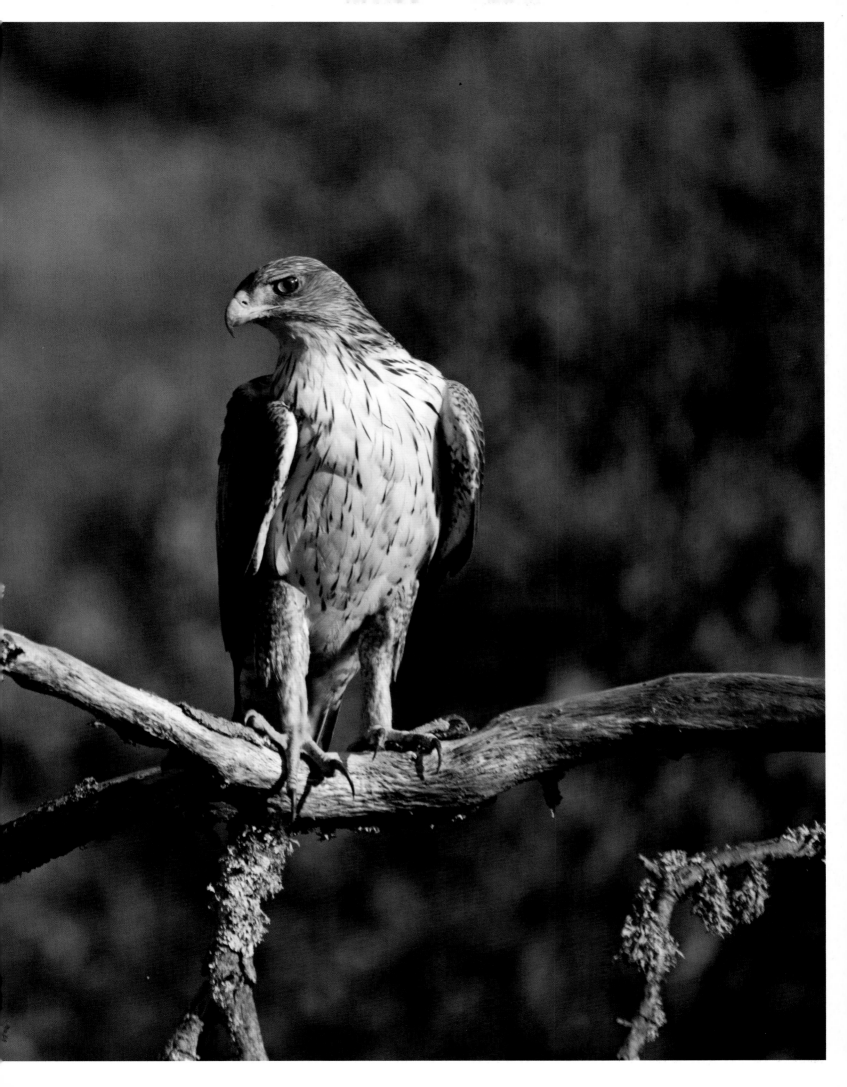

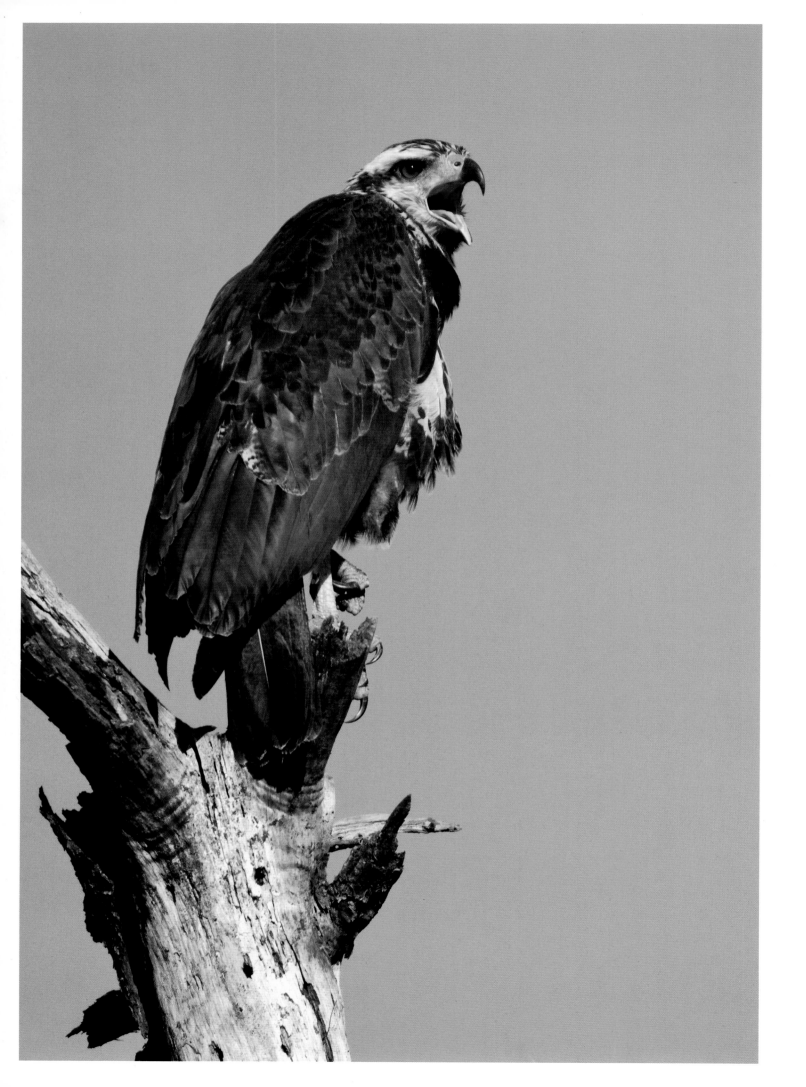

MOUNTAIN SOLITARY EAGLE

HARPYHALIAETUS SOLITARIUS

APPEARANCE
Medium to large; dark gray,
appearing black at a distance;
yellow feet and cere; white band
across center of tail and at tip;
immature plumage tinged rufous,
with paler stripes on face and crown.

SIZE
length 25–30 in. (63–76 cm)

weight 6 lb (2.75 kg)
wingspan 60–74 in. (152–188 cm)

DISTRIBUTION
Tropical and subtropical Central
and South America, from southern
Mexico to northern Argentina;
patchy distribution.

STATUS
Near Threatened

THIS RARE AND LITTLE-KNOWN EAGLE of Central and South America guards its secrets closely. In its rugged montane forest home it is a hard bird to spot. What's more, with its dark gray plumage and broad-winged profile, it is easily confused with both the Common Black Hawk (*Buteogallus anthracinus*) and Great Black Hawk (*Buteogallus urubitinga*), to which it is closely related.

A good view, however, reveals that this is a substantially bigger bird than either black hawk. It has a stocky build, with wings that appear exceptionally broad in flight and, when it is perched, reach to the tip of the short tail. Other distinctive features include a prominent white band across the tail and, in adults, a yellow cere and legs. Females have a slightly browner tinge to their plumage. Immatures are more rufous, with paler streaking around the crown and face. A slight crest is sometimes visible in adults.

Also known as the Black Solitary Eagle or Montane Solitary Eagle, this species was formerly classified as a subspecies of Crowned Solitary Eagle. Molecular evidence has since shown that the two are separate species, however, and also that both are more closely related to the hawk genus *Buteogallus* than to other eagle genera. The Solitary Eagle is a denizen of the mountainous forest, typically humid, densely wooded foothills at 1,970 to 7,200 feet (600–2,200 m) altitude. Rare observations of its hunting behavior suggest that its diet comprises a high proportion of snakes, including the tiger rat snake, which can be more than 6 feet (2 m) long. It uses the talons of both feet to clasp this prey in flight, helping it avoid any bites. Attacks are probably launched from a hidden perch in the canopy, the eagle dropping on to its prey from above. Other prey items recorded include chachalacas (pheasant-like gamebirds of tropical America), and a pair has even been observed hunting a deer fawn.

Very few Solitary Eagle nests have been observed. All those known have been sited in large trees and constructed from branches, with small twigs and green leaves used as a lining. Researchers conducting a study in the Mountain Pine Ridge area of Belize observed a pair raising a single chick in the fork of a Nicaraguan pine. In the process, they noted the unusual way in which adults transported food to the nest: instead of flying in a straight line, as most raptors do, they relied on thermals to carry them in soaring flight and thus followed a route dictated by air currents. This suggests that the distribution of this species may be limited to areas where the topography can reliably produce the conditions necessary for sustained flight.

BirdLife International lists the Solitary Eagle as Near Threatened, with a total population estimated at 1,500 to 4,000 However, given the bird's low population densities, rugged habitat, and extensive range, it is possible that the true figure is higher. The Belize Raptor Research Institute (BRRI) has been studying the Solitary Eagle since 2008, investigating its ability to persist in degraded and fragmented habitats. It hopes its findings will allow the institute to expand the network of protected areas on which the species depends.

OPPOSITE An immature Mountain Solitary Eagle has browner plumage than an adult, but shares the same short-tailed profile.

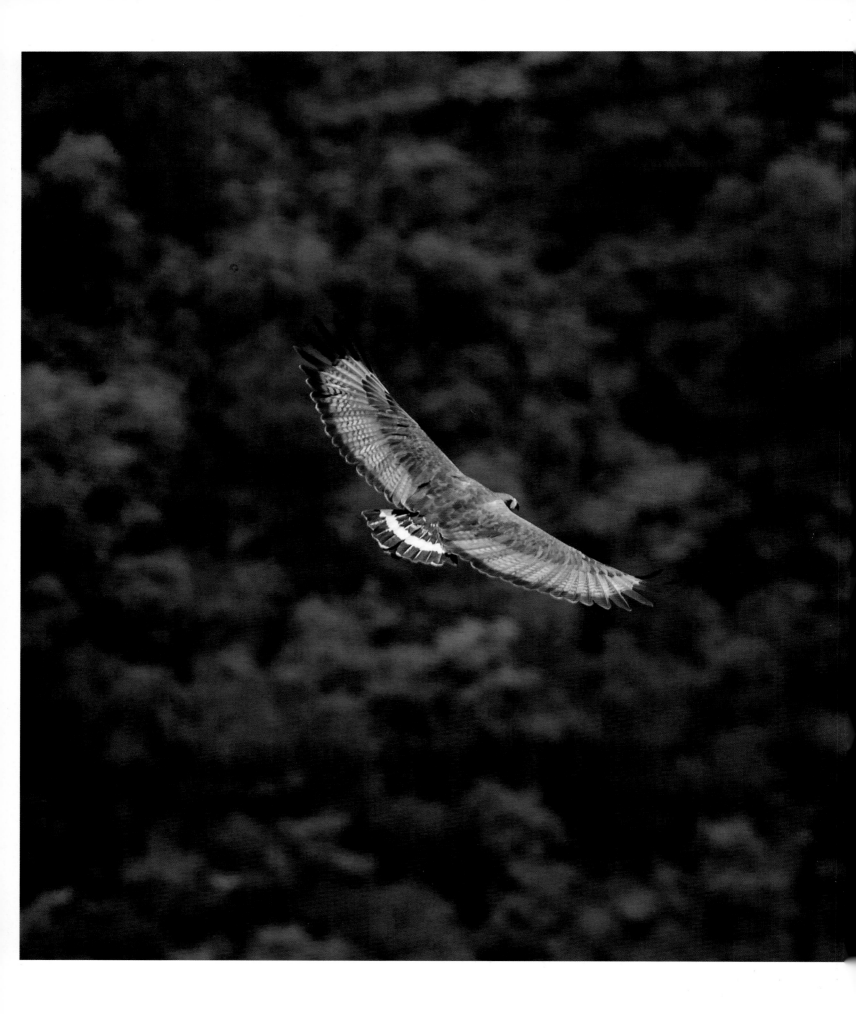

HUNTERS OF THE UPLANDS

LEFT A Mountain Solitary Eagle uses its broad wings to capture thermals and rise high over the forested mountainsides.

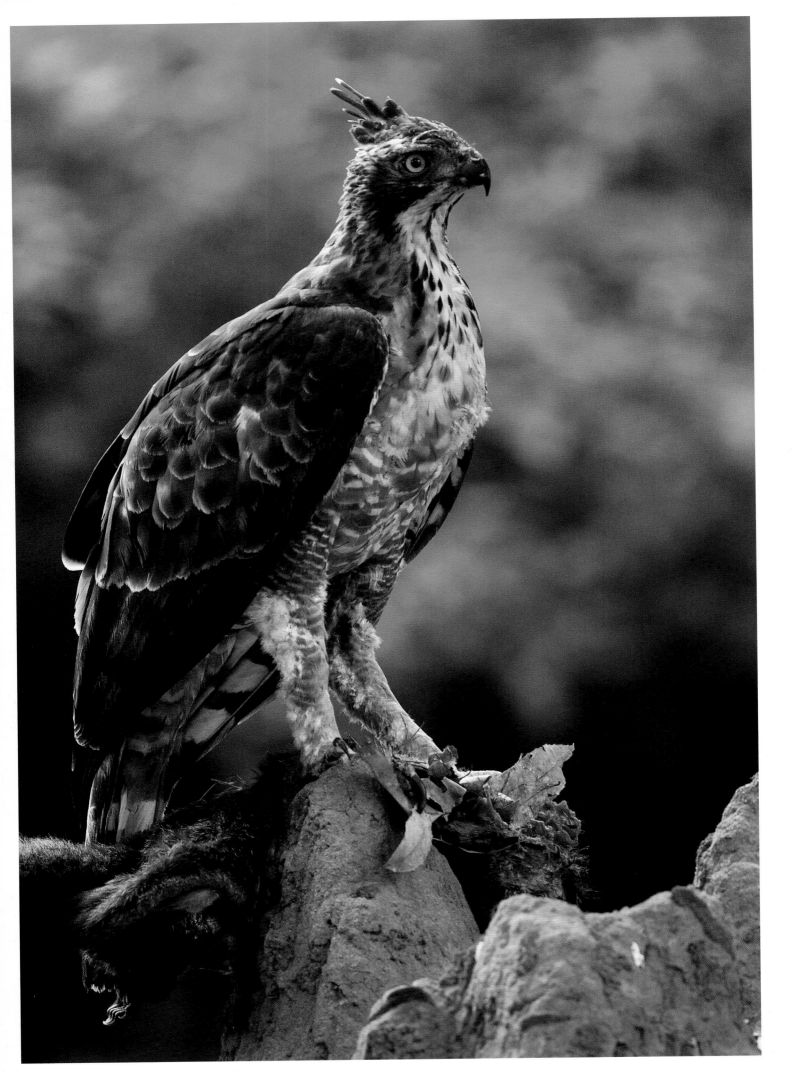

MOUNTAIN HAWK-EAGLE

NISAETUS NIPALENSIS

APPEARANCE

Medium-large brown upperparts; underparts pale with streaked throat, barred belly, and underwings; tail gray-brown above and white below with three black bands; black, pale-tipped crest; Japanese race (N. n. orientalis) larger and paler, with shorter crest; South Indian race (N. n. kelaarti) has unstreaked buff underwing coverts; immatures dark brown with buff/tawny underparts.

SIZE

length 27–33 in. (69–84 cm)

weight male 3.9–5.5 lb (1.8–2.5 kg), female 7.7 lb (3.5 kg)

wingspan 53–69 in. (134–175 cm)

DISTRIBUTION

Southern and eastern Asia, including the Himalayas, southern, north, and northeastern China, Taiwan, Indochina, northern Malay Peninsula, Japan, Russian Far East, and North Korea; South Indian race (N. n. kelaarti) in Southern India and Sri Lanka.

STATUS

Least Concern

THE MOUNTAIN HAWK-EAGLE BELONGS to the *Nisaetus* genus of hawk-eagles, which range widely across tropical Asia. With its prominent crest and densely barred plumage, it is typical of this group. However, it ranges higher into the uplands, having adapted to a high-altitude niche of its own.

This medium to large species is largely brown above, with a black, pale-tipped crest that serves to accentuate the penetrating yellow eyes. Its pale underparts are heavily streaked and barred, with three broad bands across the tail. Immatures have a plainer buff/tawny underside and often a paler head. They reach full adult plumage after three to four years. In flight, the broad wings have a pronounced curve to the trailing edge and are often held in a shallow "V"—a feature that helps distinguish this species from the Changeable Hawk-eagle.

Also known as Hodgson's Hawk-eagle, the Mountain Hawk-eagle occurs in two or three races—according to the latest taxonomy. The nominate race *N. n. nipalensis* occurs in the Himalayas, southern and eastern China, Taiwan, northern Indochina, the northern Malay Peninsula, and Vietnam.

A slightly larger and paler race, known as the Japanese Mountain Hawk-eagle (*N. n. orientalis*), inhabits the Russian Far East, North Korea, northeastern China, and Japan.

To complicate matters, a third race, known as Legge's Hawk-eagle (*N. n. kelaarti*), is regarded by some authorities—but not by BirdLife International—as an entirely separate species, based on differences in morphology, plumage, vocalization, and DNA sequences. It occurs in Sri Lanka and southern India, and has buff, unstreaked underwing coverts.

The Mountain Hawk-eagle inhabits a variety of forest types, and occurs mostly at 1,970 to 9,200 feet (600–2,800 m)—though it has been recorded at more than 13,000 feet (4,000 m) in Yunnan province, China, and below 650 feet (200 m) in Japan. It is an irruptive species, meaning that birds may make local or altitudinal migrations in response to seasonal fluctuations in their food supply.

Mountain Hawk-eagles prey on small mammals, birds, and reptiles. Like other hawk-eagles, they generally still-hunt, scanning for prey on the ground from a concealed perch then swooping down to capture it. They are most conspicuous during the breeding season, when ascending to perform courtship displays, with high circling and steep climbs. This season spans December to March in Sri Lanka, February to June in the Himalayas, and April to July in Japan. The pair work together to build their nest of sticks in a tree, which may measure up to 6 feet (1.8 m) across and 4 feet (1.2 m) deep. The female lays one to two eggs.

BirdLife International estimates the global population at 10,000—a figure that includes Legge's Hawk-eagle—and classifies its status as Least Concern. It remains reasonably common in some parts of its range. However, habitat loss is a constant threat, and the Japanese population is in decline.

OPPOSITE A Mountain Hawk-eagle perches on a termite mound with a giant squirrel it has captured.

KINABALU SERPENT-EAGLE

SPILORNIS KINABALUENSIS

APPEARANCE

Small-medium eagle; dark brown above, with rufous breast and dark head and face; heavily speckled with white on face, crown, and belly: in flight, shows broad pale band across the length of its broad wings, and broad white band across base of dark tail; short, bushy crest on head.

SIZE

length 20–22 in. (51–56 cm)

weight 2.5–5 lb (1.2–2.3 kg)
wingspan 46–50 in. (118–129 cm)

DISTRIBUTION

Endemic to Borneo, occurring at 6°N–4°N in northern and central regions, including in Brunei, Kalimantan (Indonesia), and Sarawak and Sabah (Malaysia).

STATUS

Vulnerable

AT 13,435 FEET (43,095 M), the summit of Sabah's Mount Kinabalu is the highest peak in the entire Malay Archipelago. Its forested slopes are home to a rich diversity of animal and plant life, including many species endemic to the region. Shrouded in myth and legend, the mountain makes a fitting home for one of the world's rarest and most beautiful eagles.

The Kinabalu Serpent-eagle, also known as Mountain Serpent-eagle, is confined to northern Borneo—notably Sabah's Kinabalu National Park and Gunung Mulu National Park in nearby Sarawak—where it inhabits stunted montane forest at altitudes of 2,460 to 9,500 feet (750–2,900 m). This high-altitude niche separates it from the similar and closely related Crested Serpent-eagle in regions where the ranges of the two birds overlap.

This is a small, stocky eagle, about the size of a large hawk. Its dark face and rufous breast are spangled with fine white markings, while a short crest gives a distinctive shape to the black head. Contrasting with its generally dark plumage are the bright yellow beak, feet, and cere, and a broad white band across the tail. The prominence of this white band and the overall darker plumage both help to distinguish this species from the Crested Serpent-eagle. As in all serpent-eagles, its legs are unfeathered.

For many years, scientists assumed that the Kinabalu Serpent-eagle was a subspecies of the Crested Serpent-eagle (p. 192), which is Borneo's most common eagle. It was paid little attention, and this—combined with the inaccessible terrain it inhabits—means that little is known about the biology of this rare bird. It is most often seen soaring high over ridges, where it draws attention with a repeated, high-pitched whistle, and is known, like other members of its genus, to feed on snakes and lizards—notably anglehead lizards (*Gonocephalus* genus). Equally little is known about its breeding biology, which is also assumed to be similar to that of its close relative.

This species is currently listed as Vulnerable on the IUCN Red List, with an estimated 2,500 to 9,999 individuals occurring over 14,200 square miles (36,700 km²). At higher altitudes, the eagle's habitat is too remote for agriculture, making at least some of its range secure. Lower down, however, habitat loss—due primarily to logging and oil palm plantations—remains a threat, and the species is thought to be in decline.

Nature reserves, including Malaysia's Kinabalu and Mulu National Parks and Brunei's Ulu Temburong National Park, offer some protection to the Kinabalu Serpent-eagle. Outside these parks, however, there are no specific conservation measures in place. Conservationists have recommended a number of actions, including conducting further research into the species' range and population, and a more complete assessment of the dangers posed by habitat destruction. They hope in time to expand the network of protected areas that offer sanctuary to Borneo's only endemic eagle.

OPPOSITE Kinabalu Serpent-eagles soaring over the uplands of Sabah. The white band through the flight feathers and tail of this species is conspicuous from a great distance.

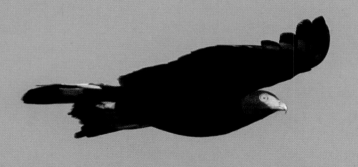

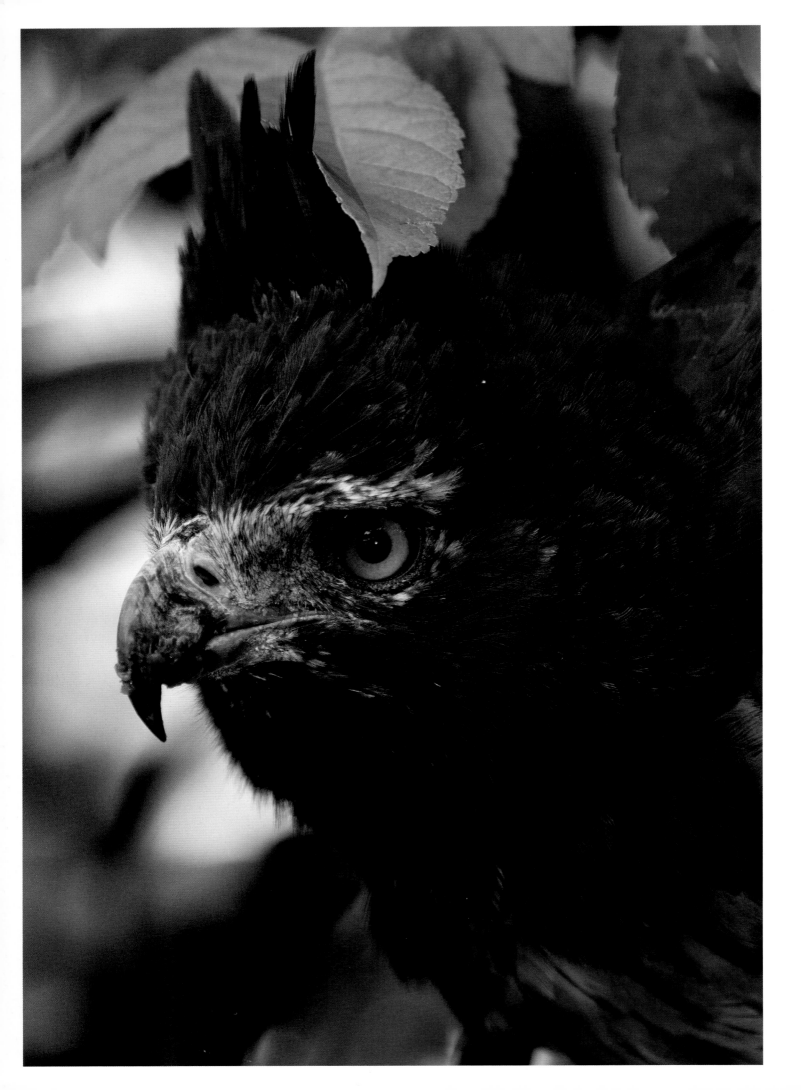

BLACK-AND-CHESTNUT EAGLE

SPIZAETUS ISIDORI

APPEARANCE
Large and stocky, with shortish tail and erect crest; upperparts, breast, and head blackish to slate-gray; underparts chestnut, streaked in black; tail grayish, with broad black subterminal band; broad wings show chestnut coverts and pale, black-tipped primaries from below; feet, eyes, and cere yellow; immatures creamy white below, with buff markings, and scaly gray above.

SIZE
*length 25–31 in. (63–80 cm)
weight no data available
wingspan 4 ft 9 in.–5 ft 5 in. (147–166 cm)*

DISTRIBUTION
The Andes: from Venezuela in the north to northern Argentina in the south; significant populations in Bolivia, Ecuador, and Venezuela.

STATUS
Endangered

IN COLOMBIA, WHERE IT WAS first discovered, this big, fearsome-looking eagle is known as *Águila real de Montaña* ("royal eagle of the mountains.") High among the mist-shrouded forests of the Andes it is indeed the largest and most powerful of raptors. But as the population of this highly endangered bird declines, its reign appears threatened.

The Black-and-chestnut Eagle is large and stocky with powerful legs, a shortish tail, and a permanently erect crest. Predominantly dark, its blackish to slate-gray head, breast, and upperparts are relieved by rich chestnut underparts streaked in black. The tail is grayish, with a broad black sub-terminal band that shows clearly in flight—when the underwings also reveal chestnut coverts and pale, black-tipped primaries. Its unfeathered parts—feet, eyes, and cere—are shades of yellow. Immatures are paler, being a creamy white below, with some buff markings, and a scaly gray on the upperparts. Their plumage gradually darkens in the four years it takes to reach maturity.

This species—also known as Isidor's Eagle—is one of the four *Spizaetus* New World hawk-eagles, all of which were once grouped with the *Nisaetus* hawk-eagles of southern

Asia. It is distributed in a long but narrow and broken band through South America's Andes, from Venezuela to northern Argentina. The most significant remaining populations are thought to be in Bolivia, Ecuador, and Venezuela. Across its range it inhabits humid montane forests.

Black-and-chestnut Eagles hunt by soaring over the canopy and plunging in to grab prey from among the branches. They take a wide variety of prey, from medium-sized arboreal mammals, including porcupines, coatis, sloths, and woolly monkeys, to medium-to-large birds such as guans and chachalacas. They also have a taste for domestic poultry, something that does not endear them to local farmers.

This species is known to breed from February to March in Colombia and from May to October in Argentina. Its big stick nest may measure 6 feet 6 inches (2 m) across and 3 feet 3 inches (1 m) deep. A female produces a single chick, brooding it while the male hunts for food. Fledging takes around four months.

With a population estimated by BirdLife International at 250 to 999 mature individuals and falling, the Black-and-chestnut Eagle is listed as Endangered. In addition to the ongoing loss of its forest habitat, threats include persecution from farmers, who resent its predation on poultry; a recent survey from one community in Colombia found that the average household in one region lost one to two domestic fowls per year to this raptor. This is a little-known species, however, and there are significant discrepancies between population estimates. As recently as 2014, a nest was discovered for the first time in Argentina's Calilegua National Park. Meanwhile, conservation projects in Colombia and elsewhere aim to raise awareness and improve protection, for example, by working to reduce conflict with poultry owners.

OPPOSITE A Black-and-chestnut Eagle peers out from the canopy of its montane forest home.

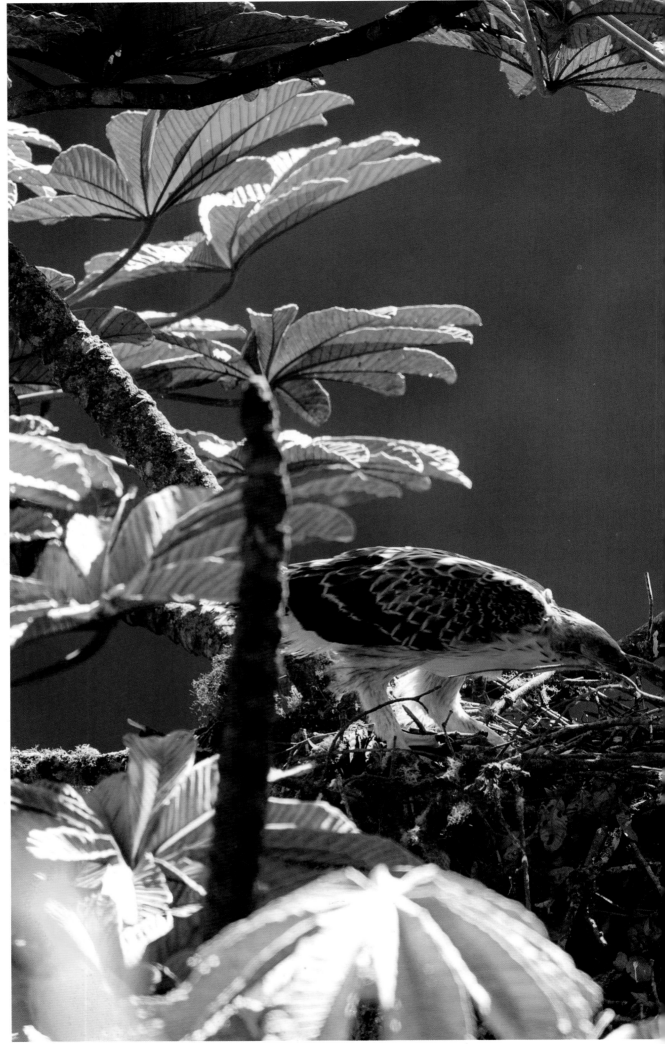

48

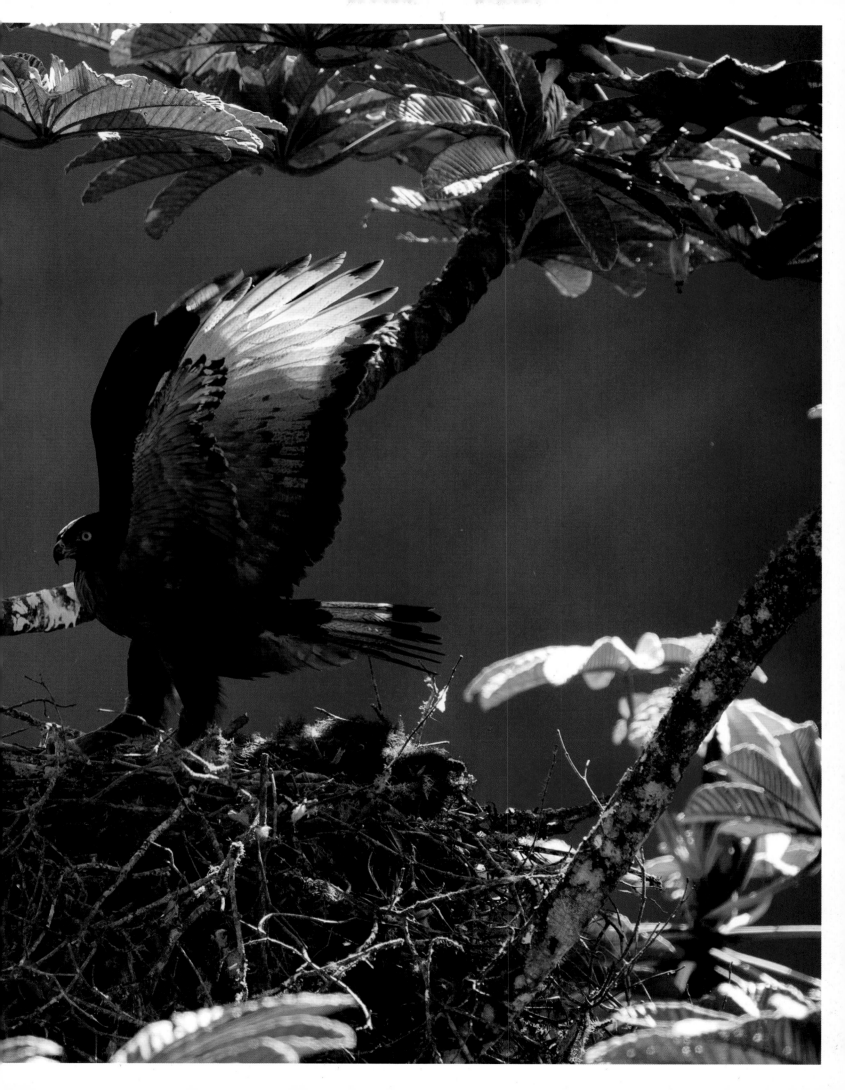

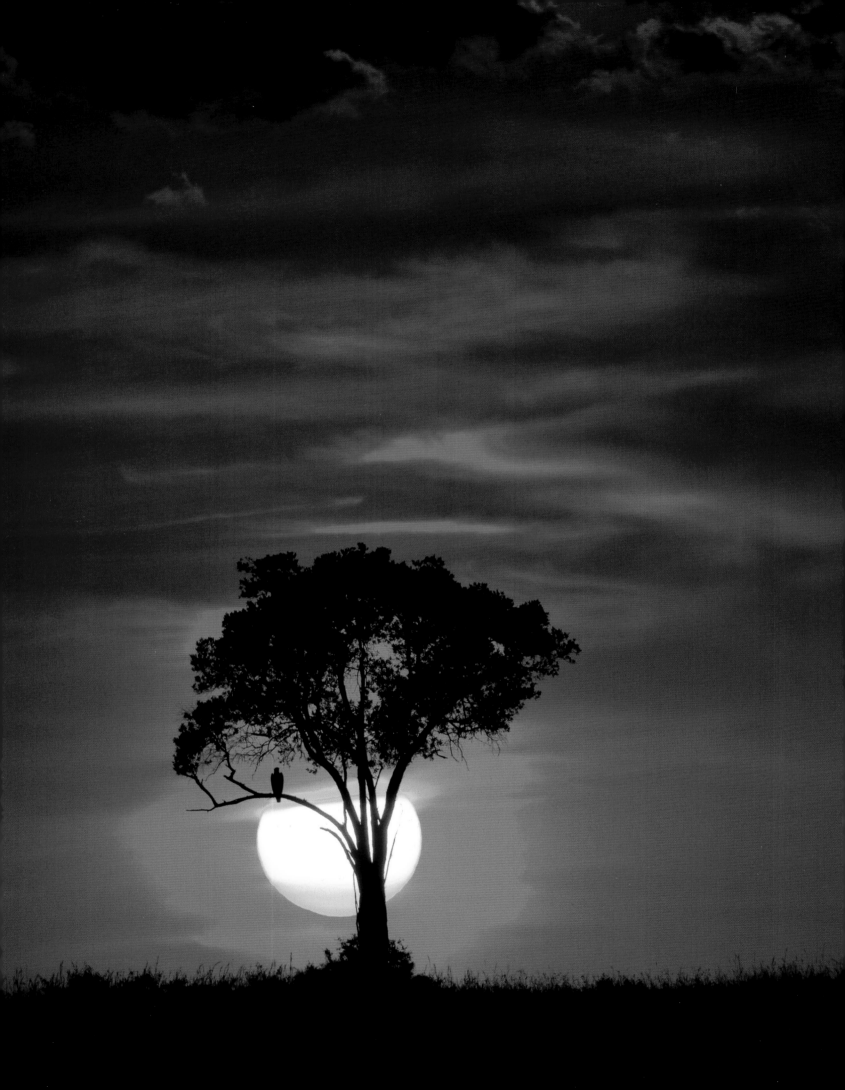

02 | PREDATORS OF THE PLAINS

THE WORLD'S GRASSLANDS COME IN many forms, but all are largely flat, open landscapes, where grasses of various kinds dominate. Some, such as the Brazilian Cerrado, are well-watered and carpeted with open woodland. Others, such as southern Africa's Kalahari, are more arid, with tree cover very sparse. All are rich habitats for wildlife, and a variety of eagles have adapted to take advantage of the rich pickings they offer.

Eagles that live in these open habitats must find their prey at ground level. Some prey on the mammals that nibble the grasses: across the steppes of Eastern Europe and Central Asia, for example, Steppe Eagles and Eastern Imperial Eagles capture ground squirrels, while in the Australian outback Little Eagles subsist largely on introduced rabbits. The mighty Martial Eagle, most powerful of Africa's savanna raptors, may even take small antelope. Such victims are often spotted from a distance, the eagle circling above the plains or perching high in a tree, then descending on its victim in a long accelerating glide, wings folded and talons swung out for the killing strike.

Other grassland eagles have adapted to a more specialized diet. Snake-eagles, such as Africa's Brown Snake-eagle, capture snakes and other reptiles among the grasses and have thickly scaled legs as protection from bites. Rather than covering distance on the wing, they tend to find a prominent perch—typically a dead tree—from where they use their phenomenally powerful eyesight to scrutinize the ground. Some snake-eagles—including the Short-toed Eagle of the Mediterranean—may hover to pinpoint prey below.

There are other specialists. In South America's Cerrado, the Crowned Solitary Eagle hunts for small mammals that venture out at dusk. In the meadows of Eastern Europe and Asia, the Lesser Spotted Eagle forages around marshy areas for frogs. It is also one of several species that sometimes feeds on insects—notably on its African wintering grounds, where it may join other raptors to feast on emerging termite swarms at the start of the rainy season. Seizing such seasonal opportunities is vital to the survival of many grassland eagles.

The small Wahlberg's Eagle—a dashing hunter of grassland birds—is among several species that gather at the nesting colonies of red-billed queleas, small birds that breed in vast numbers, to snap up discarded nestlings. It will also gather with other raptors at grass fires, pouncing on small mammals, reptiles, insects, and anything else flushed out by the flames.

The Tawny Eagle is perhaps the most versatile of all eagles. Equally adept at capturing birds, reptiles, small mammals, and insects, it is also a wily scavenger. At carcasses, it sometimes meets the colorful Bateleur, a relative of the snake-eagles that, as well as hunting live prey, will also happily join vultures—or will even use its low-level reconnaissance flights to spy leopard kills stashed in trees. The Australian outback may have fewer large predators than Africa, but it also offers abundant carrion in the form of roadkill, and the massive Wedge-tailed Eagle—a close relative of the Golden Eagle—has adapted to scavenging from dead kangaroos and other traffic casualties.

For breeding, grassland eagles require tall trees—often choosing those along water courses—although a few species, including the Steppe Eagle, have also been known to use the ground. A nest built high in a tree fork and protected by the thorny canopy is typical of many African species. With the abundance of food and other predators, any breeding pair will generally find its territory overlaps with that of other eagles, but the specialization of each species helps alleviate competition between them.

Grasslands are under threat around the world. Natural grasslands, originally created and maintained by large grazing herds of wild mammals, have given way in many areas to agricultural uses, converted to cattle pasture or fields of crops. While these modified landscapes may appear superficially similar to their natural equivalents, they offer far less prey to eagles and introduce a range of hazards, including insecticides and persecution from farmers. Many open country eagles have therefore seen their ranges contract and their numbers fall.

OPPOSITE A Martial Eagle perches silhouetted against an African savanna sunset. Isolated trees offer roosts, nest sites, and lookouts for grassland eagles.

WEDGE-TAILED EAGLE

AQUILA AUDAX

APPEARANCE
Very large, with long legs, long wings, and long tail; adults dark blackish-brown; immature birds paler, with more reddish tones on wings and head, becoming progressively darker with age; diagnostic angular flight profile, with long wings and long, diamond-shaped tail.

SIZE
*length 32–42 in. (81–106 cm)
weight male 4.4–8.8 lb (2–4 kg), female 6.6–12.7 lb (3–5.7 kg)
wingspan 6 ft–7 ft 7 in. (182–232 cm)*

DISTRIBUTION
Australia, including Tasmania; southern New Guinea (Papua and Irian Jaya).

STATUS
Least Concern

AUSTRALIAN HANGGLIDERS BEWARE! Not for nothing does the country's largest bird of prey bear the scientific name *audax*—"bold." Better known as the Wedge-tailed Eagle—or plain "wedgie," this formidable raptor has earned a reputation for taking on all-comers in its aerial territory. Videos show drones and model aircraft being ripped from the sky, and this is the only bird of prey recorded as having attacked hang gliders and paragliders—tearing the fabric with its massive talons.

You are unlikely to mistake a Wedge-tailed Eagle for anything else. Closely related to the Golden Eagle (p. 22), this is Australia's only *Aquila* species, the only similarly sized raptor within its range being the White-bellied Sea-eagle (p. 260), which differs significantly in both shape and coloration. Mature adults are dark blackish-brown. Immature birds are paler, with a reddish head and nape, becoming darker with age. When perched, this species looks like a slim, long-legged Golden Eagle. In flight, however, it shows a diagnostic flight profile, with longer wings and a longer, diamond-shaped tail. The largest wingspan ever verified for an eagle was for a female of this species that measured 9 feet 4 inches (284 cm) from tip to tip. It is significantly lighter than a Golden Eagle, however; indeed, eight or nine other species regularly outweigh it.

By population size, this is the world's commonest large eagle, found across most of Australia—including Tasmania—and also southern New Guinea. It was first described in 1801

by English ornithologist John Latham (1740–1837). Today, scientists recognize two subspecies: *A. a. fleayi* occurs only in Tasmania; *A. a. audax*, the nominate race, is found everywhere else. It frequents most habitats across its range, avoiding only rain forest and coastal heaths. The highest populations are in lightly wooded and open country in southern and eastern Australia.

Wedge-tailed Eagles may soar for hours on thermals, rising effortlessly to 6,500 feet (2,000 m) or more. Exceptionally keen eyesight allows them to spot prey from on high or by scanning from a tree, rock, or similar lookout. Most food is captured on the ground, after a rapid gliding descent. The menu is a diverse one: rabbits have been a favorite food item ever since they were introduced to Australia in the mid nineteenth century and form the staple diet in many areas, but numerous native animals are also taken, including wallabies, small kangaroos, possums, koalas, and bandicoots. Birds too fall victim, from crows and cockatoos to brush turkeys and even emus, as—less often—do large reptiles such as goannas. These raptors are resourceful hunters, able—by working together—to overcome prey larger than themselves. Equally, they will eat carrion and are a common sight along Outback verges, scavenging from roadkill.

This species mates for life—although if one partner is killed, the survivor will find a replacement. A pair occupies a home range of 3.5 to 38 square miles (9–100 km²), within which they defend a breeding territory around the nest. Both birds advertise this territory with high-altitude soaring and gliding flights, sometimes diving to repel intruders. The nest is typically in a tall tree with a good view of the surroundings. Where trees are absent, lower shrubs or cliff faces suffice. Generally, pairs nest 1.5 to 2.4 miles (2.5–4 km) apart, although they may tolerate more proximity in years of plentiful food.

The breeding season starts with pairs renewing their bonds by way of mutual preening and dramatic aerobatic display flights, the male diving down toward his partner, whereupon she may turn to fly alongside him or flip onto her back and lock talons. Both birds work to build the large stick nest—or

OPPOSITE The Wedge-tailed Eagle is the largest raptor of Australasia and a close relative of the northern hemisphere's Golden Eagle.

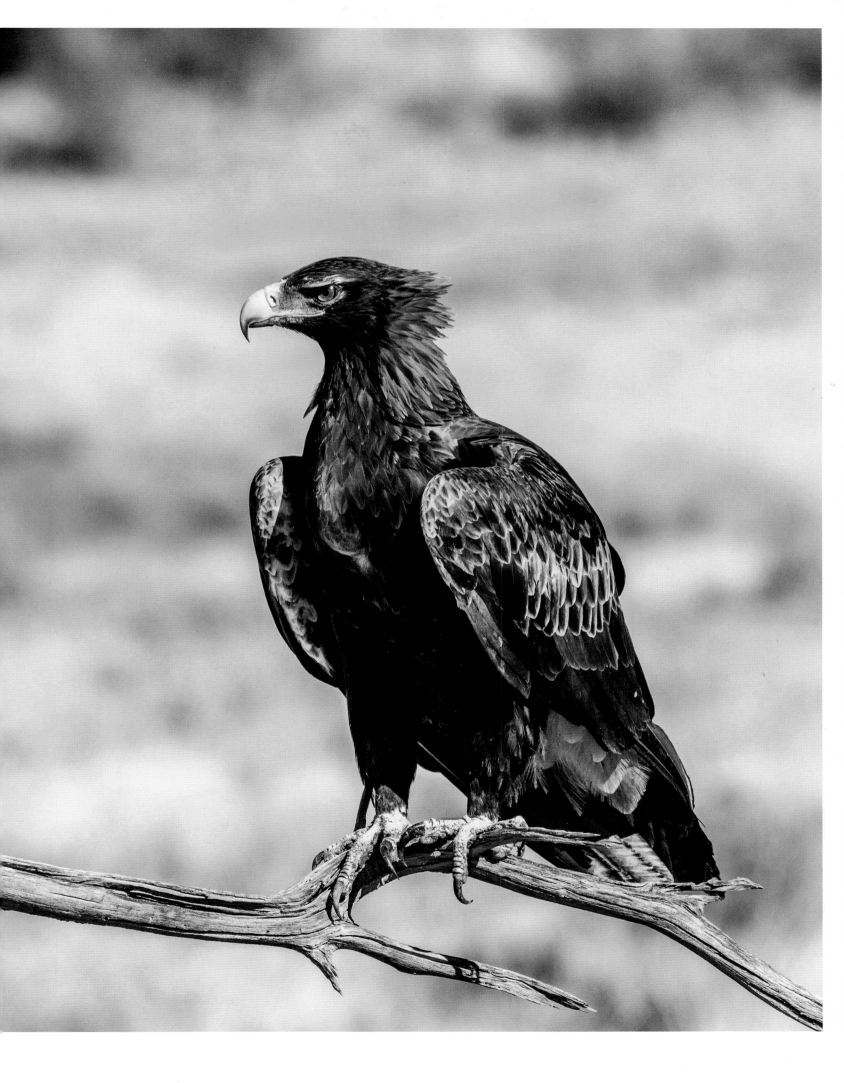

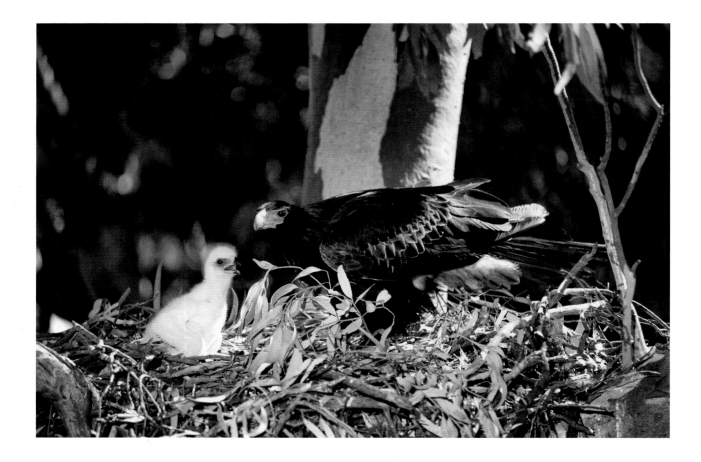

to add new sticks and leaf lining to an old nest. The resulting structure may top 6 feet (1.8 m) across and 10 feet (3 m) deep and last for many years. The female typically lays two eggs at intervals of two to four days. Both birds share incubation duties until the chicks hatch after about forty-five days. As in other *Aquila* eagles, this species practices cainism. Generally, only the older, stronger chick survives.

At about thirty days, the female stops brooding and joins her mate to hunt for food. By now, the chicks can feed themselves from food left on the nest floor. If threatened by predators, they lie flat in the nest but will defend themselves if required, falling on their back and striking upward with their talons. The youngsters stay with their parents for about eleven weeks after fledging. They leave when the next breeding season approaches, and may disperse for more than 500 miles (800 km).

Adult Wedge-tailed Eagles are apex predators, though they must defend their eggs and nestlings against crows, currawongs, and other nest raiders. They must also often deal with the unwelcome attention of smaller birds, such as magpies, butcherbirds, and masked lapwings, which will mob the raptor aggressively to drive it out of their own territories.

The Wedge-tailed Eagle has benefited from many human activities, including the opening of forests and the introduction

of rabbits, but humans pose various threats. These include the clearance of available nest sites and material in arid areas; indirect poisoning through pesticides and poisoned bait; and disturbance of nesting pairs, which may abandon their brood. For years, Wedge-tailed Eagles were persecuted as lamb-killers: a staggering 162,430 were killed in Queensland alone between 1951 and 1966. In reality, they pose little threat to livestock: most predation on sheep is scavenging. In Tasmania, the persecution took a particularly heavy toll. Conservation is now aiding recovery—as is the decline of the Tasmanian devil, which reduces competition for roadkill.

The Wedge-tailed Eagle has long been an important part of Australian culture. Today, it serves as an emblem or logo for numerous bodies, including the Northern Territory Parks and Wildlife Service, the New South Wales Police Force, the West Coast Eagles AFL football club, and the Royal Australian Air Force. The last of these has even named an aircraft after the raptor: the Boeing 737 AEW&C Wedgetail. In 1997, the mascot of the Australian Army 2nd Cavalry Regiment, a Wedge-tailed Eagle named Courage II, was charged with being AWOL after flying away from his handler and disappearing for two days. He was demoted to the rank of trooper, but in 1998 was promoted back to corporal.

ABOVE A Wedge-tailed Eagle tends its single chick at its nest in a eucalyptus tree.

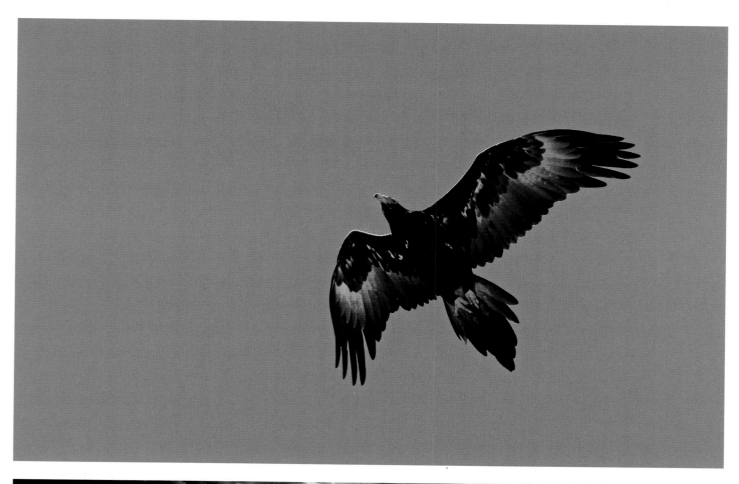

TOP Long wings and a long diamond-shaped tail give this species a flight silhouette unlike any other eagle.

BOTTOM In close-up, the wing coverts of an adult Wedge-tailed Eagle exhibit the subtle beauty of its plumage.

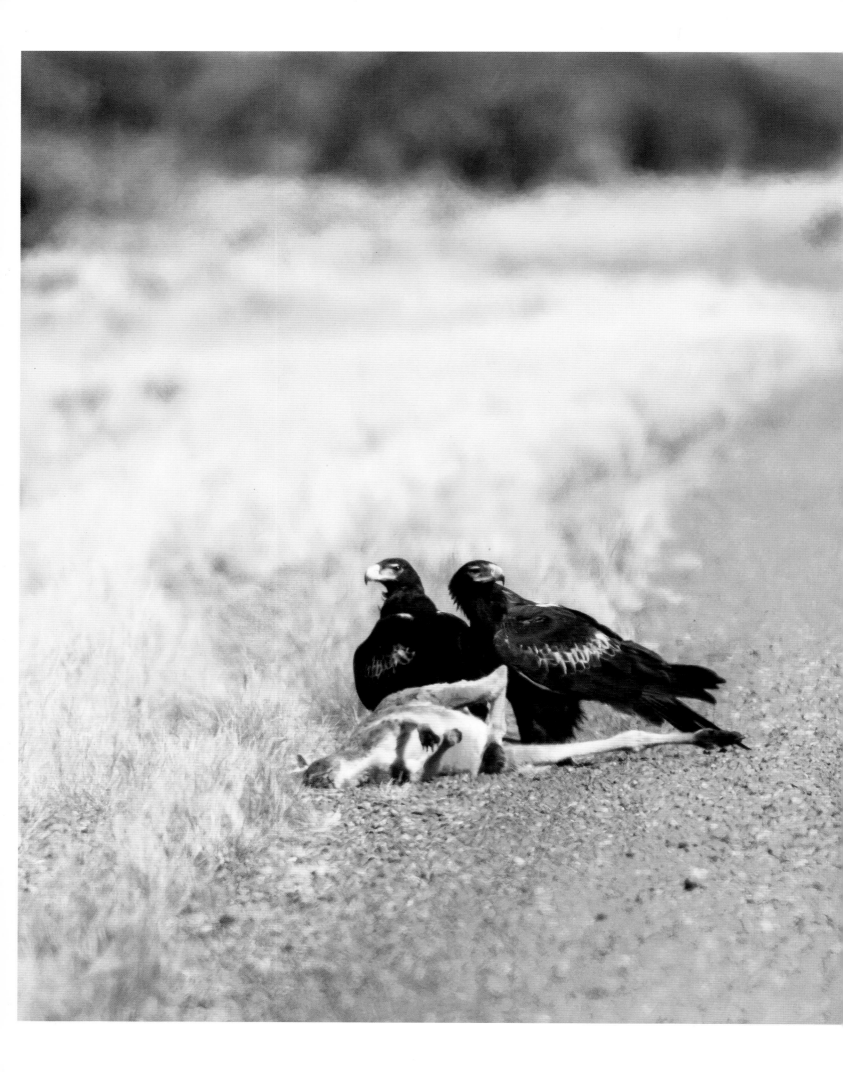

LEFT Two Wedge-tailed Eagles scavenge from a roadkill kangaroo beside an Outback highway.

PREDATORS OF THE PLAINS

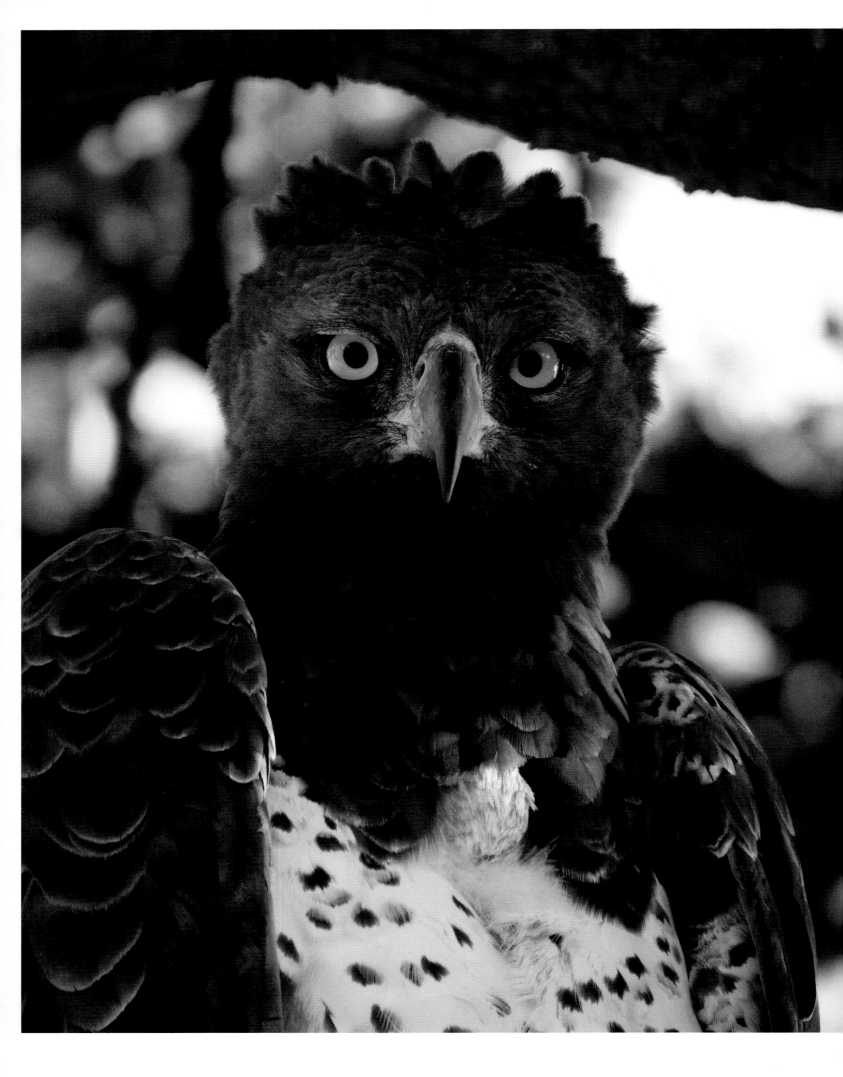

MARTIAL EAGLE

POLEMAETUS BELLICOSUS

APPEARANCE
Very large, with long legs, short crest, big bill, and yellow eyes; upperparts, head, and chest are dark gray-brown; underparts are white, lightly sprinkled with small dark spots; in flight, shows long, broad wings and relatively short tail; immatures have pearly-gray upperparts and all-white head and underparts, acquiring full adult plumage after seven years.

SIZE
length 31–38 in. (78–96 cm)

weight male 4.9–8.4 lb (2.2–3.8 kg), female 9.8–14.3 lb (4.45–6.5 kg) wingspan 6 ft 2 in.–8 ft 6 in. (188–260 cm)

DISTRIBUTION
Sub-Saharan Africa, north to Somalia, south to the Cape, and west to Senegal; commonest in eastern and southern Africa; absent from forest regions of central and western Equatorial Africa.

STATUS
Vulnerable

"MARTIAL" IS AN APT EPITHET FOR this imperious-looking bird, the largest of all Africa's eagles. There is something undeniably military about its demeanor as it perches upright atop an acacia, crest raised and blazing eyes scanning the plains. Even the scientific name, *bellicosus*, means "warlike."

This huge, powerful bird is on average the world's fifth heaviest eagle, with the fifth-largest wingspan. In sub-Saharan Africa it lords it over other raptors, with its only two rivals for size being the Crowned Eagle (p. 144) and Verreaux's Eagle (p. 28), which occupy different habitats. Adults are distinctive, their dark upperparts, head, and chest contrasting with their snow-white, spotted underparts. The Black-chested Snake-eagle (p. 98) has similar markings, but is much smaller, with unfeathered legs and unspotted underparts. In flight, the Martial Eagle's long, broad wings and short tail create a silhouette more vulture-like than any other African eagle's, and the strong contrast between white belly and dark wings is visible from afar. It has unusually long legs that are thought to be an adaptation for capturing prey in long grass.

Female Martial Eagles weigh on average 36 percent more than males and have more robust feet. Immatures are strikingly different, with pearly-gray upperparts and a white head and underparts—plumage not dissimilar to that of a young Crowned Eagle. They take seven years to acquire adult plumage, and tend to be sighted more often.

The Martial Eagle is the only species in the genus *Polemaetus*, which in turn falls within the sub-family Aquilinae of "booted eagles"—though it remains distinct from the *Aquila* eagles, such as the Golden Eagle (p. 22). It shows little genetic diversity across its range, with no known subspecies. This range comprises much of sub-Saharan Africa. The largest populations are in eastern and southern Africa, with west African populations smaller and more localized. It favors open country, especially wooded belts in savanna regions, and is absent from the closed-canopy forest of equatorial regions. In southern Africa, it may frequent more arid semidesert landscapes. It is nowhere common, however, with the most stable populations being in national parks and other protected areas.

As might be expected from those massive wings, the Martial Eagle spends much of its time airborne, often rising to great heights. When not breeding, it tends to move between hunting areas within its territory, often roosting many miles from its nest site—typically in a prominent tree. This species is a powerful, opportunistic predator that generally hunts from on high, using exceptionally powerful eyesight to spot prey at a distance of up to 3.7 miles (6 km), descending to capture it on the ground in a long stoop. It is famed both for its power and ferocity, using enormous talons—in which the hind claw may measure more than 2 inches (5 cm)—to kill its prey, and launching raking attacks on antelope many times its own size.

More than 160 species have been recorded on the Martial Eagle menu. The average prey weighs around 5 pounds (2.26 kg), comprising small mammals such as hares and hyraxes, large birds such as guinea fowl and bustards, and large reptiles such as monitor lizards. This eagle preys on a greater variety of ungulates than any other—chiefly dwarf antelope, such as suni and dik-dik (two pairs studied in Kenya's Tsavo East National Park captured eighty-six Kirk's dik-diks in one year), but also the young of larger species, such as

OPPOSITE An adult Martial Eagle is one of the most fearsome of all raptors, known for its aggression.

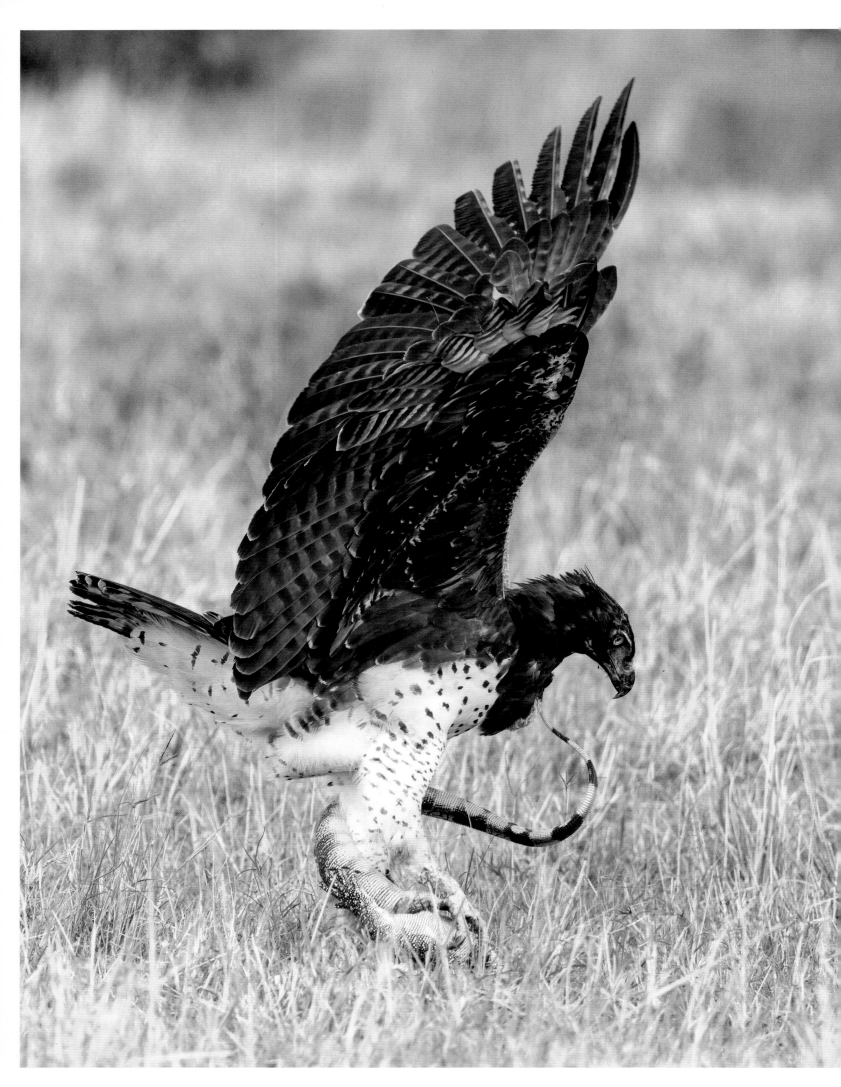

impala. Among the more remarkable prey recorded is an adult duiker weighing 82 pounds (37 kg), the largest known kill by an African raptor.

Martial Eagles occupy an average home range of 48 to 58 square miles (125–150 km²), although this is often larger in regions where prey is scarce. In southern and eastern Africa breeding is generally from April to November. It starts with a simple courtship display, the pair calling and soaring together, occasional performing sky dances and presenting talons, but without the acrobatics of many other species. They build a large nest of branches in the fork of a large tree. The nest gets bigger every year as the pair add new material, and may measure more than 6 feet 7 inches (2 m) in width and depth.

Breeding in this species is slow and erratic. A pair typically produces just one chick every second year. Occasionally, the female lays a second egg but this seldom survives. Incubation lasts forty-five to fifty-three days and is largely the responsibility of the female. After hatching, she feeds her chick with prey provided by the male until, at around nine to eleven weeks, the youngster can feed itself on prey brought to the nest—whereupon the female joins her mate for hunting and starts to roost elsewhere. Fledging takes around ninety-nine days, after which the young eagle may remain with its parents for up to six months, which partly explains why the pair may not breed again the following year. This slow cycle makes the Martial Eagle one of the most unproductive of all raptors.

The Martial Eagle has been recorded as living to 31.4 years in the wild. To reach this age, it must overcome numerous hurdles. The species is listed as Vulnerable, having undergone a steep decline in recent decades. The biggest factor is human persecution: the bird is still shot in many farming regions, despite little evidence that it poses a significant threat to livestock. Other problems include loss of habitat, collision with power lines, and, in South Africa, drowning when trying to drink from steep-sided farm reservoirs. Studies from Zimbabwe show that the majority of birds shot by farmers are immatures, which may disperse 100 miles (160 km) or more from their nest. While conservationists work to prevent habitat loss and shore up protected areas for this species, its future also depends on education of farmers and rural communities.

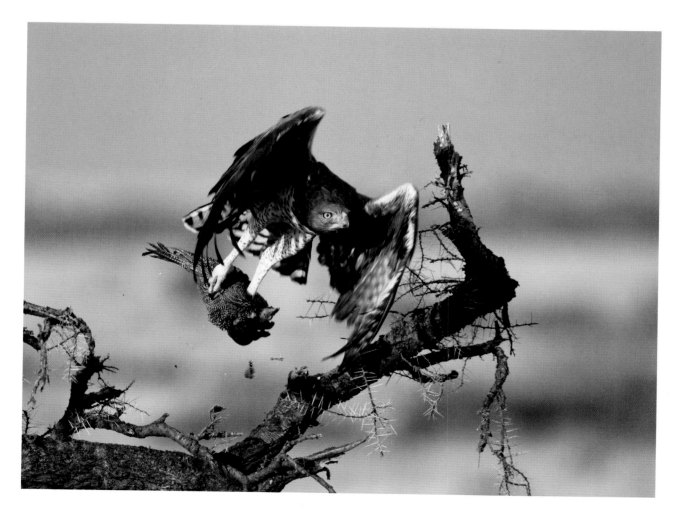

OPPOSITE A Martial Eagle uses lethal talons to subdue the struggles of a Nile monitor lizard.

ABOVE Ready to fly. A Martial Eagle takes flight with a guinea fowl it has captured.

ABOVE AND RIGHT A Martial Eagle will think nothing of seizing a baby warthog, but in this instance is frustrated by the piglet's mother, which positions itself to protect the youngster.

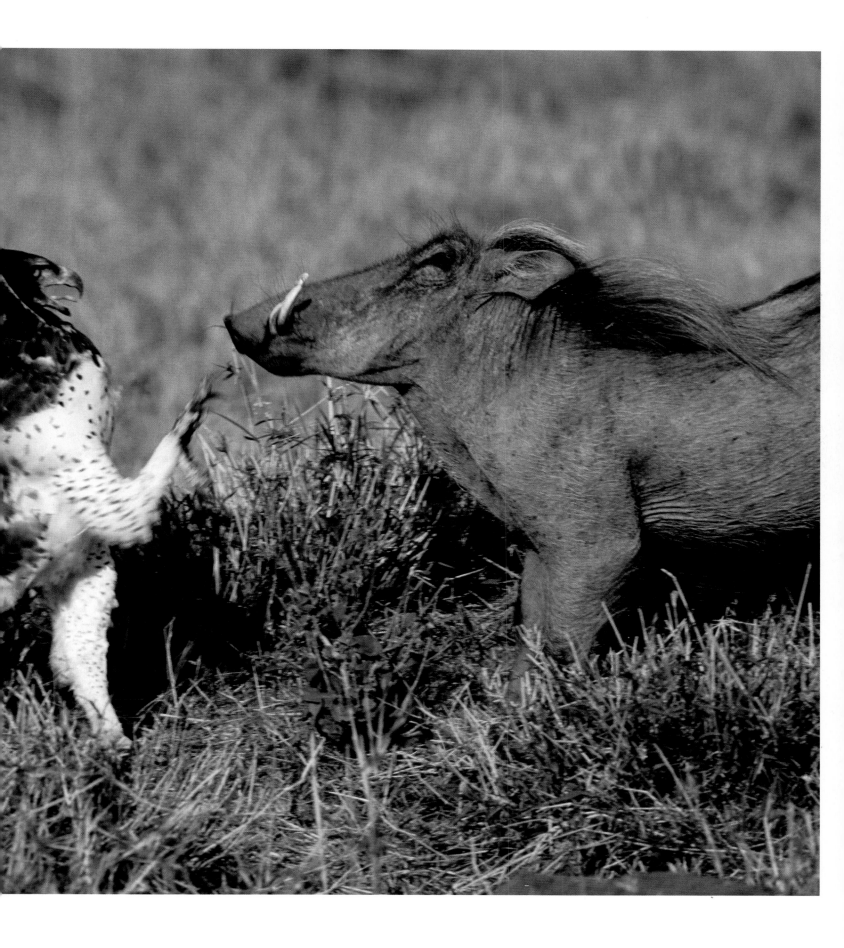

EASTERN IMPERIAL EAGLE

AQUILA HELIACA

APPEARANCE
Large; dark blackish/brown, with white scapular markings, cream/golden crown and nape, and pale gray tail base; glides with wings held flat; immatures pale buff, with dark flight feathers and paler spotting.

SIZE
length 28–35 in. (72–90 cm) weight male 4.9–8.4 lb (2.2–3.8 kg), female 5.4–10 lb (2.45–4.55 kg)

wingspan 5 ft 9 in.–7 ft 1 in. (1.8–2.16 cm)

DISTRIBUTION
Eastern Europe to central Siberia, including the Balkans, Carpathians, Caucasus, Russia, and Kazakhstan; winters in Middle East, East Africa (south to Tanzania), the Arabian Peninsula, Indian subcontinent, and southeast Asia.

STATUS
Vulnerable

THIS IMPRESSIVE EAGLE WAS once the proud emblem of the Austro-Hungarian monarchy—hence its royal name. Back in the nineteenth century, its heraldic profile would have been a familiar sight across Eastern and Central Europe. Today, however, it has disappeared from many of those former haunts.

The Eastern Imperial Eagle is very similar in appearance to the Spanish Imperial Eagle (p. 150). Indeed, the two birds were once viewed as a single species, but have since been separated on grounds of size, ecology, and molecular characteristics. This species is the more numerous and widespread, ranging from Eastern Europe as far as Siberia. It is also slightly larger and tends to inhabit more open terrain.

In general appearance, both imperial eagles resemble slightly smaller versions of the Golden Eagle (p. 22). Adults have similar dark brown to blackish plumage, with a contrasting golden crown and nape. However, both have white scapular markings (much smaller in the Eastern Imperial Eagle) and a pale gray tail base, which help distinguish them from their larger relative. While gliding, they also hold their wings flat. Immatures have pale buff plumage offset by dark flight feathers and paler spotting.

In Central and Eastern Europe, the Eastern Imperial Eagle breeds in woodlands, steppe, and farmland up to 3,280 feet (1,000 m), though it has been pushed to higher altitudes by persecution and habitat loss in its former lowland homes. Further east, it still occurs in riverine and lowland forest, but also frequents steppe and semidesert landscapes.

This species nests in large isolated trees, offering a wide view of the terrain. A male and female pair up at around four years and stay together for life. They usually build two or three nests within their territory, using them on rotation and visiting each year to make repairs as necessary. Females lay two to four eggs in spring. As in other *Aquila* eagles, generally only the oldest, strongest chick survives. Incubation lasts forty-three days, both parents taking turns. The single youngster fledges after sixty to seventy-seven days.

Typical prey comprises small mammals, from hamsters to hares. A variety of gamebirds and water birds are also taken. Eastern populations are migratory, both adults and immatures heading south to wintering grounds in the Middle East, East Africa, the Arabian Peninsula, and southern Asia. In Europe, immatures head south but adults are resident year-round.

Today, the Eastern Imperial Eagle is a rare breeding bird in Europe, with a population estimated at 1,300 to 1,900 pairs, though the rapid decline seen in the late twentieth century has slowed in recent years, with a growing population in the Carpathians. Elsewhere, the species has strongholds in Russia and Kazakhstan, with a maximum global population estimated by BirdLife International at 15,000 individuals. Familiar causes lie behind the bird's decline: the loss of breeding and hunting habitat, collision with power lines, and persecution by hunters. A European conservation action drawn up in 2010 focuses on protecting the bird and restoring its former numbers.

OPPOSITE An immature Eastern Imperial Eagle spending winter in the Hungarian lowlands perches on a hay bale.

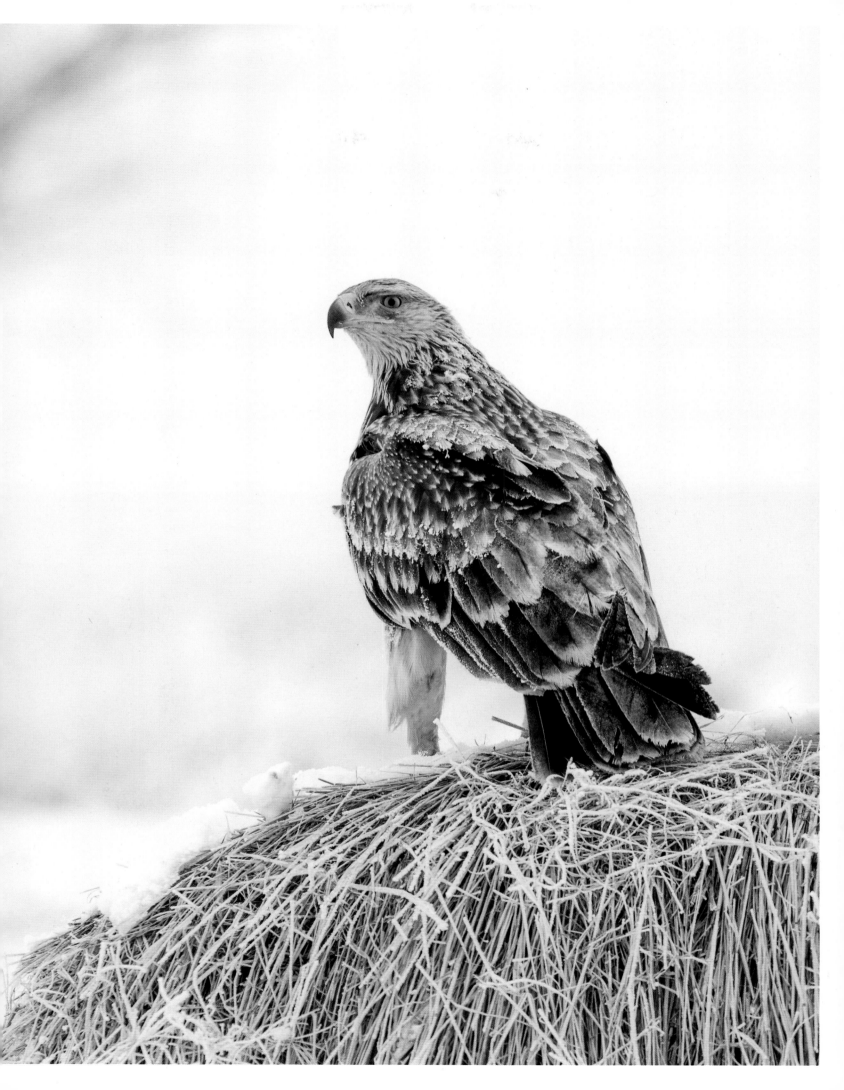

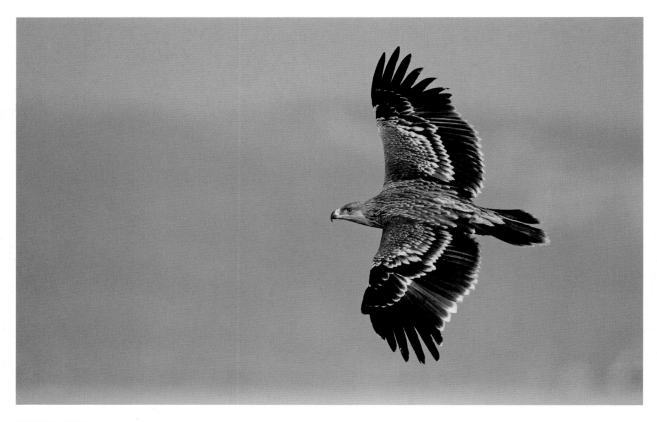

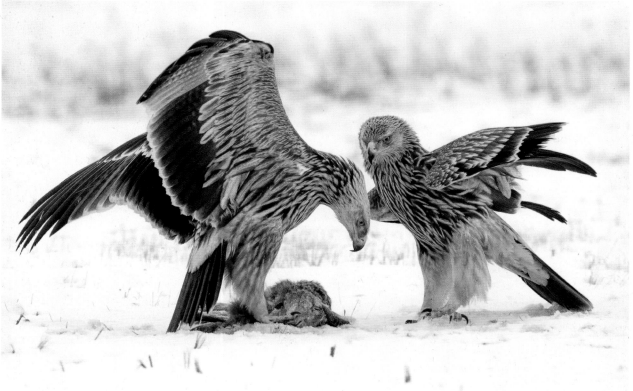

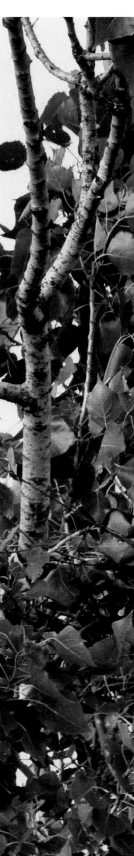

ABOVE Immature birds of this species reveal prominent pale edges to their wing coverts in flight.

BELOW Two immature Eastern Imperial Eagles contest ownership of a dead brown hare.

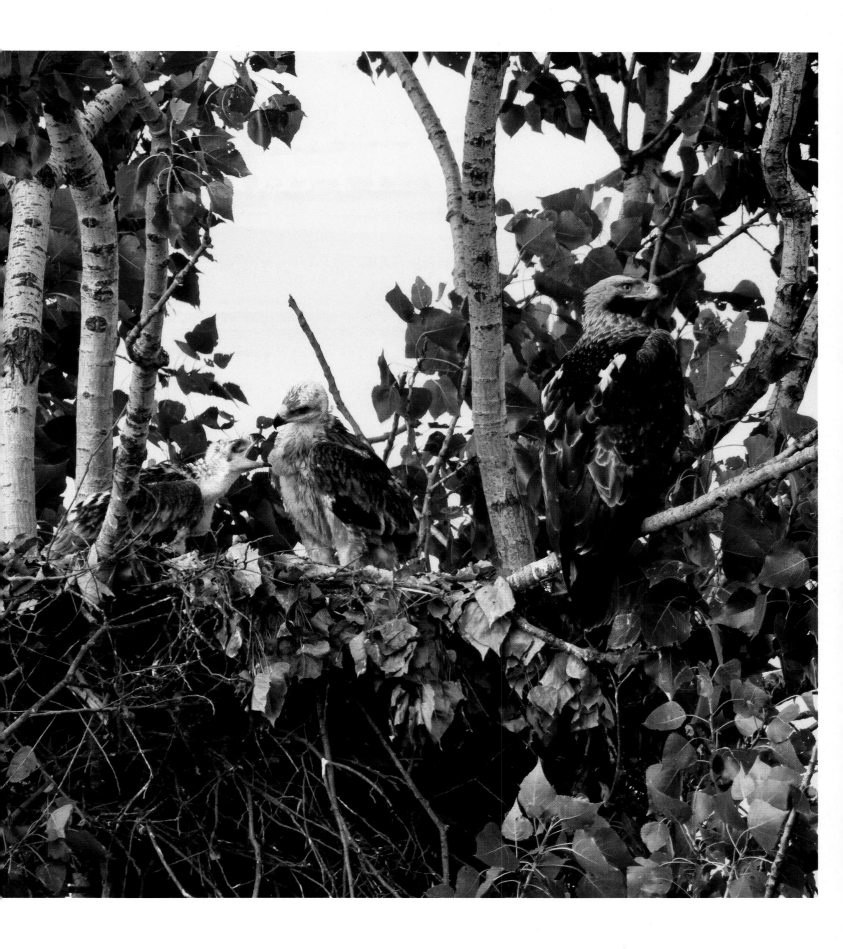

ABOVE An Eastern Imperial Eagle at its nest in eastern Slovakia with two chicks.

PREDATORS OF THE PLAINS

LESSER SPOTTED EAGLE

CLANGA POMARINA

APPEARANCE
Slim, medium-sized; short, buzzard-like bill; yellow eyes and cere; adult has pale brown head and wing coverts, darker flight feathers, and underparts; in flight, white band across rump and whitish patches on upper primary feathers; Immatures have a yellow/rufous nape, a row of white spots along the wing coverts, and, in flight, a white-tipped tail and white trailing edges to the wings.

SIZE
*length 24–26 in. (61–66 cm)
weight male 2.2–3.3 lb (1–1.5 kg), female 2.6–4.8 lb (1.2–2.2 kg)
wingspan 57–66 in. (146–168 cm)*

DISTRIBUTION
Breeds in Central and Eastern Europe, the Caucasus, Iran, Turkey, and southern Russia; winters in East and southern Africa.

STATUS
Least Concern

THE LESSER SPOTTED EAGLE IS a great traveler. Fall sees flocks hundreds-strong sailing over the Bosporus as they exit Europe by the narrowest sea crossing and head south toward their winter grounds in Africa. Some birds continue as far as KwaZulu-Natal, some 6,000 miles (9,650 km) from their northernmost breeding grounds.

Named for the prominent row of spots across the wing coverts of immatures, this is a slim, medium-sized eagle with a relatively short, buzzard-like bill. Adults have a pale brown head and wing coverts, which contrast with darker flight feathers and underparts, and a yellow eye and cere. In flight, they reveal a horseshoe-shaped white band across the rump, whitish patches on the upper primary feathers, and, from below, a clear contrast between the pale wing coverts and the darker flight feathers. Immature birds have a rufous nape and show a white-tipped tail and white trailing edges to their broad wings.

This eagle has a complex taxonomic history. Once thought conspecific with the Indian Spotted Eagle (p. 152), it is now thought more closely related to the Greater Spotted Eagle (p. 116), the two probably having arisen from a common ancestor in Central Asia during the mid-Pliocene, some 3.6 million years ago, before diverging into the separate species we know today. Indeed, hybridization between the two sometimes occurs. All three spotted eagles were grouped in the *Aquila* genus but have since been assigned their own genus: *Clanga*.

Lesser Spotted Eagles have a wide breeding range that extends across Central and Eastern Europe, as far west as Hungary, through the Caucasus and across to Iran, Turkey, and southern Russia. They inhabit patchy woodland and forest edges—especially in moist lowland areas—though have been recorded nesting at altitudes of up to 7,200 feet (2,200 m).

An opportunistic and versatile predator, this raptor feeds on small mammals, birds, reptiles, amphibians, and insects. Larger prey is generally taken by stooping from on high or gliding down from a hidden perch. To capture smaller prey, however, it often walks about on the ground. Frogs form an important part of its diet in the European lowlands. On its African wintering grounds, it often raids the nests of red-billed queleas (a small member of the weaver family that breeds in huge colonies), and flocks may gather to take advantage of seasonal termite emergences, joining forces with other raptors to snap up this insect bonanza.

The Lesser Spotted Eagle is a wary breeder that shuns human disturbance. Pairs generally make their nest in a tall tree, close to the forest edge, and breeding starts from late April. A female lays one to three eggs, with typically only the first hatchling surviving. Incubation lasts thirty-six to forty-one days and the chick fledges at around eight weeks. It reaches breeding maturity at three to four years and may survive for twenty-six years in the wild.

At present, this species is classed as Least Concern. BirdLife International estimates the global population at 44,900 to 60,500 individuals, of which some 16,400 to 22,100 pairs breed in Europe. All birds follow the same migration corridor—up to 58,000 individuals have been counted passing over the Bosporus in one season—and many thousands are still shot along the way. Other threats include the draining of wet forest and meadows on important breeding grounds.

OPPOSITE Adult Lesser Spotted Eagles do not have the spotted upperparts of immature birds, from which the species gets its name.

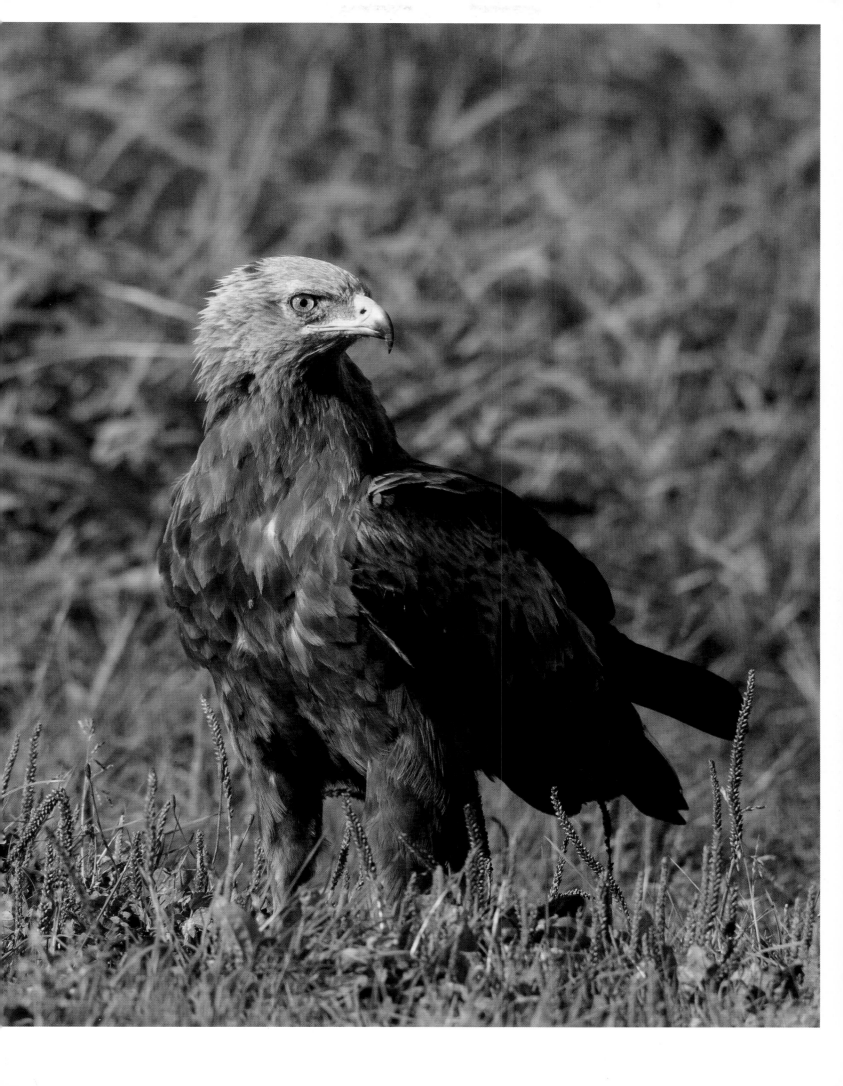

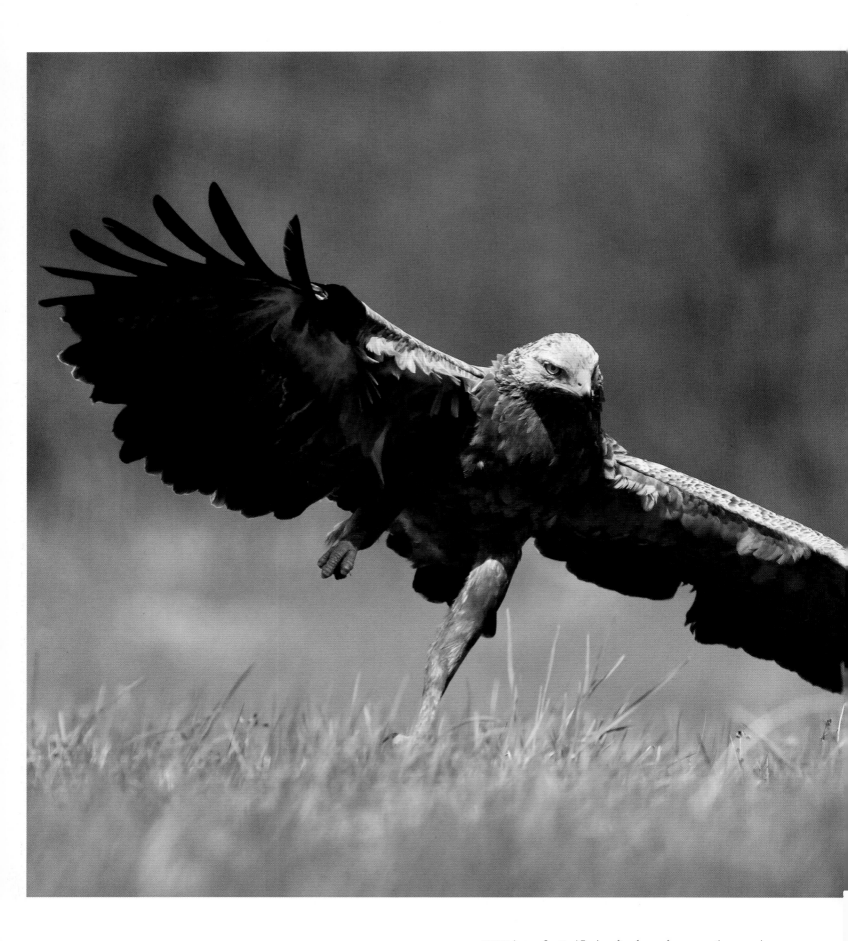

ABOVE Lesser Spotted Eagles often forage for prey on the ground,
seeking out frogs in damp meadows and marshes.

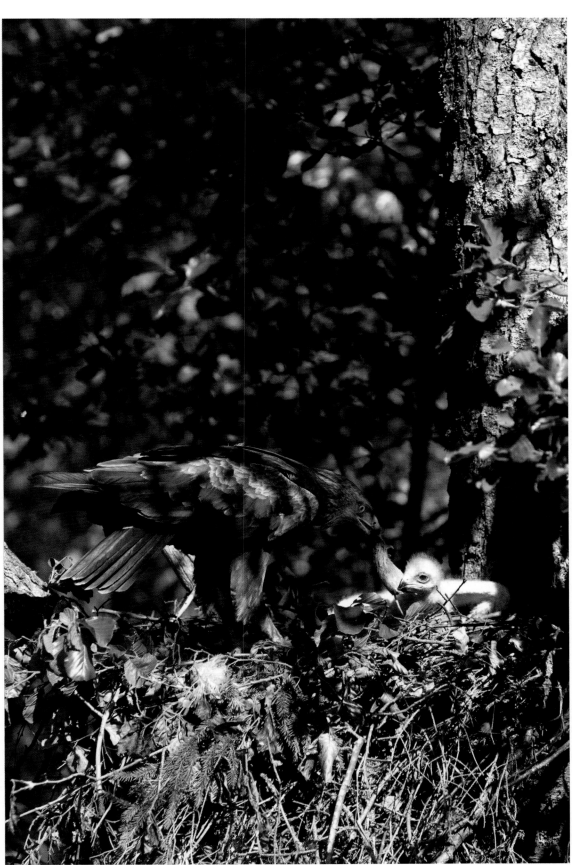

ABOVE An adult Lesser Spotted Eagle brings food to its chick at the nest, in a hidden woodland location in Eastern Europe.

PREDATORS OF THE PLAINS

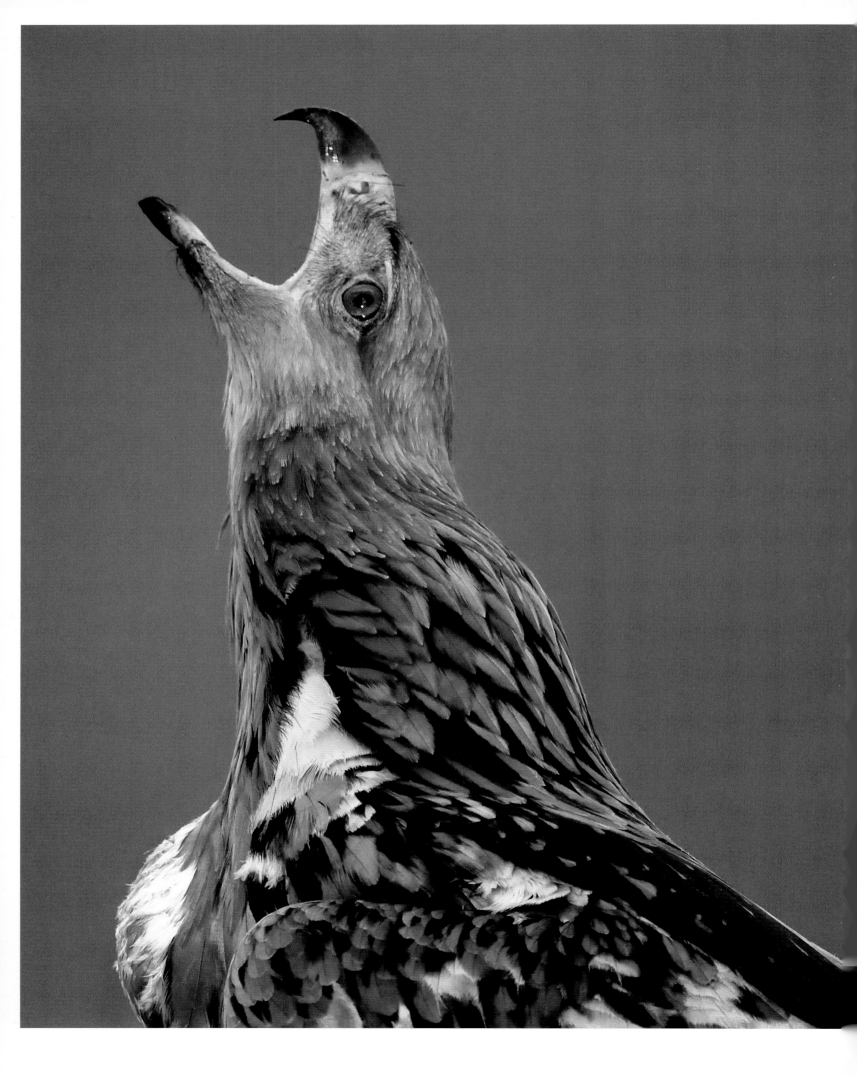

TAWNY EAGLE

AQUILA RAPAX

APPEARANCE
Medium-large; generally rusty to sandy brown, with darker flight feathers and paler lower back, but highly variable; eyes and cere bright yellow; wings broad and tail relatively short; legs heavily feathered; immatures paler, especially in first year; occurs in both dark and pale color morphs, and separate geographical races.

SIZE
length 24–30 in. (60–75 cm)

*weight 3.5–6.6 lb (1.6–3 kg)
wingspan 63–75 in.
(159–190 cm)*

DISTRIBUTION
A. r. rapax *(nominate race),
southern and eastern Africa;*
A. r. belisarius, *North and West
Africa (including Morocco, Algeria,
Sahel), and southern Arabia;*
A. r. vindhiana, *Indian subcontinent,
Myanmar, and Vietnam.*

STATUS
Least Concern

CARNAGE ON THE AFRICAN PLAINS. As a gaggle of vultures hisses and flaps over the bloody remains of a wildebeest, a Tawny Eagle perches a few yards away on a fallen branch. More agile and aggressive than the scavengers, it waits for the first opportunity to fly in and tear off a piece for itself. Not for nothing has it earned the Latin name *rapax*, or "rapacious."

This big eagle is Africa's most widespread *Aquila* species, common across the savannas of the south and east. Typical of its genus in build and coloration, it resembles a smaller Golden Eagle (p. 22) but with a rustier tinge to the plumage and without the signature golden nape. The eyes and cere are bright yellow, the tail relatively short, and the legs heavily feathered.

There are three separate geographical races, each of which may come in both darker and paler morphs, while immatures of all forms have paler, more uniform plumage. This variety can make life tricky for birdwatchers, especially when other migratory brown eagles congregate in the same areas. The slightly larger Steppe Eagle (p. 76) is especially similar. One way to tell the two apart—up close—is the yellow gape: in the Tawny Eagle this extends to level with the middle of the eye; in the Steppe it extends all the way to the back.

The similarity between the Tawny and Steppe Eagles once led scientists to classify the birds as two races of the same species. They have since been split into separate species; further

analysis revealed that the Tawny is more closely related to the two imperial eagles of Eurasia (pp. 64 and 150). The nominate subspecies, *A. r. rapax*, is the one found in southern and eastern Africa. The other two are *A. r. belisarius*, found in North and West Africa and southern Arabia, and *A. r. vindhiana*, found on the Indian subcontinent and east as far as Vietnam.

Throughout its range, this is a bird of open terrain, from savanna woodland to arid steppe. In India, it also occurs around settlements and cultivated areas, particularly near slaughterhouses. In general, it is a sedentary species—by contrast with the other migratory brown eagles—though populations in West Africa are known to make short southward movements into wooded areas between November and April.

The Tawny Eagle is an opportunistic predator, taking a variety of prey up to the size of scrub hare and guinea fowl, as well as scavenging from carcasses. It captures much of its prey on the ground but may also seize birds in flight. Reptiles, amphibians, fish, and insects are all on the menu, and it often pirates food from other large birds, such as storks—a practice known as kleptoparasitism.

Tawny Eagles breed during the dry season. Monogamous pairs renew their bonds with sky-dancing displays, during which they utter noisy croaks and grunts. The large flat nest is constructed in a tall tree or, rarely, an electrical tower, using branches, sticks, and bones. The female generally lays two eggs, of which—as with other *Aquila* eagles—just one chick generally survives. Incubation lasts thirty-nine to forty-four days and the chick fledges at seventy-seven to eighty-four days, taking another three to four years to reach maturity.

This versatile species remains relatively common, with an estimated 100,000 individuals worldwide. However, the population is in decline across parts of Africa, especially outside protected areas. Threats include poisoned carcasses left out by farmers for jackals and other predators, and collisions with power lines. Birds are also killed by vehicle traffic while scavenging by the roadside, and some drown in farm reservoirs.

OPPOSITE The Tawny Eagle is one of the most widespread and versatile eagles in Africa and Asia.

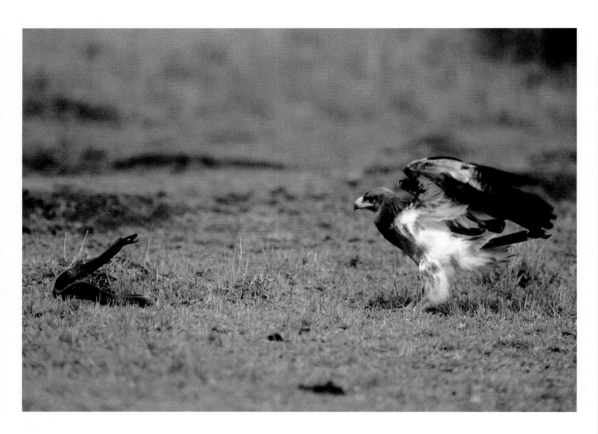

ABOVE A Tawny Eagle
confronts a cobra.

RIGHT Tawny Eagles share the African
savanna with large herds of grazing
mammals, such as this wildebeest in
Kenya's Maasai Mara National Reserve.

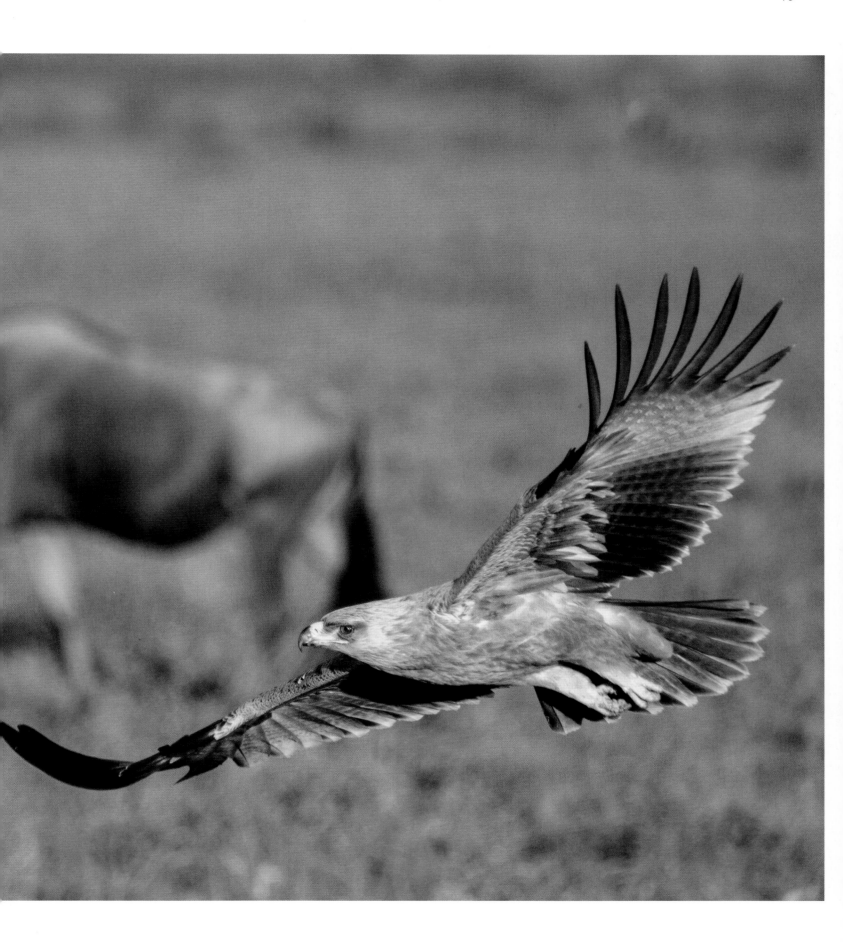

STEPPE EAGLE

AQUILA NIPALENSIS

APPEARANCE

Larger than similar Tawny Eagle; brown, with rufous nape and blackish flight and tail feathers; pale throat and long yellow gape (extends to the level of the back of the eye); immatures more uniform, with conspicuous white band along wing coverts in flight.

SIZE

length 28–32 in. (72–81 cm) weight male 4.4–6.8 lb (2–3.1 kg), female 5.1–8.5 lb (2.3–3.9 kg) wingspan 5 ft 4 in.–6 ft 6 in. (165–200 cm)

DISTRIBUTION

Two races: A. n. nipalensis (nominate race) breeds Central/ eastern Asia, from Altai Mountains south to Tibet and east to northeast China and eastern Mongolia; winters in southern Asia, largely Indian subcontinent; A. n. orientalis breeds across Central/western Asia, from Kazakhstan to southern Russia; winters in East and southern Africa and the Arabian Peninsula.

STATUS

Endangered

THIS LARGE, HANDSOME EAGLE IS, as its name suggests, the quintessential raptor of the Central Asian steppes, and appears on the national flag of Kazakhstan. In winter, it trades its arid breeding quarters for the warmer savannas of sub-Saharan Africa and the Indian subcontinent.

A typical *Aquila* eagle in both build and coloration, the Steppe Eagle has brown upperparts with a rufous nape, and blackish, lightly barred flight feathers. At a glance, it closely resembles the Tawny Eagle (p. 72) and the two were once thought to be separate races of the same species. The Steppe Eagle is larger, however, with a paler throat and a longer yellow gape. A larger bill and oval rather than round nostrils also help distinguish it from the Lesser Spotted Eagle (p. 68) and Greater Spotted Eagle (p. 116). Immature birds show a conspicuous white band along the wing coverts in flight, above and below.

Two races occur. The nominate and more easterly race, *A. n. nipalensis*, has a breeding range centered around the Altai Mountains, extending into China and Mongolia. It winters largely in the Indian subcontinent. A smaller and paler race, *A. n. orientalis*, has a more westerly breeding range, from

Kazakhstan to southern Russia, and winters in sub-Saharan Africa and the Arabian Peninsula. Throughout its range, the Steppe Eagle frequents open habitats, breeding in dry semidesert and steppe terrain—up to 7,500 feet (2,300 m)—and wintering largely in tropical savannas. On its winter quarters in southern Asia it may enter built-up areas to scavenge.

Steppe Eagles, like Tawny Eagles, are versatile predators. They hunt small mammals up to the size of hares, with susliks (ground squirrels) being a staple in many areas. They also hunt birds, sometimes on the wing, and, like many raptors, may congregate on their African winter grounds to feed on seasonal emergences of winged termites. Hunting technique varies from a high-altitude stoop to a patient vigil beside a burrow entrances to capture small mammals that emerge. This species will scavenge and pirate food from other large birds.

Breeding maturity arrives at about four years. In the past, nests were often located on the ground, but habitat changes have seen an increasing tendency to use bushes or low trees. At least two chicks generally fledge, which suggests that cainism is not the norm. Incubation lasts forty-five days and fledging fifty-five to sixty-five. Ages of up to forty-one years have been recorded in captivity.

The Steppe Eagle's decline is of concern to conservationists. In Europe, the population fell by 80 percent in fifty years, leading to extinction in Ukraine, Romania, and Moldova. No birds now breed west of southwest Russia. Today, the world population is estimated at 37,000 pairs, with the highest concentrations in western Kazakhstan and western Mongolia. Habitat destruction is the main cause—especially the conversion of steppe to agricultural land. Other factors include collision with power lines and wind turbines, direct persecution (young birds are stolen from nests in Kazakhstan for illegal sale), and—in Pakistan—poisoning by the veterinary drug Diclofenac, which has also caused a decline in vultures.

OPPOSITE The Steppe Eagle has a slightly broader wingspan than the very similar Tawny Eagle.

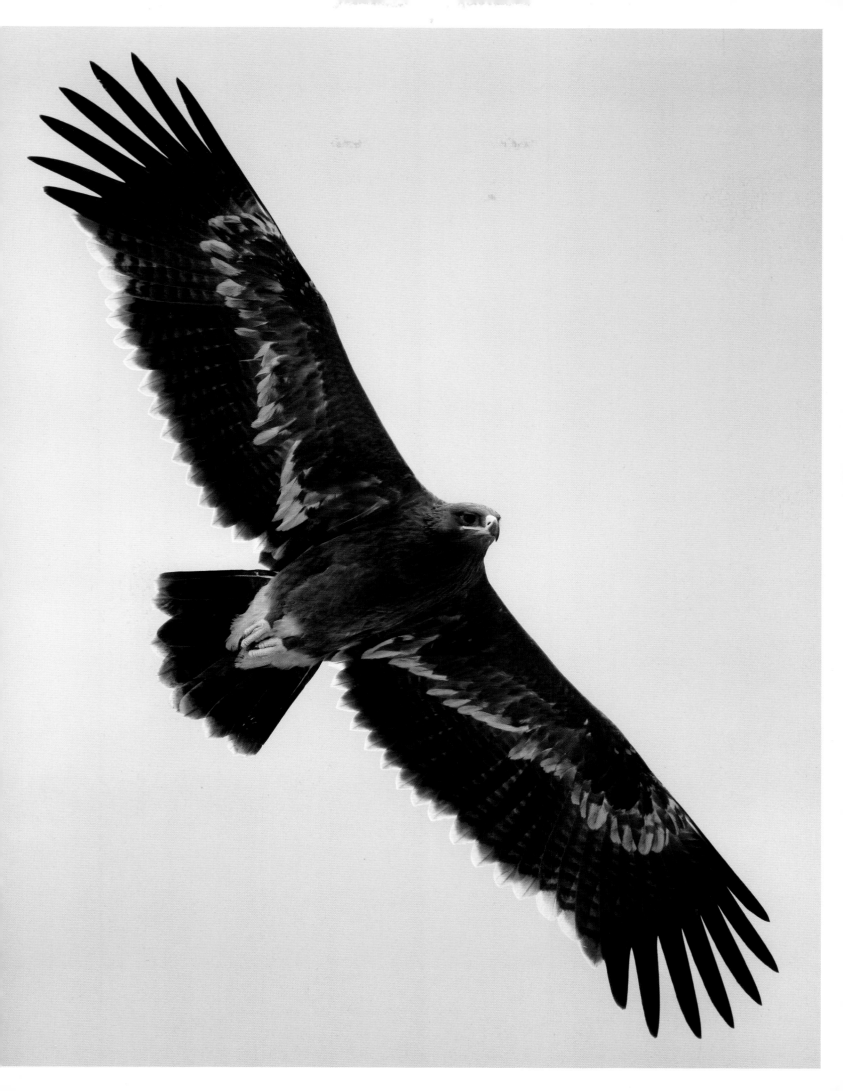

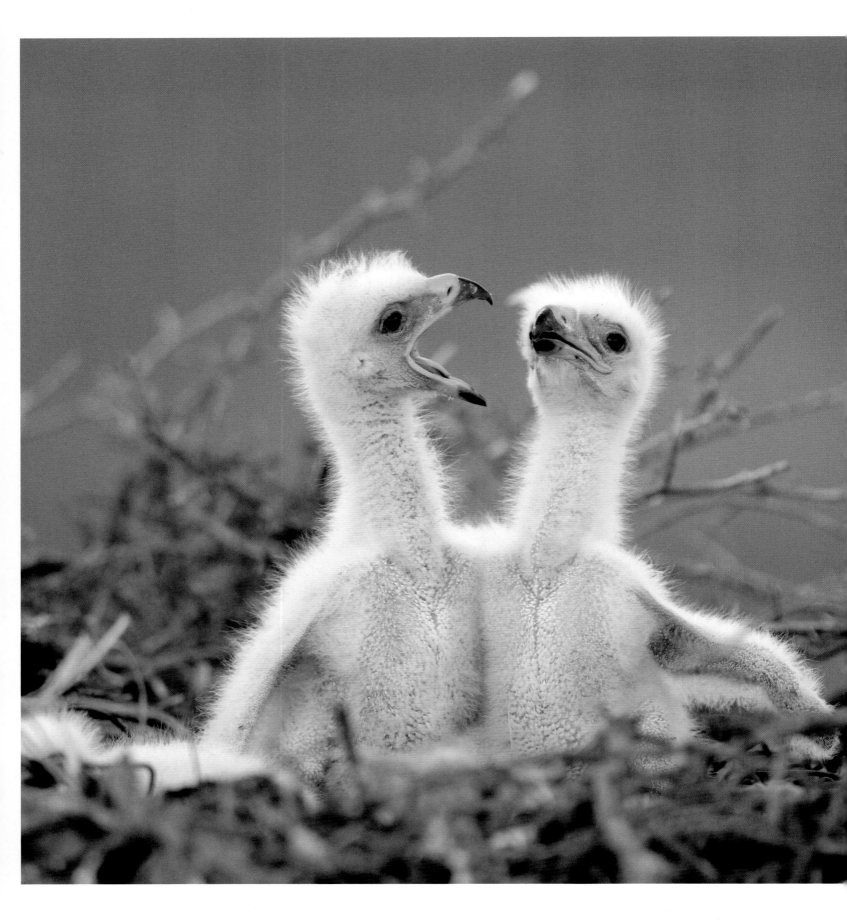

ABOVE Unusually for an *Aquila* species, the Steppe Eagle
often succeeds in rearing two chicks.

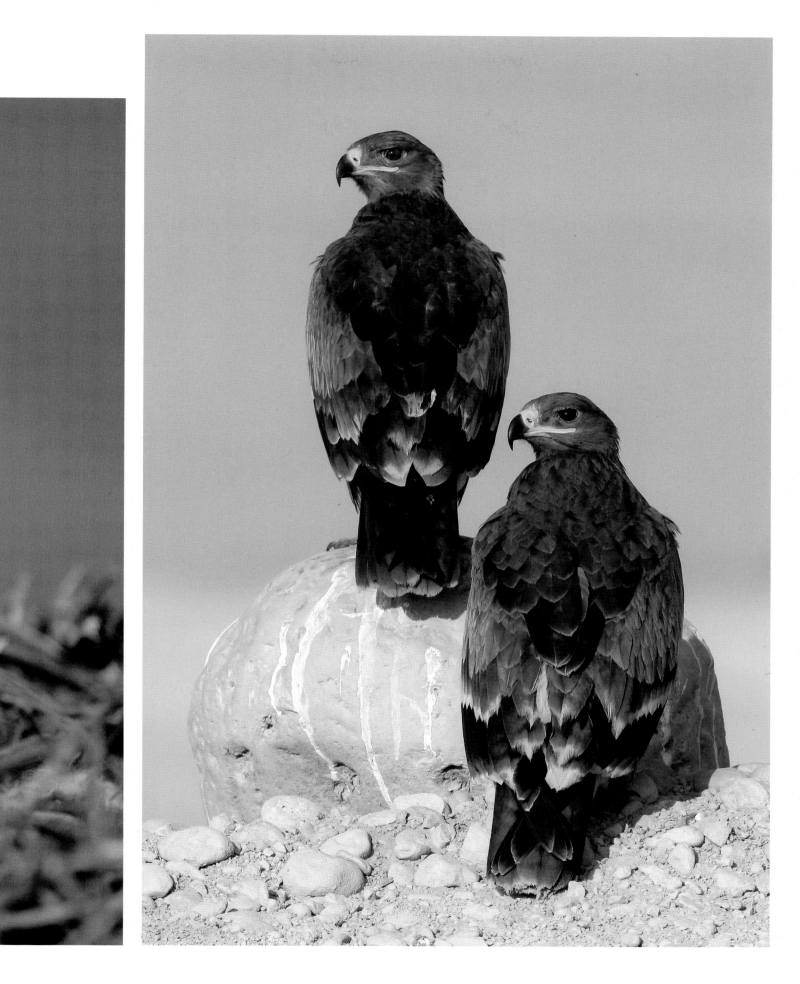

ABOVE Two Steppe Eagles in the Oman desert. This species often
occupies arid habitats during its non-breeding travels.

PREDATORS OF THE PLAINS

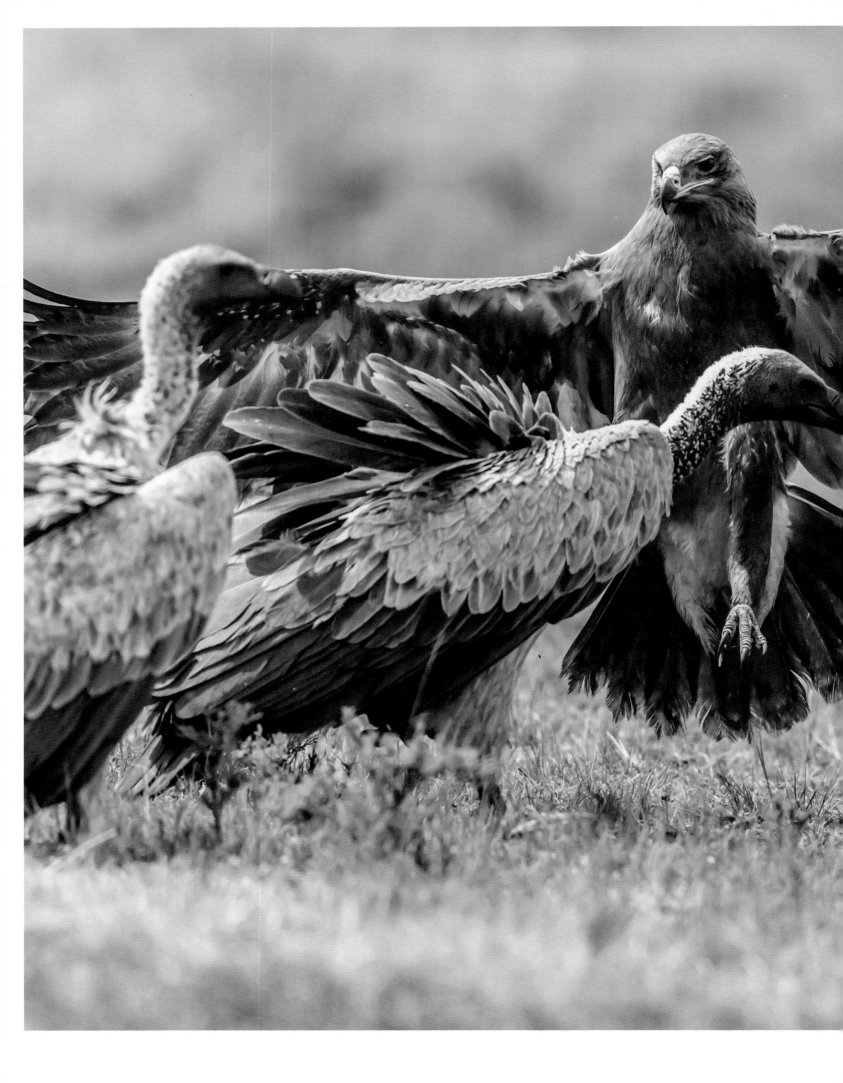

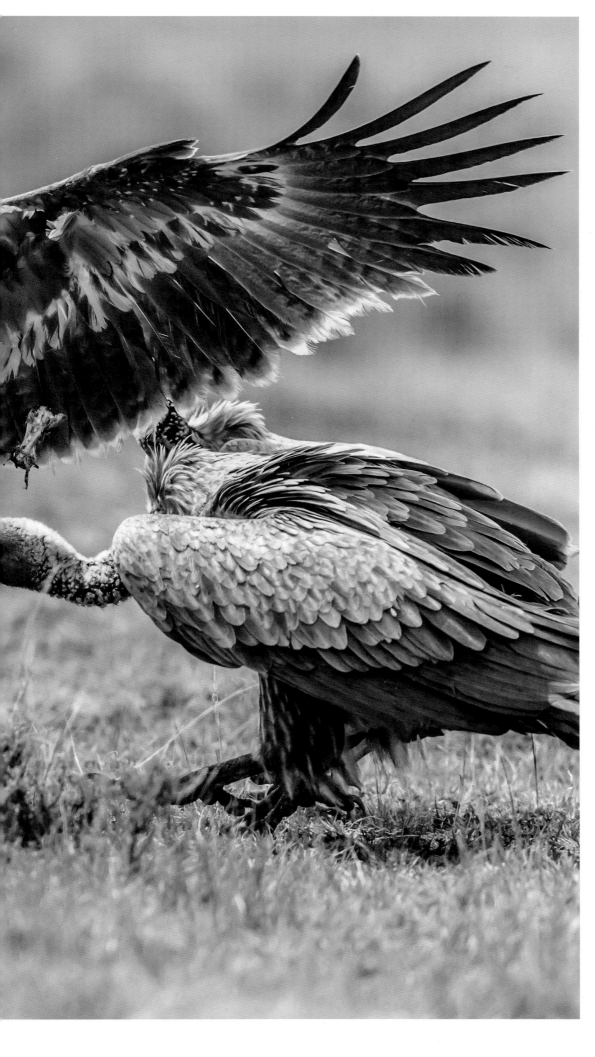

LEFT A Steppe Eagle joins a party of white-backed vultures at a carcass in the Maasai Mara National Reserve, Kenya.

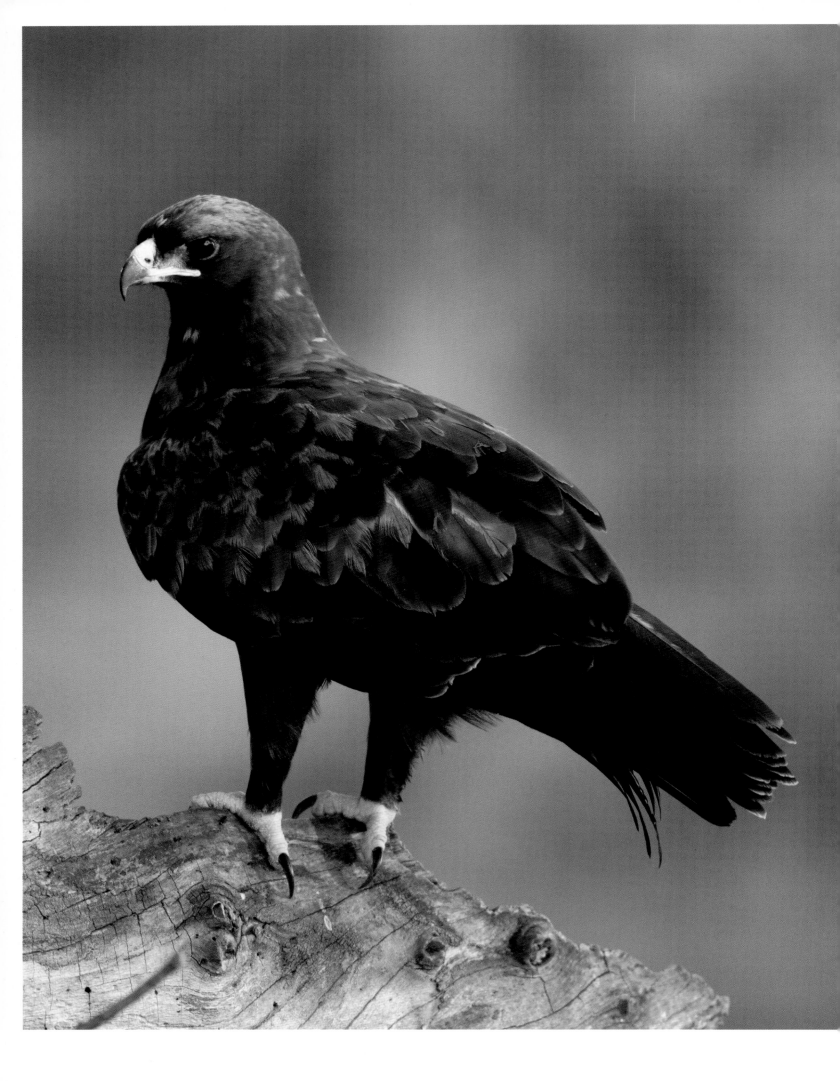

WAHLBERG'S EAGLE

HIERAAETUS WAHLBERGI

APPEARANCE
Small brown eagle; small crest, relatively small bill, yellow cere and feet; legs entirely feathered; plumage varies from rufous to dark brown and, in pale morph, almost white; in all plumages shows dark flight feathers and gray, barred undertail; nostrils round, like Spotted Eagle; immatures have paler edges on wing coverts and heavier streaking on head and neck.

SIZE
length 21–24 in. (53–61 cm)
weight male 0.9–1.8 lb (437–845 g), female 1.5–3 lb (670 g–1.4 kg)
wingspan 51–57.5 in. (130–146 cm)

DISTRIBUTION
Sub-Saharan Africa: north to Sudan, west to Senegal/Gambia, south to South Africa; absent from Horn of Africa.

STATUS
Least Concern

THIS IS ONE OF AFRICA'S SMALLEST EAGLES and it often slips under the radar, mistaken for better-known species such as the Tawny Eagle (p. 72). It takes its name from Swedish naturalist Johan August Wahlberg (1810–56), who died just days before being elected a member of the Swedish Academy of Sciences days because the news of his death—he was killed by a wounded elephant in what is now Botswana—had not made it back to Stockholm.

Wahlberg's Eagle can be tricky to identify. It comes in a confusing variety of plumages, including dark chocolate-brown, reddish brown, and an almost-white pale morph. In all plumages, however, it is appreciably smaller than a Tawny Eagle—indeed less than half its weight. It also shows a smaller bill and, when erected, a short crest at the back of the head that precludes confusion with any other brown eagle. In flight, its distinctive crosslike silhouette, with longer straight wings and a narrow square-ended tail, is unlike that of any comparable eagle and is often the best clue to identification.

Scientists have recently concluded that Wahlberg's Eagle is not related to the Tawny and Steppe Eagles, and have shifted it—on the basis of molecular evidence—from the genus *Aquila* to *Hieraaetus*, alongside the Booted Eagle (p. 122).

The relatively low profile of Wahlberg's Eagle belies the fact that it is one of Africa's most numerous eagles. Common across much of sub-Saharan Africa, it is a partial migrant, with populations in many northern regions heading south from August to September to breeding grounds in southern Africa. Wherever it occurs, its preferred habitat is woodland and wooded savanna, including cultivated areas. It avoids dense forest and arid regions.

Like other small eagles, Wahlberg's Eagle is a highly versatile predator, taking a wide variety of small mammals, birds, reptiles, and other prey. It may stoop from on high, still-hunt from a perch, capture birds (from larks to bustards) in flight, or even pursue insects on the ground. It may also pirate prey from other raptors—in particular, the Long-crested Eagle (p. 138)—pursue grass fires to snap up prey fleeing the flames; and has even been seen working in pairs to raid an egret breeding colony, with one bird distracting the adults while its partner snatches a chick from the nest.

This eagle breeds from September to February across most of its range, but in West Africa from June to November. Pairs affirm their bonds in a short, noisy breeding display of circling and occasional claw-grappling. They usually breed near water, building their stick nest in the crown of a large tree, such as a baobab, acacia, or even a large palm. The female typically lays just one egg, occasionally two. Incubation lasts forty-four to forty-six days and the chick fledges, on average, after another seventy to seventy-five. With a population estimated at 100,000 individuals, this species is not currently of conservation concern.

OPPOSITE Wahlberg's Eagle comes in several different color morphs. The dark brown plumage exhibited by this individual is the most common.

SHORT-TOED EAGLE

CIRCAETUS GALLICUS

APPEARANCE
Medium-sized; large, owl-like head, shortish tail, and long wings; bright yellow eyes; unfeathered tarsi; upperparts grayish-brown; underparts white, with soft brown markings on throat and upper breast; wings lightly barred beneath; tail has three to four brown bars.

SIZE
*length 24–26 in. (62–67 cm)
weight 2.6–5.1 lb (1.2–2.3 kg)*

wingspan 5 ft 7 in.–6 ft 1 in. (170–185 cm)

DISTRIBUTION
Mediterranean, in Europe and North Africa; Russia and Middle East; Indian subcontinent; Lesser Sunda Islands (Indonesia); western populations winter in sub-Saharan Africa north of the Equator, largely in the Sahel region.

STATUS
Least Concern

AT FIRST GLANCE YOU MIGHT TAKE this medium-sized eagle for a giant kestrel. Its long wings beat steadily as it hovers high over a hillside, its penetrating yellow eyes combing the ground for snakes. Few reptiles targeted by those talons escape.

This is a highly distinctive raptor. But despite the name, its toes are hardly the most distinctive feature. With its long wings and pale plumage, it is more likely to prompt confusion with an osprey than any other European eagle. Its behavior is equally eye-catching, whether it is hovering in midair or soaring overhead, half a snake dangling from its bill.

The Short-toed Eagle belongs to the *Circaetus* genus of snake-eagles, now thought more closely related to the Old World *Aegypiinae* vultures than to other eagles. It has the typical big, owl-like head, bright yellow eyes, and long, unfeathered tarsi of this genus, and is the only species to occur outside Africa. Once thought conspecific with two related African species, Beaudouin's Snake-eagle (p. 108) and the Black-chested Snake-eagle (p. 98), it is paler than both, with grayish-brown upperparts and largely white underparts marked with brown barring.

The range of this eagle extends east from the Mediterranean Basin to southern Russia and the Middle East, with separate populations on the Indian subcontinent and the Lesser Sunda Islands of Indonesia. Most European and Asian populations migrate south, passing via Gibraltar and the Bosporus into sub-Saharan Africa, where they spend winter in an east–west band north of the Equator—largely in the Sahel region. The Indian and Indonesian populations, however, are sedentary.

This is a bird of largely open terrain, from steppe and semidesert areas to maquis, foothills and cultivated areas; in short, anywhere that will provide a good supply of its staple diet: snakes. It will tackle individuals up to 5 feet (150 cm) long, crushing their head with its talons before swallowing them whole, if small, or tearing them up into smaller pieces.

Contrary to popular belief, the Short-toed Eagle is not immune to venom and, though it may sometimes take venomous snakes, it generally avoids any with a zigzag pattern down the spine, typical of the venomous *Viperidae* family. It hunts from the air, soaring and hovering over hillsides, often at a great height. Other prey includes lizards and small mammals up to the size of rabbits.

However open the terrain, the Short-toed Eagle requires trees in which to nest. Breeding pairs make a variety of high, whistling calls. They construct their relatively small nest of sticks and twigs in a tree, often on a hillside or cliff, building a new one every year or, occasionally, taking over the old nest of another species. The female incubates her single egg for forty-five to forty-seven days. Fledging takes a further sixty to eighty days. This species may live up to thirty years in the wild.

The Short-toed Eagle is listed as Least Concern, with a population estimated at 103,000 to 123,000 mature individuals. In Europe, however, it is in decline in many areas, the victim of changes in agricultural land use that disrupt its supply of snakes. In 2010, the European population stood at an estimated 8,200 to 10,350 pairs, with the highest numbers in Spain and Russia. Illegal persecution remains a threat, especially on migration, when large numbers are illegally shot while passing over the Mediterranean. Malta is the worst offender: one record from 1993 shows fifty individuals shot in a single day as they reached the island. BirdLife Malta is working to address this problem through education and improved law enforcement.

OPPOSITE An Indian rat snake puts up a spirited but ultimately futile defense against the deadly talons of a Short-toed Eagle.

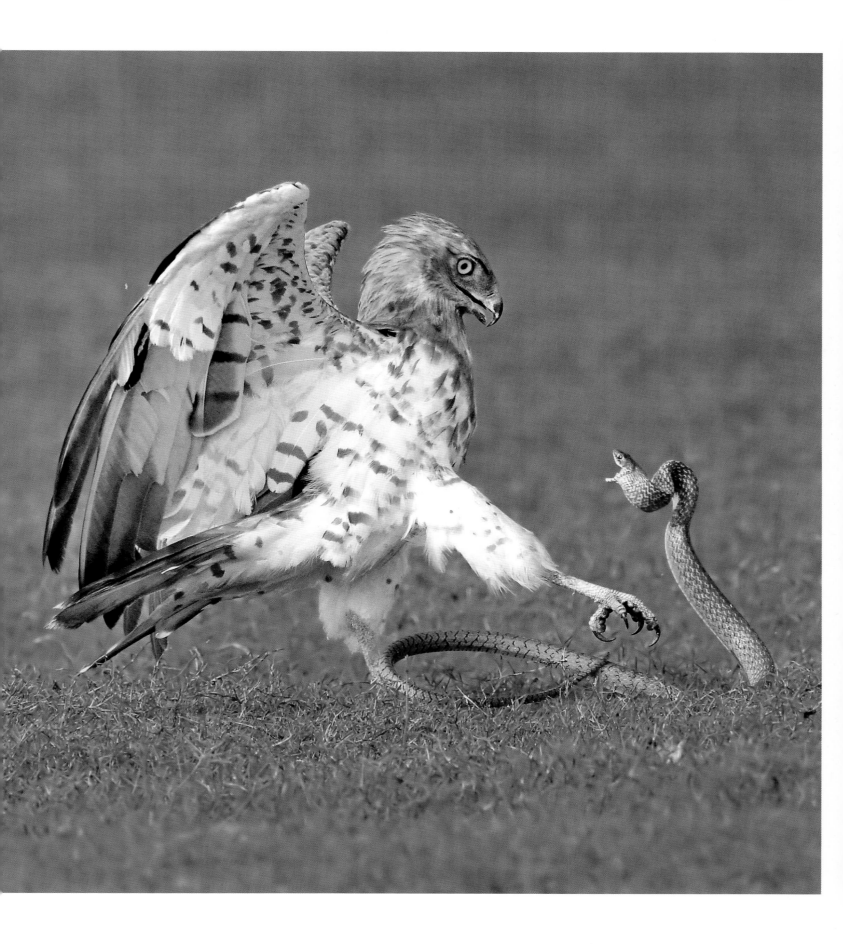

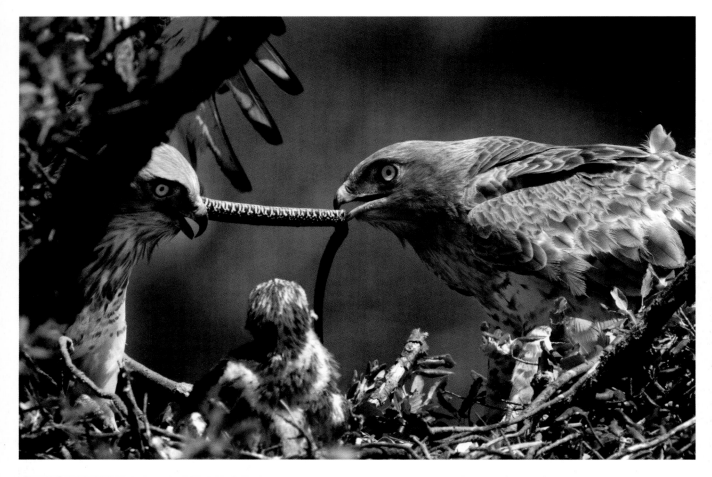

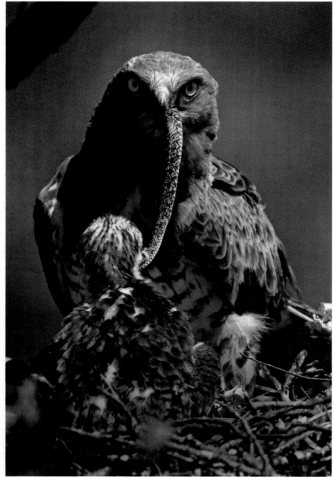

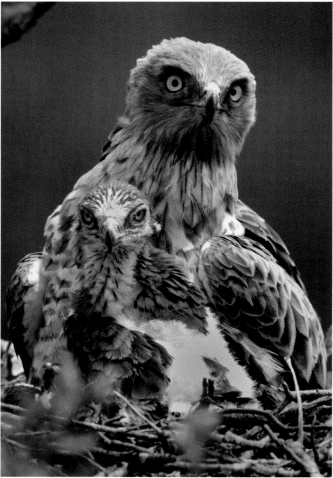

OPPOSITE A pair of Short-toed Eagles in Portugal feed a snake to their single chick.

BELOW In Europe, the pale underparts of a Short-toed Eagle preclude confusion with any other large raptor except the osprey.

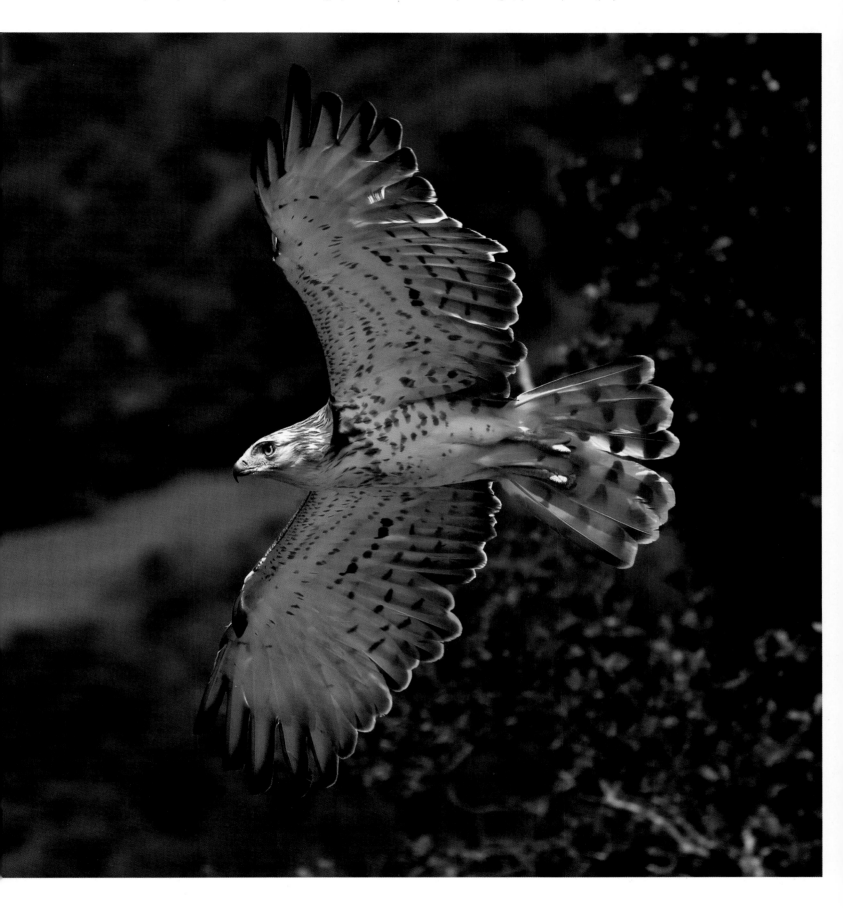

LEFT A Short-toed Eagle at sunset flying over a landscape of stone pines in Doñana National Park, Spain.

PREDATORS OF THE PLAINS

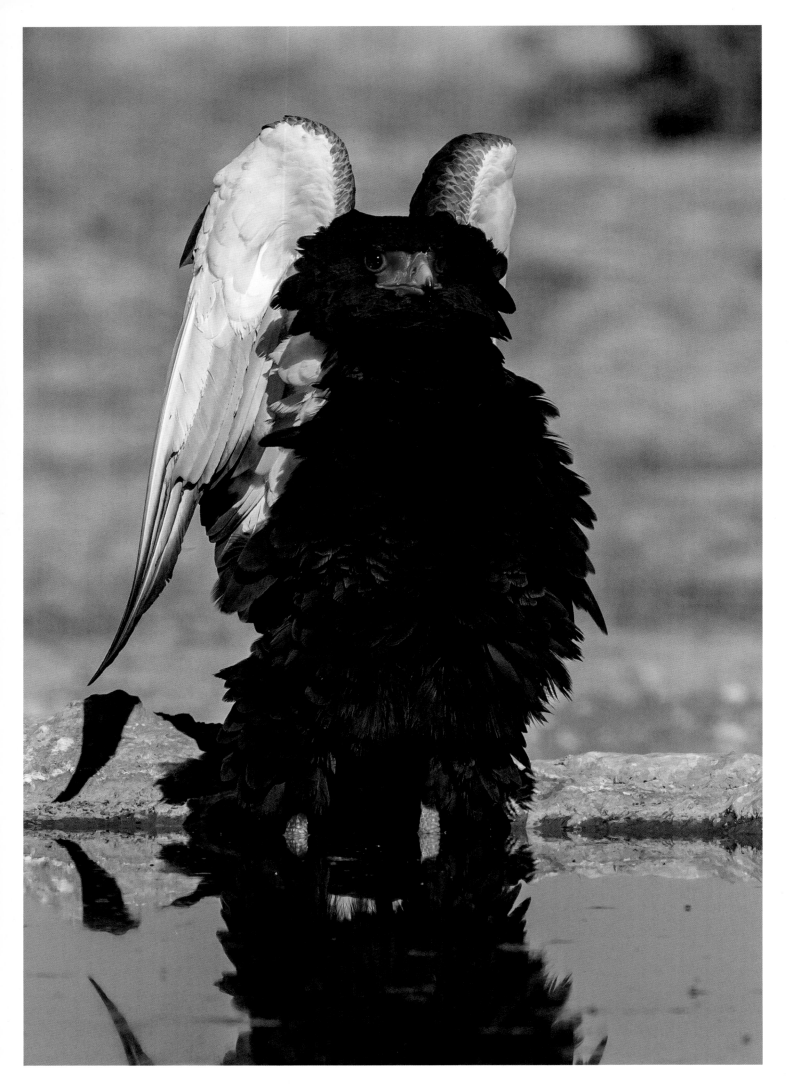

BATELEUR EAGLE

TERATHOPIUS ECAUDATUS

APPEARANCE
Medium-sized and stocky, with large head and short tail; unusually colorful for an eagle, with patchwork plumage comprising black head and underparts, chestnut mantle and tail, pale gray shoulders, and bright red face and legs; very long wings are conspicuous in flight, with primaries that protrude well beyond the end of the tail when perched; immatures are uniform brown, without bare face.

SIZE
length 22–28 in. (55–70 cm)
weight 4.7–5.2 lb (2–2.6 kg)
wingspan 6 ft 1 in. (186 cm)

DISTRIBUTION
Sub-Saharan Africa, from Senegal, east to the Horn of Africa and south as far as northern South Africa; absent from the Congo Basin; also southern Arabian Peninsula, recorded as far north as Israel.

STATUS
Near Threatened

THIS UNUSUAL BIRD IS THE CLASSIC soaring raptor of the African safari. Scan the skies above any big game park and it won't be long before one appears. Often gliding at little more than treetop height, its long-winged, almost tailless silhouette, combined with the distinctive tilting flight, immediately distinguishes it from all other similar-sized birds of prey.

It is often said that the Bateleur derives its name from the French for "tightrope walker." This would indeed be an apt description of that telltale flight action, the wings rocking as though outstretched for balance. In fact, a more accurate translation would be "street entertainer." Either way, there is certainly an element of the performer about this bird—whether sunning itself on the ground with its wings extravagantly outstretched, or tumbling through the sky in a spectacular courtship display, its talons locked with its partner's.

The scientific species name *eucaudatus* means "without a tail" and indeed the bird's tail is so short that its red feet protrude beyond the end. This strange silhouette and flight action can make the bird appear awkward, but exceptionally long primary wing feathers give the Bateleur great control in the air, allowing it to glide with minimal effort at low speed and low altitude. It may spend up to 80 percent of the day on the wing, covering more than 300 miles (500 km) as it scans the ground below for prey.

When perched, the bird's appearance is also distinctive. A medium-sized eagle, it has the large owl-like head characteristic of the *Circaetus* snake-eagles, to which it is related. However, its colorful plumage is unlike that of any other raptor, comprising a harlequin patchwork of black, pale gray, and rufous, with red legs and a patch of vivid red skin on the face contrasting with the glossy black head and neck. In flight, the snow-white underwings have a clear black margin, which is narrower in the female than the male, enabling the observer to distinguish the sexes. Immature birds are uniform brown in color but still have the adults' long-winged, large-headed shape, their tail growing shorter with each successive molt.

The Bateleur is an expert hunter of snakes and other reptiles, but these form only part of its predatory repertoire. It is equally skilled at catching birds—typically, medium-sized species such as sandgrouse and hornbills, which it may grab on the wing. It also takes a variety of mammals, from rodents to hares and even, on occasion, small antelope. And it is a ready scavenger, snatching up roadkill or visiting carcasses. Indeed, the Bateleur is often the first raptor to appear at a kill before vultures arrive, and is reputedly especially adept at finding the treed kill of a leopard; experienced safari guides will sometimes locate the big cat among the branches by first spotting a Bateleur perched patiently nearby. Ultimately, this bird is an opportunist. It will exploit any predatory opportunity, from snatching up small creatures fleeing from bush fires, to pirating prey from storks and other large birds.

For a bird that spends so much time on the wing, the Bateleur is seen on the ground more often than many other eagles. It often descends to drink at waterholes, small groups sometimes gathering, and may afterward sit back to sun itself with wings widely outstretched—rotating its body to follow the angle of the sun in a posture that is unique to the species.

This species ranges widely across sub-Saharan Africa; from Senegal, east to the Horn of Africa, and south as far

OPPOSITE A Bateleur Eagle stretches its wings at a waterhole in South Africa's Kgalagadi Transfrontier Park.

as northern South Africa. A small population also occurs in Yemen and Saudi Arabia, in the southern Arabian Peninsula, and wanderers have been recorded as far north as Israel. In April 2012, an immature was even seen in Algeciras in southern Spain—a first for Europe. Wherever it occurs, this bird's preferred habitat is open savanna and woodland. It avoids forested areas and so is largely absent from the Congo Basin, but it may thrive in semiarid habitats such as the Kalahari.

Bateleurs form strong, life-long pair bonds. They reinforce these at the start of each breeding season with spectacular aerial displays, in which the male dives down on the female in flight—she rolling on her back to present her talons as he passes by. In the process, he also performs complete barrel rolls and makes loud wing claps. The breeding season varies, from September to May in West Africa to December to August in southern Africa, and throughout the year in East Africa. Each pair actively defends its territory. The large stick nest is generally built in a tree fork, often near water, and lined with leaves. The female lays a single egg, which she incubates for fifty-four to fifty-nine days while the male guards the nest and brings food. Once hatched, the youngster usually takes at least 110 days to fledge and will stay in its parents' territory for several months. It can take up to eight years before the young

bird has shed all its immature plumage. During these early years, young birds may gather in large numbers in particular locations, such as Zimbabwe's Zambezi Valley.

In the wild, a Bateleur may live for twenty-five years. However, it faces numerous threats—mostly from humans. A shy nester, this species is easily disturbed by human activity. It is also vulnerable to poisoned bait left out by farmers, and is often struck by vehicles. On top of this comes habitat loss—notably the replacement of natural grassland with ranching and crops, which reduces the supply of available prey.

Today, the Bateleur remains common only in protected areas—especially big game parks, where the presence of large predators ensures a plentiful supply of carrion. Elsewhere, numbers are falling fast, with significant recent reductions in a number of countries, including Cote D'Ivoire, Kenya, South Africa, Sudan, and Zimbabwe. The last of these is particularly unfortunate, as the Bateleur is thought to be the species depicted by the ancient "Zimbabwe bird" statues, which have become emblematic of the nation and appear on the national flag. Today, BirdLife International lists the Bateleur as Near Threatened, with a global population estimated at 10,000 to 100,000. Conservation organizations such as The Peregrine Fund are working to protect the eagle and its habitat.

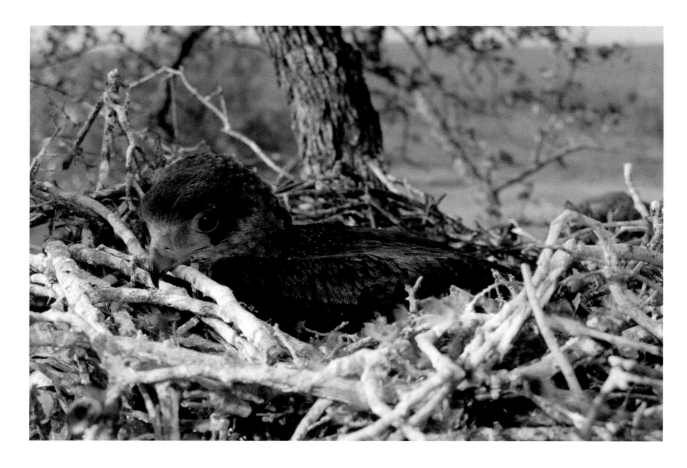

ABOVE A young Bateleur at its nest in Kruger National Park, South Africa.

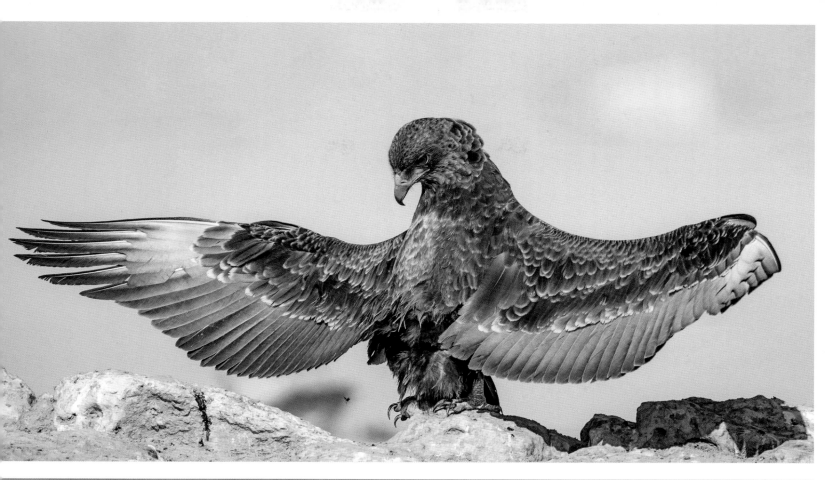

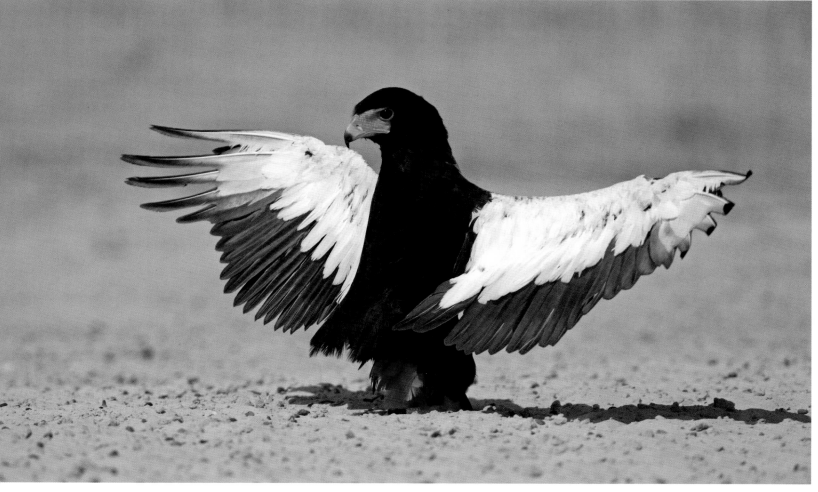

ABOVE Bateleurs often extend their wings in order to sunbathe, while perched on the ground. This strange gesture is performed both by youngsters (**ABOVE**) and adults (**BELOW**).

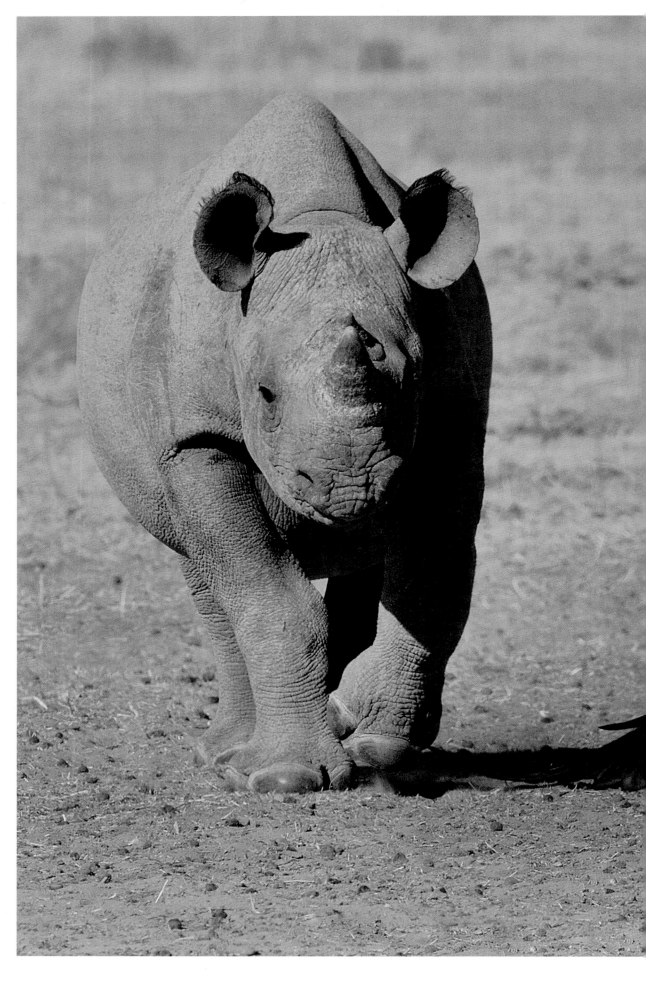

RIGHT A Bateleur takes flight as two black rhinos approach a waterhole at Namibia's Etosha National Park.

OVERLEAF An adult Bateleur (left) perches next to an immature (right) in South Africa's Kruger National Park, showing that although the two differ greatly in plumage, they share the same characteristic shape of large head, long wings, and short tail.

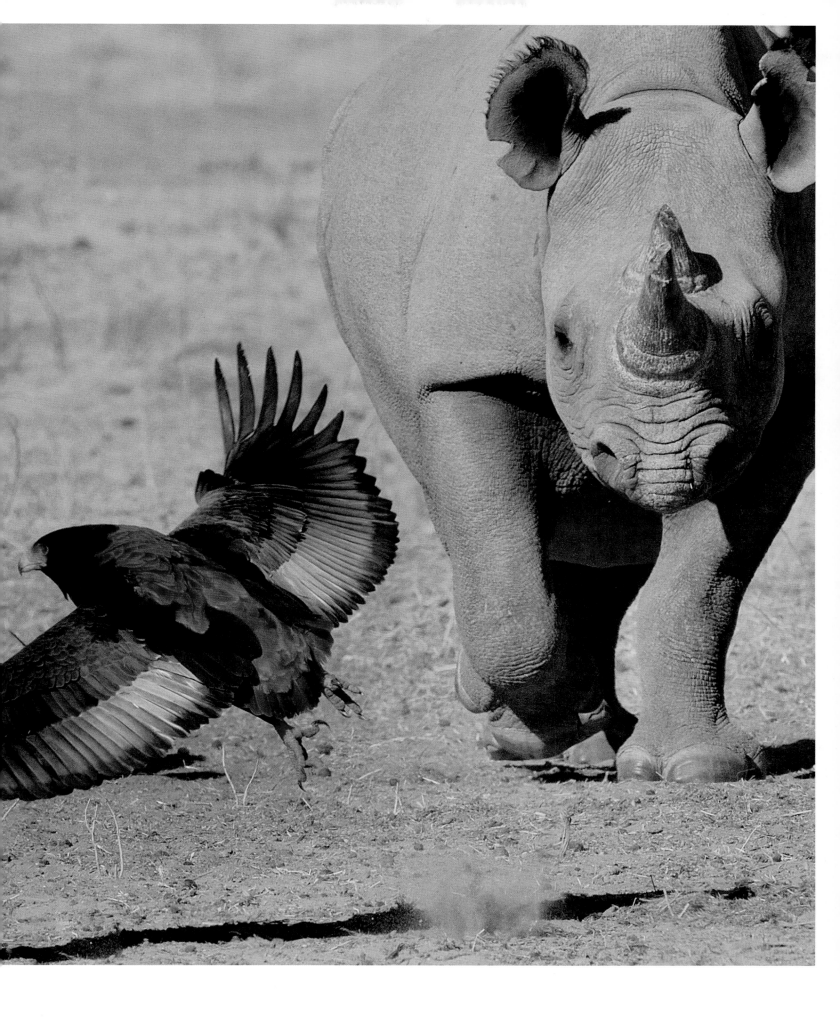

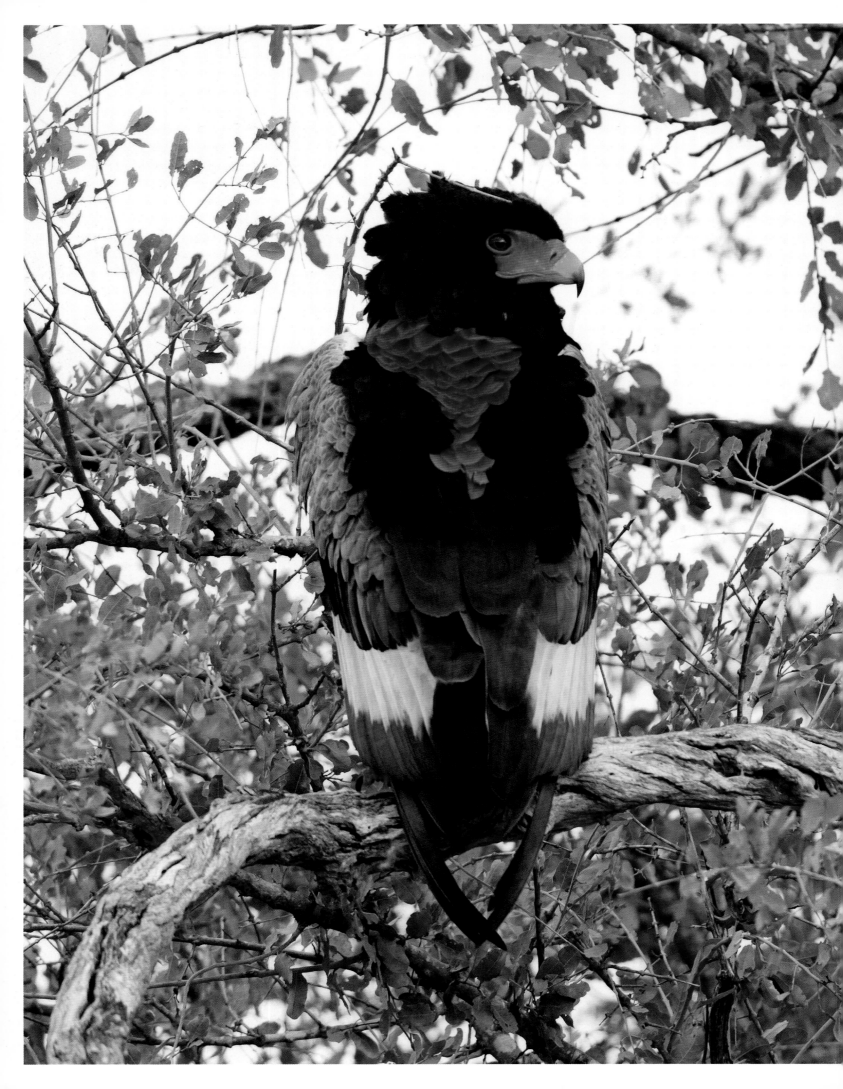

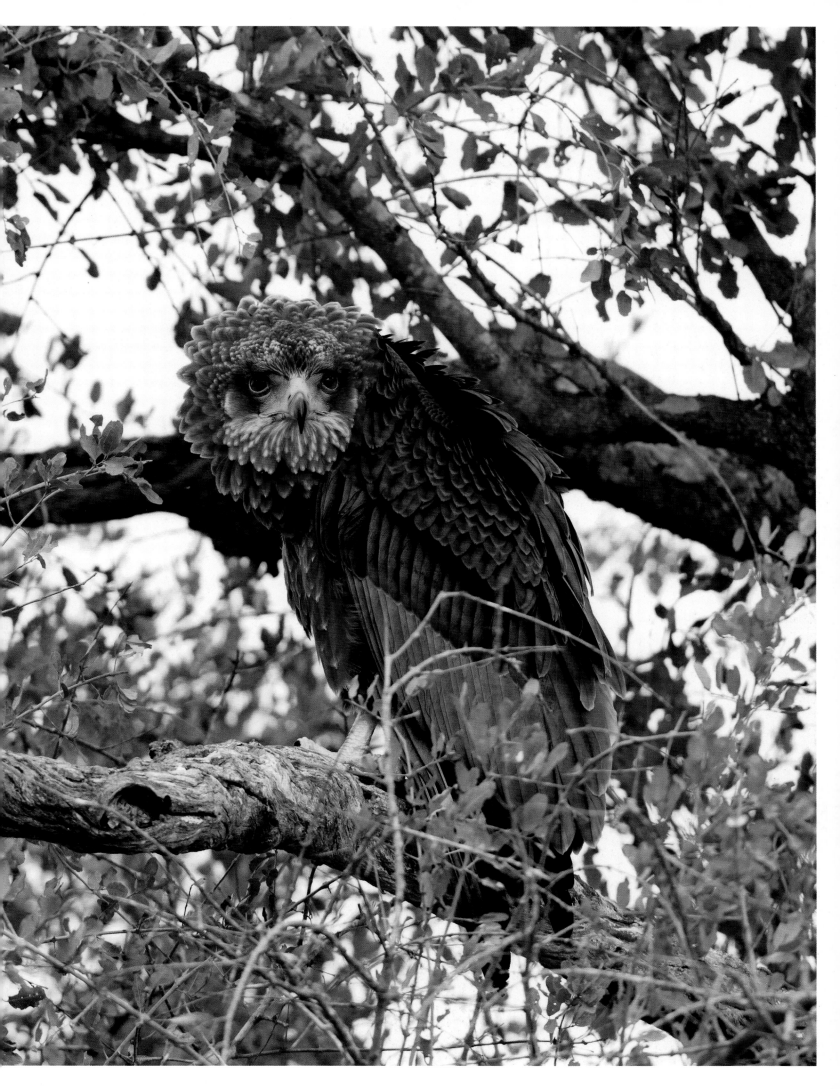

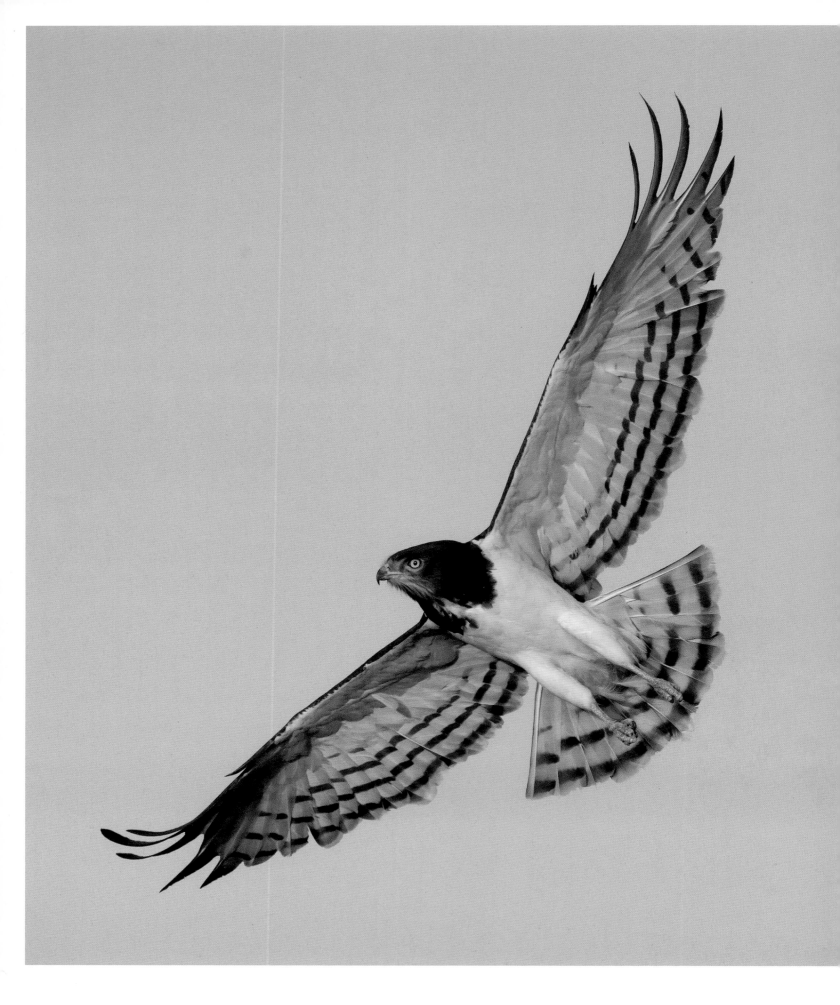

ABOVE In flight, a Black-chested Snake-eagle superficially resembles the much larger Martial Eagle, but has paler underwings and an unspotted belly.

BLACK-CHESTED SNAKE-EAGLE

CIRCAETUS PECTORALIS

APPEARANCE
Medium-sized, with long wings, bare legs, large head, and small bill; upperparts dark brown; dark head and chest contrast with white belly; underwings white, with fine barring on secondaries; three bars on tail; cere and legs gray; immatures rufous below with heavy brown spotting and barring.

SIZE
length 25–27 in. (63–68 cm)
weight 2.6–5 lb (1.2–2.3 kg)
wingspan 5 ft 10 in. (178 cm)

DISTRIBUTION
Eastern and southern Africa, from Ethiopia and Somalia and Sudan south to South Africa; largely absent form West Africa and the Congo Basin.

STATUS
Least Concern

THIS MEDIUM-SIZED SPECIES IS PERHAPS the most distinctive of the *Circaetus* snake-eagles, with its striking plumage set off by blazing yellow eyes. Closely related to the Short-toed Eagle (p. 84) and Beaudouin's Snake-eagle (p. 108), with which it forms a "super species," it replaces these more northerly birds over much of sub-Saharan Africa.

The other eagle with which this species is most often confused is the unrelated and larger Martial Eagle (p. 58). This reflects the two birds' similar plumage combination of brown upperparts and snow-white underparts—and their shared propensity for perching conspicuously atop a lone tree. A good view reveals that A Black-chested Eagle's underparts lack the brown spotting of a Martial Eagle's and that, in flight, it shows white rather than brown underwings. Furthermore, the Black-chested Snake-eagle—which is only half the Martial Eagle's size—shows that characteristic large-headed snake-eagle shape.

Black-chested Snake-eagles occur across eastern and southern Africa, from Ethiopia south to South Africa, but are largely absent from West Africa and the Congo Basin. Across their range, they require open terrain—typically arid grassland and woodland savanna—that provides both good visibility in which to hunt snakes and suitable trees for nesting.

They thrive in more arid areas, such as the Karoo and Kalahari. Some populations are resident; others can be highly nomadic, according to conditions. Groups of up to 200 have been recorded roosting together outside the breeding season.

As its name suggests, this bird is a specialist predator of snakes. By dropping unseen on its prey and immediately crushing the skull in its talons, it is able to overcome large and venomous species, including cobras and boomslangs. Like the Short-toed Eagle but unlike the Brown Snake-eagle (p. 100), whose range it shares, it typically hunts from the air and descends on its prey in stages. With larger snakes, it may sometimes find itself in a protracted struggle on the ground, occasionally ending in the death of both combatants. Typically, it consumes its prey in flight, headfirst, and is often seen with a length of half-swallowed serpent still dangling from its bill. Like other snake-eagles, it may also take other terrestrial prey, including small mammals and lizards.

The breeding season varies by region: June to August in South Africa, for example, but September to October in Namibia. A pair works together to build the shallow, saucer-like nest, which measures 23 to 27 inches (60–70 cm) across and is usually sited 11 to 24 feet (3.5–7.5 m) above the ground in a tall tree, such as an acacia. The pair lines the nest with green leaves and camouflages it with foliage, but it rarely lasts more than one season. The female incubates her egg for fifty to fifty-two days. The chick fledges after another ninety to 113 days and is usually independent after six months, though may stay with its parents for a year or more.

Population statistics are not known, but this species is not thought threatened. In South Africa, in common with several other eagles, the Black-chested Snake-eagle sometimes drowns in steep-sided farm reservoirs.

BROWN SNAKE-EAGLE

CIRCAETUS CINEREUS

APPEARANCE
Medium-large; big, owl-like head, shortish tail; yellow eyes; gray legs and cere; unfeathered tarsi; upperparts entirely dark brown, except for pale barring on tail and pale gray flight feathers, best visible on underwing in flight.
SIZE
length 28–30 in. (71–78 cm)

weight 3.3–5.5 lb (1.5–2.5 kg)
wingspan 5 ft 4 in.–6 ft (160–185 cm)
DISTRIBUTION
Sub-Saharan Africa: from Mauritania east to Sudan and Ethiopia; across East and southern Africa to northern South Africa; absent from Congo Basin.
STATUS
Least Concern

ON THE DUSTY GROUND IN South Africa's Kruger Park, a violent drama unfolds. A large brown raptor struggles in the gleaming coils of a big but clearly injured snake. Around the two stalks a female leopard; it prods warily with one paw, sensing an easy meal but unsure of the risk. And its caution is wise: the snake, though fatally injured, strikes out whenever the cat comes close. Meanwhile, the bird's flaps weaken as the snake's venom takes effect.

This extraordinary scene, captured on amateur video, is one of several clips available online that illustrate the predatory daring of the Brown Snake-eagle. The snake is a black mamba, more than 6 feet (1.8 m) long and equipped with venom that can fell a giraffe. The bird, which weighs no more than a domestic hen, appears to have launched an over-ambitious attack and is now paying the price. The leopard is simply an opportunist. Other clips show a Brown Snake-eagle confronting a large cobra, its hood raised, and another that has killed a python.

This is the largest of the *Circaetus* snake-eagles. It has the typical traits of the genus—a big, owl-like head, long bare legs, and piercing yellow eyes—but differs markedly in plumage,

being a uniform dark brown, except for pale barring on the tail and pale gray flight feathers that show clearly from below. Its legs and cere are also pale gray, and there is a hint of a crest.

The Brown Snake-eagle is widespread across sub-Saharan Africa, ranging from Mauritania to Sudan and south to northern South Africa. It inhabits wooded savanna, but avoids dense forest and very arid areas. Though largely sedentary, some populations make seasonal irruptive movements—especially those in West Africa, which often head south during the dry season.

This eagle is typically seen perched upright atop a tree or electrical tower, or circling the savanna on flat wings. It generally still-hunts, rather than hovering in the manner of some other snake-eagles. And it appears to think little of taking on extremely large prey, trusting to speed and surprise—and to the protective properties of its thick, fluffed-up plumage and heavily scaled legs. Nonetheless, snakes may turn the tables, as witnessed in the Kruger video. There are even records of Brown Snake-eagles blinded by spitting cobras. Prey also includes lizards and small mammals. Unlike other *Circaetus* species, this species does not consume its victims in flight.

A pair of Brown Snake-eagles generally nests in a tall tree, often taking over the abandoned nest of another large raptor. Noisy displays accompany the courtship period, after which the female lays one egg, which she incubates for forty-eight to fifty-three days. The single chick fledges after a further ninety-six to 113 days. Records suggest this species lives up to ten years in the wild. At present, it is not thought to be of serious conservation concern. However, habitat loss and human disturbance remain a threat—especially in West Africa, where its woodland breeding grounds are shrinking.

OPPOSITE Brown Snake-eagles typically perch very upright while watching for prey on the ground below.

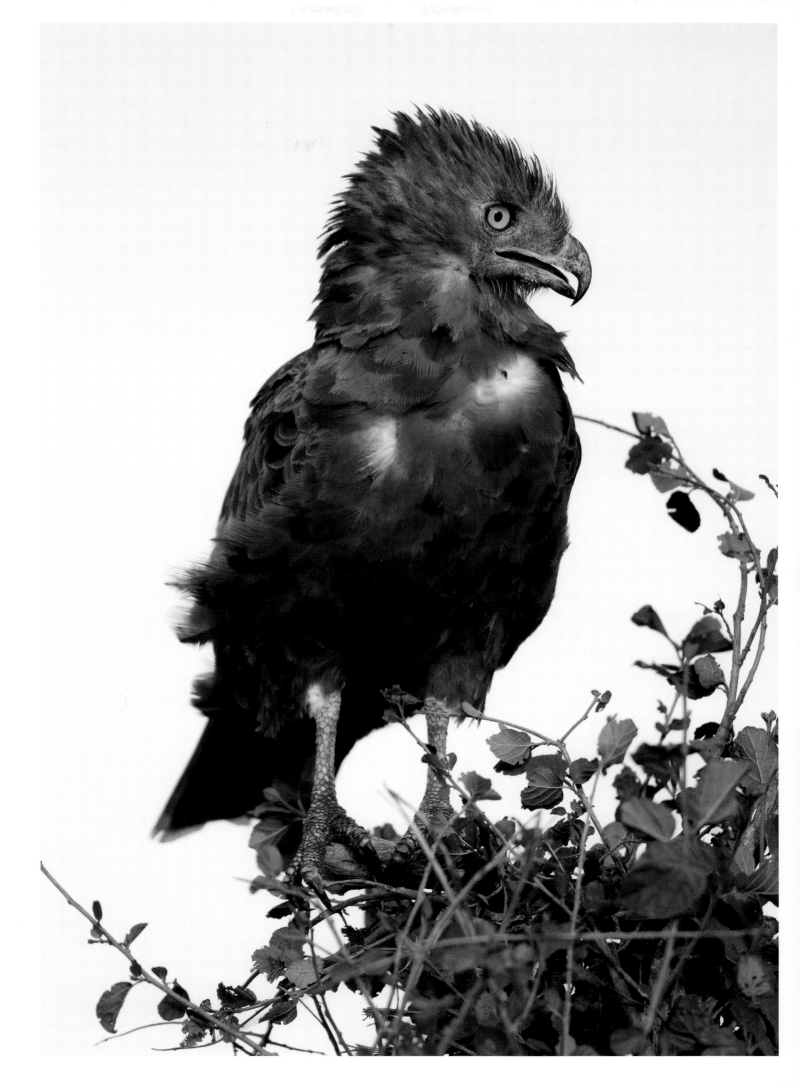

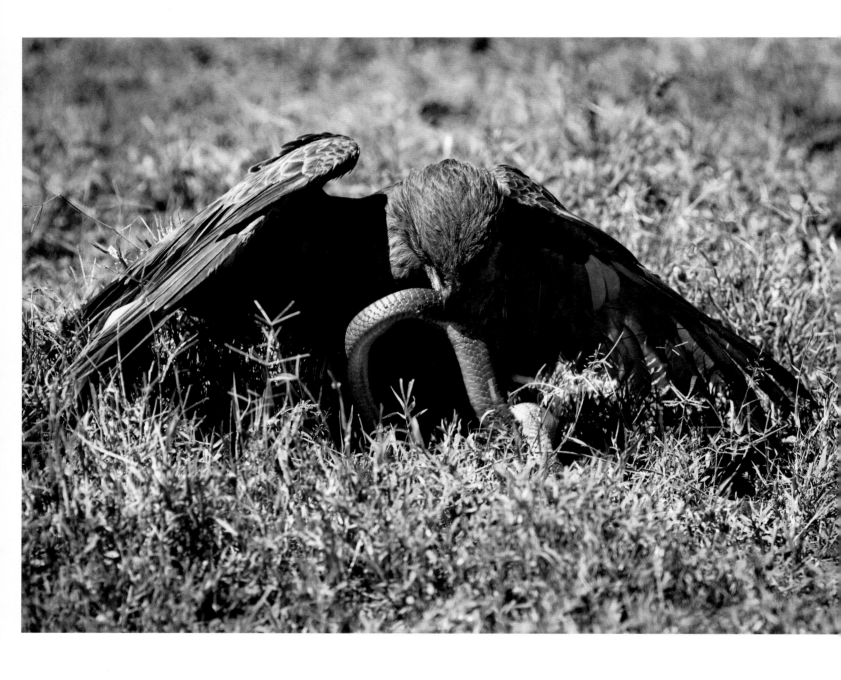

ABOVE A Brown Snake-eagle uses its wings to mantle a snake it has caught, while dispatching the catch with its talons and bill.

OPPOSITE In flight, this species shows pale underwings—a helpful identification feature when it is seen soaring high overhead.

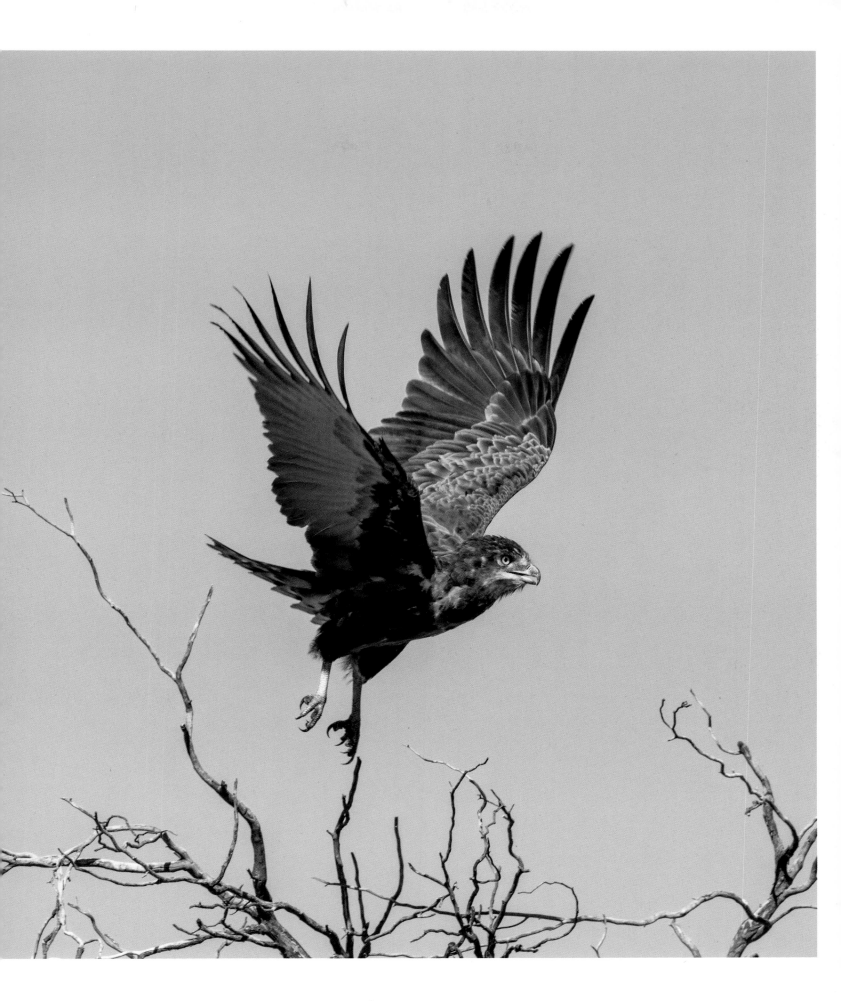

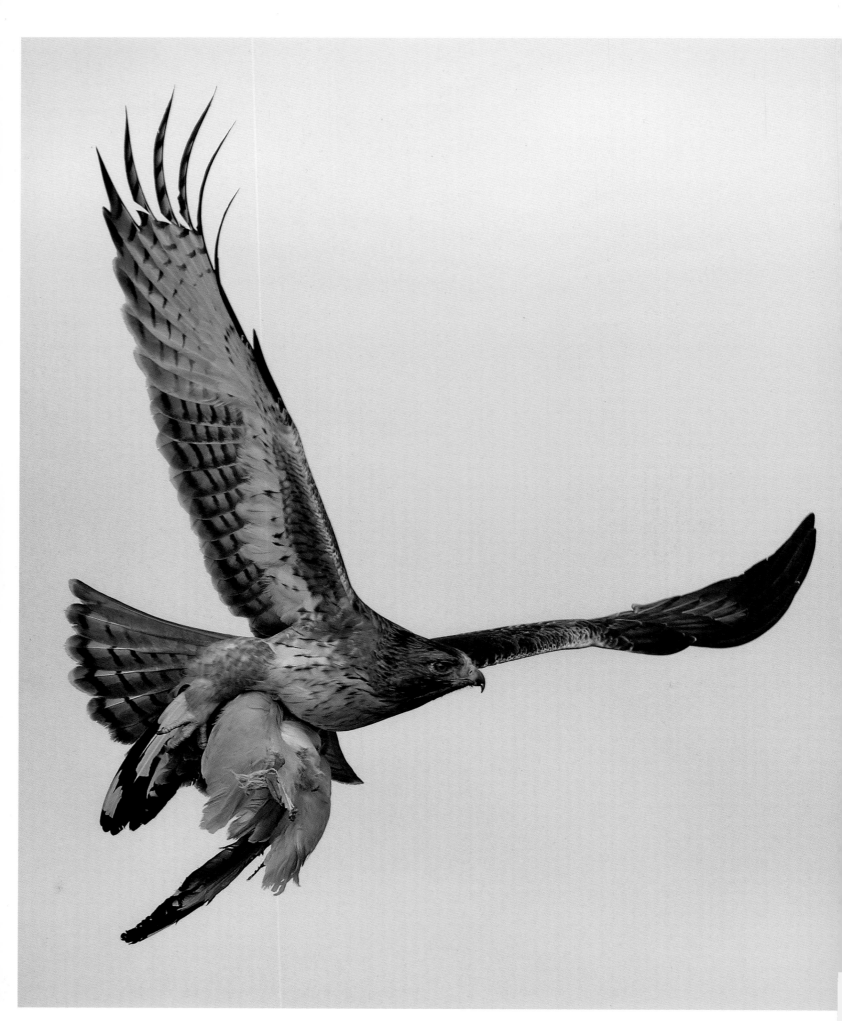

LITTLE EAGLE

HIERAAETUS MORPHNOIDES

APPEARANCE
Small and compact, with thickly feathered legs; pale morph is dark brown above and pale sandy below with fine dark streaking on head and throat; dark morph has underparts darker brown; rufous morph is more reddish all over; square, barred tail; in flight, shows pale, broken "M" markings across back and wing-coverts; immatures more rufous and uniform.

SIZE
length 17–21.5 in. (45–55 cm)
weight 1 lb–1.8 lb (440–815 g)
wingspan 3 ft 2 in.–4 ft 5 in. (100–136 cm)

DISTRIBUTION
Australia; widespread except for true desert and heavily forested regions.

STATUS
Least Concern

THIS POCKET-SIZED EAGLE IS ONE OF THE most rapacious predators of the Outback, punching well above its weight, capturing rabbits three times its size and dashing through the scrub in search of anything else it can get its talons into.

The Little Eagle is closely related to the Booted Eagle (p. 122), radiating a similar sense of power, with its hooked bill, imperious expression, and thickly feathered legs. It comes in different color morphs: the pale morph (most common) is dark brown above and sandy below, with fine streaking on the head and breast; there are also less common dark and rufous morphs. In all plumages it has a square, distinctly barred tail. Females are nearly twice the weight of males.

Once thought conspecific with the Pygmy Eagle of New Guinea (p. 216), it was separated on DNA evidence in 2009. These two species, together with the Booted Eagle, are probably the closest relatives of the extinct Haast's Eagle of New Zealand (p. 13), the largest eagle ever known.

The Little Eagle occurs across most of Australia. It frequents open woodland habitat, avoiding forest, and is most abundant in hilly landscapes with a mosaic of woodland and open areas. Some populations are migratory, making local, seasonal movements. This bird is typically spotted soaring in tight circles above the bush. It hunts both in flight and from a lookout, swooping down to snatch prey from the ground or snatching birds among the foliage.

Humans have had a great impact on the Little Eagle's menu. The raptor once subsisted largely on small native mammals, such as bandicoots, bettongs, and immature wallabies. Once European settlers introduced the rabbit and the red fox, and native mammals fell into decline, rabbits quickly became the raptor's staple food, supplemented by birds, reptiles, and the odd remaining native mammal. A recent crash in the rabbit population caused by calicivirus has since made this dependency problematic. Little Eagles may also scavenge and have been seen to steal fish from other birds.

A pair of Little Eagles claims a territory in an undulating display flight, with loud calling and steep dives. They build their stick nest in a tall tree, often along a tree-lined watercourse, or may take over an old crow's nest. The female lays one to two eggs in late August to early September, incubating them with the help of her mate for around thirty-seven days. The chicks fledge after eight weeks and reach breeding maturity in two to three years.

Although classified as Least Concern, the Little Eagle is declining in many areas and has been declared Vulnerable in New South Wales and Australian Capital Territory. Threats include loss of breeding habitat and a reduction in the rabbit prey on which it depends, thus also forcing it into intensified competition with the much larger Wedge-tailed Eagle (p. 52). An increase in the latter may have increased competition for carrion—also once an important food source.

OPPOSITE A Little Eagle carries a silver gull it has captured on the wing.

PREDATORS OF THE PLAINS

CROWNED SOLITARY EAGLE

BUTEOGALLUS CORONATUS

APPEARANCE	SIZE
Large and stocky, with bushy crest; plumage smoky-gray with white band across base and tip of tail; broad wings, with black wing tips and trailing edge; cere and legs yellow; immatures brown above, with buff head and heavily barred lower belly and legs.	*length 29½–33½ in. (75–85 cm)* *weight 6.3 lb (2.9 kg)* *wingspan 5 ft 6 in.–6 ft (170–183 cm)* **DISTRIBUTION** *Confined to South America, from Brazil and Bolivia to Paraguay and Argentina; formerly Uruguay.* **STATUS** *Endangered*

THIS LARGE SOUTH AMERICAN EAGLE IS the armadillo's nemesis. It seizes these largely nocturnal mammals just as they emerge at dusk, piercing their body armor with its powerful talons. Sadly, it is now a highly endangered species, declining fast as its habitat continues to disappear.

With its long bushy crest, the Crowned Solitary Eagle resembles the mighty Harpy Eagle (p. 164). Though considerably smaller than the Harpy, it is nonetheless the largest eagle in much of its range. In addition to the prominent, black-tipped crest, its plumage is a uniform smoky-gray, relieved by a prominent white band across the base of the tail and a thinner white band across the tip. In flight, the underwings show black tips and a black trailing edge. Its cere is yellow, as are its long bare legs. Immatures are brown above, with buff head and heavily barred lower belly and legs.

This species, also known as the Chaco Eagle, was once thought to be conspecific with the slightly smaller Mountain Solitary Eagle (p. 38). However, both are more closely related to black hawks than they are to other eagle genera. Consequently, they have been reclassified from the genus *Harpyhaliaetus* to the genus *Buteogallus*.

Crowned Solitary Eagles occur in Brazil, Bolivia, Paraguay, and Argentina. They inhabit open and semi-open lowland country, including dry chaco grasslands, tropical cerrado savannas, sparse woodland, and, in some areas, cattle ranches. They may also frequent hilly areas and gallery forest.

A good indication of this bird's presence is its long powerful whistle, which carries for up to 1.2 miles (2 km). A largely crepuscular predator, it still-hunts by twilight for small mammals and reptiles. It may also feed on fish and carrion.

A pair of Crowned Solitary Eagles build their large platform nest in a tree or ravine. The female lays a single white egg, which she incubates for thirty-nine to forty-five days. The chick fledges at sixty-five to seventy days and may depend on its parents for over a year—which means that a pair generally breeds once every two years.

This bird's population is highly fragmented and declining: BirdLife International estimates numbers at just 350 to 1,500 individuals. Principal threats come from habitat loss: in Brazil, cerrado habitats are giving way to mechanized agriculture, while elsewhere the encroachment of invasive grasses and non-native eucalyptus plantations all deplete prey populations. With such a small population, other causes of mortality, including collision with cars and power lines, and drowning in water tanks, are significant. Despite being legally protected in most of its range, it sometimes falls victim to farmers' guns—blamed, wrongly, for predation on livestock—and, in Argentina, at least a dozen individuals have been recorded in illegal trade. Effective conservation requires further research. This is underway in Argentina with the Centro para el Estudio y Conservación de las Aves Rapaces en Argentina, but similar initiatives are needed elsewhere if the bird is to survive.

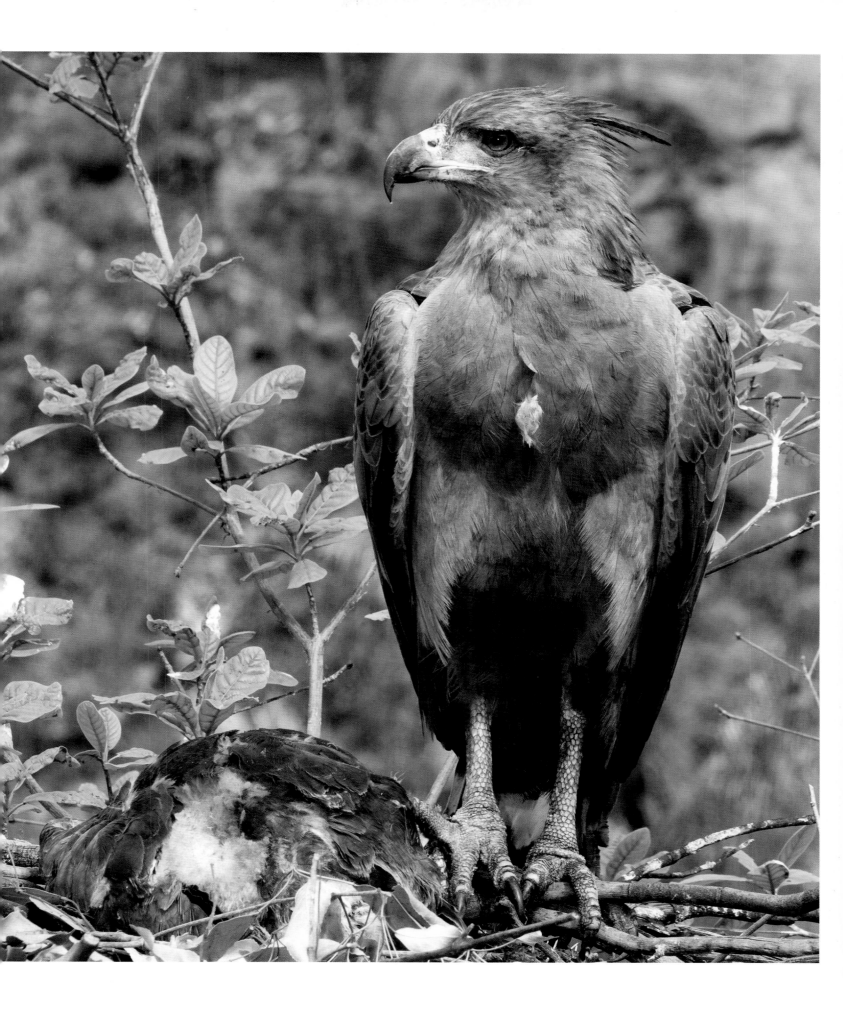

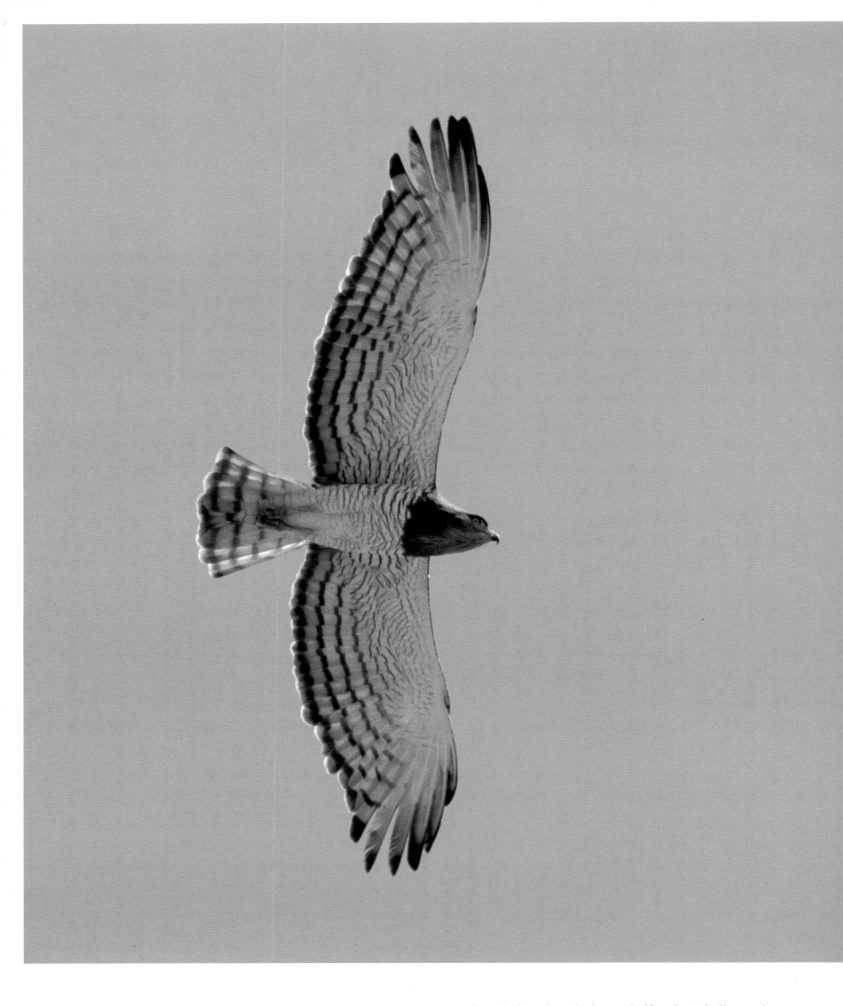

ABOVE Beaudouin's Snake-eagle can be distinguished from the similar Short-toed
Eagle by its darker head and more heavily marked underwings.

BEAUDOUIN'S SNAKE-EAGLE

CIRCAETUS BEAUDOUINI

APPEARANCE
Medium-sized, with bare legs, large head, and small bill; upperparts, head, and chest gray-brown; belly white, with fine dark brown barring; underwings white, with barring on flight feathers; four bars on tail; eyes bright yellow; cere and legs gray; immatures rufous-brown, with pale streaking on head and flanks.

SIZE
length 23½–26 in. (60–66 cm)

*weight no available data
wingspan 5 ft–5 ft 6 in.
(155–170 cm)*

DISTRIBUTION
The Sahel region (north Africa); from Senegal, Gambia, and south Mauritania in the west, through southern Mali east to Sudan and south to the Central African Republic; migrates north during the rains and south during the dry season.

STATUS
Vulnerable

BEAUDOUIN'S SNAKE-EAGLE is an "in-between" bird. It inhabits the Sahel, the broad strip of semiarid savanna that lies in-between Africa's Sahara Desert and its equatorial forests. And its appearance falls in between that of two close relatives: the slightly darker Black-chested Snake-eagle (p. 100) and the slightly paler Short-toed Eagle (p. 84). Only in the twenty-first century have taxonomists recognized this raptor as a species in its own right.

It is clear at a glance that this bird belongs to the *Circaetus* snake-eagles, with its large head, upright stance, and long, bare legs. In plumage, it shows a soft gray-brown head, chest, and upperparts, and white underparts finely barred in dark brown. The bill is black and the large eyes bright yellow. It appears strikingly pale in flight from below, with fine dark barring on the otherwise white underwings and three to four dark bars across the tail. Immatures are a rich rufous-brown, with paler streaking on the head and barring on the flanks.

Winter brings migrant Short-toed Eagles into the range of Beaudouin's Snake-eagle. The two species, together with the Black-chested Snake-eagle, are now thought to form a "super species," all having recently diverged from a common ancestor to occupy different geographical regions. Beaudouin's Snake-eagle is the rarest of this trio. Its range extends in a relatively narrow band, from Senegal, Gambia, and south Mauritania in West Africa, east through southern Mali and Burkina Faso to Sudan, and south into Cameroon and the Central African Republic. There have also been sightings in Uganda and unverified reports from Kenya. Wherever it occurs, it inhabits open terrain, from arid grassland to woodland savanna, and may take to cultivated regions if enough suitable nesting trees remain.

True to its name, this raptor subsists largely on snakes and other reptiles, supplementing this diet with large insects and occasional small mammals. Like all snake-eagles, it is largely a sit-and-wait hunter, taking up position on a prominent perch from which to drop on prey, but sometimes also hovering above open ground. In West Africa It breeds from November to March, building a relatively small nest of sticks in the crown of a tall tree. The female lays a single egg, which she incubates for forty-five days. The chick fledges seventy days later.

This eagle is today under severe pressure. The human population of the Sahel increased roughly threefold in the thirty years up to 2010, and over roughly the same time period, the number of Beaudouin's Snake-eagles in Senegal and Niger declined by an estimated 86 to 93 percent. With people comes agriculture, bringing overgrazing, woodcutting, and many other factors that compromise the raptor's habitat. The spraying of insecticides onto cotton fields has been especially damaging, depleting the bird's insect food while also introducing a chain of pollution that affects its breeding success. Today BirdLife International lists this species as Vulnerable, with an estimated population of 3,500 to 15,000 individuals.

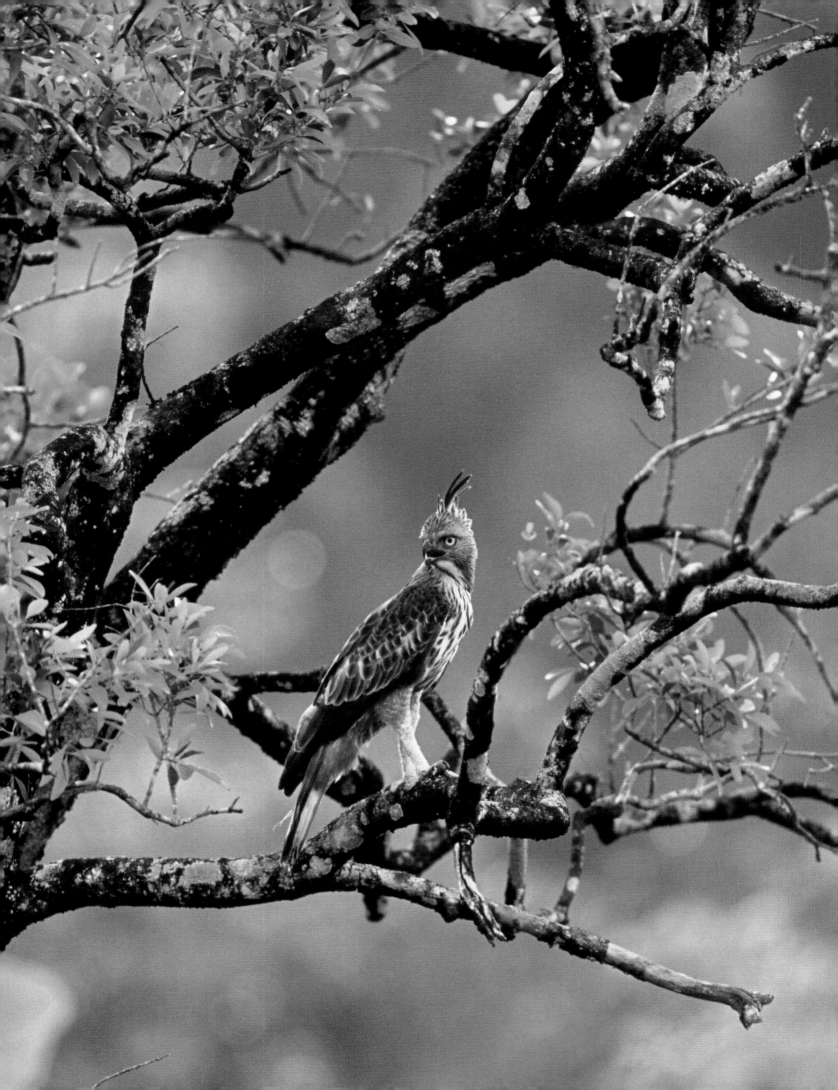

03 | ASSASSINS OF THE WOODLANDS

WOODLAND IS A TRICKY HABITAT to define. Technically, it comprises low-density forest with an open canopy that allows plentiful sunlight to penetrate between the trees, encouraging a rich understory of shrubs and grasses below. In simple terms, it is halfway between forest and grassland, and the eagles that frequent this habitat have evolved lifestyles that incorporate adaptations to both. A number of eagles described in this chapter also occur in grassland or forest habitats, while some eagles from the forest and grassland chapters may also hunt in woodlands.

The African Hawk-eagle is a case in point. A distribution map shows that this medium-sized eagle frequents the African savanna. But within that biome, it seeks out wooded areas, hunting among the trees rather than over the plains. As a predator, this gives it options: it can forage in and around clearings, swooping down from a perch to capture hares or other ground-dwelling prey, but is also capable of pursuing birds in flight among the trees. The smaller but equally rapacious Booted Eagle of Europe and parts of Africa occupies a similar niche: hunting over a broad habitat mosaic, it is also adept at taking pigeons flying above patches of woodland and rabbits grazing on open hillsides.

Some woodland eagles are essentially forest species that have adapted to a less congested habitat. The Crowned Eagle, probably Africa's most powerful raptor, is an apex predator of the equatorial rain forest, where it captures monkeys from the canopy. It has also colonized savanna woodland, penetrating into open country along watercourses and branching out into a wider variety of prey, from guinea fowl to small antelope, which it captures in clearings and along woodland edges. In South America, the Black Hawk-eagle belongs to the largely forest-dwelling genus of *Spizaetus* hawk-eagles, but as well as capturing monkeys and other canopy dwellers it may also prey on birds and reptiles in clearings and forest edges.

Some species are tied to particular types of woodland. In Africa, the Western Banded Snake-eagle hunts from a perch along wooded riverbanks, while its relative the Southern Banded Snake-eagle prefers coastal woodlands on the Indian Ocean floodplain. In Central Asia and Eastern Europe, the Spotted Eagle frequents damp, marshy woodland, where it finds frogs and other semi-aquatic prey, and in winter migrates south to the wetland and mangrove woodlands of the Indian subcontinent.

For some woodland eagles, however, specialization has proved problematic. The magnificent Spanish Imperial Eagle depends on the cork oak woodlands of southern Spain and the rabbits that thrive in the surrounding fields and hillsides. The felling of the former and the decline of the latter, due to myxomatosis, precipitated a steep decline in this species until, at a nadir of only thirty pairs by the 1960s, it was one of the rarest birds in the world. Thankfully, concerted conservation has since helped it recover.

Other eagles have proved more adaptable. Thus, in southern Asia, the Changeable Hawk-eagle—naturally a forest species—often frequents stands of woodland around tea plantations, while in Africa the Long-crested Eagle hunts around sugar-cane fields and nests in eucalyptus plantations. In both cases, the birds use the cover of trees from which to hunt for prey in the open. Gurney's Eagle in New Guinea and the Philippine Serpent-eagle of the Philippines are naturally forest dwellers, but with the loss of much of the forest cover on their islands, both have taken to the mosaic of cultivation that has replaced it, finding reptiles and other prey in the clearings, and nest sites among the remaining stands of trees.

Woodland eagles can be secretive and retiring. Most build their nests in the forks of tall trees deep inside the woods, sometimes taking over the nests of other woodland birds, such as common buzzards and crows. The best time to observe them is generally at the start of the breeding season, when pairs perform spectacular swooping and looping display flights high above the trees. Indeed, for such little-known species as Ayres's Hawk-eagle of central Africa and Blyth's Hawk-eagle of southeast Asia, it is often the only time.

OPPOSITE The Changeable Hawk-eagle is a typical woodland species, finding prey both among the trees and in the surrounding open country.

AFRICAN HAWK-EAGLE

AQUILA SPILOGASTER

APPEARANCE

Medium-sized; upperparts blackish-brown; underparts white, strongly streaked with black; in flight, underwing white with black trailing edge and black coverts; upperwing shows pale patch on primaries; undertail white with thin bars; immatures brown above and rufous below.

SIZE

length 21.5–25.5 in. (55–65 cm) weight male 2.4–3 lb (1.1–1.4 kg),

female 3–3.8 lb (1.4–1.75 kg) wingspan 4 ft 2 in.–5 ft 2 in. (130–160 cm)

DISTRIBUTION

Widespread across sub-Saharan Africa, from Gambia east to northern Ethiopia and south to northeastern South Africa; absent from the Congo Basin and heavily forested equatorial regions, also from very arid regions, including much of the Horn of Africa.

STATUS

Least Concern

AN ACT OF VIOLENCE HAS SHATTERED the midday lull of the African bush. Seconds ago, a flock of guinea fowl was scratching around in the dusty clearing. Now, they have vanished into the thickets, in a chorus of clucking. At the back of the clearing, defiant amid a cloud of feathers, is an African Hawk-eagle, with a lifeless victim clutched in its talons.

This medium-sized eagle is widespread but often overlooked, being a shy species that tends to use concealed perches. However, it is highly distinctive, its blackish-brown upperparts contrasting strongly with its white underparts that are heavily streaked in black. In flight, where it may be seen soaring at a great height, its black-and-white underwing pattern distinguishes it from other similar-sized eagles. From above, a whitish patch on the primaries is another diagnostic feature. Immatures are brown above and rufous below.

The African Hawk-eagle was once thought conspecific with Bonelli's Eagle (p. 32). The two birds are very similar in appearance and behavior, with this species distinguished by its more contrasting plumage. Taxonomists have since split the two, on DNA evidence. Together they form a super-species, which has been moved from the *Hieraaetus* genus of hawk-eagles to the *Aquila* genus of booted eagles. This is a bird of woodland and wooded savanna, particularly in hilly regions, where rocky cliffs and river courses offer good nesting habitat. It occurs across

sub-Saharan Africa, from Gambia to Northern Ethiopia and south as far as South Africa, but is common nowhere. It is absent from forested equatorial regions as well as arid regions, including much of western southern Africa and the Horn of Africa.

Though only a medium-sized eagle, this rapacious predator may take prey three times its own weight. Its menu includes a variety of small mammals, from hares and hyraxes to squirrels, and also medium-to-large birds, such as francolins, guinea fowl, and bustards. Records even exist of a young klipspringer (small antelope) falling victim. African Hawk-eagles generally hunt from the cover of their woodland habitat, spying for prey from a perch and then seizing it on the ground, or sometimes—with birds—striking it in midair. They may wait at a concealed vantage point near a waterhole and swoop down on drinkers, or even pursue prey on foot into a thicket. Pairs often work together, one bird flushing the victim out while the other swoops in to grab it.

African Hawk-eagles are monogamous. A pair performs a soaring courtship display, calling loudly, then works together in building a large stick nest that may measure 3 feet (1 m) across. This structure is typically sited in the fork of a large tree along a wooded riverbank, although cliff faces and even electrical towers offer alternative locations. Several nests may be built and used on rotation: one pair studied had twelve nests. The female lays one to two eggs, usually in October to March north of the Equator and April to July farther south. The parents share incubation, which lasts forty-two to forty-four days. Siblicide is the norm: the single chick fledges at seventy-three days, on average, and is independent after three months. Parents guard their brood jealously and will attack intruders, including—according to anecdotal evidence—humans.

Though afforded Least Concern status by the IUCN, the African Hawk-eagle is classed as Near Threatened in South Africa. It suffers across its range from the loss and degradation of suitable woodland habitat, and is persecuted in some areas for killing poultry.

OPPOSITE The African Hawk-eagle perches near the Chobe River in northern Botswana, looking for prey in the surrounding riparian woodland.

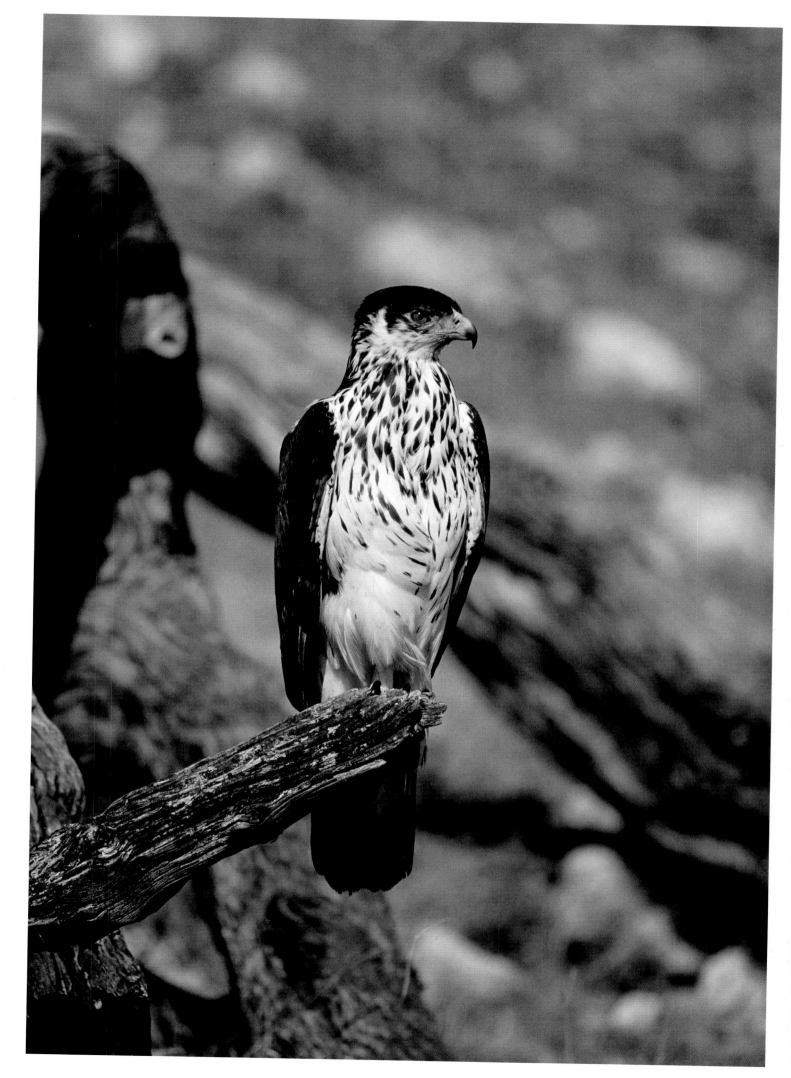

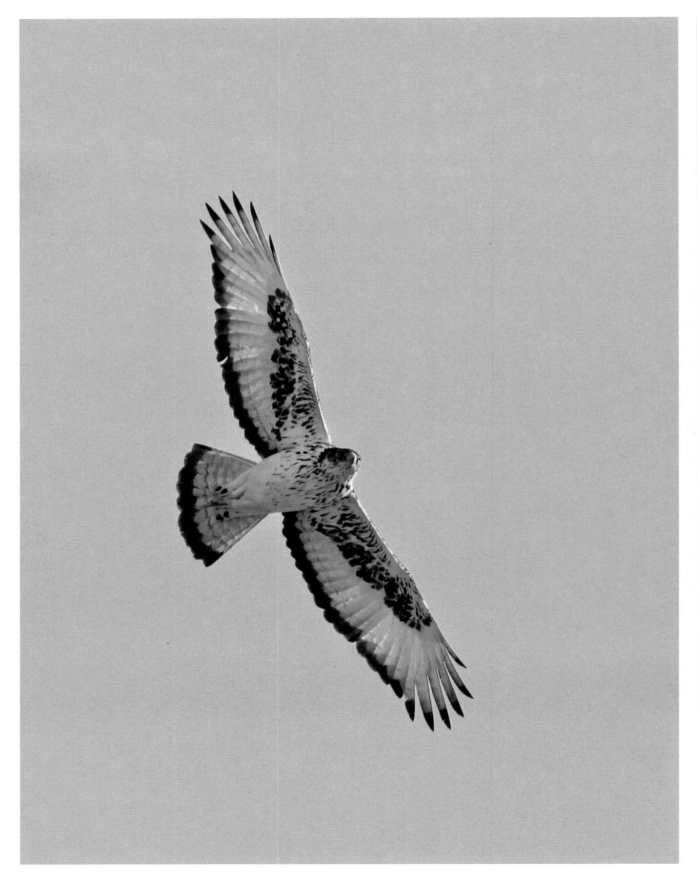

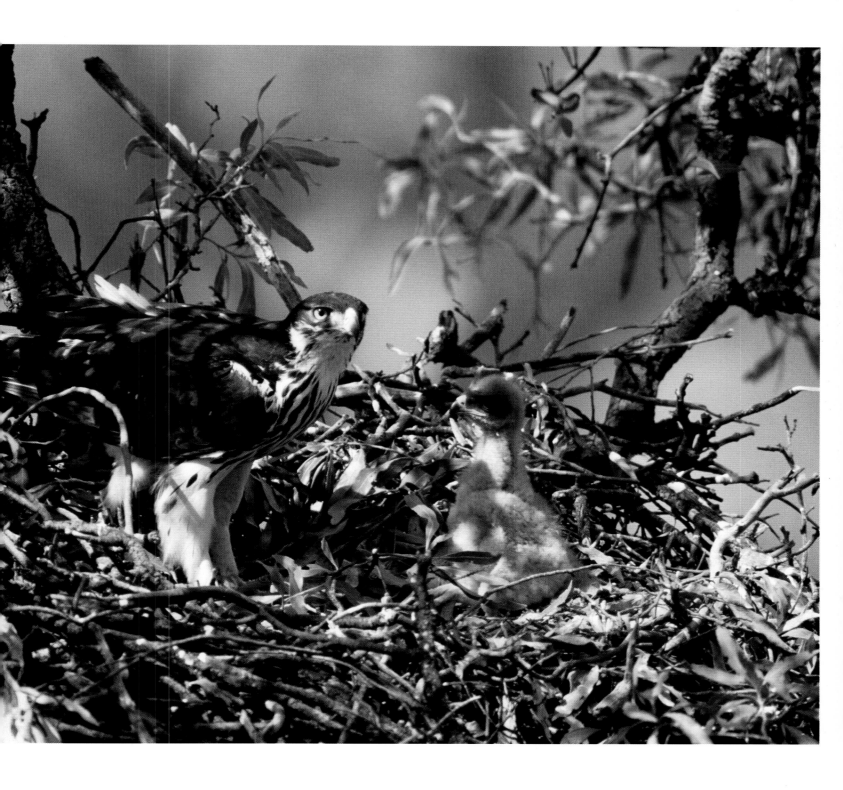

ABOVE Like other members of the *Aquila* genus, the African Hawk-eagle generally raises only a single chick.

OPPOSITE An African Hawk-eagle keeps its eyes level while its body twists and turns in pursuit of prey.

GREATER SPOTTED EAGLE

CLANGA CLANGA

APPEARANCE
Medium-sized; yellow eyes and cere; mid to dark brown, with darker flight feathers; in flight, white band across rump; immatures have white spotted wing coverts that show as white wing bars in flight.

SIZE
length 23–28 in. (59–71 cm)
weight male 3.7–4.2 lb (1.7–1.9 kg), female 4–5.5 lb (1.8–2.5 kg)

wingspan 5 ft 1 in.–5 ft 10 in. (157–179 cm)

DISTRIBUTION
Breeds from Eastern Europe and the Baltic, across Russia and Kazakhstan to Siberia, China, and Mongolia; winters in southeastern Europe, northeastern Africa, Middle East, and the Indian subcontinent.

STATUS
Vulnerable

THIS SPECIES IS CLOSELY RELATED TO the Lesser Spotted Eagle (p. 68) and the Indian Spotted Eagle (p. 152). All three were once classified as *Aquila* eagles but have since been assigned their own genus, *Clanga*. Their common name derives from the pale spots on the wing coverts of youngsters. Adults are unspotted, however, and so are easily mistaken for other similar brown eagles, such as the Steppe Eagle (p. 76), Tawny Eagle (p. 72), and Eastern Imperial Eagle (p. 64), with whose ranges theirs often overlaps.

So, which spotted eagle have you spotted? In the field, telling the three apart is a serious challenge. This species is the largest. Medium-sized, its plumage tends to be darker than that of the Lesser Spotted Eagle and the Indian Spotted Eagle, and adults have a paler eye than the latter. In flight, it reveals a similar white horseshoe on the rump and, in immature birds, white lines along the wing coverts, but it lacks the pale primary markings of the Lesser Spotted. Like the other two, it glides with flat wings and characteristic drooping "hands," but its wings are slightly broader and, with its relatively short tail, can produce a silhouette more like that of a small sea-eagle.

Scientists believe that the Greater Spotted Eagle and Lesser Spotted Eagle diverged from a common ancestor about 3.6 million years ago, somewhere around present-day Afghanistan, and then split about 1.5 million years later into

an eastern species (Greater Spotted) and western (Lesser Spotted). The fact that these two species occasionally hybridize with one another indicates how closely they are related—and further complicates identification.

The Greater Spotted Eagle is rarer than the Lesser Spotted, with a fragmented breeding range that extends from Eastern Europe east to Siberia, China, and Mongolia. Like the Lesser Spotted, it is strongly migratory, wintering in southeastern Europe, northeastern Africa, the Middle East, and the Indian subcontinent. Small groups travel together, joining other raptors such as Black Kites and Steppe Eagles. One adult satellite-tagged in 1993 migrated 3,434 miles (5,526 km) from its wintering grounds in Yemen to its breeding grounds in west Siberia, covering an average of 93 miles (150 km) per day. Vagrant birds may turn up as far west as Germany.

This is a bird of lowland forests, especially near wetlands and meadows, where it hunts for small mammals, water birds, and reptiles and often forages on the ground for frogs. On its Indian wintering grounds, its liking for wetland habitats, including mangroves, helps separate it from the Indian Spotted Eagle. It may also take carrion and pirate prey from Black Kites.

Greater Spotted Eagles breed in spring, with a pair performing soaring displays while calling loudly, then building a large stick nest high in a tree—sometimes on a rock face or even on the ground. The female lays one to three eggs, which the pair incubates for forty-two to forty-four days. Both parents care for the chicks, which fledge in August after sixty to sixty-seven days.

Today, this species is struggling. The world population is estimated at fewer than 4,000 breeding pairs, with some 800 to 1,100 in Europe. Among numerous threats are shooting, poisoning, wetland drainage, and afforestation. In Belarus, the introduced American mink is thought to pose significant competition for wetland prey. This country now has a dedicated national action plan for the species' conservation.

OPPOSITE It is the pale markings on the upperparts of immature birds from which this species derives the "spotted" part of its name.

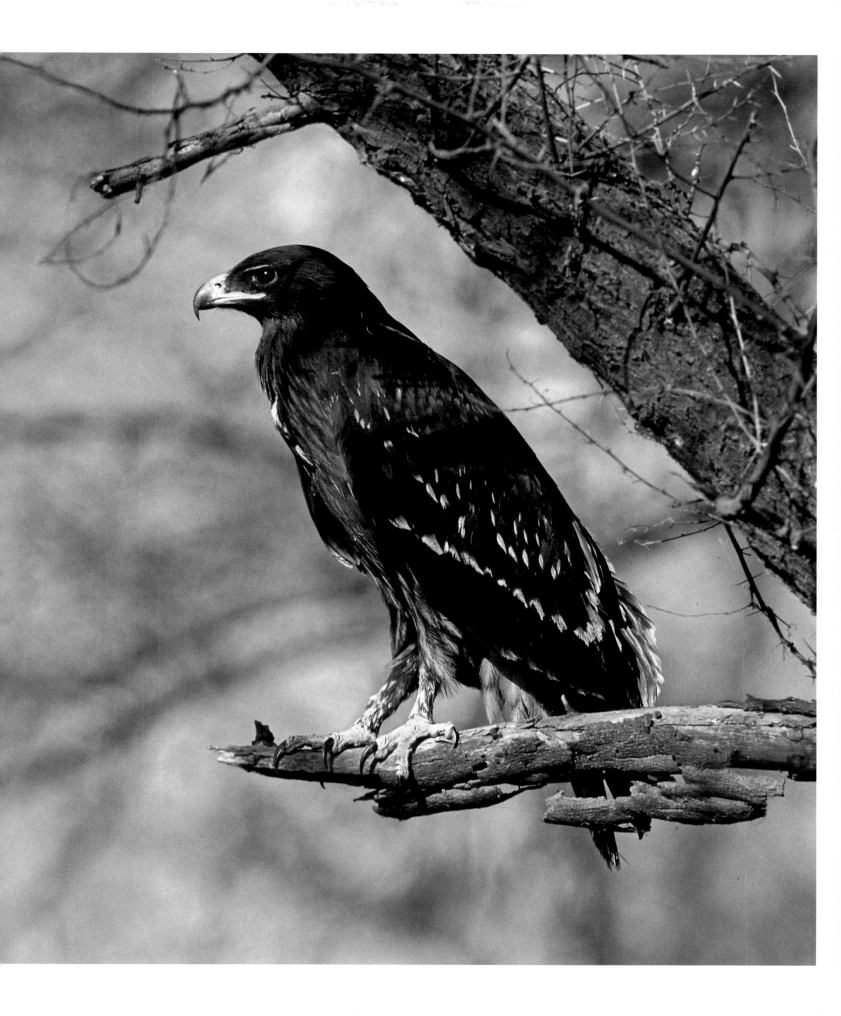

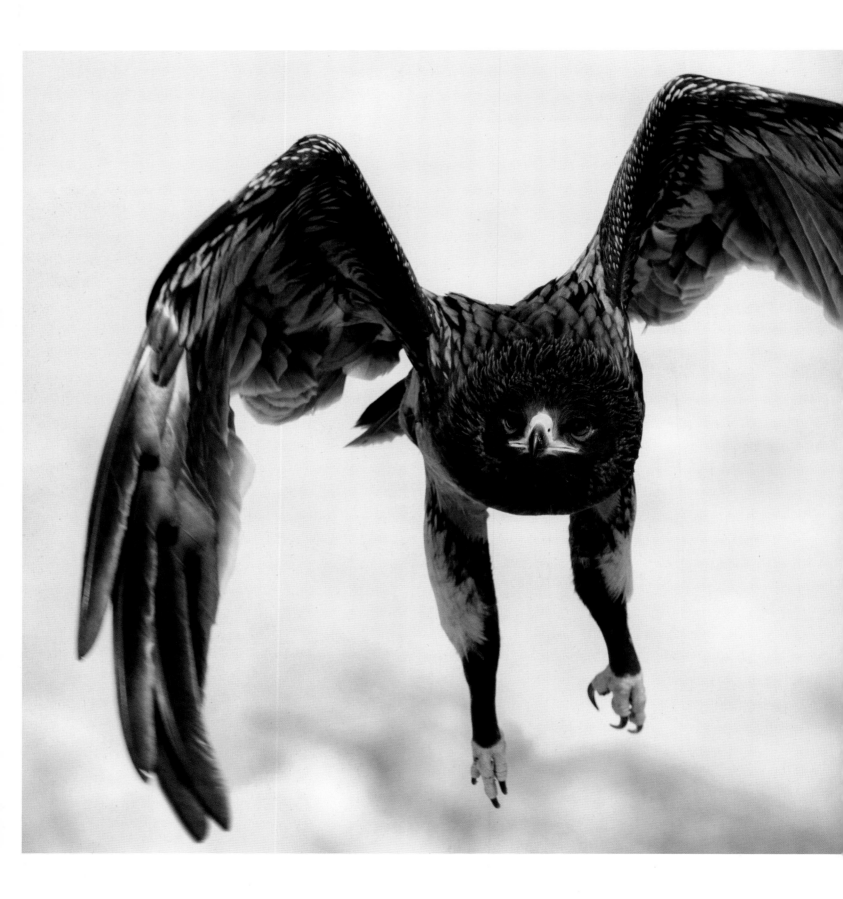

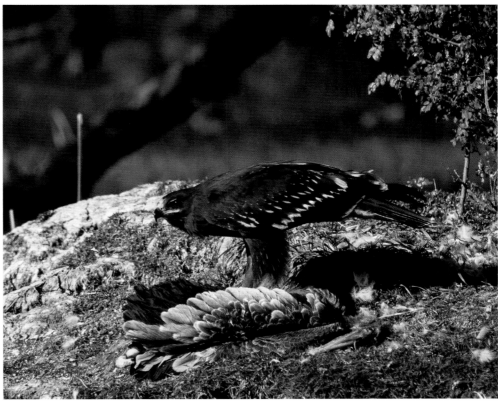

ABOVE A Greater Spotted Eagle feeds on a painted stork in Keoladeo National Park, Bharatpur, India.

OPPOSITE An immature Greater Spotted Eagle takes flight in Salalah, Dhofar, Oman.

RIGHT A Greater Spotted Eagle perches close to a European starling. The smaller bird has little to worry about, as the eagle generally targets larger prey.

BOOTED EAGLE

HIERAAETUS PENNATUS

APPEARANCE

Small; pale morph is brown above with black flight feathers and creamy markings, and whitish below with streaking on the breast; dark morph is similar above but mid- or rufous-brown below, with creamy pants; in flight, both morphs show paler markings across the scapulars, coverts, and rump and a small white spot (known as a landing light) on each shoulder; immatures are similar in plumage; females are around 10 percent larger than males.

SIZE

length 16.5 – 21 in. (42 – 53 cm) weight male 1.1 – 1.8 lb (0.5 – 0.8 kg), female 1.8 – 2.2 lb (0.8 – 1 kg) wingspan 3 ft 6 in. – 4 ft 4 in. (110 – 135 cm)

DISTRIBUTION

Three races occur, each with a distinct distribution: nominate race, H. p. pennatus, breeds in southern and eastern Europe, North Africa, and the Caucasus, wintering from sub-Saharan Africa to northern South Africa; H. p. harterti breeds in southwest and Central Asia and winters in the Indian subcontinent; H. p. minisculus breeds in western South Africa and Namibia and is largely sedentary.

STATUS

Least Concern

DEEP IN A SPANISH CORK OAK the feathers of a jay flash brilliant blue among the leaf litter. Just above them—perched on an old, gnarled stump—is the killer, still methodically plucking its victim. It's a Booted Eagle. No larger than a common buzzard, this is Europe's smallest eagle and one of the smallest worldwide. Yet that fierce glare, as it looks up from its task, shows that size isn't everything. A dashing predator, it strikes terror into these Mediterranean woodlands, hurtling from the sky to capture prey as large as itself.

The Booted Eagle may be the size of a common buzzard but it has the demeanor of a miniature Golden Eagle (p. 22), whose range it sometimes shares. It is a dimorphic species, occurring in two color morphs. The more common pale morph birds have brown upperparts, with black flight feathers and creamy markings, and whitish underparts, with a buff throat and streaking on the breast. Dark-morph birds are similar above but mid- or rufous-brown below, with conspicuous creamy pants. In flight, birds of both morphs show paler markings across the scapulars, coverts, and rump. Most individuals show a distinct small white spot on each shoulder that is clearly

visible as the bird flies toward you. These spots—known as "landing lights"—are a diagnostic ID feature that quickly separates this species from the several other medium-sized raptors with which it might be confused, including common buzzards, honey buzzards, harriers, and, in Africa, Wahlberg's Eagle (p. 82) and Ayres's Hawk-eagle (p. 142).

The last two of these are, in fact, closely related to the Booted Eagle. Along with the Little Eagle (p. 104) and Pygmy Eagle (p. 216) of Australasia, they make up the *Hieraaetus* genus of eagles—though were previously classified in the genus *Aquila*. The name "booted" refers to the legs and tarsi that are thickly feathered all the way to the toes, a feature also typical of the *Aquila* eagles.

The Booted Eagle is strongly migratory, with a complex pattern of distribution across both the Northern and Southern Hemispheres. Scientists recognize three separate races. The nominate race, *H. p. pennatus*, has a breeding range that extends from the Mediterranean—in both southern Europe and North Africa—east across Eastern Europe and the Caucasus, with most birds from this region wintering in sub-Saharan Africa, as far south as northern South Africa. A separate race, *H. p. harterti*, breeds in southwest and Central Asia and winters in the Indian subcontinent. And a third race, *H. p. minisculus*, breeds in western South Africa and Namibia. This last race—which was not recognized until 1972—does not join with the migrant birds of the nominate race when they arrive during the southern African winter, though may make small northward movements of its own during this season.

Across its range, this species frequents rocky, hilly terrain, preferring a patchwork of wooded and open areas—generally at 1,000 to 3,300 feet (300 – 1,000 m) above sea level, although has been recorded up to 9,800 feet (3,000 m). It may also inhabit arid and semidesert regions, especially in Africa, and often hunts around villages and settlements. On migration, birds tend to cover a broader array of habitats—anything except closed-canopy forest.

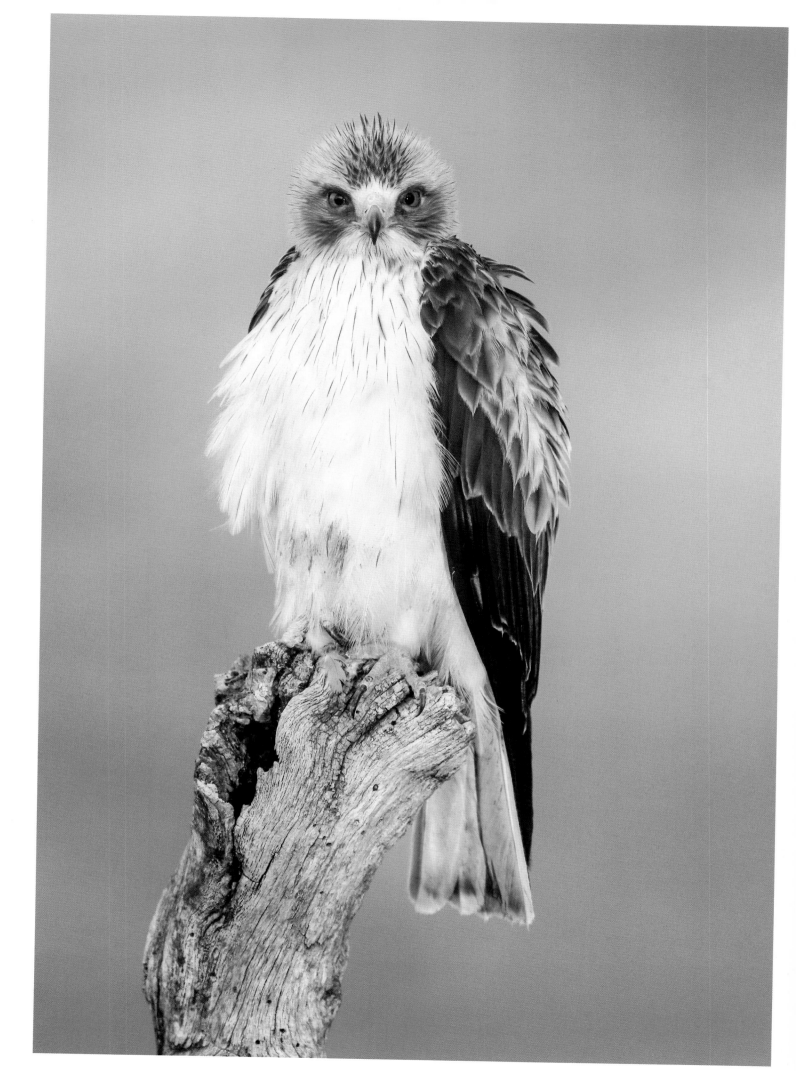

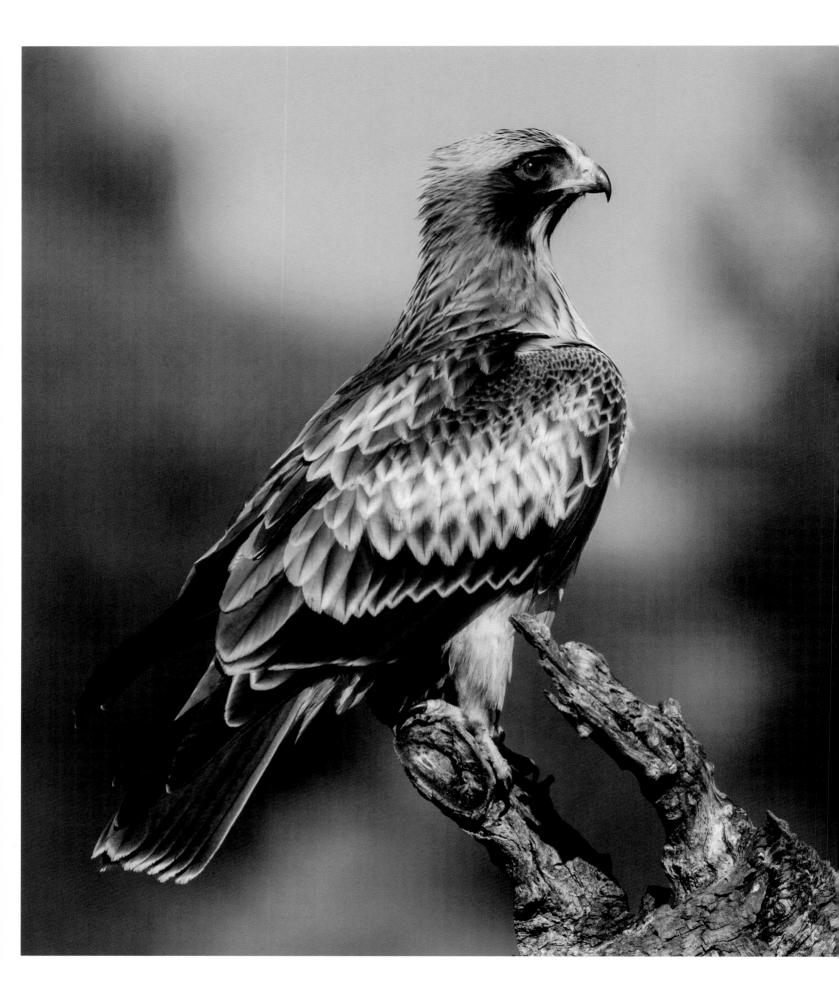

ABOVE This Booted Eagle is a pale morph individual, the more common of two plumage morphs.

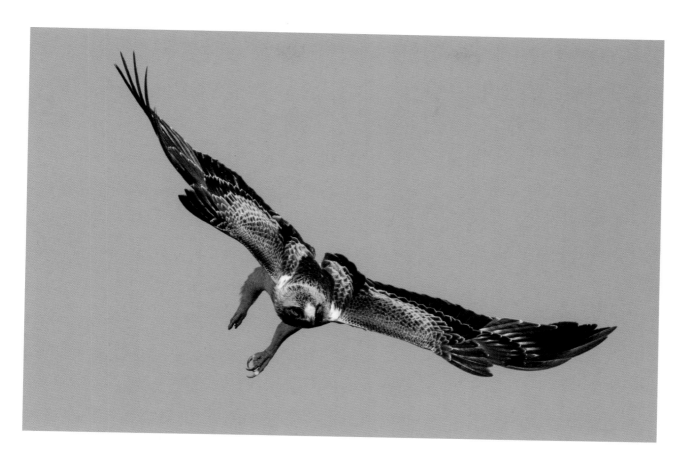

Migration movements are complex: the most northerly breeding populations travel the farthest, leaving around late September for their African winter quarters and returning to their breeding grounds in March. A few of the more southerly breeding population—notably in southern Spain (including the Balearic Islands), North Africa, and northern India—are sedentary, remaining on their territories year-round. Migrants travel individually, in pairs, or in small groups of up to five, but do not join the larger migratory flocks of some other raptor species. They pass through bottlenecks such as Gibraltar when crossing the Mediterranean, but may also cross water on a broad front.

This eagle is a highly dynamic hunter. It may capture birds in flight, chasing them through the canopy like a goshawk or dropping in a breathtaking stoop from on high like a peregrine falcon. Equally, it will still-hunt from a perch or even pursue smaller prey on the ground. In some areas, birds comprise more than 50 percent of its diet, the selection ranging from small fare such as larks and starlings to pigeons, partridges, crows, and sandgrouse. Small mammals, up to the size of ground squirrels and young rabbits, are also on the menu, as are reptiles, amphibians, and large invertebrates. Observers have seen this enterprising raptor raid other birds' nests for their nestlings and, in South Africa, drop a tortoise

from above in order to crack open its shell—a ploy also known in Golden Eagles. As with some other eagles, pairs sometimes hunt cooperatively together.

Booted Eagles form monogamous life-long pairs. Breeding starts with an impressive aerial display, the male climbing high and calling loudly before swooping on the female who, in midair, flips on her back to lock talons with her partner. Their nest of sticks is built in a tree or on a crag—cliffs invariably being chosen in the southern African race. Sometimes a pair may take over the old nest of another species, such as, in southern Africa, white-necked raven or Egyptian goose. Either way, they line the nest with green leaves and the female lays one to three eggs, typically two, which she incubates for thirty-six to forty days, while her male feeds her. Fledging takes fifty to fifty-five days, with the female guarding the nest and young fiercely while the male brings food. Siblicide is not the norm for this species, and both chicks usually reach maturity. For eagles, they become independent quickly: about two weeks after leaving the nest.

This species has lived for up to twelve years in captivity. As a smaller eagle, it is more vulnerable than some to other wild predators—notably the Eurasian eagle owl, which takes both adults and youngsters from their nests at night. Its conservation status remains Least Concern.

ABOVE In flight, the Booted Eagle reveals distinctive white spots where the wings join the body.

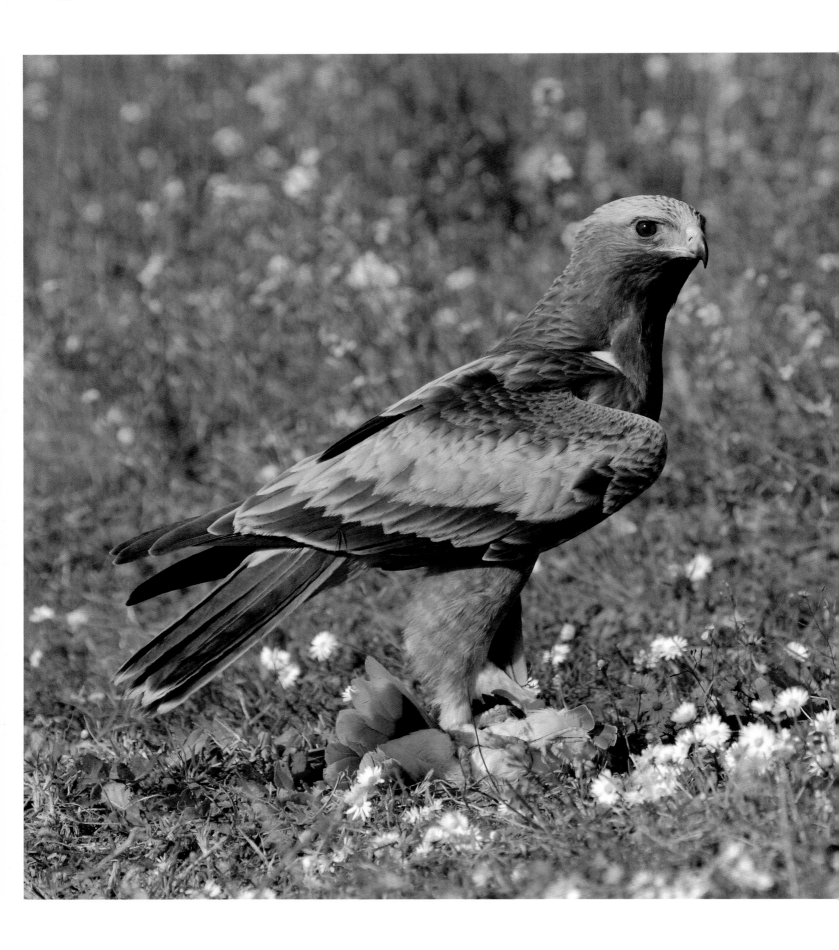

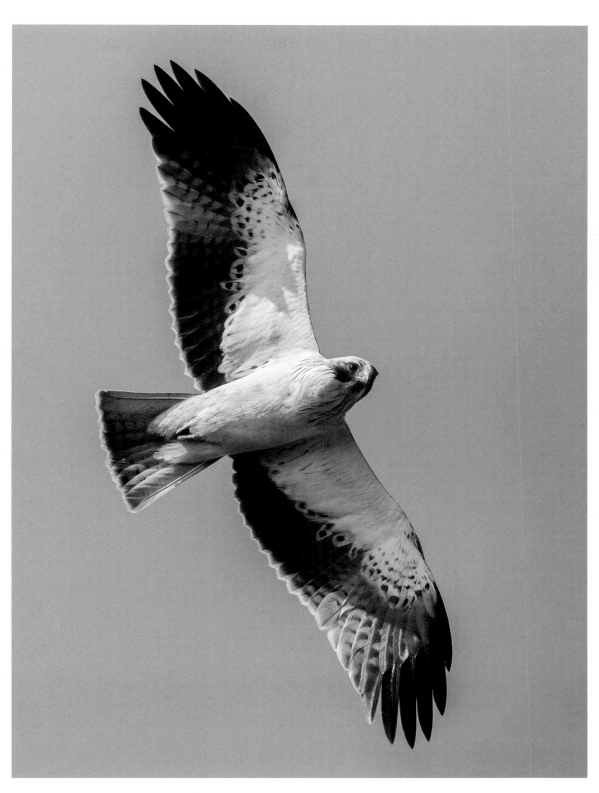

ABOVE A pale morph Booted Eagle shows extensive white on the underside.

OPPOSITE A dark morph Booted Eagle in Spain stands over a dove it has captured in flight.

ASSASSINS OF THE WOODLANDS

RIGHT A Booted Eagle feeds its single young chick at its nest in a pine. This species often rears two chicks to maturity.

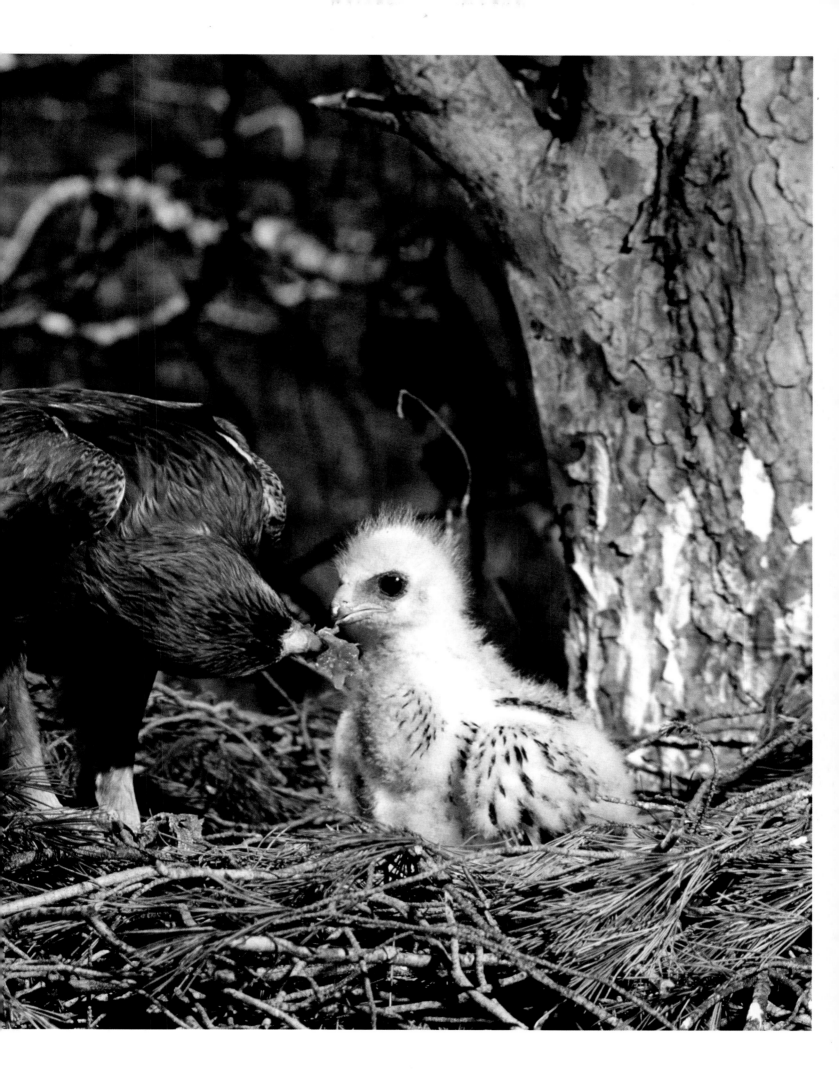

BLACK HAWK-EAGLE

SPIZAETUS TYRANNUS

APPEARANCE
*Small/medium eagle with prominent
crest; predominantly black plumage
with fine white speckling on the
lower underside and four prominent
gray bars across the tail; eyes
yellow-orange and feet yellow;
distinctive flight silhouette shows
relatively short, paddle-shaped
wings and a longish, closed tail; pale
barring is also visible toward the
wing tips; immatures paler, with
white markings on upperparts and
white head streaked with black.*

SIZE
*length 23–28 in. (58–71 cm)
weight 2–2.9 lb (0.9–1.3 kg)
wingspan 4 ft 4 in.–4 ft 7 in.
(135–145 cm)*

DISTRIBUTION
*From Central Mexico south through
Central America and across much
of northern South America
(S. t. serus); also, separately,
Atlantic Brazil and northern
Argentina (S. t. tyrannus).*

STATUS
Least Concern

THIS SMALL/MEDIUM-SIZED EAGLE is one of the most frequently seen of the neotropical forest eagles, its loud whistling calls sounding as it circles above its woodland habitat. A handsome bird, decked out in silky black plumage with a jaunty crest, it is very similar to the Ornate Hawk-eagle (p. 178) but much darker in overall coloration.

A closer look at the bird's plumage reveals fine white speckling and barring on the belly and legs, and four prominent gray bars across the tail. The yellow-orange eyes and yellow feet also stand out. In flight, it has relatively short, paddle-shaped wings and a longish tail that is generally held closed. Pale barring is also visible toward the wing tips. The immature is paler, with white edges to the wing and tail coverts and a white head streaked with black.

This species shares much of its range with the Ornate Hawk-eagle, but tends to live at lower elevations and in more open woodland habitats, avoiding dense rain forest. Taxonomists recognize two subspecies: *S. t. serus* occurs from

Central Mexico through much of Central America and into Colombia, Trinidad, Paraguay, and northwestern and western Brazil; *S. t. tyrannus* occurs in a smaller discontinuous range across eastern Atlantic Brazil and into northern Argentina.

The Black Hawk-eagle is also known as the Tyrant Hawk-eagle; like many smaller eagles, it punches well above its weight as a predator. In Brazil, it is called *Gavião-pega-macaco*, or "monkey-eating eagle," and indeed it does often prey on monkeys, as well as other mammals such as opposums, bats, and large rodents. It also takes snakes, and birds up to the size of toucans, macaws, and chachalacas—generally still-hunting from a perch and snatching victims on the ground or in flight. The precise composition of its diet varies significantly by region. One study in Mexico found that birds comprised 82 percent of prey; another in Guatemala found that mammals comprised 96 percent, with 31 percent of these being bats.

Little is known about the breeding behavior of this species. Nests, located in tall trees, measure up to 3 feet 6 inches (1.1 m) and are built largely of sticks. The female lays a single egg, which she incubates for forty-two to forty-five days. The youngster fledges after seventy days, but remains dependent on its parents for long after—explaining why a pair breeds only once every two to three years.

The Black Hawk-eagle has a conservation status of Least Concern, reflecting its wide range. However, it is not numerous, and BirdLife International estimates the global population as no higher than 50,000 individuals. Farmers still persecute this species, which they blame for taking poultry. Habitat loss is a graver threat, however: at the current rate of Amazon deforestation, conservationists predict that this eagle will lose 25 to 45 percent of its habitat within the next three generations.

OPPOSITE A Black Hawk-eagle gradually sheds the white in its plumage as it ages. By maturity it will have a fully black head.

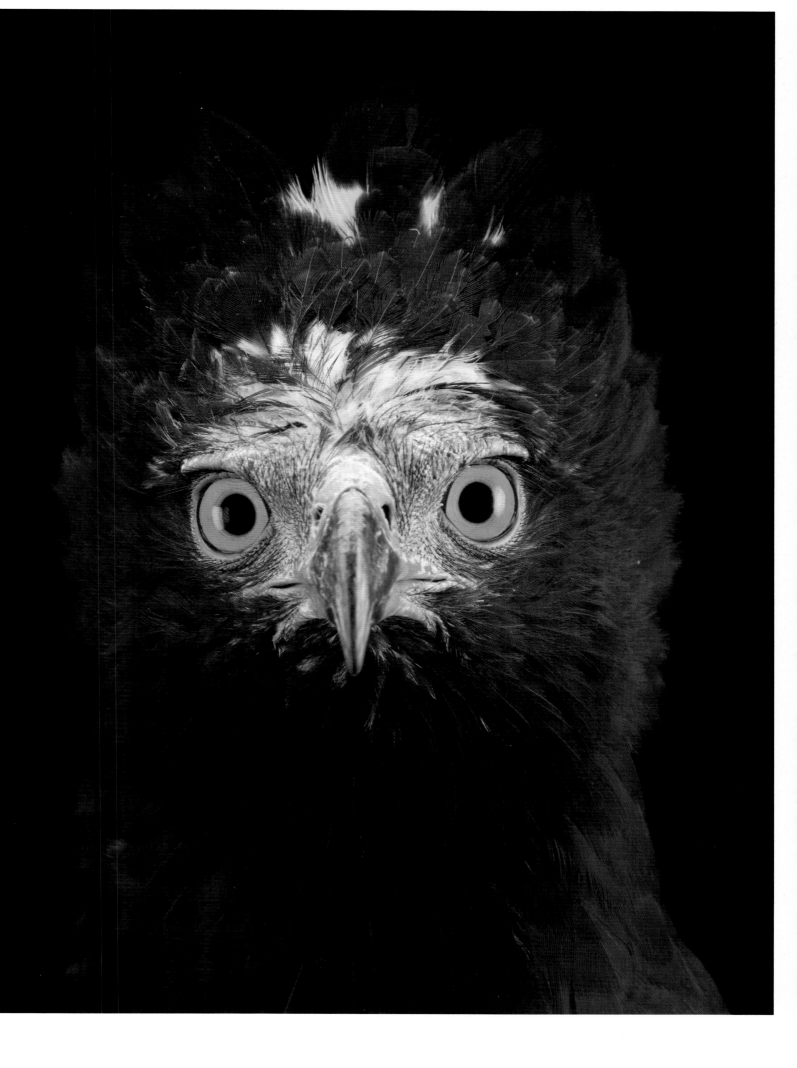

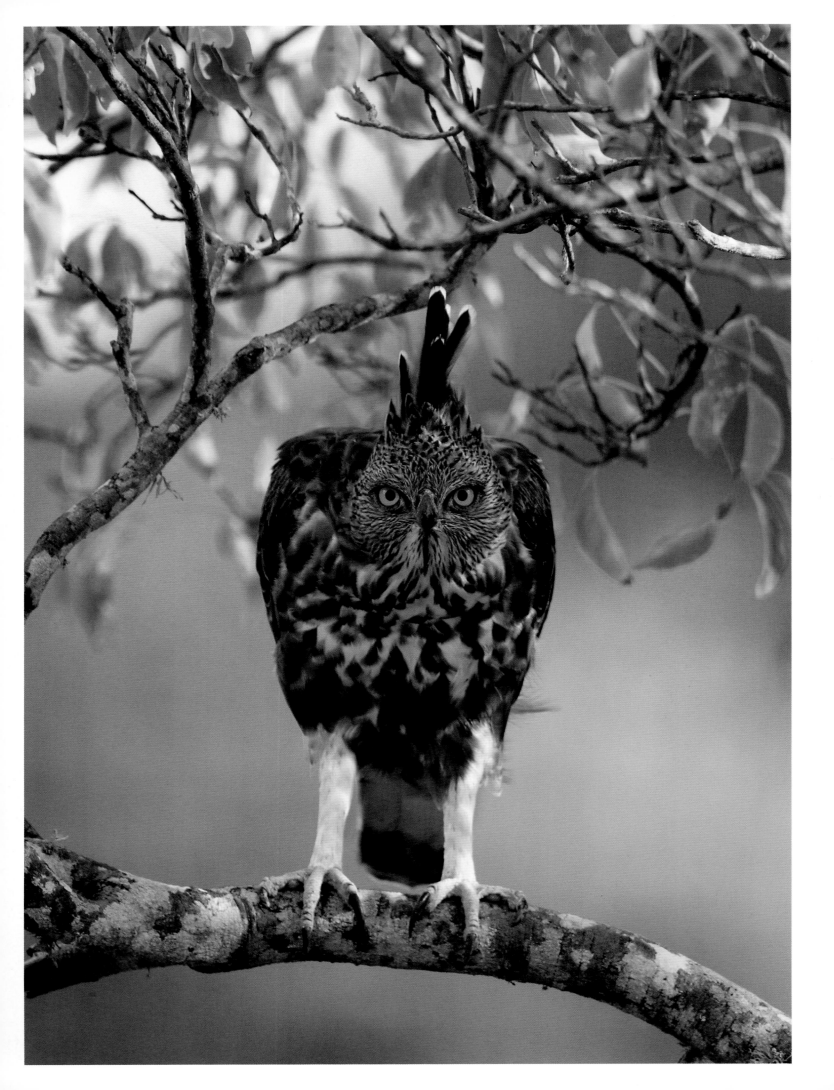

CHANGEABLE HAWK-EAGLE

NISAETUS CIRRHATUS

APPEARANCE	SIZE
Medium-sized, relatively slender, with long floppy crest in some races but no crest in others; upperparts brown; underparts white to buff, streaked with black and chocolate-brown; rounded wings, heavily barred below; tail barred; legs long and feathered; immatures paler, with white to buff head and white underparts streaked in brown.	*length 24–28 in. (61–71 cm)* *weight 2.6–4.2 lb (1.2–1.9 kg)* *wingspan 4 ft 2 in.–4 ft 5 in. (127–138 cm)*
	DISTRIBUTION
	Southern and southeast Asia from India to Indonesia, including Sri Lanka and the Philippines.
	STATUS
	Least Concern

THE CHANGEABLE HAWK-EAGLE lives up to this name by being perhaps the most variable in plumage of any of the world's eagles. It occurs in at least five different subspecies— some of which occur in both dark and pale morphs.

It is a medium-sized, relatively slender eagle that in all its races has largely brown upperparts, and underparts that are white to buff and streaked with black and chocolate-brown. In flight, its rather rounded wings are held flat, and it shows heavy barring on the flight feathers and tail. The legs are long and feathered. Females are around 15 percent larger than males. Immatures are much paler than adults.

The Changeable Hawk-eagle is the most widespread of ten Asiatic hawk-eagle species that together make up the genus *Nisaetus*. All were once grouped with the *Spizaetus* hawk-eagles of the New World, but molecular studies have revealed their different lineages. This species is found across southern and southeast Asia. Taxonomists recognize five subspecies. Two of these are crested and occur in central/southern India and Sri Lanka; another three have barely any crest and occur from northern India east to the Philippines, on

the Andaman Islands, and across Indonesia to Sulawesi. The Flores Hawk-eagle (p. 190) was once also considered a race but has now been granted species status in its own right.

This versatile raptor frequents a variety of woodland and semi-forested habitats, including wooded savanna, tea plantations, and the edges of suburban areas. It generally occurs below 5,000 feet (1,500 m), though has been recorded at up to 7,200 feet (2,200 m). Pairs are largely sedentary, remaining in the same territory all year. Immatures disperse widely.

A variety of small mammals are on this eagle's menu, along with reptiles and medium-large birds such as pheasants and jungle fowl. It hunts from a lookout, typically perched bolt upright in a tree overlooking a forest clearing from where it swoops down to snatch prey or grabs birds among the branches, pursuing them in fast, agile flight.

The Changeable Hawk-eagle is usually silent but becomes vocal when breeding, making soaring display flights and calling with a high-pitched "ki ki ki ki ki ki kee" that crescendos to a scream. The breeding season is from November to May in southern India and January to February farther north. A pair builds a large stick platform roughly 3 feet (1 m) across, high in a tree, which they line with leaves. The female incubates her single pale egg for thirty-five to forty-four days and the chick fledges after sixty-five to seventy days.

This is the most widespread and common of the Asiatic hawk-eagles and is not currently of conservation concern. In a few areas, including Singapore, the population has shown recent increases, but the population as a whole has not been quantified. Some subspecies, including the Andaman Islands race (*N. c. andamanensis*), occupy much smaller ranges and so are more vulnerable. Threats include shooting and habitat loss.

OPPOSITE The crest of a Changeable Hawk-eagle adds a feathered exclamation mark to its penetrating expression.

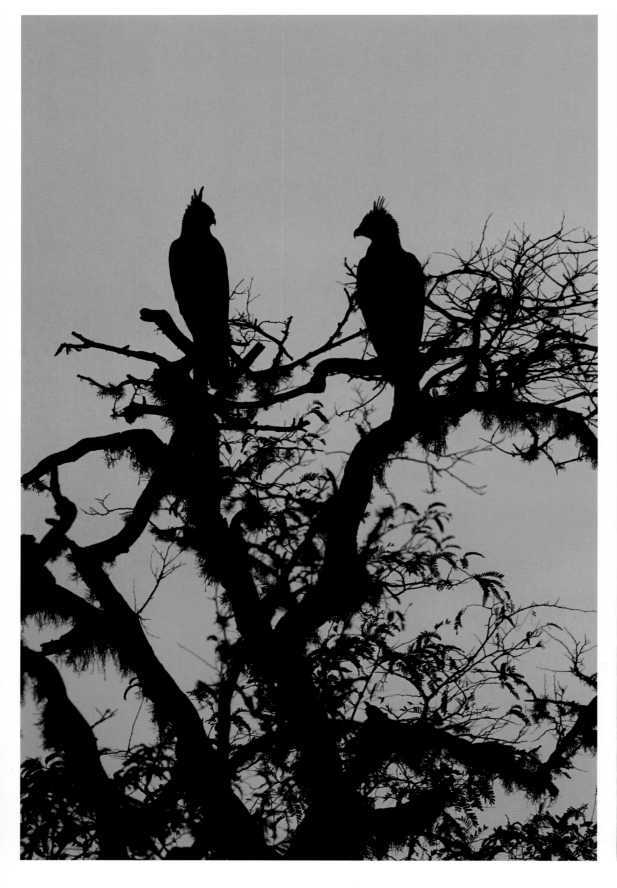

ASSASSINS OF THE WOODLANDS

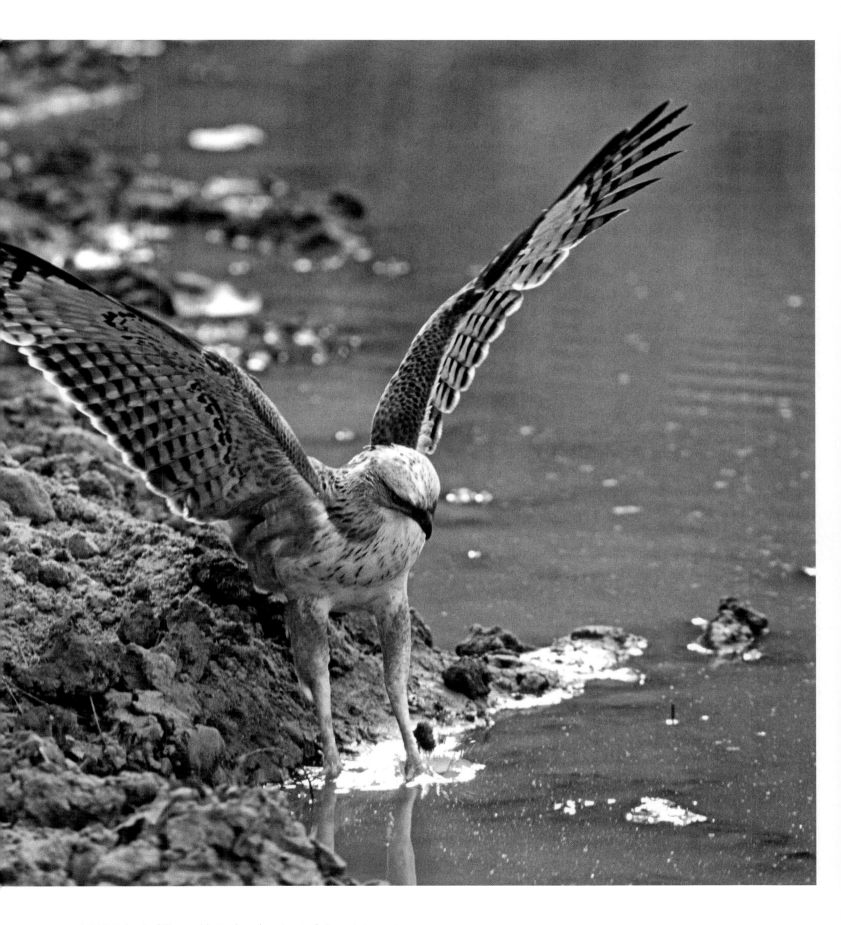

OPPOSITE A pair of Changeable Hawk-eagles return to their roost at sunset.

ABOVE The immature of this species is much paler than the adult, as with most hawk-eagles.

ASSASSINS OF THE WOODLANDS

BLYTH'S HAWK-EAGLE

NISAETUS ALBONIGER

APPEARANCE
Small; black upperparts; white below, with bold black streaking on throat and breast, and black barring across the belly and legs; prominent black crest, yellow eyes, white throat with black stripe; broad white band across tail; broad, rounded wings, white below with heavy barring on flight feathers; immatures dark brown above, with paler brown head and underparts.

SIZE
length 20–23 in. (51–58 cm)
weight 1.8 lb (830 g)
wingspan 3 ft 3 in. –3 ft 8 in. (100–115 cm)

DISTRIBUTION
Malay Peninsula, Singapore, Sumatra, and Borneo.

STATUS
Least Concern

THIS EAGLE IS ONE OF SEVERAL Asian birds named in honor of English zoologist Edward Blyth (1810–73), one-time curator of the Asiatic Society of Bengal. Known in his time as the "father of Indian ornithology," and an ardent correspondent of Charles Darwin (1809–82), Blyth also gave his name to a pipit, a parakeet, a hornbill, and a kingfisher.

Blyth's Hawk-eagle is one of the smallest of the *Nisaetus* genus of Asiatic hawk-eagles, appreciably smaller than the Changeable Hawk-eagle (p. 133), whose range it overlaps. It is largely black above and white below, with bold black streaking down the throat and breast, and black barring across the belly and long, feathered legs. A prominent black crest, together with yellow eyes and a black stripe down the white throat, all serve to give this bird a particularly piercing expression. In flight, it shows a broad white band across both sides of its tail, and the white underside of its broad, rounded wings shows heavy barring on the flight feathers. Immatures are dark brown above, with a paler brown head and underparts.

This is a monotypic species, with no recognized subspecies. It was once considered part of the *Spizaetus* hawk-eagles group but has since been reclassified as one of the ten species making up the *Nisaetus* genus of Asiatic hawk-eagles. It is presumed to share much of its biology with its relatives.

Blyth's Hawk-eagle is confined to southeast Asia, occurring in the Malay Peninsula, as far north as southern Myanmar and southern Thailand, and across the islands of Singapore, Sumatra, and northern Borneo. It is a bird of open woodland and forest edges, and generally prefers steep, hilly country, up to altitudes of 5,600 feet (1,700 m).

Hunting behavior has seldom been observed, but the bird is often seen circling overhead while scanning for prey and also perched in a strategic vantage point overlooking a clearing—sometimes in trees alongside road verges. Food is thought to comprise small mammals, birds, and lizards. Relatively short, rounded wings allow this species hawk-like agility in the air, and one report records an individual hunting bats in the mouth of a cave. It is also said to have a predilection for poultry—a fact that is unlikely to endear it to farmers.

Blyth's Hawk-eagle builds a nest platform of sticks in a tall, emergent tree, with a cup deep enough to conceal the body of the sitting adult when seen from side-on. It tends to choose hilly locations, often just at the edge of the montane zone. The clutch is thought to comprise a single chick, with the incubation and fledging times likely to mirror those of other *Nisaetus* hawk-eagles. Adults continue to add leafy branches to the nest lining throughout the breeding period.

This species' conservation status is currently Least Concern, with a population estimated by BirdLife International at between 1,000 and 10,000 individuals. However, the loss of habitat—notably through rampant slash-and-burn agriculture across much of its island range—poses an ongoing threat.

OPPOSITE An adult Blyth's Hawk-eagle is the most boldly marked of all the *Nisaetus* hawk-eagle species

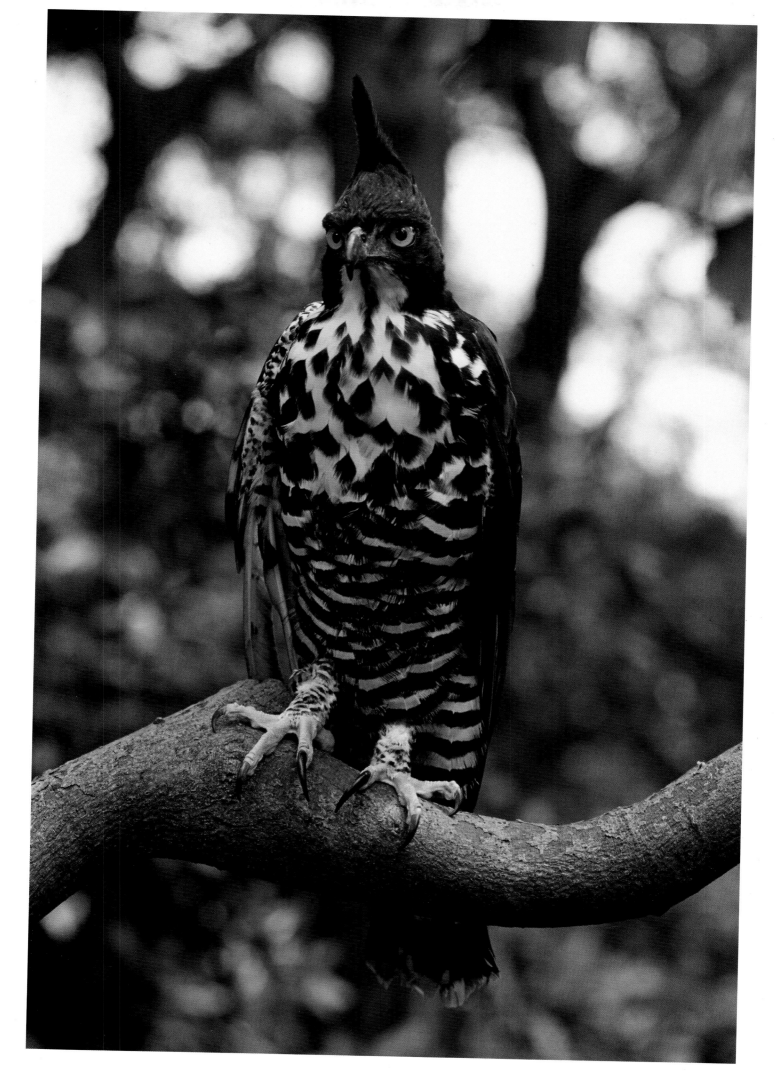

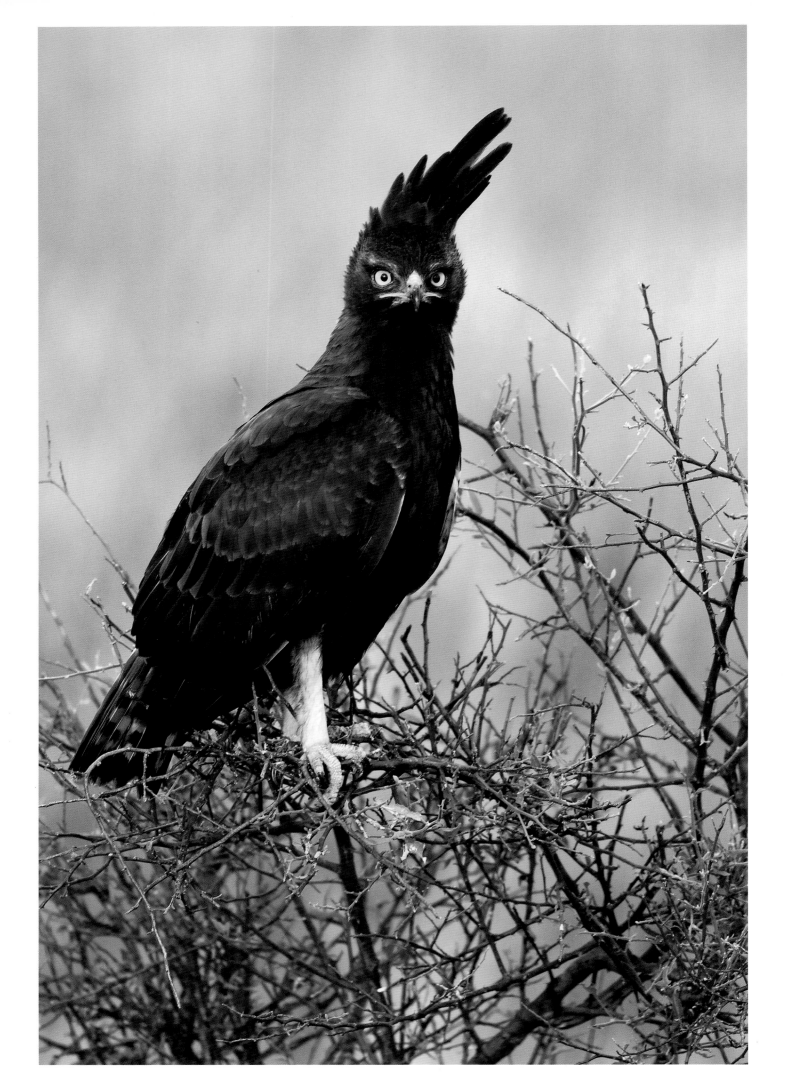

LONG-CRESTED EAGLE

LOPHAETUS OCCIPITALIS

APPEARANCE
Small-medium; distinctive upright profile, with shortish tail and long, floppy crest on back of head; plumage dark sooty-brown all over, with whitish feathered legs and gray barring across flight feathers and tail; conspicuous white patch on primaries prominent in flight; immatures paler with barely visible crest.

SIZE
*length 21–23 in. (53–58 cm)
weight male 32–46 oz (0.9–1.3 kg),
female 46–53 oz (1.3–1.5 kg)
wingspan 3 ft 8 in.–4 ft 2 in.
(112–129 cm)*

DISTRIBUTION
Sub-Saharan Africa; from Senegal to Ethiopia, south to Botswana, Namibia, and South Africa's Eastern Cape.

STATUS
Least Concern

THIS EAGLE LOOKS MORE DANDY than deadly as it perches atop a roadside telegraph pole, long crest flopping in the breeze. But woe betide the rodent that ventures onto the verge below. Little escapes that penetrating yellow-eyed stare.

Unmistakable even from a distance, by virtue of its long crest and all-dark plumage, this species also has the habit of perching on conspicuous, exposed perches. From close up you will see that the overall blackish-brown coloration is relieved by whitish feathered legs and gray barring across the wings and tail. In flight, it also reveals a conspicuous white patch toward the end of each wing—visible from above and below. Females are larger than males, with a shorter crest and dirtier brown legs, and immatures are paler overall with no crest to speak of.

The Long-crested Eagle was once classified with hawk eagles in the genus *Spizaetus* but has since been assigned its own genus, *Lophaetus*, of which it is the only member. The latest molecular studies suggest that it may form a clade with the spotted eagles (genus *Clanga*), but this research is ongoing.

Whatever its taxonomy, this eagle enjoys a wide distribution across sub-Saharan Africa, ranging from Senegal in the west to Ethiopia in the east, and south to Northern Botswana, northern Namibia, and South Africa's Eastern Cape. Across this range, it lives in forest edges and moist woodlands, especially near grasslands, streams, and marshy areas. It also thrives around sugarcane fields and is among the few African

species that take to eucalyptus plantations. Though recorded at up to 9,800 feet (3,000 m), it is seldom seen higher than 6,600 feet (2,000 m). Most populations are sedentary, although those in more arid regions are more nomadic.

The common factor behind all these habitats is a healthy supply of rodents, which in some studies have been found to comprise up to 98 percent of this eagle's diet. In southern Africa, it shows a particular preference for Vlei rats (*Otymys* species), the greater cane rat, the African marsh rat, and the four-striped grass mouse. The standard hunting technique is scanning from a high perch then dropping on victims when they appear below. Among other recorded prey are birds, including owls and the young of other raptors, amphibians, fish, and even fruit.

Long-crested Eagles have a piercing, high, descending whistle and become especially vocal when breeding, which generally takes place during the wet season when prey is abundant. Males start things off with a noisy aerial display, involving steep dives and a rocking flight on the horizontal. Male and female work together to build their stick nest, usually in the mid canopy of a tree near the forest edge, but may also appropriate the old nest of another raptor, such as a great sparrowhawk or lizard buzzard. The female lays one to two eggs, which she incubates for forty-two days while the male keeps her fed. The young fledge after fifty-three to fifty-eight days, and remain dependent on their parents for a further two to three months.

This species' conservation status is currently Least Concern, with a population estimated at 10,000 to 100,000 individuals. It remains vulnerable to various threats, from the degradation of wetland habitats to collisions with power lines and vehicles, but has enjoyed some benefits from human activity, including the provision of new habitat through agricultural clearances and exotic plantations. As a rat catcher, farmers tend to look upon it more kindly than they do many other raptors.

OPPOSITE The crest of a Long-crested Eagle will point in whichever direction the breeze takes it.

ASSASSINS OF THE WOODLANDS

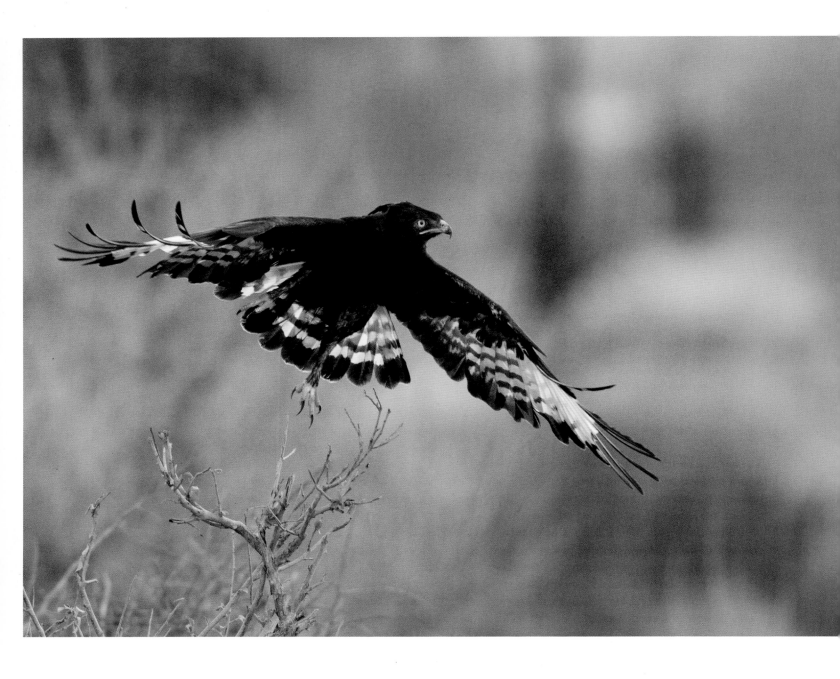

ABOVE In flight, the Long-crested Eagle reveals bold wide patches on its primaries that are seldom visible when perched.

OPPOSITE A grass fire offers excellent hunting opportunities for a Long-crested Eagle by flushing rodents out of hiding.

AYRES'S HAWK-EAGLE

HIERAAETUS AYRESII

APPEARANCE
Small; black upperparts mottled white; white underparts, spotted in black; white throat and legs; from below, broad underwings and gray tail boldly barred in black; female larger than male, with denser spotting, but lacks white on forehead and supercilium; immatures grayish-brown above, with rufous crown, nape, and mantle, and faintly streaked buff underparts.

SIZE
length 17.5–24 in. (45–61 cm)
weight 1.5–2.2 lb (0.7–1 kg)
wingspan 3 ft 3 in.–4 ft 3 in. (106–137 cm)

DISTRIBUTION
Sub-Saharan Africa, from Sierra Leone east to Somalia and as far south as northern Namibia and northeast South Africa.

STATUS
Least Concern

THIS UNOBTRUSIVE, LITTLE-KNOWN raptor resembles a large hawk more than an eagle, as it dashes through the woodland canopy in hot pursuit of a dove. Smallest of Africa's endemic eagles—and lighter, on average, than a northern goshawk—it is primarily a bird hunter, its broad, rounded wings an adaptation for high-speed twisting and turning among the branches.

Though much smaller than the African Hawk-eagle (p. 112), to which it was once thought related, Ayres's Hawk-eagle has similar two-tone plumage. Its black upperparts, mottled in white, contrast strongly with its white underparts, which are heavily blotched and spotted in black except for the striking white throat and legs. Seen in flight from below, its broad underwings are boldly barred in black, and its ashy-gray tail sports three or four broad black bars and a black terminal band. The female is larger than the male, with denser spotting, but lacks the white on the forehead and supercilium that accentuates her mate's fierce expression. Immatures are generally a grayish-brown above, with a rufous crown, nape, and mantle, and have faintly streaked, buff underparts.

This species derives its name from South African ornithologist Thomas Ayres (1838–1913). Other birds to receive that honor include Ayres's cisticola (*Cisticola ayresii*) and the white-winged flufftail (*Sarothrura ayresii*). Ayres also collected many species for ornithologist Gustav Hartlaub (1814–1900), and retains a special affection in South African ornithology as the mentor of Austin Roberts (1883–1948), author of Africa's first field guide. Today, taxonomists place Ayres's Hawk-eagle alongside the Booted Eagle (p. 122) and Wahlberg's Eagle (p. 82) in the genus *Hieraaetus*.

Ayres's Hawk-eagle is distributed across sub-Saharan Africa, from Sierra Leone east to Somalia and as far south as northern Namibia and northeast South Africa. It inhabits woodland, forest edges, and plantations, and during the rainy season, when the foliage thickens, makes local movements from dense woodland into more open savanna woodland. These movements take it from central Africa to more southerly areas, and in South Africa it is known to enter suburban areas to feed on feral pigeons. Most sightings occur when the eagle circles high above a woodland. Otherwise, it may sit for long periods on a concealed perch, scanning. Prey comprises mostly medium-sized birds, from pigeons to starlings, hornbills, and bulbuls. Once prey is sighted, the eagle launches into rapid pursuit and grabs the victim in midair, sometimes folding its wings to drop peregrine-style on its target. It may also take other arboreal prey, including squirrels and fruit bats.

A pair of Ayres's Hawk-eagles conceal their stick-platform nest in the fork of a well-leafed large tree. The female generally lays a single egg—typically in April to May—which she incubates for forty-three to forty-five days. The chick fledges in seventy-three to seventy-five days, but does not become fully independent for another three months.

This species is nowhere common, but by virtue of its large range and apparently stable population is classed as Least Concern. BirdLife International estimates the overall population at 670 to 6,700 mature individuals. Threats include the clearance of its woodland habitat and pesticide contamination acquired through its prey. In South Africa, it has also suffered persecution for preying on homing pigeons.

OPPOSITE Ayres's Hawk-eagle reveals distinctive two-tone plumage during its fast flight.

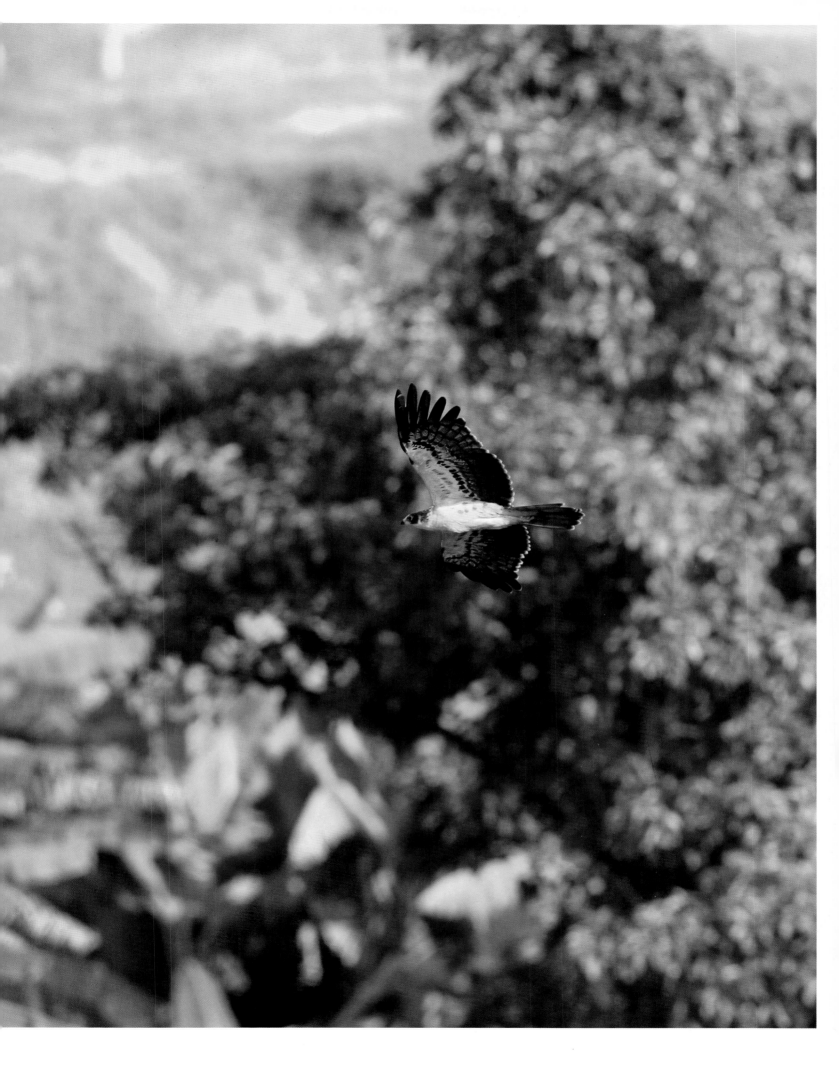

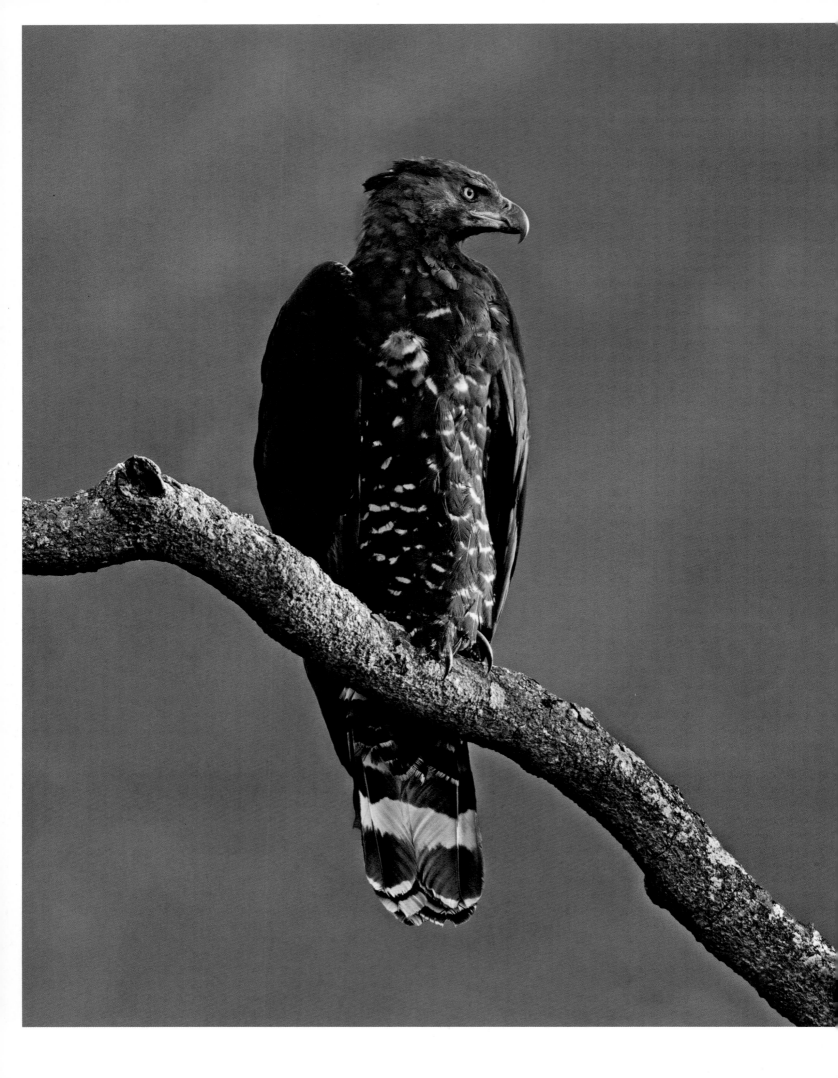

CROWNED EAGLE

STEPHANOAETUS CORONATUS

APPEARANCE
Very large, with crest, long tail, and relatively short, broad wings; huge talons and pale yellow eyes; upperparts blackish-brown; underparts white, blotched, and barred in black, ocher, and cream; underwings show rich rufous coverts and paler flight feathers heavily barred in black; tail gray with three black bands; immatures have white head and underparts, and gray/brown back with pale feather edges.

SIZE
length 31–39 in. (80–99 cm)
weight male 5.8–9.1 lb (2.5–4.1 kg), female 7–10.5 lb (3.2–4.7 kg)
wingspan 5 ft–5 ft 10 in. (151–181 cm)

DISTRIBUTION
West Africa, including the Guinean forests; Congo Basin; East Africa and eastern southern Africa south to Knysna, South Africa.

STATUS
Near Threatened

TALES OF GIANT EAGLES CARRYING people off have been the stuff of myth since ancient times. In real life, sensational "true stories" of eagle attacks seldom stand up to scrutiny. Africa's Crowned Eagle, however, might just, very occasionally, target *Homo sapiens*. Credible accounts exist of human remains found at the bird's nests and in one authenticated case a seven-year-old boy was rescued only by his mother wielding a hoe. Evidence also comes from prehistory: in 1924, South African scientists unearthed the skull of a three-year-old *Australopithecus afarensis*, one of our hominid ancestors, pierced by an eagle's talons. This infant, known as the Taung child, would have weighed around 25 pounds (11 kg), little more than monkeys routinely targeted by this formidable predator.

The Crowned Eagle, as you might expect from such stories, is thought to be Africa's most powerful raptor. But, though a very big eagle it is not quite Africa's largest, weighing slightly less on average than both the Martial Eagle (p. 58) and Verreaux's Eagle (p. 28). Irrespective of size, this is a striking bird. It is blackish/brown above, with a black-tipped double crest, and has pale underparts heavily blotched and barred in black, ocher, and cream. When perched, it reveals massive talons—which, with a hallux (hind claw) of up to

2 ½ inches (6.2 cm) are the largest of any African eagle. In flight, it shows a longer tail than other large eagles, and the broad, relatively short wings typical of a forest hunter. The gray tail has three black bars, and the heavily barred underwings are set off by rich rufous coverts. Females are 10 to 15 percent larger than males. Immatures resemble immature Martial Eagles, being largely white on the head and underparts.

This species—also known as the Crowned Hawk-eagle—is the only extant member of the *Stephanoaetus* genus. It is found from West Africa, including the Guinean forests, across the Congo Basin to East Africa and south into eastern regions of southern Africa. Across this wide range, its habitats span tropical rain forest, montane forest, and, in southern and Eastern Africa, savanna woodland. Habitat loss in many regions has left populations highly fragmented, although in southern Africa the species has shown a capacity to adapt to non-native eucalyptus plantations.

In the rain forest, the Crowned Eagle is an apex predator. Prey comprises 90 percent mammals, and especially primates: indeed, the Crowned Eagle takes proportionally more primates than any other eagle. The species of choice varies by region; any primate up to 33 pounds (15 kg) is fair game, including young baboons and even infant chimps.

The menu is more varied in woodland regions, and includes small antelope, as well as the young of larger species. A Crowned Eagle has even been known to kill a 66-pound (30 kg) adult bushbuck, six times its own weight. Other mammals taken include hyraxes, hares, and smaller carnivores. Larger birds, including storks and guinea fowl, sometimes also fall victim; domestic animals are also fair game. Headlines from suburban areas of South Africa's KwaZulu-Natal regularly report the loss of family cats and dogs to those massive talons.

Crowned Eagles generally make their kill on the forest floor, swooping down from a concealed perch, although

OPPOSITE A Crowned Eagle in Wondo Genet, Ethiopia scans the canopy for prey.

they may also soar over the canopy and snatch prey from the branches. Monkeys may be located from a distance by their calls, the eagle then moving through the trees until close enough to launch an attack. The prey often dies on impact, the eagle piercing its skull with crushing talons, but sometimes succumbs to asphyxiation or trauma. One Crowned Eagle was observed stalking a bushbuck calf over two days, waiting until its mother relaxed her guard then making a strike and, when the injured youngster could no longer keep up with its mother, returning to finish the job. Prey is generally carried up to a branch to feed but, if too heavy, may be dismembered, eaten on the spot, or even cached in vegetation for later consumption.

The breeding season is the easiest time to observe Crowned Eagles, when they soar high above the canopy in noisy, undulating display flights. The male calls repeatedly, throwing back his head in a penetrating "kwee-kwee-kwee." He may climb to 6,600 feet (2,000 m) before diving toward the female, the two locking talons and tumbling through the air. The massive stick nest is built high in a tall forest tree and may, exceptionally, measure 8 feet 2 inches (2.5 m) across by 9 feet 9 inches (3 m) deep. The female lays one to two eggs, which she incubates for forty-nine to fifty days while the male provides food. Crowned Eagles protect their nests fiercely and will attack any intruders, including humans. Fledging takes ninety to 115 days. This eagle practices cainism, and there is no record from the wild of more than one chick surviving. After fledging, the chick remains with its parents for nine to twelve months. This means that the entire breeding cycle lasts up to 500 days: three times as long as most raptors and one of the longest known of any bird. It explains why breeding takes place only once every two years.

Crowned Eagles have a life expectancy in the wild of fourteen years. Though widespread, their numbers have declined due to deforestation—especially for logging and charcoal burning—and they are now most common in protected areas. In some equatorial regions, people persecute them as a threat to livestock—and also as competitors for bush meat. Today, their conservation status is Near Threatened, with a population estimated by BirdLife International in the 5,000 to 50,000 category. Among falconers, training this most formidable of raptors is seen as a serious challenge, with the bird considered particularly intelligent and temperamental.

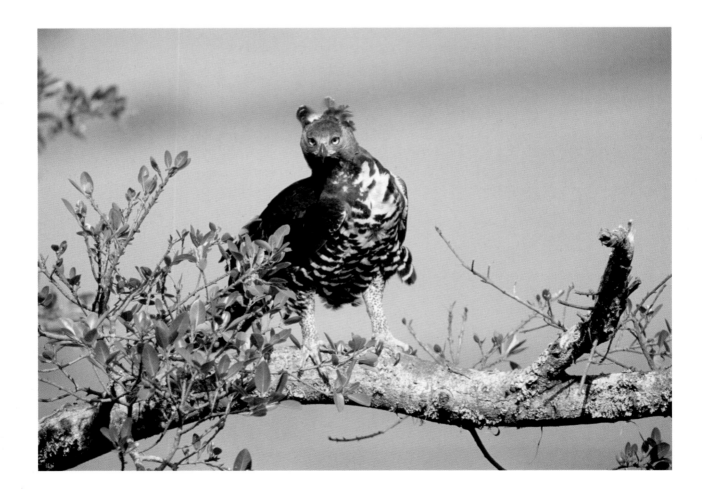

ABOVE A Crowned Eagle erects its crest when agitated.

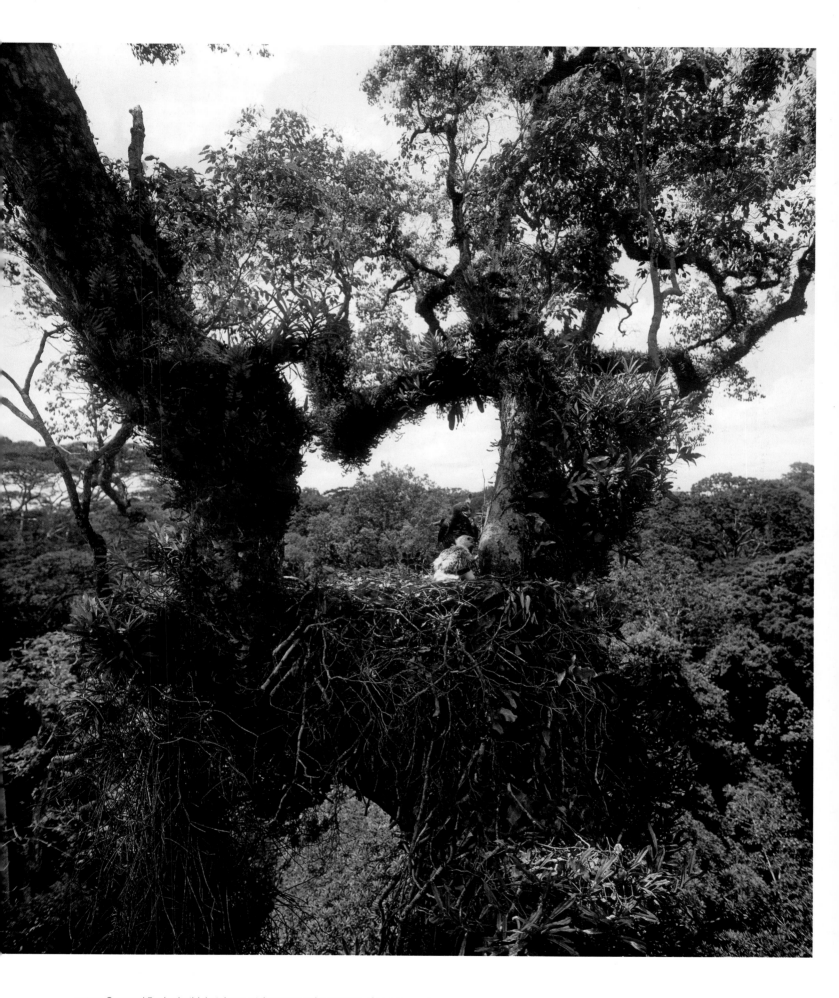

ABOVE Crowned Eagles build their huge stick nest near the very top of an emergent tree, giving them a commanding view of the surrounding country.

ASSASSINS OF THE WOODLANDS

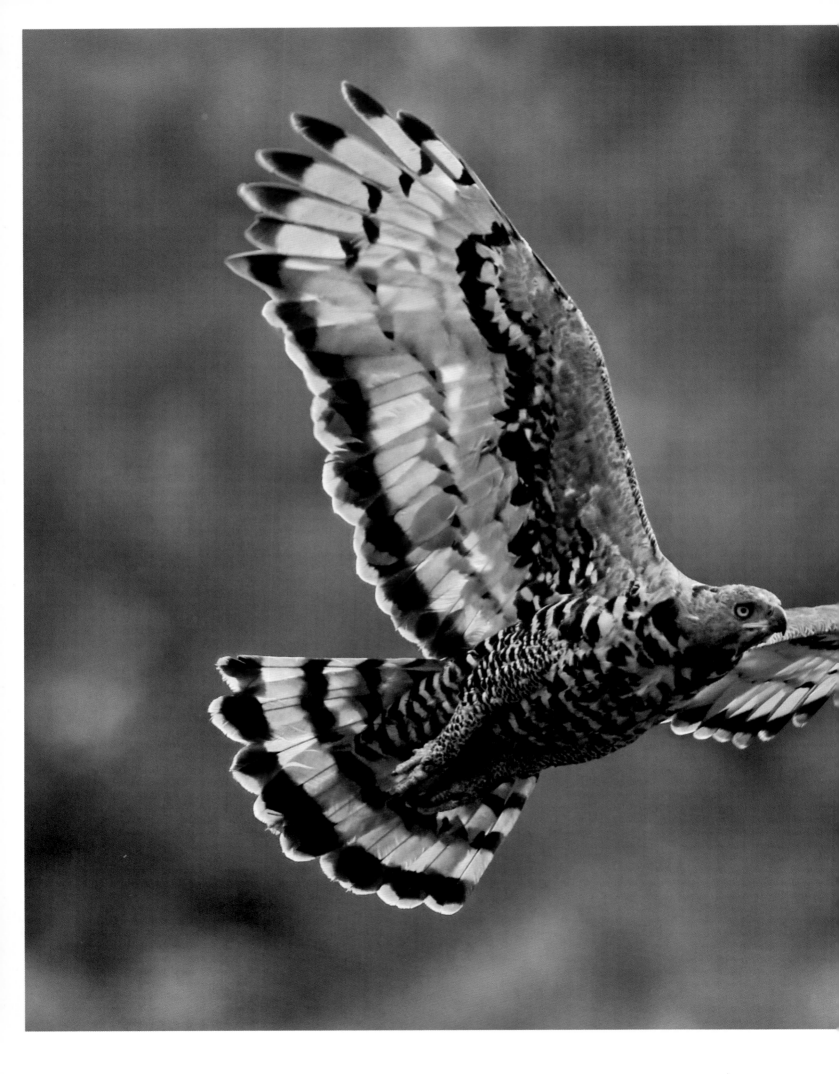

LEFT In flight, this Crowned Eagle reveals its rich underwing patterning as well as surprisingly short wings for such a large eagle—an adaptation for hunting among trees.

SPANISH IMPERIAL EAGLE

AQUILA ADALBERTI

APPEARANCE
Large; dark blackish/brown, with prominent white shoulders, cream crown and nape, and pale gray tail base; immatures red-brown to pale brown, with dark flight feathers and paler edges; glides with wings held flat.

SIZE
length 31–32 in. (78–82 cm)

weight 5.5–7.7 lb (2.5–4.6 kg)
wingspan 5 ft 10 in.–6 ft 9 in. (180–210 cm)

DISTRIBUTION
Central and southwest Spain; adjacent areas of Portugal; immature birds disperse to Morocco and may wander more widely.

STATUS
Vulnerable

THIS HANDSOME EAGLE represents a welcome conservation success story. By the 1960s, the world's population stood at only thirty pairs, confined to one small area of Spain. The bird was on the brink. But last-ditch conservation efforts managed to arrest the decline and since then the population has slowly risen. Today, it stands at around 300 pairs: tiny, but stable.

What those first conservationists did not realize, as they rescued this species from the brink of extinction, was that it was a species. In the 1960s, the Spanish Imperial Eagle was thought to be an Iberian subspecies of the Eastern Imperial Eagle. It is only more recently that molecular and morphological studies have persuaded taxonomists to grant this bird species status in its own right.

The Spanish Imperial Eagle is a large eagle, typical of the *Aquila* genus in appearance and behavior. This species is distinguished from its eastern cousin by the much greater extent of white on its shoulders. Adults are otherwise dark brown, with a cream crown and nape and a pale gray upper tail. Immatures are red-brown, fading to pale brown, with dark flight feathers. Like the Eastern Imperial Eagle, this species glides with wings held flat.

This eagle is confined to a small area of central and southwest Spain and adjacent Portugal. It inhabits dehesa woodlands and cork oak forests, extending to the flood plains and dunes of the Guadalquivir and the high mountain slopes in Sistema Central. While dependent on woodland for breeding, it may survive in open agricultural country if there is a good supply of rabbits. Unlike the Eastern Imperial Eagle, it does not migrate. Immature birds disperse widely, however, many crossing the Mediterranean to Morocco and some wandering as far south as Senegal. Travelers in the other direction have turned up as far north as the Netherlands.

Rabbits are the staple diet, generally spotted during a soaring flight then captured on the ground after a rapid descent. In one study of pellets, 93 percent of the remains were rabbit. Other mammals taken include hares, rodents, and even foxes. This eagle may also hunt birds such as partridges, pigeons, and crows, and in winter pursues wildfowl that gather in the wetlands of southern Spain, often capturing them in flight.

A pair of Spanish Imperial Eagles typically nest in the fork of a large oak tree, located away from human interference. The female lays one to four eggs (usually two to three). Incubation lasts thirty-nine to forty-two days. Both the male and female incubate the chicks, which fledge at seventy-five days. As in other *Aquila* eagles, siblicide is common and accounts for 58 percent of nestling deaths. Youngsters hang around their natal area for 116 to 162 days before dispersing. A captive individual has lived for up to forty years.

Today, the Spanish Imperial Eagle is classed as Vulnerable. Collision with power lines is a leading cause of mortality. Poisoning takes its toll, through intentional persecution and via lead-shot ingested when feeding on wildfowl.

OPPOSITE An adult Spanish Imperial Eagle perches close to its nest in a cork oak woodland.

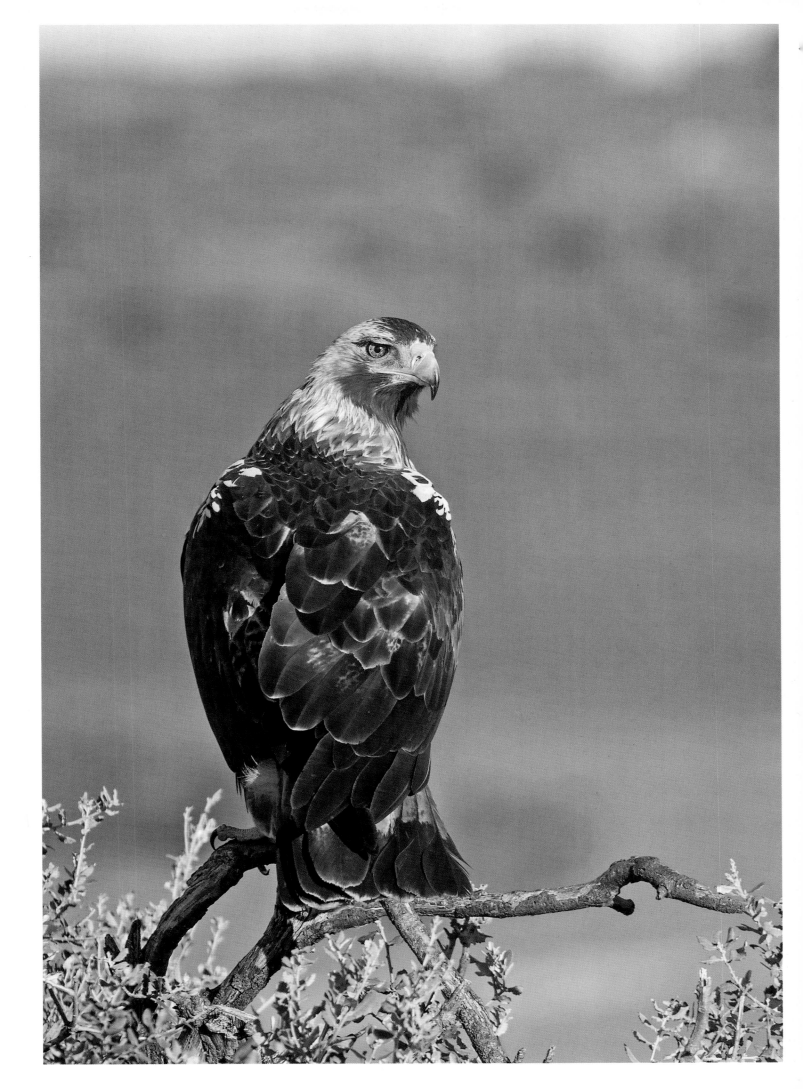

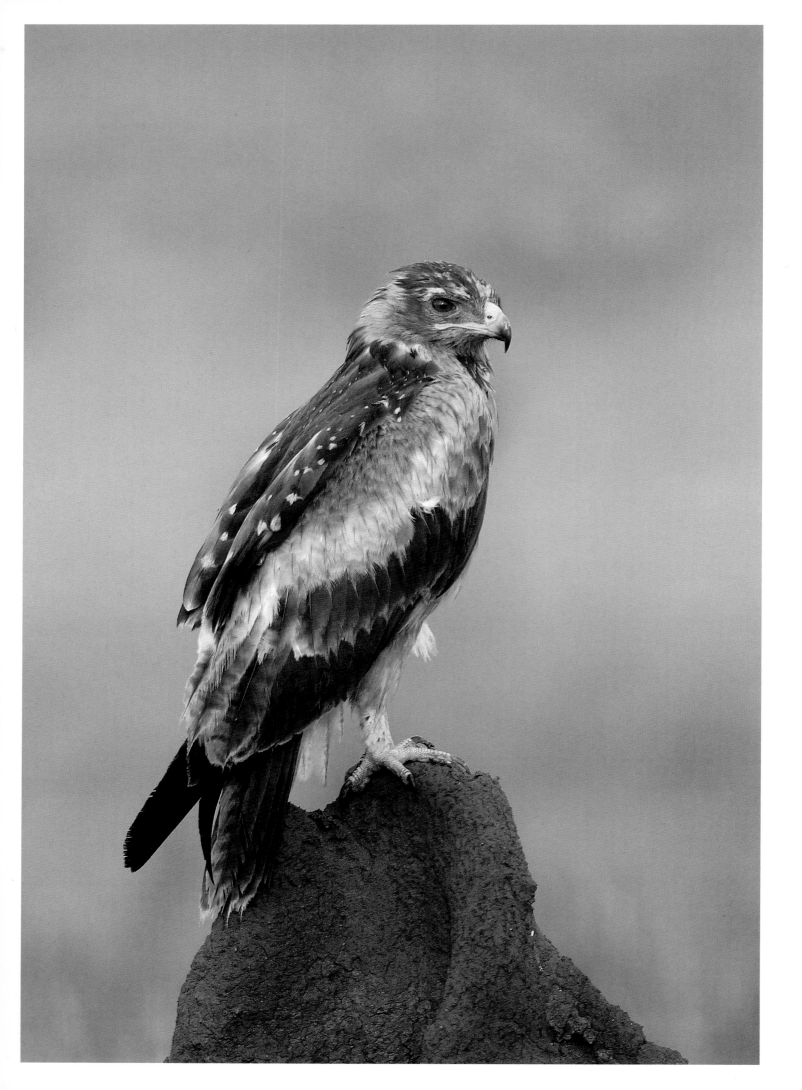

INDIAN SPOTTED EAGLE

CLANGA HASTATA

APPEARANCE

Medium-sized and stocky, with broad wings, a broad head, and a relatively short tail; adult mid-brown with contrasting dark flight feathers; has darker eyes and wider gape than other two Clanga eagles, with conspicuous fleshy "lips"; immatures have glossy brown plumage with fine cream spotting on the head and neck, becoming darker and less spotted with age.

SIZE

length 23–26 in. (59–67 cm)
weight 3–4 lb (1.4–1.8 kg)
wingspan 5 ft–5 ft 6 in. (154–168 cm)

DISTRIBUTION

India; also Nepal and Myanmar; now feared extinct in Bangladesh; separate small population in northern Cambodia.

STATUS

Vulnerable

THIS STOCKY BROWN EAGLE IS ONE of three closely related species that together make up the genus *Clanga*. Conservationists are today concerned by evidence of its apparent decline, although it may have been overlooked in some areas. Its status therefore remains uncertain.

Like the Lesser Spotted Eagle and Greater Spotted Eagle (pp. 68 and 116), the Indian Spotted Eagle is a medium-sized species that gets its name from the conspicuous pale spots on the plumage of immatures—although this feature is very variable. Adults are generally a lighter brown than in the other two species, with paler wing coverts that contrast more markedly with their dark flight feathers. They also have darker eyes, a broader head, and a wider mouth than the other two, with conspicuous fleshy "lips" at the gape. Immatures start life with glossy brown plumage and fine creamy spotting on the head and neck, but molt after eighteen months into a darker plumage, with fewer and less contrasting spots than in their two relatives. They lack the creamy/buff nape patch of the Lesser Spotted Eagle. In all plumage, this species shows broad wings and a relatively short tail.

The Indian Spotted Eagle has its stronghold in India, as the name would suggest, and is found across the Gangetic Plains and south to Tamil Nadu. It also occurs in Nepal, notably in Chitwan and Bardia National Parks, and has small populations in Myanmar and Bangladesh—although it may be extinct in the latter. In 2009, a captive discovered in northern Cambodia revealed that a separate population exists in that country, with subsequent photos of wild birds confirming this. The bird's apparently discontinuous range—with a gap between Myanmar and Cambodia—may simply reflect a lack of observation and records across the adjoining regions.

This species inhabits lowland tropical and subtropical dry forests. It tends to avoid plantations and farmland, though has been observed in paddy fields and urban parks. Unlike the Greater Spotted Eagle, it has no particular liking for wetlands—a helpful factor in differentiating the two species. It is the only one of the three spotted eagles that is not migratory.

For a large raptor, this is an approachable bird, and it reveals its presence with a high-pitched cackling call. It hunts by quartering over open ground—often in or around forest clearings. Prey comprises mostly small to medium-sized mammals, but it may also take frogs and birds. A pair starts the breeding season with a conspicuous courtship display that involves wing claps, undulations, and a loop-the-loop. They build their nest in a tree near open habitat. The female lays one to two eggs and shares incubation duties with the male.

The Indian Spotted Eagle is widespread but poorly known. BirdLife International estimates its population within the 2,500 to 9,999 bracket and its conservation status as Vulnerable. The discovery of the Cambodian population suggests that other populations may have been overlooked.

OPPOSITE An Indian Spotted Eagle shows more variegated plumage than other Spotted Eagle species, and a distinct fleshy yellow gape.

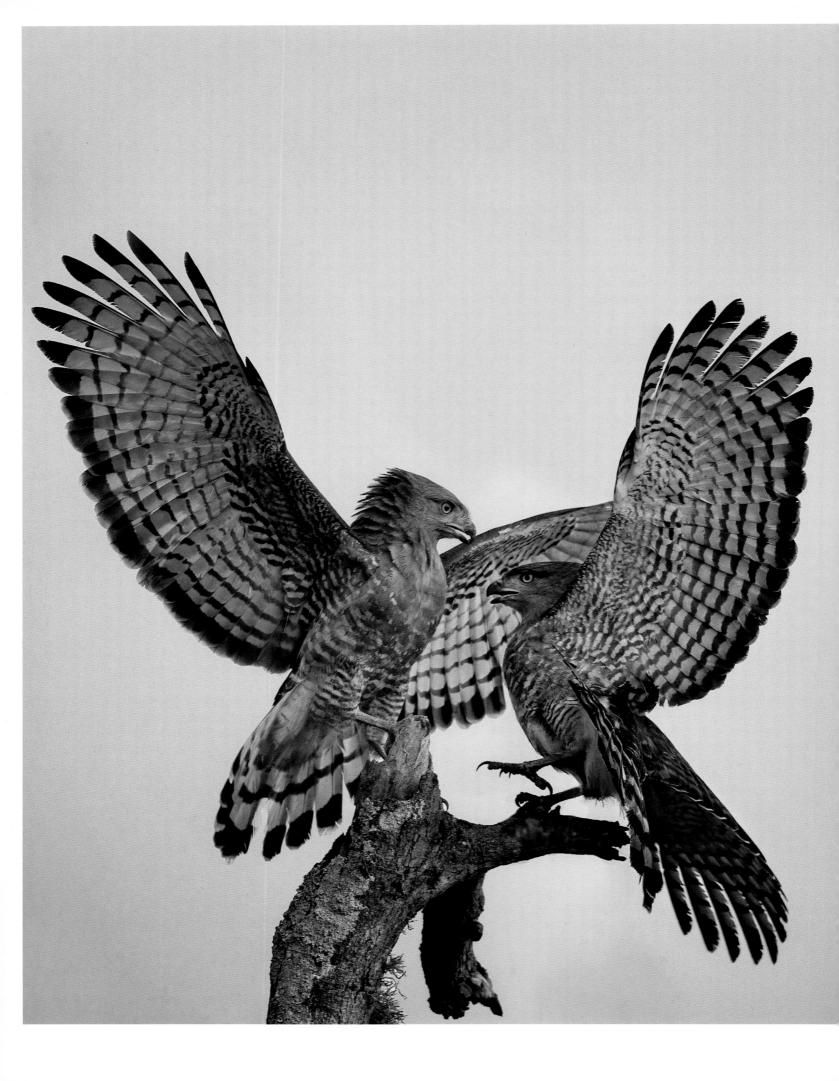

SOUTHERN BANDED SNAKE-EAGLE

CIRCAETUS FASCIOLATUS

APPEARANCE
Small and stocky, with unfeathered legs and large, owl-like head; upperparts blackish-brown; head gray-brown; breast brown and belly pale, barred with gray-brown; tail has three or four black bars; eyes pale yellow; feet and cere yellow; wings white below with heavy barring; immatures lacks gray head and have pale streaked underparts.

SIZE
length 22 ½–24 ½ in. (57–63 cm)

weight 2–2.4 lb (0.9–1.1 kg)
wingspan ±3 ft 10 in. (120 cm)

DISTRIBUTION
Occurs in a narrow band down the east coast of Africa, from southern Somalia to South Africa's KwaZulu-Natal; seldom more than 12.5 miles (20 km) from the coast, except for along a few major rivers where it penetrates farther inland.

STATUS
Near Threatened

EAGLE-WISE, THIS BIRD DOES NOT at first appear one of the most impressive. Small and squat, it perches for long periods on a branch just below the canopy, doing apparently very little. But those yellow eyes don't miss a trick, and when an unsuspecting snake appears below it unfurls its wings and glides silently down to pinion the reptile in deadly talons.

The Southern Banded Snake-eagle is one of the smaller *Circaetus* snake eagles. Also known as the Fasciolated Snake-eagle, this is a stocky bird, with the unfeathered legs and characteristic large, owl-like head of all its kind. It has a gray-brown head, blackish-brown upperparts, a brown breast, and a pale belly barred with gray-brown. The tail has three or four distinct black bars. The large eyes are pale yellow, as are the feet and cere. The broad, relatively short wings are heavily barred below. Immatures lack the gray head, and their pale underparts are marked with dark streaks on the face, throat, and breast.

This species has one of the most limited distributions of Africa's eagles, occurring only in a narrow band down the east coast, from southern Somalia to South Africa's KwaZulu-Natal.

It seldom occurs more than 12.5 miles (20 km) inland, except for along a few major rivers, such as the Tana in Kenya and the Save in Zimbabwe and Mozambique. Prime habitat comprises evergreen coastal forests, but it also ventures into woodland terrain and may nest in eucalyptus plantations. It is a largely sedentary species.

Were it not for its call—a harsh, high-pitched "ko-ko-ko-kaw," uttered when perched and in flight, especially early in the morning—this eagle would often be overlooked. It seldom soars, except during courtship displays, and tends to fly with fast, shallow beats of its rounded wings. Hunting takes place below the canopy, the eagle scanning a clearing from an open branch then dropping onto snakes and other small prey, which may include lizards, frogs, large insects, and even chickens.

Breeding generally starts with the male calling loudly from high above the canopy. The male and female work together to build the stick nest, which is usually placed in a tree fork, supported and concealed by creepers, and measures roughly 19 to 27 inches (50–70 cm) across. The female lays her single egg in July to October (September to October in southern Africa). She handles the bulk of the incubation, which lasts about fifty days. Both parents feed the young.

This species is listed as Near Threatened, with an estimated 670 to 2,000 individuals remaining. In South Africa, its range has contracted, with only around forty to fifty pairs left, mostly in and around the Greater St Lucia Wetland Park of KwaZulu-Natal. Populations between the Limpopo and Save rivers in Mozambique have also been lost to human expansion. The species' decline is attributed to the degradation of its coastal forest habitat, exploited for timber, charcoal, and firewood. Its nestlings also fall prey to the African Fish-eagle (p. 254).

OPPOSITE Two Southern Banded Snake-eagles compete over a treetop perch in Phinda Reserve, South Africa.

GURNEY'S EAGLE

AQUILA GURNEYI

APPEARANCE
Medium-large with rounded tail;
largely dark brown to sooty black,
with pale gray flight feathers
and tarsi; gray cere, yellow eyes, and
yellow legs; immatures mottled
brown above, with light brown
head and underparts, and
cream belly and legs.

SIZE
length 29–34 in. (74–86 cm)

weight 6.7 lb (3 kg)
wingspan 5 ft 5 in.–6 ft 2 in.
(65–190 cm)

DISTRIBUTION
New Guinea (both Papua and
Irian Jaya); Maluku (Indonesia);
various outlying islands around
New Guinea, including within
the Torres Strait.

STATUS
Near Threatened

THIS FAIRLY LARGE, ALL-DARK EAGLE belongs to the *Aquila* genus, alongside the Golden Eagle (p. 22) and its Australasian relative the Wedge-tailed Eagle (p. 52). Named after John Henry Gurney (1819–90), an English banker, politician, and amateur ornithologist, it inhabits New Guinea and Maluku.

Amid the dense forest of this tropical island home, Gurney's Eagle is best seen when it soars above the trees. Dark brown to sooty black, it is most easily confused with the Black Eagle (p. 218), where the ranges of the two overlap in Maluku, but shows a flight profile more like that of a Golden Eagle, though it soars on flatter wings. A closer look shows paler gray flight feathers and tarsi that relieve its dark coloration. Other distinctive features include a rounded tail, a gray cere, and yellow legs and eyes. Immatures are brown above, mottled with gray and buff, and have a light brown head and underparts, fading into cream on the belly and legs.

Gurney's Eagle occurs right across the Island of New Guinea, in both Papua and Irian Jaya, and to the west on the Indonesian archipelago of Maluku (the Moluccas), with outlying populations on various islands in-between—including

Saibai and Boigu in the northwestern Torres Strait, which brings the species into Australian Territory. It frequents various forest habitats, ranging from primary rain forest to swamp forest and hill forest, up to altitudes of 4,900 feet (1500 m). One study suggests that primary forest occupies only 12 to 34 percent of its territory, however, with the rest given over to plantations, cultivation, grassland, and coastal areas. In parts of its coastal range, it competes with the slightly larger White-bellied Sea-eagle (*Haliaeetus leucogaster*), though where this species is rare—such as on Biak Island, north of New Guinea—Gurney's Eagle is the dominant large raptor.

Little is known about this eagle's predatory behavior. The few available records suggest that it preys largely on arboreal mammals, such as possums and fruit bats, as well as large lizards, and that it can capture prey by still-hunting inside the canopy and in flight from above. Pairs have been seen hunting together and consuming their kills on the ground. Its breeding cycle is also little-known, although pairs are often observed performing their diving, undulating display flights. It is probable that they behave in a similar way to other *Aquila* species, nesting in a tall tree and producing a single chick, with incubation and fledging times similar to relatives such as the Wedge-tailed Eagle.

BirdLife International categorizes this species as Near Threatened, with a population estimated at 1,000 to 10,000 individuals. Other sources report 800 to 900 pairs on North Maluku alone, which suggests that the overall population may be toward the higher end of the BirdLife estimate. Either way, the species is not common and, with the ongoing loss and degradation of habitat on its island home, likely to be in decline.

OPPOSITE Gurney's Eagle perches below the canopy in order to spy prey among the trees, but may also scan for prey while circling above.

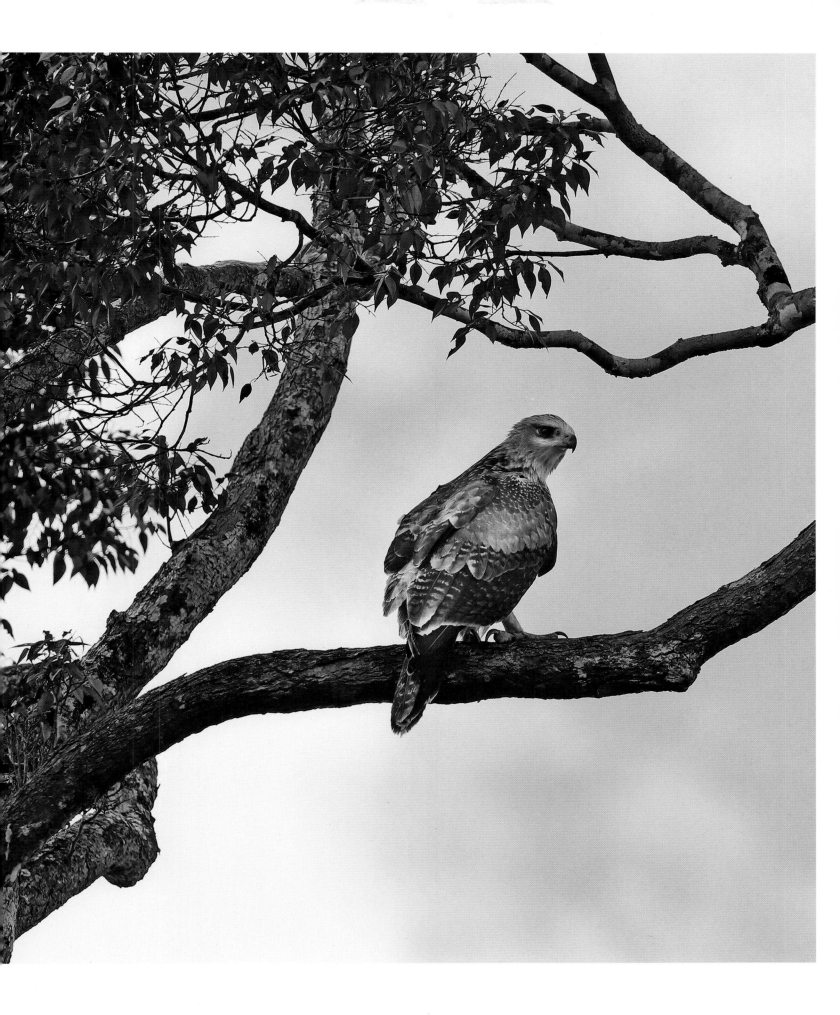

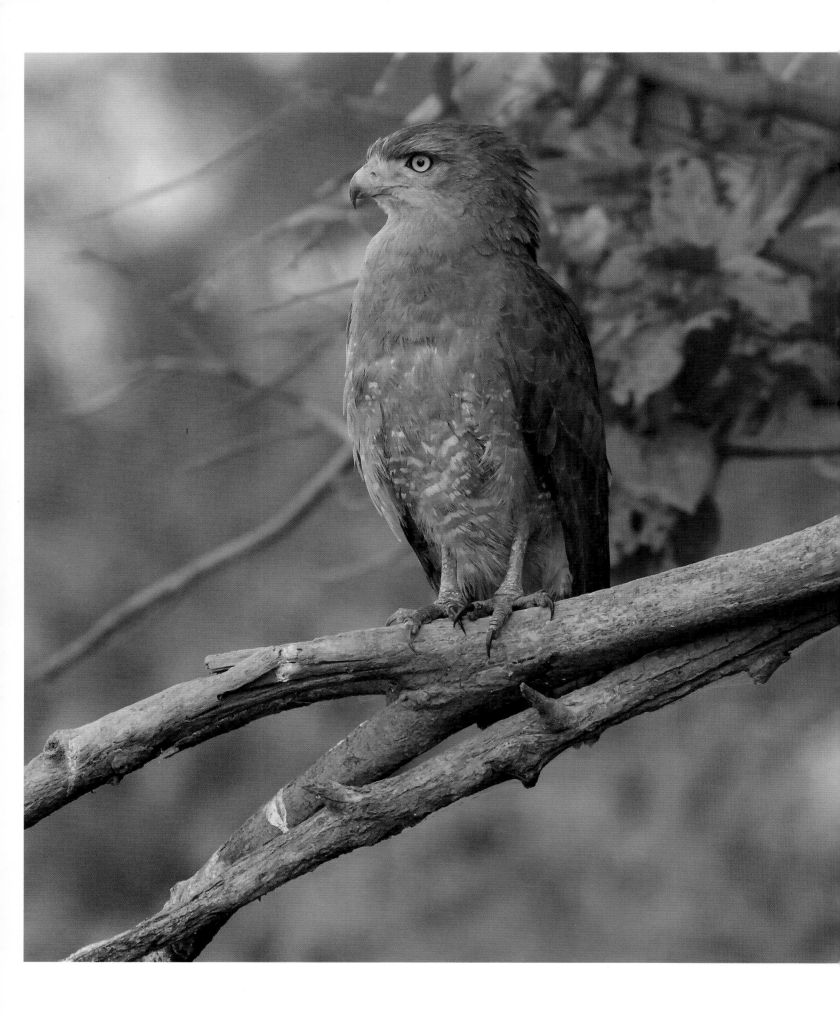

WESTERN BANDED SNAKE-EAGLE

CIRCAETUS CINERASCENS

APPEARANCE
Small and stocky, with unfeathered legs and large head; upperparts brown; head gray-brown; underparts paler brown, with limited barring on lower belly and thighs; tail black with broad white central bar; eyes pale yellow; feet and cere orange-yellow; broad, rounded wings strongly barred on underside; immatures browner and paler, with a cream-buff underside, streaking on head, breast, and throat, and light brown tail with dark band.

SIZE
length 22–24.5 in. (56–62 cm)
weight 2.4 lb (1.1 kg)
wingspan 3 ft 6 in.–3 ft 10 in. (110–120 cm)

DISTRIBUTION
Sub-Saharan Africa, from Senegal and Gambia in the west to Ethiopia in the east; south as far as northern Botswana, Zimbabwe, and Namibia; absent from much of the lowland forests of the Congo Basin.

STATUS
Least Concern

"Kow-kow-kow-kow." A harsh, squawking call is often the first you'll know about this rather reclusive eagle. A denizen of the tree canopy in riverine woodland, it can sit for hours on end without revealing itself—either to the human observer or to the snakes for which it is patiently watching.

Once seen, the Western Banded Snake-eagle reveals the squat, large-headed profile typical of the *Circaetus* snake eagles. It is very similar in appearance to the Southern Banded Snake-eagle (p. 154), to which it is closely related, but can be distinguished by the broad white band across the center of its tail, and by having much less barring on its underparts. Otherwise, it is a similar gray-brown, darker on the back than on the head, with yellow eyes and legs and an orange-yellow cere. On the wing, its underparts show heavily barred flight feathers. Females tend to be a little darker than males. Immatures are browner and paler than adults, with a cream-buff underside, a light brown tail with a dark sub-terminal band, and streaking on the head, breast, and throat.

This snake-eagle has a broad but patchy distribution across sub-Saharan Africa, ranging from Senegal and Gambia in the west, in a band across central Africa, to Ethiopia in the east, and south as far as Botswana, Zimbabwe, and Namibia. It is absent from much of the lowland rain forest of the Congo Basin, preferring woodland habitats—especially in riverine areas and along forest edges. Prey comprises largely snakes, up to about 30 inches (75 cm) in length, as well as other small vertebrates, including lizards, frogs, tortoises, and even fish. This eagle still-hunts from a perch below the canopy, swooping down to collect prey from the ground or, with arboreal snakes such as boomslangs, from foliage and tree trunks.

Solitary and secretive, the Western Banded Snake-eagle is hard to spot unless betrayed by its raucous call. In the breeding season it is more conspicuous, calling loudly while performing its soaring, circling, and tumbling display flight, a pair sometimes claw-grappling in midair. The two birds work together to construct a new nest each year. This relatively small stick structure is placed in a tall tree, generally close to water, measures 18 to 24 inches (45–60 cm) across, and is well-concealed among creepers and foliage. The female lays a single egg and is responsible for the bulk of incubation, which lasts thirty-six to forty-two days. The male provides food for his brood by draping dead snakes over nearby branches. The youngsters fledge at fifty-two to fifty-nine days.

The Western Banded Snake-eagle is classed as Least Concern due to its large range. However, it is locally rare—Namibia, for example, has an estimated population of only fourteen pairs, confined to the Caprivi Strip—and the loss of riverine habitat, among other threats, suggests that some populations may be in decline.

OPPOSITE The Western Banded Snake-eagle perches inconspicuously but is often revealed by its raucous call.

PHILIPPINE SERPENT-EAGLE

SPILORNIS HOLOSPILUS

APPEARANCE
Small and compact, with large head, bushy crest, and shortish tail; brown upperparts and rufous underparts spotted in white and cream; bare yellow face and legs; broad pale band through the flight feathers and tail; underparts have well-defined spots and crown is no darker than nape; immatures are rufous-brown above and white-cream below, with white head and dark cheeks.

SIZE
length 18.5–21 in. (47–53 cm) weight male 1.3–1.5 lb (0.6–0.7 kg), female 1.5–3.5 lb (0.7–1.6 kg); wingspan 3 ft 4 in.–3 ft 10 in. (105–120 cm)

DISTRIBUTION
Endemic to the Philippines; occurs on Luzon, Mindanao, and most major islands except Palawan.

STATUS
Least Concern

THIS SMALL, BEAUTIFULLY MARKED EAGLE is one of three eagle species endemic to the Philippines. It is very similar to the Crested Serpent-eagle (p. 192), which also occurs on the archipelago—but not on the same islands.

Like all the *Spilornis* serpent-eagles, the Philippine Serpent-eagle is often seen soaring high above the forest, when the broad pale band that runs through the flight feathers and tail is conspicuous from a distance. At a closer view, it reveals warm brownish upperparts and rich rufous underparts, with extensive spotting in white and cream that creates an attractive spangled effect. It also has a short bushy crest. Like the Crested Serpent-eagle it has a bare yellow face and legs. It differs from its more common relative, however, in its better-defined spots and the absence of a dark crown. Immatures are brown above with a rufous tint, but have white to cream underparts and a white head with dark cheeks and spotting.

Scientists are still debating the taxonomy of the Asian serpent-eagles. This species is one of six now recognized in the *Spilornis* genus, of which the Crested Serpent-eagle is the basic form and the other five are all island offshoots that have adapted to their isolated homes. Once treated as subspecies of the Crested Serpent-eagle, each of these—by virtue of various ecological, morphological, and molecular distinctions—is now recognized as a species in its own right. It is possible that other island subspecies may yet acquire that honor.

The Philippine Serpent-eagle occurs on Luzon, Mindanao, and most of the Philippines' major islands, with the exception of Palawan, which is home only to the Crested Serpent-eagle. It frequents both primary and secondary forest, usually below 4,900 feet (1,500 m), but is equally at home in open woodlands and cultivated land with scattered trees.

The high rising whistle of this eagle is, like that of its relatives elsewhere, a prominent feature of the landscapes it inhabits. By day, it spends much of its time soaring high on thermals. Most hunting takes place from the canopy, however, the raptor sitting motionless as it scans for snakes and other reptiles and amphibians on the ground below. It has sometimes been seen to follow snakes on the ground.

A dead female Philippine Serpent-eagle found in April had an egg in its oviduct, which suggests that this is the month in which the species lays. Otherwise, little is known about the bird's breeding cycle. It is likely to resemble that of the Crested Serpent-eagle and its other *Spilornis* relatives, involving a single egg laid in a high tree nest and incubated for about forty days, with the chick fledging after a further two months.

BirdLife International categorizes this species as Least Concern, with a population estimated at more than 10,000 individuals. It faces threats from habitat depletion and illegal hunting, but to date has shown itself versatile enough to withstand these.

OPPOSITE The Philippine Serpent-eagle is the most heavily spotted of the *Spilornis* serpent-eagles, and frequents more open habitat.

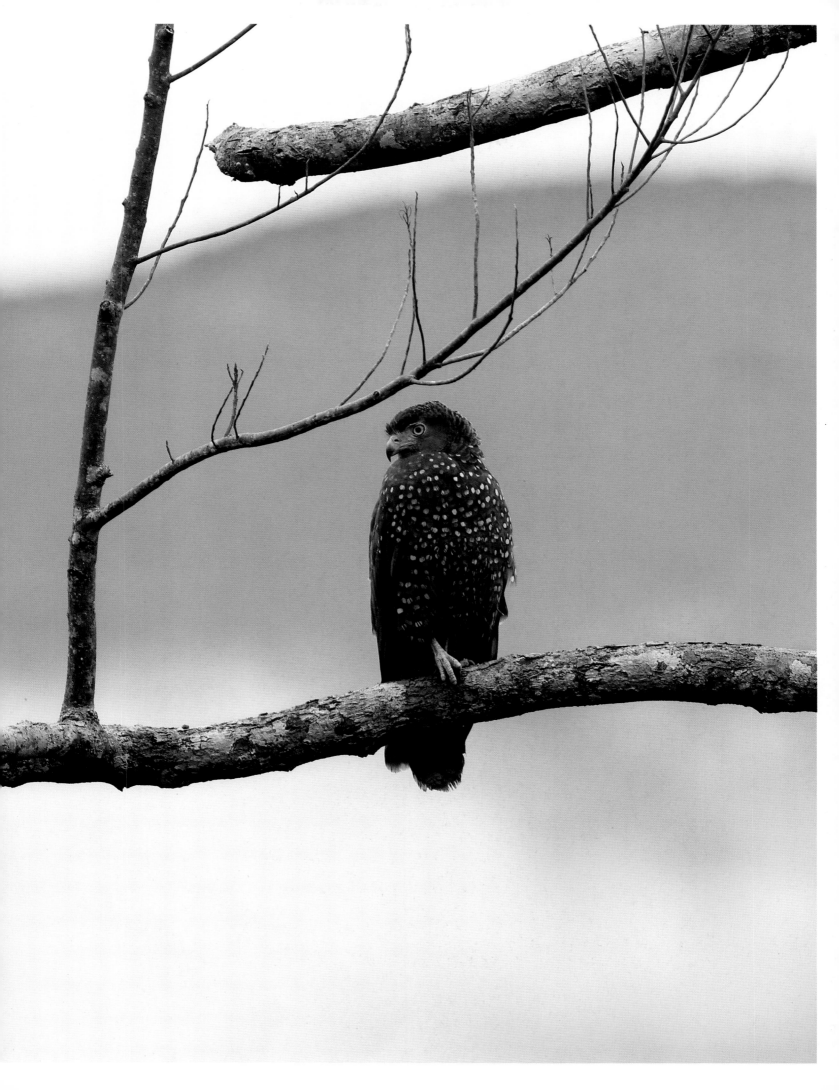

04 | RAPTORS OF THE RAIN FOREST

TROPICAL FORESTS ARE EARTH's most biodiverse habitat. Covering no more than 6 percent of its surface area, they are home to between half and three-quarters of its plant and animal species, including some 60 percent of its 10,000 or so birds. It is thus not surprising that rain forests harbor more eagles than any other habitat. But variety does not mean familiarity. Many forest eagles are among the least studied of birds. The Madagascar Serpent-eagle, for example, was thought extinct for nearly fifty years until it was rediscovered during the 1970s.

The key to a rain forest's biodiversity is its constant warm, wet climate. This allows a proliferation of plants to flourish, in turn creating multiple ecological niches for animals. Many such animals are arboreal, spending their entire lives amid the branches and creepers. Up here, eagles occupy an apex predator role comparable to that of big cats on the forest floor. Indeed, the largest forest eagles, the Philippine Eagle and Harpy Eagle, are the most powerful of all avian predators, with enormous talons adapted for killing monkeys and other substantial prey. Others, including Africa's Crowned Eagle (see Chapter 3), South America's Crested Eagle, and New Guinea's Papuan Eagle are almost as big and equally fearsome.

Such eagles generally approach hunting differently from their savanna cousins. Their prey is often invisible from the air, so—rather than flying high above to scan—they perch inside the canopy, waiting for a sign of movement. Hearing is important when hunting in this manner: the Harpy Eagle's feathered facial ruff works like that of an owl to help amplify sounds. The final attack is rapid and often requires great agility to hit the target. Thus, the wings of forest eagles are comparatively shorter and broader than those of open-country eagles, adapted more for acceleration and maneuverability than for soaring. Many forest species also have a comparatively long tail, offering extra balance when twisting and turning at speed.

Such dashing pursuit is characteristic of sparrow hawks, hence the name hawk-eagle, which is given to many eagles that largely inhabit forests. The *Nisaetus* hawk-eagles of tropical Asia are the most diverse group. These illustrate the evolutionary phenomenon of adaptive radiation, whereby several very similar species have each evolved from a single ancestor to find a unique niche in the isolated forests of their island homes. The Javan Hawk-eagle, Sulawesi Hawk-eagle, and Wallace's Hawk-eagle all evolved on their respective islands from the Changeable Hawk-eagle of the mainland.

The *Spizaetus* hawk-eagles of South and Central America are unrelated to the *Nisaetus* species but have evolved in a similar way, each finding a niche in a particular forest type. They include the Ornate Hawk-eagle and the Black-and-white Hawk-eagle, which specialize in capturing forest birds. In Asia, the serpent-eagles of the *Spilornis* genus have adapted to hunting around forest clearings for the snakes and other reptiles that they spy on the ground. This group also exhibits adaptive radiation, with island species such as the Great Nicobar Serpent-eagle and Andaman Serpent-eagle having adapted to the specific ecology of their respective island homes.

Other forests around the world have their own eagles. Cassin's Hawk-eagle of equatorial Africa is an *Aquila* species that has adapted to a more thickly forested environment than its cousins elsewhere. The diminutive Pygmy Eagle is New Guinea's rain forest version of Australia's closely related Little Eagle. The Black Eagle of tropical Asia, in a genus all its own, is an expert plunderer of other birds' nests in the forest canopy.

Forest eagles are at their most secretive when breeding, their nests located deep in the canopy and generally invisible from the forest floor. Little is known about the life cycle of many species. What we do know, however, is that rain forests are under threat worldwide, many disappearing fast under the pressures of agriculture—whether slash-and-burn farming in Madagascar or palm oil plantations in Indonesia. Many eagles described in this chapter are threatened, and some, such as the Philippine Eagle and Flores Hawk-eagle, critically endangered. Unless we act to safeguard the forests to which they have so perfectly adapted, we may never find out more.

OPPOSITE On Mindanao Island in the Philippines, a Philippine Eagle sits out a rainstorm beside its nest in the rain forest canopy.

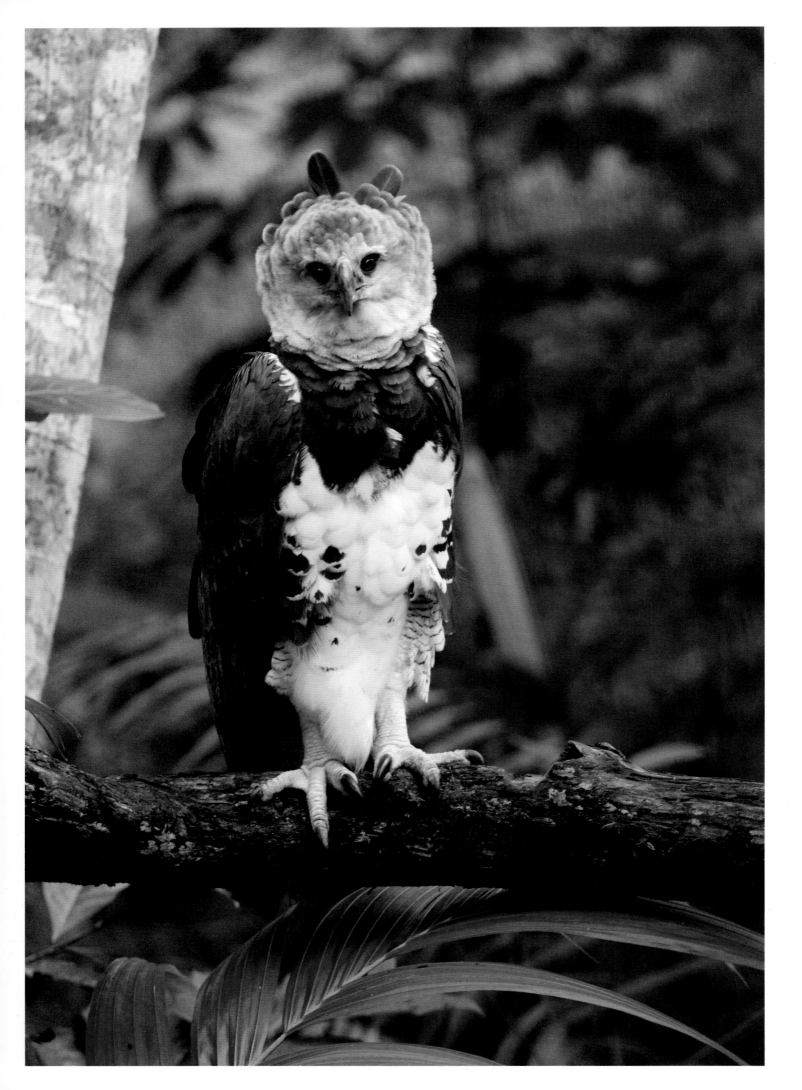

HARPY EAGLE

HARPIA HARPYJA

APPEARANCE
Huge and powerful; slate-gray upperparts; white underparts with broad black breast band; gray head, with long double crest sometimes erected in fan; tail black with three pale gray bands; wings broad and strongly barred below; immatures have white head and neck.

SIZE
length 34–42 in. (86.5–107 cm)
weight male 8.8–10.6 lb
(4–4.8 kg), female 13–20 lb (6–9 kg) wingspan 5 ft 9 in.–7 ft 4 in. (176–224 cm)

DISTRIBUTION
Tropical and subtropical Central and South America, from Mexico to northern Argentina; almost extinct in much of Central America and Atlantic Brazil; population concentrated in Amazon Basin.

STATUS
Near Threatened

A RUSTLE OF FOLIAGE, a whoosh of wingbeats, and another sloth is carried away. There is no struggle: the animal was dead before it even left the cecropia branch, its skull crushed by the world's most powerful talons. Now its lifeless body dangles high above the canopy as its killer wings back toward a hungry chick waiting at the nest.

The tree canopy of the Amazon rain forest may present a seemingly impenetrable wall of green, but in Harpy Eagle country any creature that lingers on an exposed branch is tempting fate. This massive raptor is the apex predator of the neotropical treetops, occupying an equivalent ecological niche to the jaguar on the forest floor below.

The talons are the largest of any raptor in the world: the hallux (hind claw) measures up to 5 inches (13 cm) along the curve—longer than a grizzly bear's claws—and the crushing grip of up to 320 pounds per square inch (224,982 kgf/m²) is eight times more powerful than that of a human hand and stronger than the jaws of a rottweiler. Such formidable weaponry, mounted on legs as thick as a human wrist, enables this fearsome bird to lift victims weighing 15 pounds (7 kg). Only Africa's Crowned Eagle (p. 144) takes prey of a comparable average size.

Diet varies by region. Across much of Amazonia, sloths dominate the menu: one study in Parintins, Brazil found that these slow-moving leaf-munchers comprised 79 percent of prey. Monkeys also often fall victim, the eagles preferring larger primates such as capuchins and howler monkeys to smaller ones such as tamarins. Other arboreal mammals targeted include porcupines, anteaters, squirrels, opossums, and kinkajous, along with canopy-dwelling reptiles, forest birds such as macaws, and terrestrial mammals such as capybaras, armadillos, peccaries, and agoutis. Even adult red brocket deer, which weigh around 66 pounds (30 kg), have fallen victim. Large prey is consumed in situ or torn into pieces to take to the nest.

Hunting technique varies. The Harpy Eagle usually follows a "sit-and-wait" strategy, watching for long periods from a high perch, overlooking a clearing or river edge. It may also move more rapidly between perches, making short flights from tree to tree until it spots prey. Powerful hearing is a vital tool in locating prey, and this eagle is unusual in being able to erect the feathers around its face into a disk that, like an owl's, amplifies sound by directing it toward the ears. It may also search for prey while in flight, gliding above or through the canopy, and sometimes chases birds in the manner of a giant sparrow hawk, showing surprising agility among the branches.

This is the largest eagle in the Americas, and one of the top three biggest worldwide. Its average length of 3 feet 4 inches (98.5 cm) is second only to that of Philippine Eagle (p. 170), while its average weight of 13.1 pounds (6 kg) is topped only by Steller's Sea-eagle (p. 230). Exceptionally big individuals, weighing up to 20 pounds (9 kg), are as large as any eagle known. The wingspan, however, does not make the eagle top six. This is because, like most forest raptors, the Harpy Eagle has shorter, more rounded wings for greater maneuverability.

Size apart, this is a striking bird to look at. Its dark-gray upperparts and black barred tail contrast with white underparts and a broad black breast band. A long black crest crowns a dove-gray head, on which the facial feathers can be fanned out dramatically. In flight, the white underside shows strong dark barring on the wings and three bands across the tail. The cere and bill are blackish while the feet and toes are yellow. Immatures are pale gray with a white head.

OPPOSITE The Harpy Eagle is probably the world's most powerful avian predator, with talons longer than the claws of a grizzly bear.

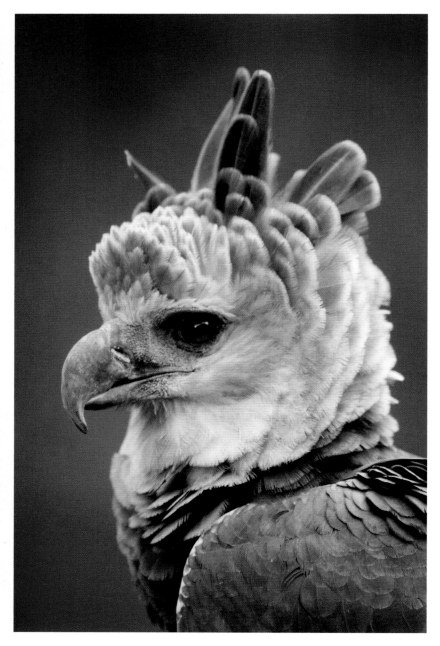

The Harpy Eagle was first described by Linnaeus in his ground-breaking *Systema Naturae* (1758). Initially classified as *Vultur harpyja*, it was named after the harpies of Greek mythology: spirits with the face of a woman and the body of an eagle that transported the dead to Hades. Today, it is the only member of the genus *Harpia*, its closest relatives being the Crested Eagle (p. 206) and the Papuan Eagle (p. 210), sometimes known as New Guinea Harpy Eagle.

This is a species of lowland tropical rain forest up to a height of around 3,000 feet (900 m), though it will also hunt over semi-open and cultivated areas along forest margins. It nests in the tallest forest trees, often perching in emergents to scan the canopy. Its range extends from Mexico to the very north of Argentina, but across most of Central America it is now extremely rare or extinct. Only in the Amazon Basin, primarily Brazil, do reasonable numbers still occur.

Harpy Eagles mate for life. A pair will reuse the same nest for many years. This big stick platform is usually located high in the fork of a giant tropical hardwood, such as a kapok or Brazil nut tree. The breeding territory averages about 16.6 square miles (430 km²), and each pair will usually keep a distance of at least 1.9 miles (3 km) from any neighbors. One chick is raised every two to three years. The female generally lays two eggs, but the second is ignored and normally fails to hatch unless the first perishes. Incubation takes around fifty-six days and is the job of the female, although the male puts in occasional shifts between hunting trips. The chick takes its first steps at thirty-six days and fledges at around six months. The parents continue to feed it for another six to ten months. Five years pass before the youngster reaches breeding maturity.

The only wild predators that might threaten a Harpy Eagle are the puma and jaguar, and circumstances in which this might happen are hard to imagine. Nonetheless, the species is under serious threat from people. A notoriously shy breeder, it has lost much of its forest habitat to logging, mineral prospecting, and cattle-ranching. In some areas, it suffers persecution due to a misconception that it threatens livestock—and even humans. Today, BirdLife International categorizes the species as Near Threatened, with a total population estimated within the 20,000 to 49,000 bracket. It is extinct in El Salvador and has all but disappeared from Nicaragua, Costa Rica, and Atlantic Brazil. There are numerous conservation initiatives, including in Panama's Darién Gap and the Rio Bravo Conservation Management Area of Belize, where a number of captive birds have been released—including one named Hope, set free in 2009 as an ambassador for Climate Change Action. Education programs aim to boost awareness and understanding of this magnificent predator, which in Panama is venerated as the national bird.

ABOVE A Harpy Eagle can erect its facial feathers into a ruff that helps amplify hearing, aiding it to detect prey among the dense foliage of the rain forest canopy.

OPPOSITE ABOVE The relatively short wings of a Harpy Eagle provide it with acceleration and agility as it pursues prey through the forest canopy.

OPPOSITE BELOW A female Harpy Eagle makes a brief visit to its nest in a towering almendro tree in Panama's Darién National Park, departing quickly in search of more food for the youngster.

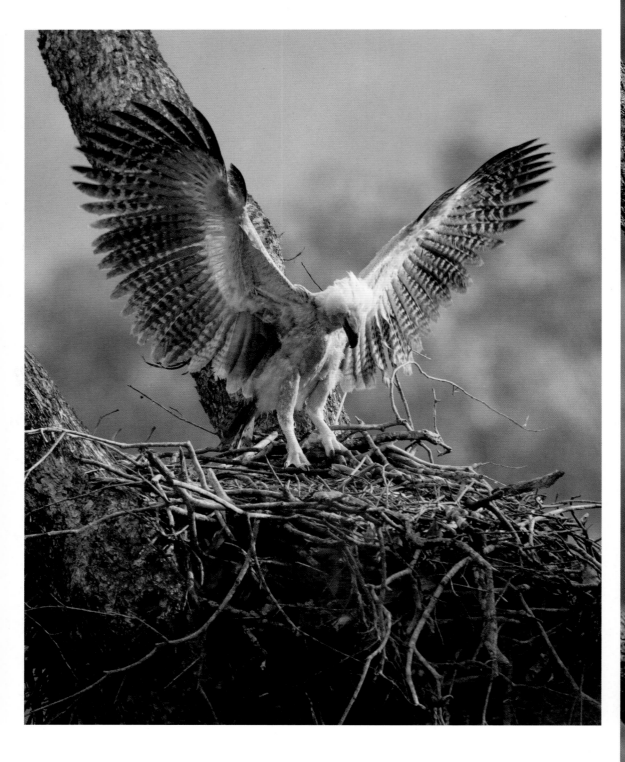

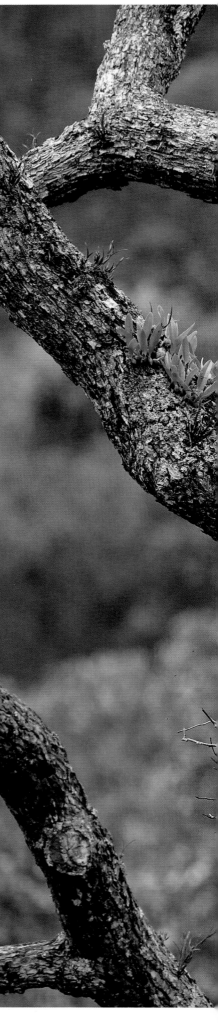

ABOVE A young Harpy Eagle stretches its wings at the nest. Immatures of this species are much paler than adults.

RIGHT In the Brazilian Amazon, a female Harpy Eagle mantles her clutch protectively as her mate delivers fresh green leaves to the nest.

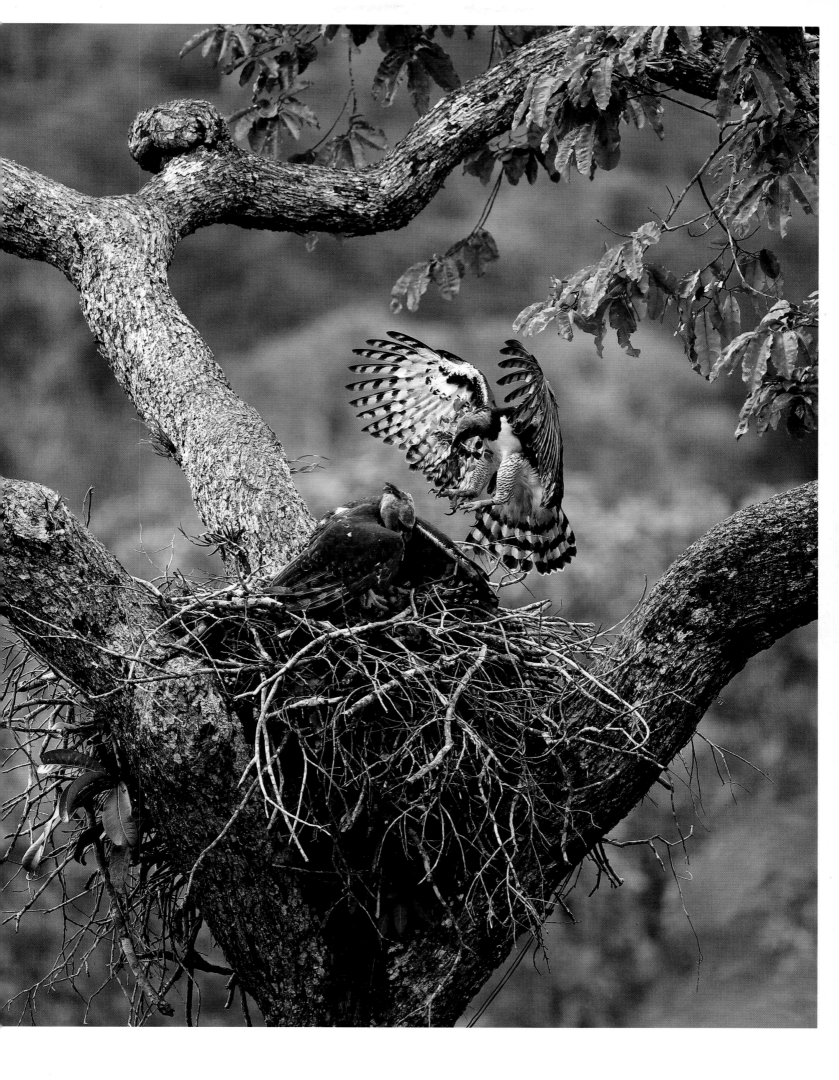

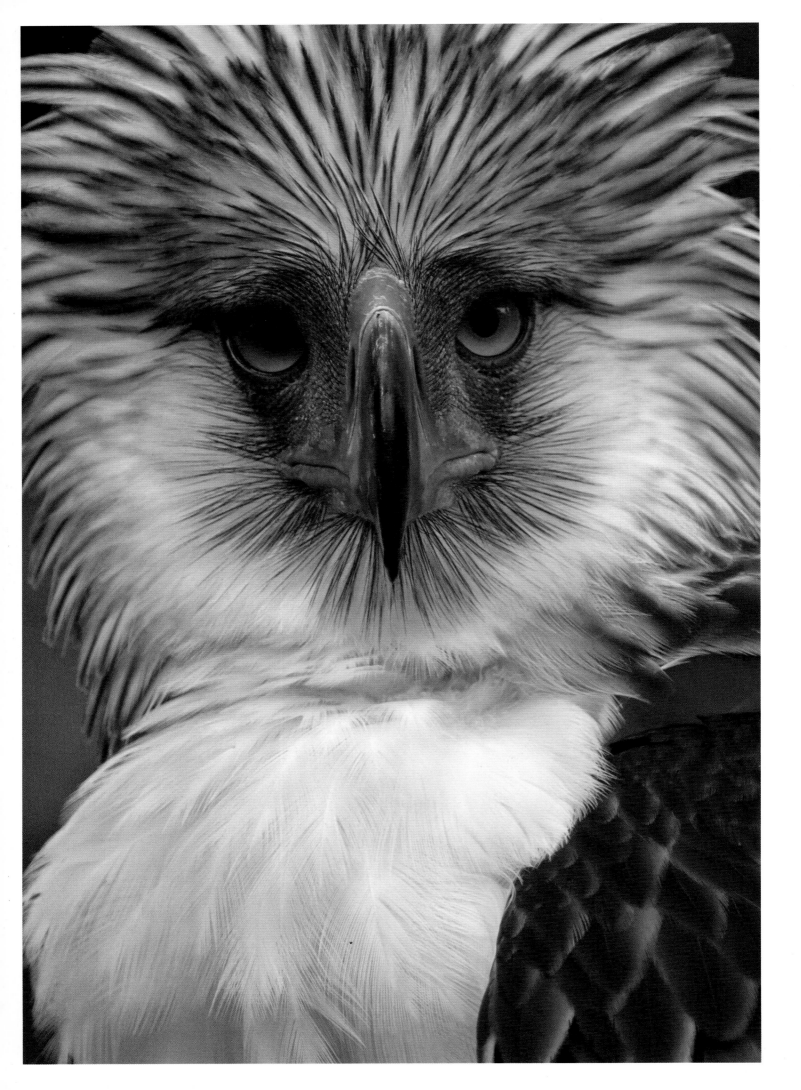

PHILIPPINE EAGLE

PITHECOPHAGA JEFFERYI

APPEARANCE
Huge and powerful; dark face with blueish eyes and blue-gray bill; mane of long nape feathers may be erected into ruff; upperparts brown and lightly barred; underparts white, with fine dark streaking on belly and thighs; long, yellow legs with huge talons; in flight, broad wings are whitish-buff below with a brown trailing edge and longish tail has a brown terminal band; Immatures have paler fringing; females 10 percent larger than males.

SIZE
*length 34–41 in. (86–105 cm)
weight 10.4–17.6 lb (4.7–8 kg)
wingspan 6 ft–7 ft 4 in. (184–220 cm)*

DISTRIBUTION
Endemic to the Philippines: Mindanao, Samar, Leyte, and Luzon.

STATUS
Critically Endangered

THIS ENORMOUS EAGLE'S NAME has an interesting history. The genus *Pithecophaga*, of which it is the only member, derives from the Greek terms *pithecus* and *phagus*, meaning "monkey" and "eating," and for many years the bird was indeed known as the Monkey-eating Eagle. It owed this title to English explorer and naturalist John Whitehead (1860–99) who, in 1896, became the first European to see one. His specimen, shot by his servant Juan, contained undigested pieces of monkey in the stomach. The skin was sent back to Scottish ornithologist William Robert Ogilvie-Grant (1863–1924) in London who, after showing it off in a local restaurant, made the first scientific description. The species name *jefferyi* honors Whitehead's father.

It was not until 1978 that, by proclamation of Philippines president Fidel Ramos, this bird received its more prosaic new name. But it seems right that this magnificent animal should be named for the islands to which it is endemic. In 1995 it was proclaimed the Philippines national bird. Sadly, status is no guarantee of security. Today, this is one of the world's rarest raptors, and with a population estimated at around 300 pairs is listed by the IUCN as Critically Endangered.

The Philippine Eagle is easily described. More than a meter tall, it is the world's largest eagle in terms of average length and wing surface area, and falls only fractionally behind the Harpy Eagle (p. 164) and Steller's Sea-eagle (p. 230) in average weight. Its formidable demeanor is amplified by an enormous hatchet of a bill, rivaling that of the Steller's Sea-eagle as the largest of any eagle, and a spray of cream-tawny elongated nape feathers that it can erect into a lion-like mane. Its plumage is largely brown above and white below, with fine brown streaking on the belly and thighs. The powerful legs are bright yellow. In flight, it appears largely whitish-buff below, with a brown terminal band to its longish tail. Immatures have paler fringing to the upperparts. Females are typically 10 percent larger than males.

The close resemblance of this species to South America's Harpy Eagle explains why for many years it was classified in the subfamily *Harpiinae*. This was proved to be incorrect in 2005, when molecular research revealed its taxonomic affinities with the snake-eagles in the subfamily *Circaetinae*.

The Philippine Eagle once ranged widely across the archipelago but today occurs on just four islands, where it inhabits primary forest up to heights of more than 5,900 feet (1,800 m). The bulk of the population is on Mindanao, where an estimated 233 breeding pairs are largely confined to three national parks. A few also survive on the islands of Samar (two pairs), Leyte (two pairs), and Luzon.

Wherever this species occurs, it is not only the largest raptor but also the most powerful predator of any kind. Its original name was not wrong: it does sometimes prey on the long-tailed macaque, the only monkey on the Philippines. However, monkeys form a much smaller proportion of its diet than in that of the Harpy Eagle or Crowned Eagle (p. 144). On Mindanao its staple prey is the Philippine flying lemur, an arboreal mammal the size of a large squirrel. Other prey includes monitor lizards, palm civets, large snakes, flying-foxes, giant cloud-rats, and large birds such as hornbills. Indeed, most animals found in the Philippines may make the menu, including young pigs and small dogs. Prey identified from remains at one nest ranged from a 0.35-ounce (10 g) bat to a 31-pound (14 kg) Philippine deer.

OPPOSITE The Philippine Eagle has the joint largest bill of any eagle.

This eagle captures its prey among the trees or on the forest floor. It either still-hunts from a perch or forages from branch to branch. Pairs may hunt cooperatively, especially when targeting monkeys, which can be dangerous adversaries and have been known to break an adult eagle's leg.

Philippine Eagles are slow to reproduce. They raise one chick every two to three years, with their breeding cycle of nearly two years being slower than that of any other eagle except the Crowned and Harpy. Pairs form monogamous, life-long bonds, renewed at the start of every breeding season, usually in July, with tumbling aerial displays and high-pitched whistling calls. The collecting of new nesting material signals a readiness to breed. The nest is a large stick platform up to 4 feet 11 inches (1.5 m) across. Pairs space themselves widely: the average distance between nests is 8.1 miles (13 km). The female lays one egg. If this fails, she may lay another the following year. Incubation lasts fifty-eight to sixty-eight days (typically sixty-two) and for the first seven weeks both parents take turns sheltering the hatchling. The youngster fledges at four to five months but will stay around the nest, receiving its parents' care, for up to another eighteen months. The earliest a chick has been observed making a kill is at 304 days. Females reach sexual maturity at five years and males at seven. Adults may live at least thirty years in the wild, with captive birds having reached forty-six years.

The Philippine Eagle is listed as Critically Endangered, with its population estimated in 2016 at 600 individuals, including up to 250 pairs on Mindanao. Despite a conservation program, the species continues to decline. The principal threat remains habitat loss, with much indigenous forest lost to logging, cultivation, and mining, and only 3,559 square miles (9,220 km²) of old-growth forest in the bird's range remains. Other threats include pollution, pesticides, and snares set for other animals. Illegal hunting persists, despite the fact that killing this bird is punishable by up to twelve years in prison. With the population so low, severe weather events—such as Typhoon Haiyan, which struck the islands in 2013, bringing floods and mudslides—have a severe impact.

Conservation for this species began in the 1970s, prompted by the interest of celebrated U.S. aviator Charles Lindbergh. The Philippine Eagle Foundation, based in Davao City, Mindanao, oversees captive-breeding efforts and the monitoring and conservation of wild populations. In 2004, the first captive-reared bird was released at Mount Apo but, sadly, electrocuted on a power line nine months later. Another released on Mindanao in 2008 fell victim to hunters after four months. Despite these setbacks, the reintroduction program continues. Meanwhile, major efforts are being made to raise local awareness through education, and research into the bird's distribution, numbers, ecological needs, and threats is ongoing.

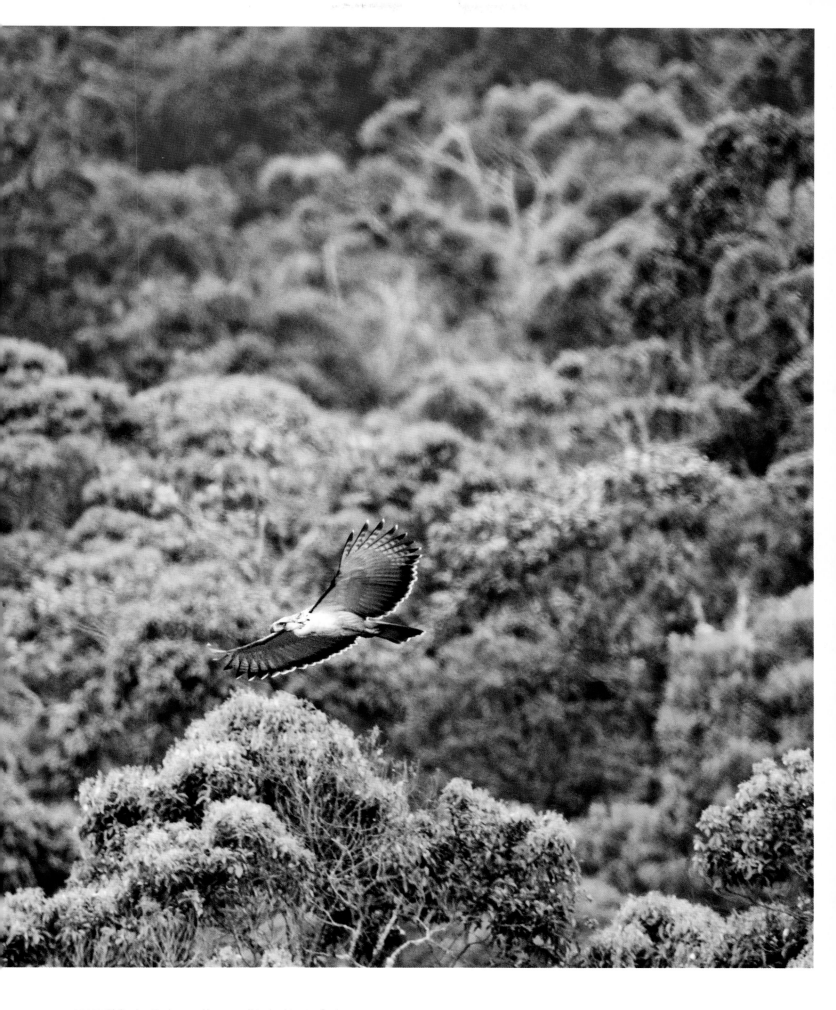

ABOVE Philippine Eagles need large, undisturbed tracts of primary forest, a habitat that is now in short supply across the Philippines.

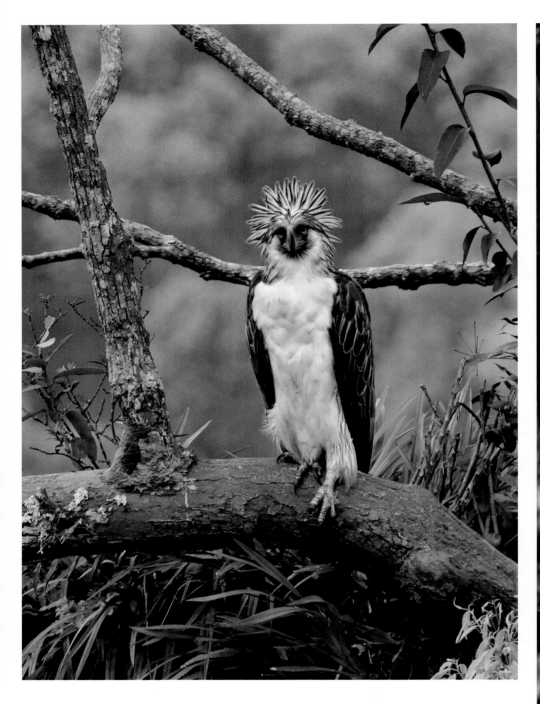

ABOVE When alarmed, a Philippine Eagle may erect its mane of nape feathers into a crown.

RIGHT A Philippine Eagle visits its chick on the nest. This youngster may require its parents' care for more than eighteen months.

RAPTORS OF THE RAIN FOREST

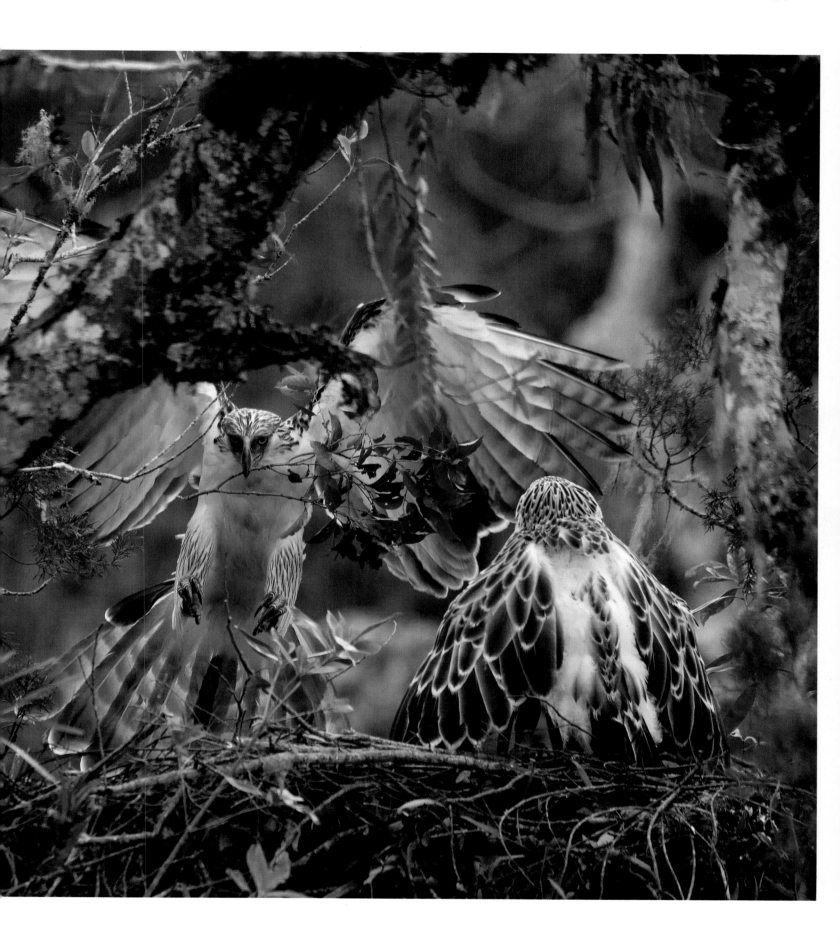

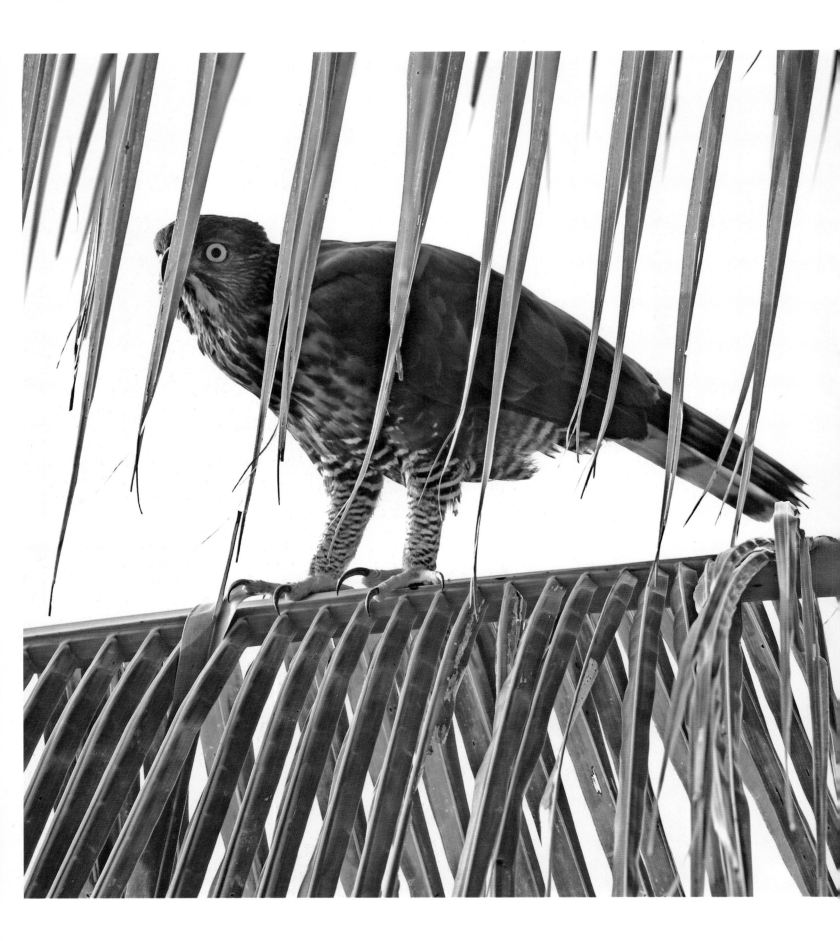

SULAWESI HAWK-EAGLE

NISAETUS LANCEOLATUS

APPEARANCE
Small/medium, with feathered legs, shortish wings, and a longish tail; face and nape streaked white and rufous; upperparts blackish-brown; tail brownish-gray with black bars; throat white, with two black median stripes and one central malar stripe; breast rufous; belly, flanks, and thighs white with barring; eyes and feet yellow; immatures have white head and underparts.

SIZE
*length 22–25 in. (56–64 cm)
weight no available data
wingspan 3 ft 6 in.–4 ft 5 in.
(110–135 cm)*

DISTRIBUTION
Endemic to Indonesian island of Sulawesi and nearby islands, including Buton, Muna, Banggai, and the Sula Islands.

STATUS
Least Concern

THIS POORLY KNOWN EAGLE IS confined to Sulawesi in Indonesia, plus a few outlying islands. Formerly considered an island race of the Changeable Hawk-eagle (p. 132), taxonomists now consider it a species in its own right. It thus joins the nine other species formerly grouped alongside New World *Spizaetus* hawk-eagles that today make up the Asiatic genus *Nisaetus*.

The Sulawesi Hawk-eagle is a small/medium-sized species, with long feathered legs, shortish rounded wings, and a longish rounded tail. It lacks the prominent crest of the Changeable Hawk-eagle, and shows fine white and rufous streaking on its cheeks and nape. The upperparts are blackish-brown with three to four black bars across the brownish-gray tail. The underparts are more colorful, with a white throat outlined by three black stripes, a rich rufous breast, and bold blackish-brown barring across the white belly, flanks, and thighs. The eyes and feet are both bright yellow. Immatures have dark brown upperparts scaled with paler edges, and a white head and underparts that become more heavily streaked as they grow toward adult plumage.

This species is one of ninety-six endemic birds found on Sulawesi, which has one of the highest proportions of endemism of any island worldwide. It is a sedentary species, ranging widely across the island and also occurring on such close offshore islands as Buton, Muna, Banggai, and the Sula Islands. Its preferred habitats are primary and secondary rain forest from sea level to heights of up to 6,500 feet (2,000 m), although it may also venture onto farmland and the edges of cleared areas.

Sulawesi Hawk-eagles often perch in the crown of a tree, their presence revealed by a loud, laughing call that accelerates and then descends. Their behavior has been little studied but they are thought, like other *Nisaetus* hawk-eagles, to hunt largely from a concealed perch, swooping down to capture prey on or near the ground. Small mammals, reptiles, and small to medium birds—including domestic chickens—are all targeted. Individuals have also been observed hunting low over treetops.

Breeding takes place from May to August, heralded by the pair circling over their nest site. The nest is built on a branch near the top of a tall forest tree, often on a platform of epiphytes. The female is thought to lay only a single egg, with incubation lasting forty to fifty days. The fledging process is likely to be similar to that of the Changeable Hawk-eagle.

Though confined to Sulawesi, this species appears to be faring reasonably well across the archipelago and remains common in some areas, including Dumoga-Bone National Park in the north. Threats such as disturbance and deforestation persist. Nonetheless, BirdLife International has downgraded the species from Near Threatened to Least Concern, with an estimated population of 670 to 6,700 mature individuals.

OPPOSITE The Sulawesi Hawk-eagle, in common with other *Nisaetus* species, generally hunts from a concealed perch.

ORNATE HAWK-EAGLE

SPIZAETUS ORNATUS

APPEARANCE

Small to medium; yellow eyes and pointed black crest; crown and upper parts blackish-brown; neck and sides of breast chestnut; underparts white, with black barring and black stripe either side of white throat; wings broad, rounded, and white below with black barring; tail long and rounded, with three broad black bars; feet yellow; immatures have white head, white underparts, barred flanks and legs, gray crest, and brown upperparts.

SIZE

length 22–27 in. (56–68.5 cm)
weight male 2.1–2.2 lb (0.96–1.0 kg), female 3–3.5 lb (1.4–1.6 kg)
wingspan 46–56 in. (117–142 cm)

DISTRIBUTION

Central and South America, from southern Mexico and the Yucatán Peninsula south to Peru and northern Argentina.

STATUS

Near Threatened

ORNATE IS AN APT NAME FOR this beautiful raptor, whose plumage is among the most richly patterned of any eagle. Its fine markings provide excellent camouflage among the dappled light of the forest canopy, ensuring that the bird's victims seldom see their nemesis until it is too late.

This smallish, elegant eagle is no heavier than a common buzzard. It has a prominent pointed crest, which it raises when excited, accentuating the fierce expression of its piercing golden eyes. Its blackish-brown crown and upperparts contrast with a rich chestnut neck that extends to the sides of the breast. The white underparts are heavily barred in black on the flanks, belly, and legs, and the white throat is framed by black malar stripes. In flight, its broad, rounded wings reveal heavy black barring on the underside and its long, rounded tail shows three broad black bars. The powerful feet are bright yellow. Immatures have a white head and underparts, a gray crest, and brown upperparts with barring on the flanks and legs.

The Ornate Hawk-eagle inhabits tropical forests in Central and South America, ranging from southern Mexico to northern Argentina. Scientists recognize two subspecies:

S. o. vicarius occurs in southeastern Mexico, through Central America to western Colombia and western Ecuador; *S. o. ornatus* occurs in eastern Colombia, east to the Guianas and Trinidad, and south through Ecuador, Peru, Bolivia, and Brazil to Paraguay and Argentina. The Black Hawk-eagle (p. 130) was once considered a color morph of this species but molecular studies show that the two are not closely related.

This striking raptor is inconspicuous when perched but often draws attention with a high-pitched call. It is most easily seen when soaring high over the forest, its long circular glides interspersed with short bursts of fluttering wingbeats. Though a relatively small eagle, it is a powerful predator and may take prey of up to 17.6 pounds (8 kg), five times its own weight. Its diet comprises mostly medium to large birds, which it takes in flight or from the branches. Mammals are also taken.

Ornate Hawk-eagles generally breed only every third year—typically April to May, though this varies by region. The male performs an impressive looping display flight, diving with folded wings upon the female, who flips over to meet him with raised talons. The pair build their large stick nest high in a big tree such as a ceiba. The female lays a single egg, which she incubates for forty-eight days. Fledging takes place at sixty-six to ninety-three days, at which point the male takes over all care. Youngsters can hunt for themselves after a year. They have been observed honing their skills by diving and clutching at hanging fruit.

The Ornate Hawk-eagle is threatened in many areas by habitat destruction and hunting. It has a wide range, however, and has shown a capacity to withstand the fragmentation of its habitat, breeding in forest patches as small as 500 acres (200 ha) and sometimes on the edge of cities. BirdLife International lists the species as Near Threatened, with an estimated population of 13,300 to 33,300 mature individuals.

OPPOSITE Despite its striking markings, the Ornate Hawk-eagle can be hard to see among the dense foliage of the rain forest.

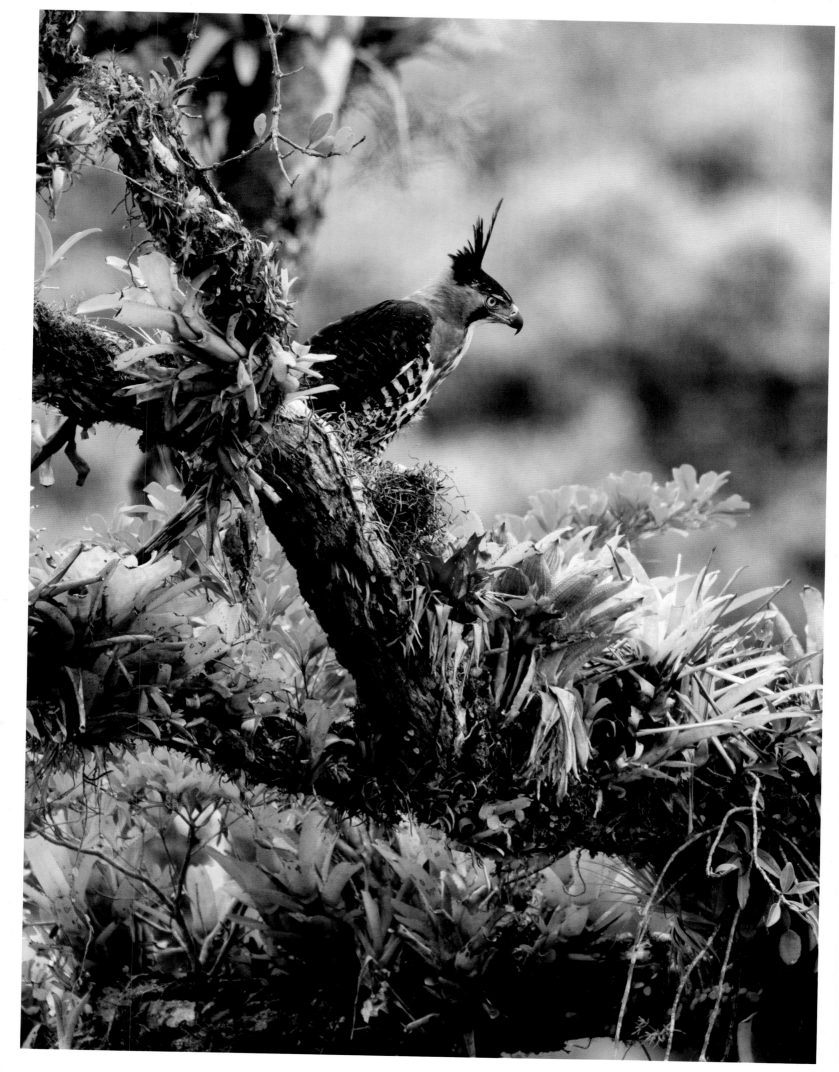

RIGHT An Ornate Hawk-eagle brings fresh foliage to provide a soft lining for its nest.

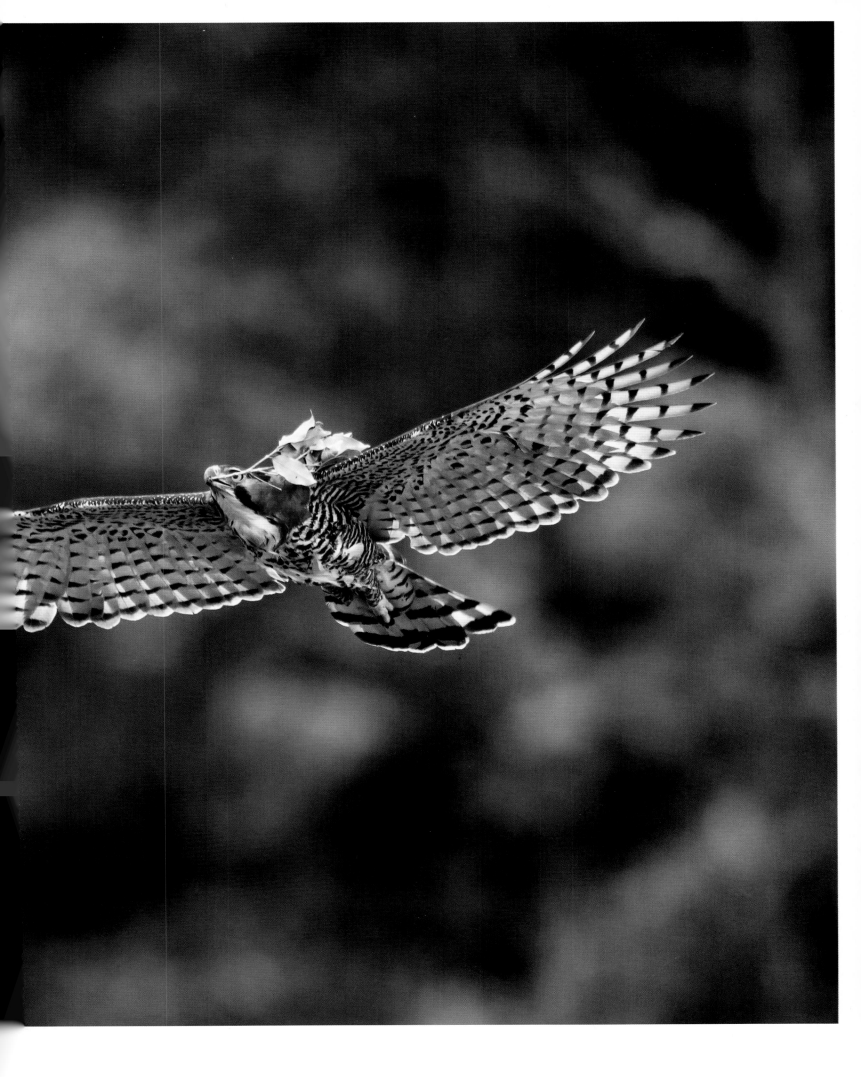

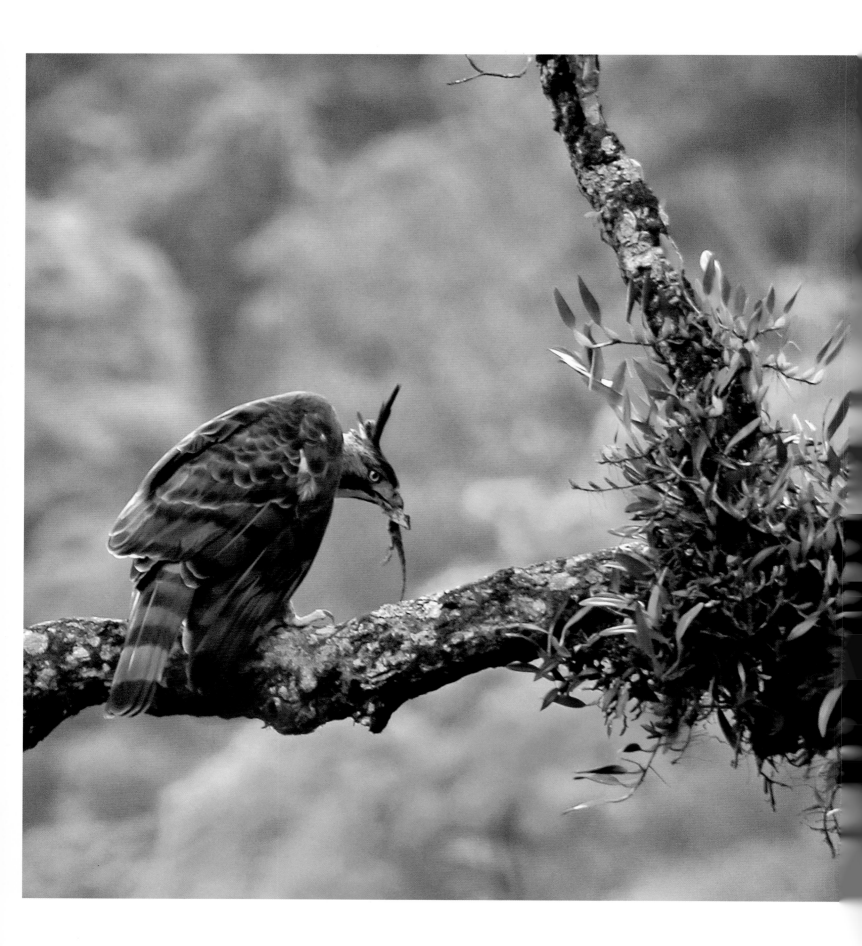

JAVAN HAWK-EAGLE

NISAETUS BARTELSI

APPEARANCE
Small/medium; long black crest; rufous head and neck; upperparts dark brown; tail paler with broad cream stripes; creamy throat with prominent black stripe; white breast and white belly heavily barred in black; rounded wings heavily barred beneath; eyes and feet yellow; cere gray; immatures plainer brown.

SIZE
length 23½ in. (60 cm)

weight no available data
wingspan no available data

DISTRIBUTION
Endemic to Java, Indonesia; confined largely to protected areas, including national parks of Bromo Tengger Semeru, Meru Betiri, Alas Purwo, Gunung Halimun, and Gunung Gede-Pangrango.

STATUS
Endangered

NO LIVING EAGLE QUITE MEASURES up to the Garuda. This half-human/half-bird figure appears in Hindu and Buddhist mythology as the vehicle (*vahana*) of the Lord Vishnu, where it blows down houses with the hurricane-like force of its wingbeats. Today, the Garuda survives in heraldic form as the national emblem of Indonesia and its airline. And the living species on which all modern depictions are based is the Javan Hawk-eagle—a rather smaller but nonetheless splendid bird that is endemic to the island for which it is named.

This raptor is another in the *Nisaetus* group of hawk-eagles that range across southern and southeast Asia. Small to medium-sized, it is similar in many ways to the Changeable Hawk-eagle (p. 132), but differs in its more rufous head and neck. The upperparts are dark brown, the tail paler with broad cream stripes, and the underparts grade from a white throat—with a prominent black stripe—to a white breast and a belly heavily barred in black. Like other *Nisaetus* species, it has short, rounded wings heavily barred beneath. The eyes and feet are bright yellow and the cere gray. Immatures are a plainer brown.

The Javan Hawk-eagle is endemic to Indonesia, where it breeds only on Java. It inhabits primary and secondary rain forest, usually at altitudes of 1,600 to 3,300 feet (500–1,000 m) but occasionally higher. Today, it is confined largely to protected areas, including such national parks as Bromo Tengger Semeru, Meru Betiri, Alas Purwo, Gunung

Halimun, and Gunung Gede-Pangrango. With natural forests rapidly diminishing, it may also venture onto plantations and cultivated areas. In recent years, it has also been seen on Bali.

This species is one of ten Asiatic hawk-eagle species that were once grouped alongside New World *Spizaetus* hawk-eagles but are now known to make up the genus *Nisaetus*. It was formerly considered an island race of the widespread Changeable Hawk-eagle, but in 1953 was granted species status. Relatively little is known about the biology of this rare raptor, most often seen soaring high above the treetops when the weather is clear. Like other *Nisaetus* species, it generally hunts from a concealed perch, swooping down to capture prey that largely comprises mammals, notably tree shrews, fruit bats, and large rodents such as Javanese rats.

Breeding usually takes place from May to August, though has been recorded all year round. Recent research has estimated a pair's average home range to be around 1.5 square miles (4 km²). The two birds build a stick nest high in a tall forest tree. The female lays a single egg. Incubation lasts forty-seven to forty-eight days and fledging takes a further sixty-eight to seventy-two days. Birds reach breeding maturity at three to four years and breed every two years.

The Javan Hawk-eagle is one of the world's rarest raptors. Its decline is due largely to habitat loss, with Java's forests giving way to agriculture under the relentless pressure of the island's growing population. Other problems include hunting: at least thirty to forty birds are reported captured every year for the pet trade. With an already limited range, the destruction caused by Java's frequent volcanic eruptions takes its toll. Today, BirdLife International classifies the bird as Endangered, with an estimated population of 600 to 900 individuals. Conservation measures include distribution and ecology surveys, as well as awareness campaigns using radio broadcasts and school visits. Without more effective enforcement of legislation, however, conservationists fear the bird may become extinct by 2025—leaving Indonesia without a living Garuda.

PHILIPPINE/ PINSKER'S HAWK-EAGLE

NISAETUS PHILIPPENSIS / PINSKERI

APPEARANCE
Small to medium-sized; erect black crest; head, nape, and underparts rufous; upperparts dark brown; throat white, with black malar and mesial stripes; "pants" barred in black and white; tail dark brown with darker, narrow bands; wings broad, rounded, and heavily barred beneath; immatures have white head and underparts, and brown upperparts and tail; Nisaetus pinskeri *slightly smaller, with a paler, more heavily barred underside.*

SIZE
length 25 ½–27 ½ in. (65–70 cm)
weight female 2.5–2.8 lb (1.16–1.28 kg)
wingspan 3 ft 5 in.–4 ft 1 in. (105–125 cm)

DISTRIBUTION
Endemic to the Philippines: Nisaetus philippensis *on Luzon, Mindoro, and a few smaller islands;* Nisaetus pinskeri *on Mindanao, Leyte, Samar, and Negros.*

STATUS
Endangered

THE PHILIPPINES ARE HOME TO some impressive birds and a number of extremely rare ones. This raptor ticks both boxes. It is similar in appearance and behavior to its widespread relative, the Changeable Hawk-eagle (p. 132). However, in being an endemic raptor that evolved on the islands and is now perilously close to dying out there, it has more in common with its huge cousin, the Philippine Eagle (p. 170).

To complicate matters, this rare raptor may comprise two separate species. Scientists have long recognized both a southern and a northern race. The former, sometimes known as Northern Philippine Hawk-eagle (*N. p. philippensis*), is confined largely to Luzon, with a few on neighboring Mindoro. The latter, known as Pinsker's Hawk-eagle (*N. p. pinskeri*), Southern Philippine Hawk-eagle, or Mindanao Hawk-eagle, occurs on the more southerly islands of Mindanao, Leyte, Samar, and Negros. Molecular studies published in 2005 revealed significant differences, leading some authorities to recognize Pinsker's Hawk-eagle as a new species (*N. pinskeri*). At the time of writing, BirdLife International continues to group the two.

The Philippine Hawk-eagle is one of the more striking *Nisaetus* hawk-eagles, sporting a jaunty crest and a rich rufous head and underparts that contrast with its dark brown upperparts. Neat black malar stripes frame the white throat, which also has a mesial stripe down the center, and the "pants" are finely barred in black and white. The dark brown tail has four to five darker bands, and the broad, rounded wings are heavily barred beneath. Immatures have a white head and underparts, which contrast with brown upperparts and tail. They take four years to reach adult plumage. Pinsker's Hawk-eagle differs from its northerly counterpart in being slightly smaller, with a paler and more heavily barred underside.

The ranges of the two races (or species) do not overlap. However, both inhabit similar subtropical or tropical moist lowland forest up to altitudes of 6,200 feet (1,900 m). They often perch out of sight in the dense foliage of the canopy but may be seen during frequent soaring circuits above the treetops. Little is known about their biology, but they are thought to feed on a variety of forest birds and small mammals and to follow a breeding cycle similar to that of other *Nisaetus* species.

The Philippine Hawk-eagle is thought to have suffered population declines of more than 50 percent over the past three generations. This can be attributed largely to habitat loss: the Philippines have been ravaged by logging, mining, and other uncontrolled exploitation, with an estimated 40 percent of forest cover lost between 1970 and 1990. Illegal hunting and trapping have also taken their toll, with legislation in many protected areas not enforced. Today, both birds (whether races or full species) are classed as Endangered, with an estimated combined population of 600 to 900 individuals remaining. Ongoing conservation action includes ecology and distribution surveys, as well as working toward stronger enforcement of legislation to control hunting and trading.

OPPOSITE Pinsker's Hawk-eagle occurs in the south of the Philippines and is considered by some authorities to be a species in its own right.

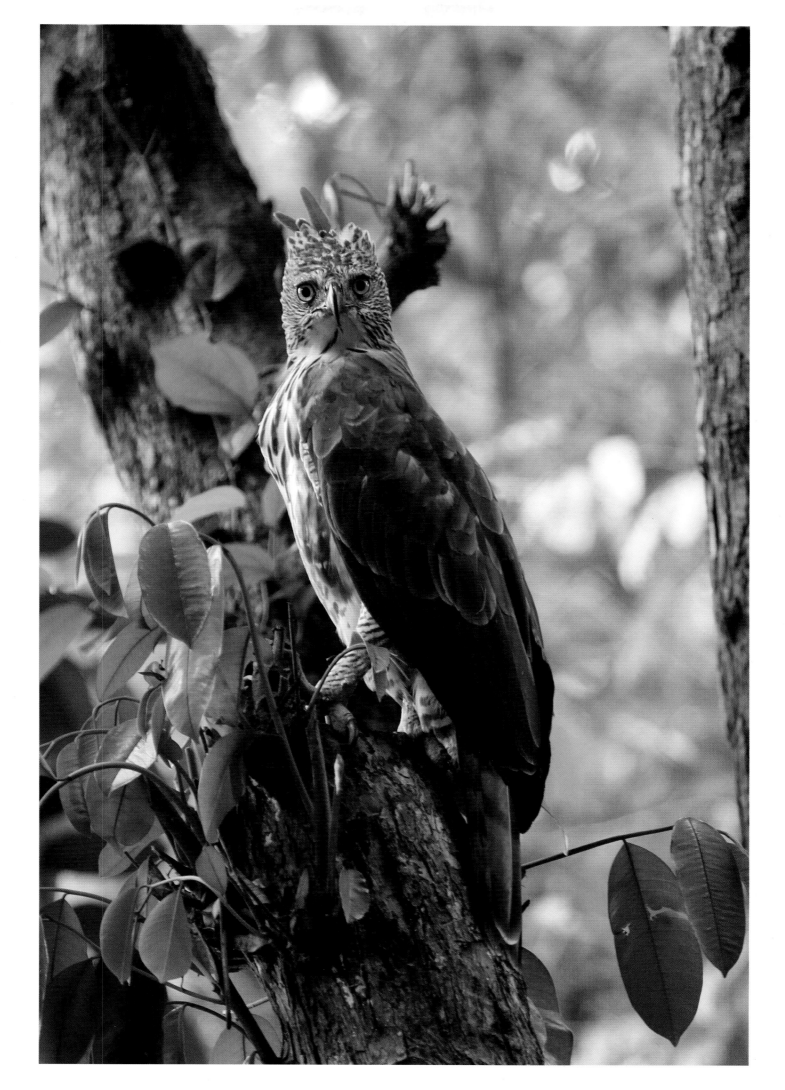

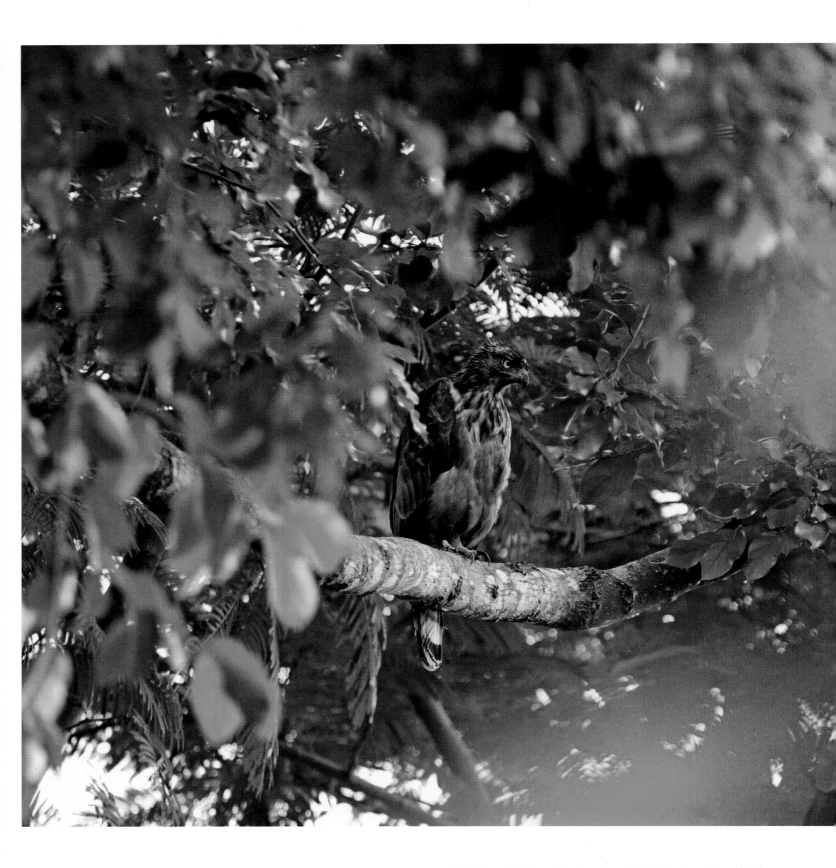

ABOVE AND RIGHT In the north of the archipelago, the Philippine Hawk-eagle is confined largely to the island of Luzon. It is darker and slightly larger than Pinsker's Hawk-eagle.

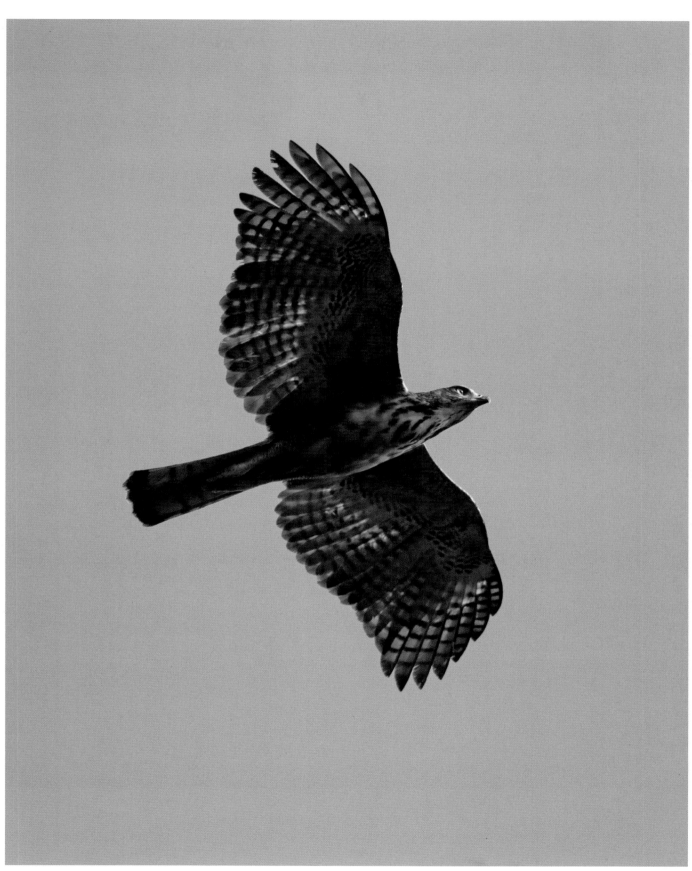

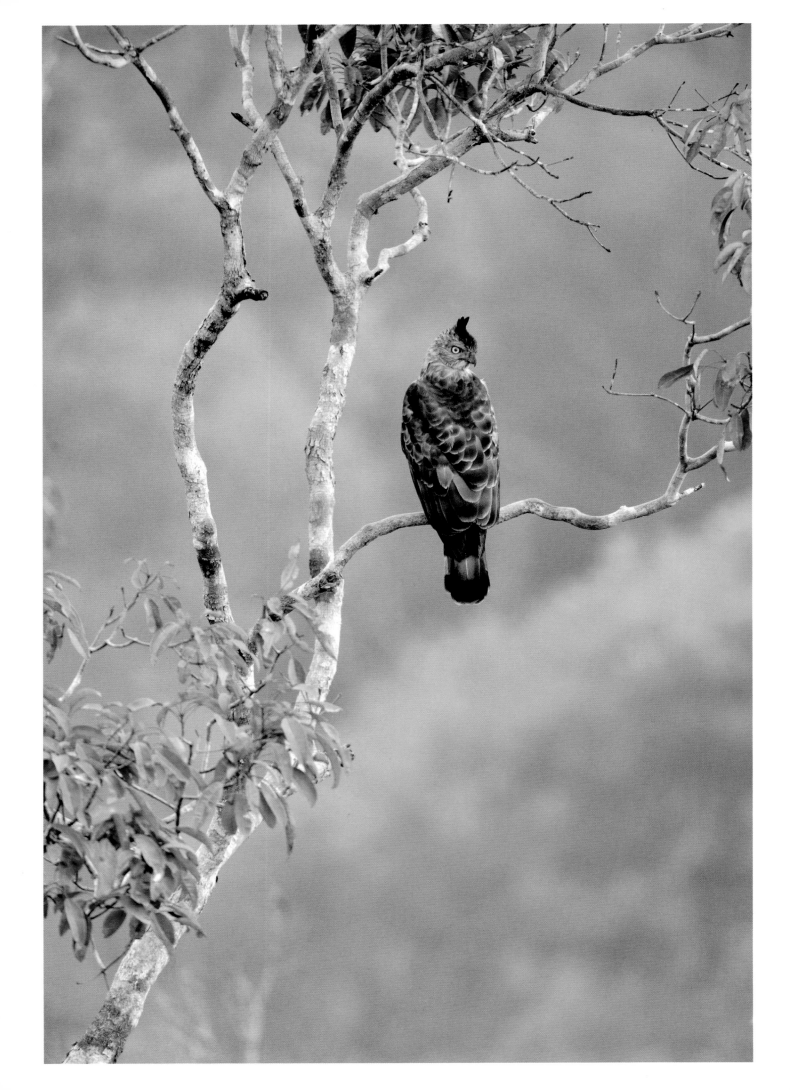

WALLACE'S HAWK-EAGLE

NISAETUS NANUS

APPEARANCE
Small; rufous head topped with short, black, white-tipped crest; upperparts mid-brown; underparts creamy buff, with fine black streaking on breast and stronger black barring on belly, flanks, and pants; throat white, outlined with dark malar stripes; tail gray-brown with three dark bands; underwings buff to white, barred in black; eyes and feet yellow; cere black-gray; immatures uniform buff-brown—

almost identical to immature Blyth's Hawk-eagle.

SIZE
length 18 in. (46 cm)
weight 1.1–1.3 lb (500–610 g)
wingspan 3 ft 1 in. –3 ft 5 in. (95–105 cm)

DISTRIBUTION
Southern Myanmar, southern Thailand, and the Malay Peninsula; Borneo; Sumatra.

STATUS
Vulnerable

THIS DIMINUTIVE EAGLE TAKES its name from British naturalist and explorer Alfred Russel Wallace (1823–1913). Known as the father of biogeography, Wallace played a pioneering role in the development of evolutionary theory and proved an inspiration to Darwin, who was formulating similar ideas at the same time in another part of the world. The eagle—one of ten very similar species that evolved from a single ancestor to spread across the islands of southeast Asia—is eloquent evidence that the great man was spot on.

Among the smallest of the world's eagles, Wallace's Hawk-eagle has a largely rufous head, topped with a short black white-tipped crest, and a white throat outlined with dark malar stripes. The upperparts are mid-brown and the underparts creamy buff, marked with fine black streaking on the breast and stronger black barring on the belly, flanks, and pants. The tail has three dark bands and the buffish underwings are barred in black. The eyes and feet are yellow and the cere black-gray. Immatures are almost identical to those of the slightly larger and more widespread Blyth's Hawk-eagle (p. 136), with which

this species shares much of its range. Like all Asiatic hawk-eagles, Wallace's Hawk-eagle once sat alongside New World hawk-eagles in the genus *Spizaetus* but has since been moved to the genus *Nisaetus*. An inhabitant of tropical or subtropical forest, it is closely related to Blyth's Hawk-eagle but, where the two species occur together, prefers lower elevations. Two subspecies are recognized: the nominate race *N. n. nanus* is found in southern Myanmar, Thailand, the Malay Peninsula, Borneo (Kalimantan, Brunei, Sarawak, and Sabah), and Sumatra; a separate race, *N. n. stresemanni*, is found only on Nias Island, off western Sumatra.

The biology of this little-known raptor is thought to be broadly similar to that of other *Nisaetus* hawk-eagles. It is known to still-hunt from a perch, taking birds, bats, frogs, lizards, and other smallish prey. Observation of nesting pairs suggests that it generally breeds between November and February, nesting high in the tree canopy, and that adults continue to add small sticks to the nest until their chick fledges. One chick is thought to be the norm; a larger clutch has never been recorded. Incubation and fledging times are likely to be similar to those of Blyth's Hawk-eagle.

Wallace's Hawk-eagle is broadly distributed across southeast Asia, but populations are thought to be declining rapidly. The problem lies in habitat destruction, with this region having lost vast tracts of lowland rain forest to logging and plantations, notably of palm oil and rubber. Forest fires have exacerbated this process. In Thailand, where virtually all lowland forest has disappeared, this species may be close to extinction. BirdLife International estimates the total population as 3,500 to 15,000. Research into status and distribution, especially relative to that of Blyth's Hawk-eagle, is ongoing.

OPPOSITE One of the smallest eagles, Wallace's Hawk-eagle weighs no more than a large pigeon.

FLORES HAWK-EAGLE

NISAETUS FLORIS

APPEARANCE
Medium-sized; upperparts brown with six dark bars across tail and white patch visible on upperwings in flight; underparts white; head white, with short crest and brown streaking on crown; underwings white, barred lightly across the flight feathers; immatures similar to adult.

SIZE
length 30–31 in. (75–79 cm)

weight no available data
wingspan no available data

DISTRIBUTION
Endemic to Indonesia; confined to East Nusa Tenggara province, on the islands of Flores, Lombok, Sunbawa, Satonda, Rinca, and Alor; also reported from Komodo and Paloe.

STATUS
Critically Endangered

THIS MEDIUM-SIZED eagle has the dubious honor of being perhaps the rarest eagle in the world. Fewer than 100 breeding pairs are thought to remain on the small Indonesian islands to which it is confined, and with its forest habitat continuing to shrink year by year, its future hangs in the balance.

Flores was named by the Portuguese—who first set foot there in 1511—for the floral beauty of the flame trees that grew along its shores. One of more than 13,000 islands that make up Indonesia, it today falls within the province of East Nusa Tenggara. The Flores Hawk-eagle is one of many endemic species found on the island and its satellite islands; others include the Komodo dragon. Its evolution here is a reflection of the region's great biodiversity but its rarity, sadly, attests to great environmental destruction.

Today, the Flores Hawk-eagle is effectively confined to six islands. In addition to Flores, it breeds on neighboring Lombok, Sunbawa, Satonda, and Rinca, and has recently been discovered on Alor. There have also been reports of sightings from Komodo and Paloe—these birds perhaps having crossed the narrow straits between islands while dispersing from their natal range. Wherever it occurs, the species inhabits dense forest, from the lowlands to heights of 5,200 feet (1,600 m). It may be sighted over cultivated areas, but only where intact forest remains close by.

This medium-sized eagle is easily identified, should you be lucky enough to spot one. One of the largest of the *Nisaetus* hawk-eagles, it is paler than other species, with white underparts and a striking white head—streaked on the crown in brown—resembling an immature Changeable Hawk-eagle (p. 132). The upperparts are brown, with six bars across the tail and a white patch visible on the upperwing in flight. The white underwings are barred lightly across the flight feathers and the head has a slight crest.

Very little is known about the biology of this raptor. It probably takes a variety of birds, lizards, snakes, and small mammals, still-hunting from a forest perch in a similar way to other *Nisaetus* hawk-eagles. Display flights and mating have been observed on Flores in June and July, but the bird's eggs and nest have never been described.

Today, BirdLife International estimates the total population at just 100 to 240 individuals, making it Critically Endangered. With its precious forests giving way rapidly to logging and plantations, and an estimated territorial requirement of 15 square miles (40 km²) for each breeding pair, the suitable habitat within its range is thought to hold no more than 100 pairs. Other threats include persecution—at least one bird has recently been shot on Alor for alleged predation of domestic chickens—and capture for the caged bird trade, which remains rife across Indonesia. Conservationists are now engaged in a program of research, local education, and forest protection in a last-ditch effort to save the species.

OPPOSITE The white head of the Flores Hawk-eagle instantly distinguishes it from the adults of other *Nisaetus* species.

CRESTED SERPENT-EAGLE

SPILORNIS CHEELA

APPEARANCE
Medium-sized and stocky, with short tail and big head; mid- to dark brown, tinged rufous/cinnamon below; white and ocher spotting on lower belly, wing coverts, and shoulders; dark mane on nape expands into ruff; bare yellow face, eyes, and cere; thick, scaled bare legs; glides with broad wings held in shallow "V"; from below, shows pale band through black flight feathers and across center of tail; immatures have white head and underparts.

SIZE
*length 21 ½ – 30 in. (55 – 76 cm)
weight 1 – 4 lb (0.45 – 1.8 kg)
wingspan 3 ft 6 in. – 5 ft 6 in. (109 – 169 cm)*

DISTRIBUTION
South and southeast Asia; including the Indian subcontinent, Himalayan region, Sri Lanka, southern China, Malay Peninsula, Greater Sundas, Japan, and parts of the Philippines.

STATUS
Least Concern

IT'S UNFORTUNATE FOR SNAKES that they have no hearing. If they did, the piercing, three-note call of this eagle would send them slithering immediately for cover. As it is, they have no idea that their nemesis perches on a branch above them. One glimpse of a gleaming coil will bring it swooping down.

The Crested Serpent-eagle is a stocky, medium-sized species widespread across southern and eastern Asia. Like Africa's *Circaetus* snake-eagles, it has a distinctive short-tailed and big-headed profile. A closer view shows brown plumage, tinged cinnamon on the underparts and spangled with white and ocher, on the lower belly and across the wing coverts and shoulders. A mane of long dark feathers forms a hood on the nape and, in alarm, can be erected into a ruff, framing a face that is bare and, like the eyes and cere, bright yellow. The powerful, bare legs are thickly scaled as protection against the bites of prey. In gliding flight, the broad wings are held in a shallow "V" and, from below, show a diagnostic pale band. Immatures have a largely white head and underparts.

This species ranges from the Indian subcontinent across southeast Asia as far north as Japan, taking in the Himalayan region, India and Sri Lanka, southern China, the Malay Peninsula, the Greater Sundas, and the Philippines. It frequents many forest types, from rain forest to deciduous forest, but also savanna, mangroves, and tidal creeks. Across much of its range, it remains below 4,920 feet (1,500 m). This is the commonest species in the *Spilornis* genus. All were formerly grouped with Africa's *Circaetus* snake-eagles, which they resemble in many ways, and today the two genera make up the family *Circaetinae*. Its wide range has produced much geographical variation in size and plumage, with scientists recognizing up to twenty-one different subspecies. Several forms once regarded as subspecies have since been assigned species status, and are treated in this book as separate species.

The Crested Serpent-eagle is a sit-and-wait predator. It spends the bulk of its time—up to 98 percent, according to one Taiwan study—perched inside the canopy scrutinizing the ground and dropping on any prey that appears. As well as snakes, it may target lizards, frogs, birds, small mammals, and even, in wetland areas, eels and crabs. It may sometimes land to pursue prey on the ground.

A pair establishes its territory during late winter, calling loudly and performing tumbling display flights. They build a platform nest in a tall tree, often near water and sometimes isolated from surrounding forest. Studies suggest that in India pairs generally refurbish an old nest each season, but in Penang they tend to build a new one. Either way, the nest measures 19 to 24 inches (50–60 cm) across and is lined with leaves. The female generally lays one egg; if two are laid, only one survives. Incubation lasts thirty-five days, performed by the female alone, and the single chick fledges around two months later. The cinereous tit often nests in close association with this raptor, whose aggressive behavior is thought to offer it protection against other predators, such as crows.

The Crested Serpent-eagle has lived to fifty years in captivity. With its wide range and its tolerance of some habitat disturbance, it is not currently threatened and is classed by BirdLife International as Least Concern. Nonetheless, several island subspecies have been reduced by habitat loss and persecution to very low numbers.

OPPOSITE A Crested Serpent-eagle spreads its wings to bathe in the first rays of the early morning sun.

LEFT A young Crested Serpent-eagle, newly fledged, begs for food from its parent.

RAPTORS OF THE RAIN FOREST

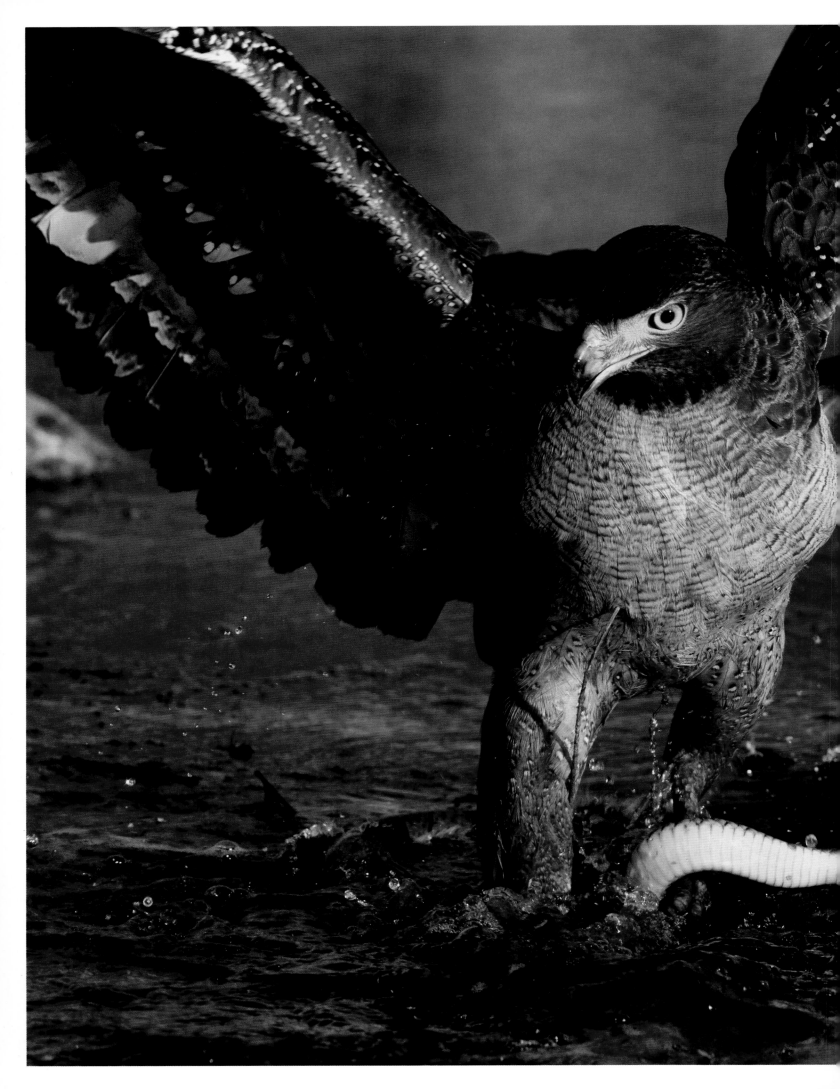

LEFT A Crested Serpent-eagle lives up to its name by capturing a snake in the shallows.

RAPTORS OF THE RAIN FOREST

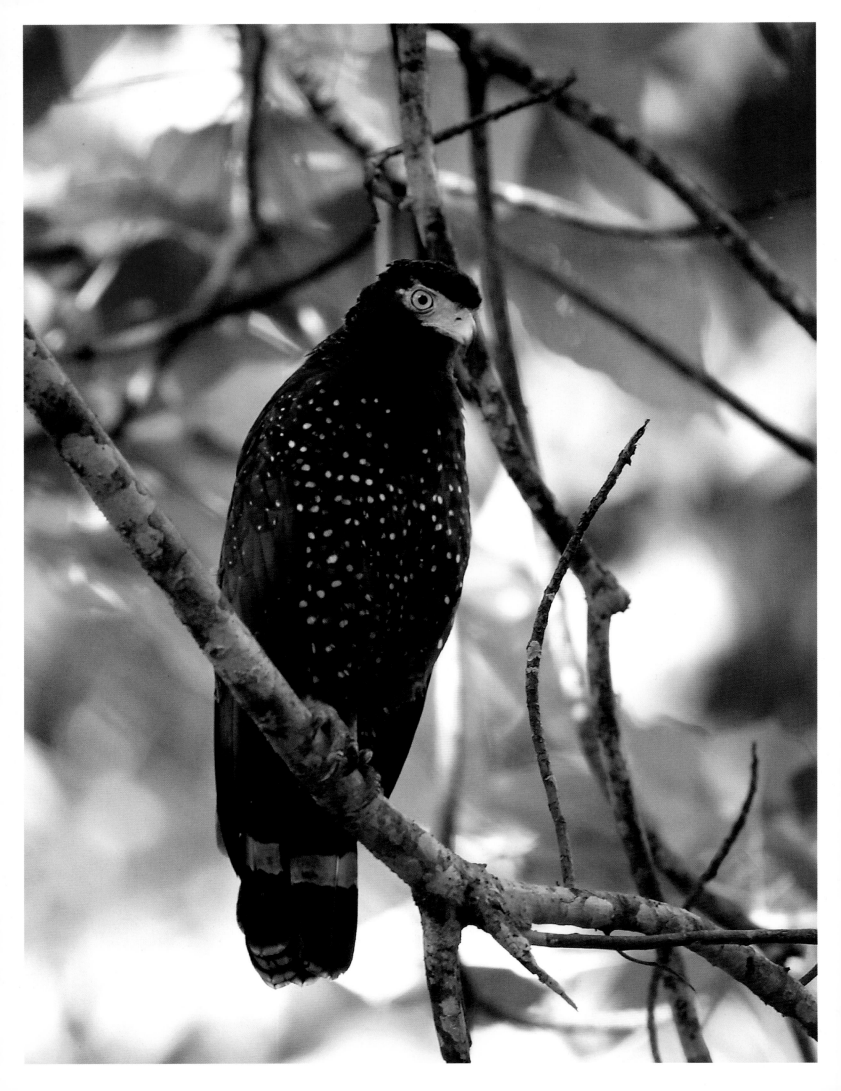

ANDAMAN SERPENT-EAGLE

SPILORNIS ELGINI

APPEARANCE
Small and stocky, with large head and short tail; upperparts and underparts dark brown, spotted with white and ocher on belly, legs, shoulders, and wing coverts; bare face, cere, eyes, and legs yellow; dark crest on nape—may be erected into ruff around the face; wings broad and rounded; broad continuous white band through flight feathers and tail.

SIZE
length 20–23 in. (51–59 cm)
weight 1.7–2.2 lb (0.8–1 kg)
wingspan 3 ft 8 in.–4 ft 5 in. (115–135 cm)

DISTRIBUTION
Endemic to the Andaman Islands (India), from North Andaman Island to Little Andaman Islands.

STATUS
Vulnerable

THE ANDAMAN ISLANDS, LOCATED SOUTH of Myanmar in the Bay of Bengal, are among the world's most mysterious and remote outposts. The islands' native peoples long had little contact with the outside world and, despite a sometimes bloody history that encompassed both British colonialism and Japanese military occupation, still preserve a unique culture all their own, complete with ancient animist religions.

Such island seclusion has also proved a fertile ground for the archipelago's wildlife, which includes numerous endemic mammals, reptiles, and birds. This eagle is typical of Andaman species that have evolved their own unique form in isolation from a mainland ancestor. An island version of the Crested Serpent-eagle (p. 192), it was once considered a subspecies but, by virtue of anatomical, molecular, and ecological distinctions, is now recognized as a species in its own right. Its close relative, the Great Nicobar Serpent-eagle (p. 200), evolved in very similar conditions in the Nicobar Islands.

Both these birds were once classified within the *Circaetus* snake-eagles of Africa but now, along with the four other serpent-eagle species, make up the *Spilornis* genus, confined to tropical Asia. The taxonomy of this group is, like the birds themselves, constantly evolving: other island subspecies of the

Crested Serpent-eagle may yet acquire full species status. The Andaman Serpent-eagle is smaller and generally darker than the Crested Serpent-eagle, but shares the same basic shape and coloration, namely a large, crested head and short tail, dark brown plumage spangled with white spots, and a bright yellow face and legs. It also has a bare yellow face and legs, and in flight its underside shows the same broad continuous white band through the flight feathers and tail.

The Andaman Serpent-eagle is widely distributed across the islands, and inhabits forests in the island interiors—venturing to the coast in some areas, where it inhabits mangroves, and also into some degraded forest and agricultural land. The Crested Serpent-eagle, which also occurs on the Andamans, occupies a separate ecological niche, occurring almost entirely in coastal forests.

This eagle, like all *Spilornis* species, is often first located by its persistent call: a clear and rapid "chee-o, chee-o, chee-o." It still-hunts from a perch, taking a variety of rodents, lizards, and snakes, as well as smaller fare such as crabs and prawns. Its breeding cycle remains undescribed but is likely to be similar to that of the Crested Serpent-eagle.

The Andaman Serpent-eagle has a very limited range and, though widespread across the islands, is threatened by the continued exploitation of the forested interiors. BirdLife International classes the species as Vulnerable, with a population estimated at 1,000 to 4,000 individuals. The Andaman and Nicobar Department of Environment and Forests has initiated a program to conserve all endemic bird species, while the Zoological Survey of India is monitoring populations. Meanwhile, further research is needed into many aspects of its conservation, including population size, breeding biology, territory size, and the impacts of hunting.

OPPOSITE The Andaman Serpent-eagle has evolved from the Crested Serpent-eagle to claim its own unique island niche.

GREAT NICOBAR SERPENT-EAGLE

SPILORNIS KLOSSI

APPEARANCE

Small and compact, with short tail and large head; flat black crown with short crest; bare yellow face, eyes, and cere; gray cheeks; unspotted soft cinnamon-buff underparts and darker brown upperparts; belly, flanks, and thighs white; in flight, underwings show a continuous broad white band through the flight feathers and tail; immatures probably paler than adult, with buff head and three pale bands on tail.

SIZE

*length 15–16½ in. (38–42 cm)
weight no available data
wingspan 2 ft 10 in. –3 ft 1 in.
(85–95 cm)*

DISTRIBUTION

Endemic to Great Nicobar, the largest of the Nicobar Islands (India); also on the smaller outlying islands of Pujo Kunji, Little Nicobar, and Menchal.

STATUS

Near Threatened

THIS SMALL, STOCKY EAGLE IS the smallest of the *Spilornis* serpent-eagles and the most restricted in distribution. Once thought to be an island race of the larger Crested Serpent-eagle (p. 192), it was split from this ancestral form on the basis of molecular evidence and given species status—just like the Andaman Serpent-eagle, which occupies the Andaman Islands within the same archipelago.

In shape, the Great Nicobar Serpent-eagle resembles the Crested Serpent-eagle, which occurs elsewhere on the Nicobar Islands, but is smaller and more compact, with a shorter crest to its rather flat black crown. In addition to the yellow face, eyes, and cere characteristic of all *Spilornis* species, it has distinct gray cheeks. The dark brown and cinnamon-buff underparts are more uniform than in other serpent-eagles, with no conspicuous white spotting, and the belly, flanks, and thighs are white. In flight, the underside shows a continuous broad white band through the flight feathers and tail—a diagnostic feature of all serpent-eagles. Immatures are not well described but, like other *Spilornis* species, are probably paler than adults, with a buff head and three pale bands on the tail.

Serpent-eagles were once classified alongside the *Circaetus* snake-eagles of Africa but have since been placed in the exclusively Asian *Spilornis* genus. This species is endemic to the island of Great Nicobar, the largest of the Nicobar Islands—which are, administratively, part of India—and also occurs on the smaller outlying islands of Pujo Kunji, Little Nicobar, and Menchal. It inhabits mixed evergreen forest, generally at canopy level, but may also occur in grassland and regenerating habitats, from sea level to 300 feet (100 m). Adults are probably sedentary. Immatures may wander—although, within the species' limited range, they have little space in which to do so.

The Great Nicobar Serpent-eagle has been very little studied, so our knowledge of its natural history is largely inferred from that of other serpent-eagles. The stomach contents of one individual yielded lizards, rats, a small bird, and one emerald dove, and it is likely that this raptor takes a variety of reptiles, small mammals, and birds. Its breeding cycle remains undescribed but is likely to be similar in duration and behavior to that of the Crested Serpent-eagle.

Similarly, the conservation status of the species is uncertain. Surveys conducted from 2009 to 2011 concluded that the bird was uncommon. The population has not been quantified, but with Great Nicobar Island measuring only 332 square miles (860 km²), and increasing settlement on the islands accelerating habitat loss and degradation, BirdLife International has listed the species as Near Threatened. No specific conservation work is currently underway. Research into its population size and relative abundance in different habitat types would help in planning a way to safeguard its future—as, of course, would securing its rapidly shrinking habitat.

OPPOSITE The Great Nicobar Serpent-eagle species is one of the smallest serpent-eagles, with the fewest markings.

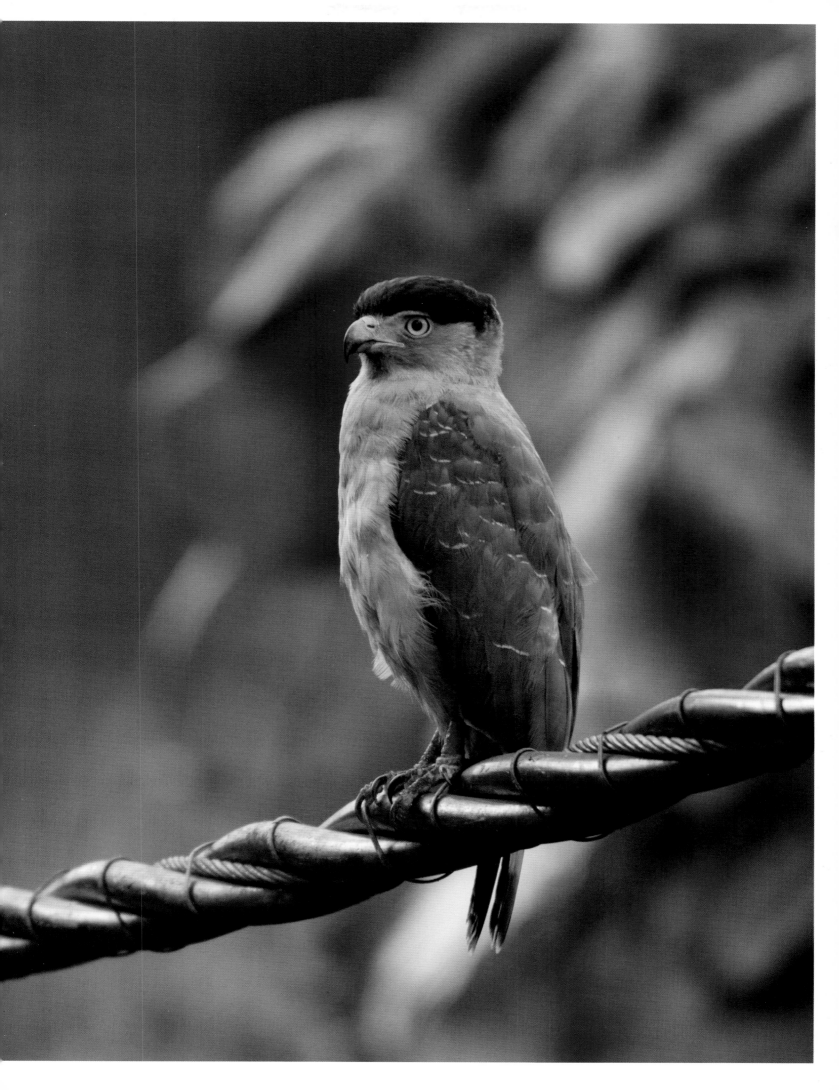

RIGHT A young Great Nicobar Serpent-eagle perches in a tree fern. As in all *Spilornis* species, it is much paler than the adult.

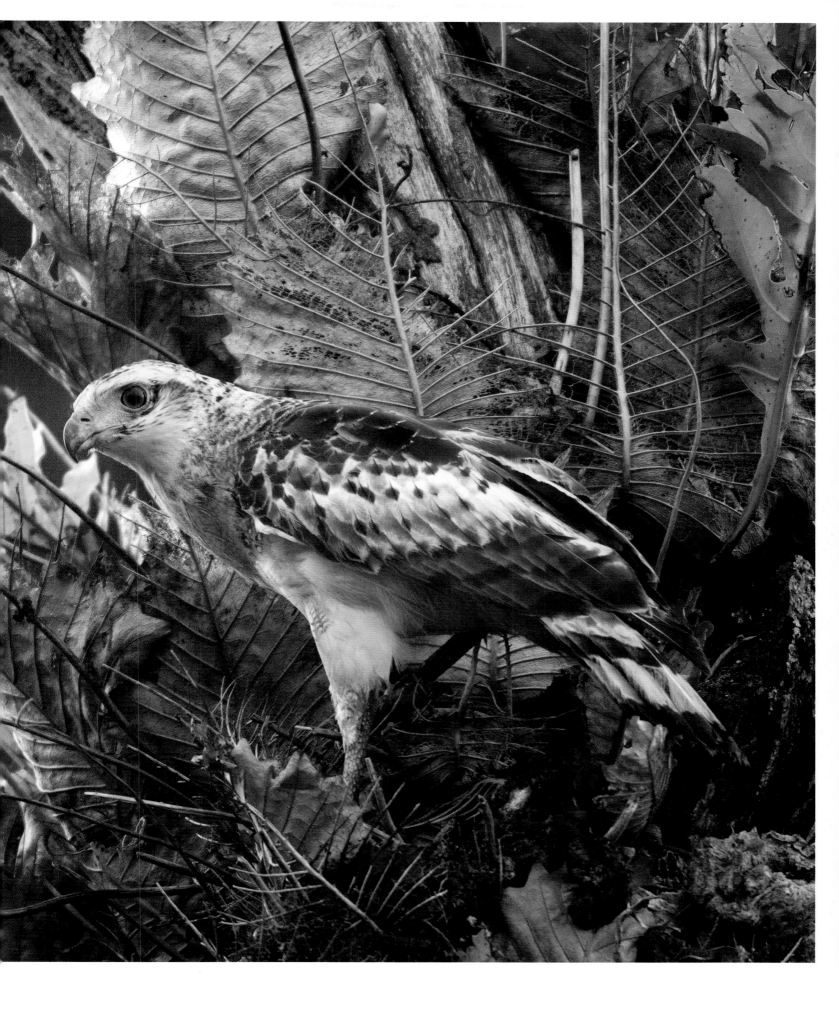

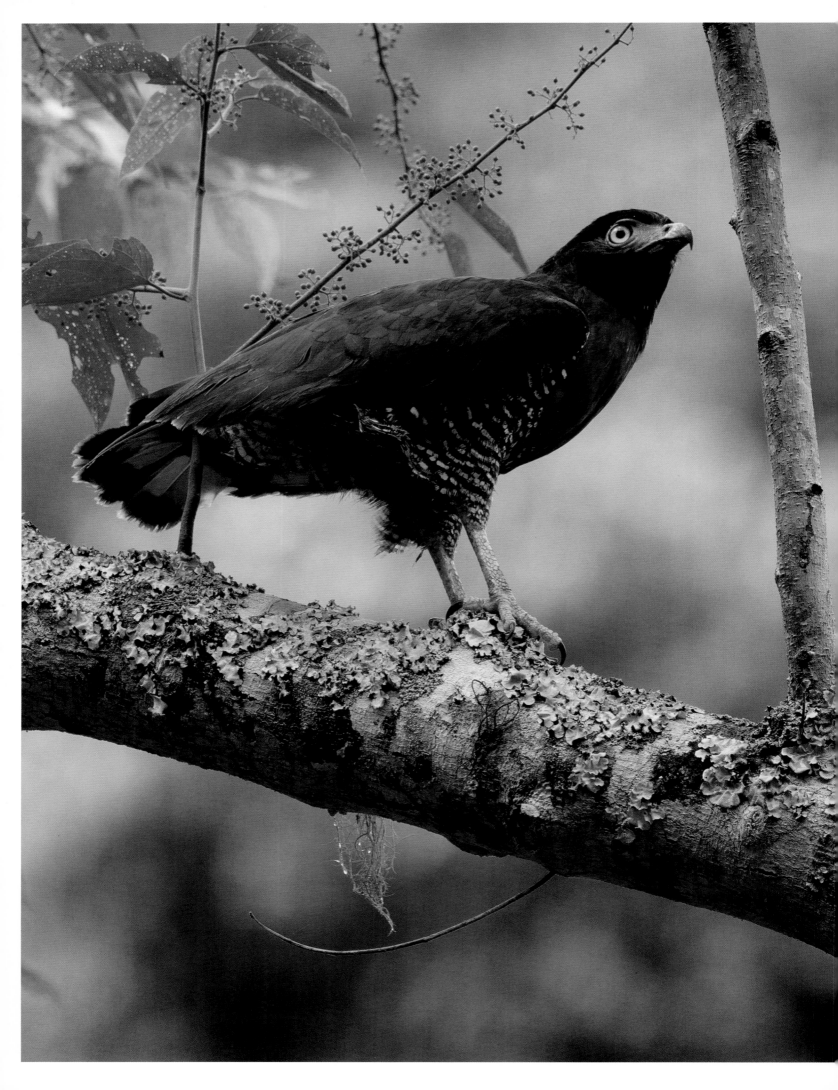

SULAWESI SERPENT-EAGLE

SPILORNIS RUFIPECTUS

APPEARANCE

Medium-sized and compact, with large head and shortish tail; crown and nape rufous-buff with short, bushy crest; bare yellow face, eyes, and cere; cheeks dark gray and throat black; upperparts dark brown; breast rufous; belly and thighs dark brown, strongly spotted and barred in white; tail black with white central band; underwings show broad pale-gray band through black flight feathers; immatures paler below, with creamy head and dark patch behind eye.

SIZE

length 16–21 in. (41–54 cm)
weight no available data
wingspan 3 ft 5 in.–3 ft 11 in. (105–120 cm)

DISTRIBUTION

Endemic to Sulawesi and neighboring Sula archipelago (Indonesia).

STATUS

Least Concern

THE SULAWESI SERPENT-EAGLE, like the Sulawesi Hawk-eagle (p. 176), is one of many endemic bird species found on the forested Indonesian island of Sulawesi and the neighboring Sula archipelago. In common with such close relatives as the Andaman Serpent-eagle (p. 198) and Philippine Serpent-eagle (p. 160), it evolved from the Crested Serpent-eagle (p. 192) of mainland Asia. The isolation of its island home has since allowed it to develop into a unique form—now, with the benefit of molecular research, recognized as a species in its own right.

This is a medium-sized serpent-eagle, sharing the same basic large-headed, short-tailed shape of all those in the *Spilornis* genus. The crown and nape are rufous-buff and topped with a short, bushy crest. The bare yellow face, eyes, and cere contrast with dark gray cheeks and a black throat. The upperparts are dark brown, the breast rufous, and the dark brown belly and thighs strongly spotted and barred in white. An off-white band runs through the center of the tail and continues through the flight feathers—a feature that, when seen from below, is diagnostic of all serpent-eagles. The immature is paler below, with a creamy head and nape, and dark patches behind the eyes that create a masked appearance.

Sulawesi is heavily forested, although much of the native forest has been lost to agriculture and logging. The Sulawesi Serpent-eagle inhabits forest across the island but has also adapted to hunt over forest edges and adjacent grassland or cultivated areas, including rice fields and coconut groves. It occurs at up to 3,300 feet (1,000 m) above sea level, although is more often found at 670 to 2,800 feet (205–850 m). Scientists recognize two subspecies: *S. r. rufipectus* occurs on Sulawesi and surrounding islands; *S. r. sulaensis* is found on the nearby Sula archipelago and can be distinguished by its greater size, paler coloration, and more boldly barred underparts.

This species, like many serpent-eagles, is often first detected by its call—a shrill, repeated "keek" or "kek." It is usually seen flying low above the canopy—occasionally soaring higher—or perching on an exposed branch at the forest edge, sometimes in pairs. It is thought to follow a similar sit-and-wait hunting strategy to the Crested Serpent-eagle, dropping from a perch on to lizards, snakes, rodents, and other small prey on the ground. It is also known to feed around grass fires, swooping on small creatures flushed out by the flames.

Little is known about the breeding cycle of the Sulawesi Serpent-eagle, though it is probably similar to that of the Crested Serpent-eagle. Fledged young have been found in May, which suggests that the breeding season is January to April. This species is widespread and remains common in parts of its range—for example, in Dumoga Bone National Park in northern Sulawesi. It is listed as Least Concern by BirdLife International, with an estimated population of 10,000 mature individuals, though the supporting data is poor and deforestation undoubtedly poses an ongoing threat.

OPPOSITE The Sulawesi Serpent-eagle often perches on an exposed branch overlooking a forest clearing.

CRESTED EAGLE

MORPHNUS GUIANENSIS

APPEARANCE

Large and slender with longish tail; big head with long, black-tipped, single-pointed crest; broad, rounded, and relatively short wings; pale morph (more common) has light brownish-gray head, back, and chest, white belly finely barred in brown, and white underwings with black barring on flight feathers; dark morph has sooty-black breast and upperparts and mottled black underwing coverts; immatures have white head and chest, and marbled-gray back; dark morph immatures are darker.

SIZE

length 28–35 in. (71–89 cm)
weight (male) 2.9–6.6 lb (1.3–3 kg), female thought to be 14 percent heavier
wingspan 55–70 in. (138–176 cm)

DISTRIBUTION

Central and northern South America, from Northern Guatemala south to northern Argentina; strongholds in subtropical Andes and Amazon Basin; also in the Guianas and Atlantic Brazil; many gaps in distribution.

STATUS

Near Threatened

THIS IMPRESSIVE-LOOKING EAGLE IS, in some ways, a smaller version of the better-known Harpy Eagle (p. 164). Similar both in appearance and lifestyle, it would rule Latin America's raptor roost were it not for the presence of its mighty cousin. The two birds overlap in both range and habitat, divvying up the prey animals of the canopy by size. Unfortunately, their rain forest home is subject to some of the planet's worst environmental exploitation, so rarity is something else that these birds share.

The Crested Eagle is one of the largest eagles of the Americas and may stand nearly as tall as the Harpy Eagle—though, being relatively slender, is only about half the weight. It has a long black-tipped crest that, unlike a Harpy Eagle's, reaches only a single point when erect. In flight, it shows a long tail and, like most forest raptors, wings that are broad, rounded, and relatively short—for easier movement among trees.

Two color morphs occur. The more common pale morph has the head, back, and chest light brownish-gray, with a white belly, finely barred in brown. Its underwings show white coverts and black barring on the flight feathers. The less common dark morph has a sooty-black breast and upperparts, and mottled black underwing coverts.

Until 1949, this dark morph was considered an entirely separate species. Immatures resemble immature Harpy Eagles, with a white head and chest and a marbled-gray back; dark morph immatures are darker.

Crested Eagles may perch in the same place for hours, often revealing their presence with a high double whistle. They either still-hunt from a concealed perch or scan for prey while soaring over the treetops, then swoop in to snatch it from the branches. They are known to ambush birds such as trumpeters and guans feeding in fruit trees, and even to snatch Guianan cock-of-the-rocks displaying at their leks. They also target small arboreal mammals, including tamarins, opossums, kinkajous, and immature monkeys, as well as reptiles such as emerald tree boas. In general, they take smaller prey than Harpy Eagles, thus avoiding competition with the larger raptor.

The breeding season for Crested Eagles is March to April, the borderline between the dry and wet seasons across much of the neotropics. A pair builds its huge nest of large sticks typically in the fork of a tall emergent tree with a clear view of the surroundings. The female rears a single chick and is responsible for all nest duties and incubation, which lasts forty to fifty days. After a month, she joins the male to collect food. The youngster fledges after 100 to 110 days but may remain around the nest for another year or more, continuing to receive help from its parents. For this reason, a pair only produces young once every two to three years.

The Crested Eagle remains widespread but has lost much of its former range, and—with a population estimated at no more than 10,000 individuals—is classed by BirdLife International as Near Threatened. Like many rain forest birds of the neotropics, it is threatened by forest clearance. Perceived in some areas as a danger to livestock, it is also targeted by hunters. This species occurs at low densities and in densely forested areas may escape detection. More research is needed to clarify its numbers and conservation status.

OPPOSITE A Crested Eagle chick waits in its nest at the top of a tall cuipo tree.

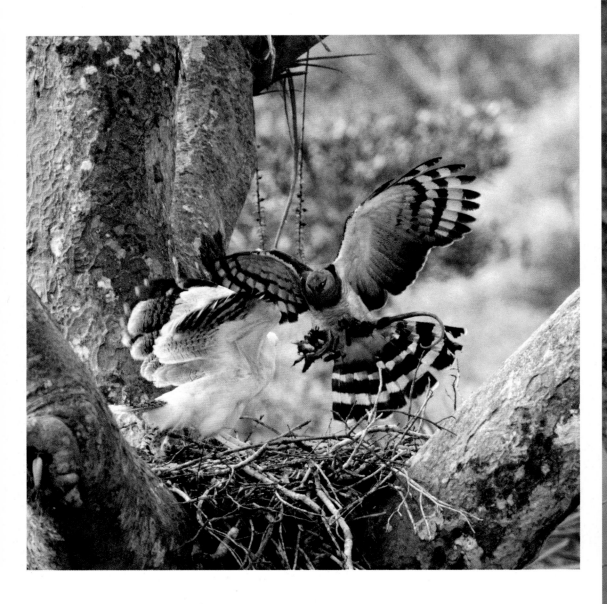

ABOVE AND RIGHT A female Crested Eagle delivers an iguana to its single chick. After the Harpy Eagle, this species is the most powerful raptor of the neotropical rain forest, and takes a wide variety of prey.

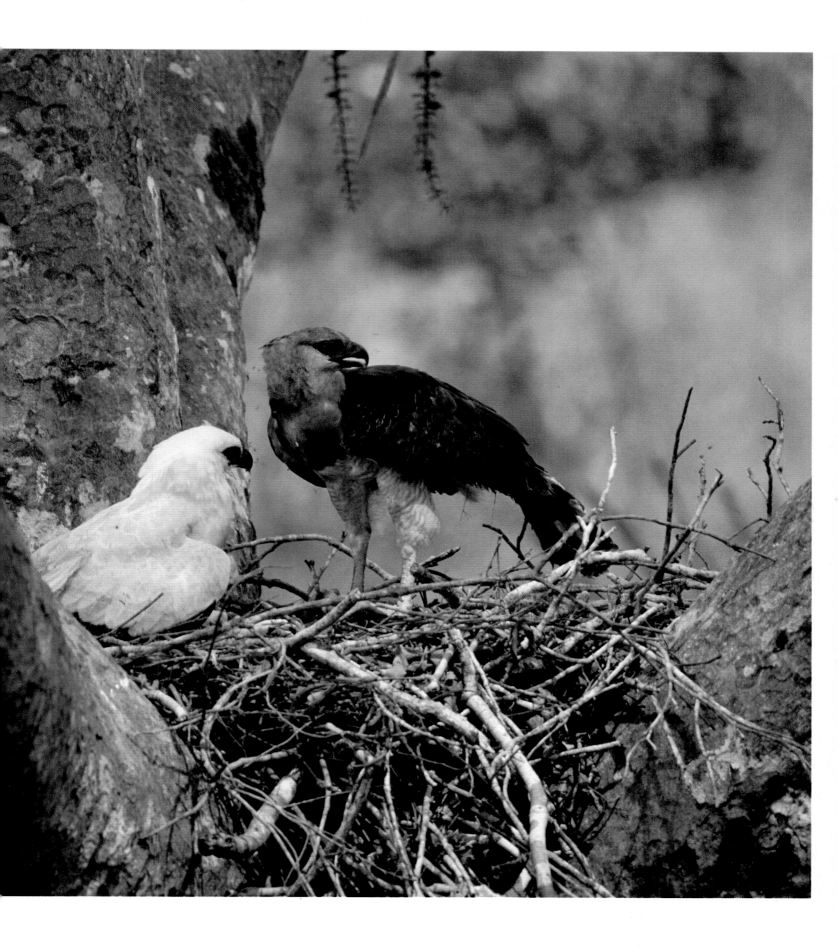

PAPUAN EAGLE

HARPYOPSIS NOVAEGUINEAE

APPEARANCE
Large, with bushy crest, long, rounded tail, large bill, massive talons, and broad, rounded wings; white belly; grayish-brown breast, head, and upperparts; tail and underwings barred; legs unfeathered; eyes orange-brown, contrasting with black cere and bill; immatures paler, with buff underparts.

SIZE
length 29½–35 in. (75–90 cm)
weight 3.5–5.3 lb (1.6–2.4 kg)
wingspan 5 ft 1 in. (157 cm)

DISTRIBUTION
Endemic to New Guinea; found in both Papua New Guinea and Irian Jaya (Indonesia).

STATUS
Vulnerable

DEEP IN A MOUNTAIN RAIN FOREST in the heart of New Guinea, a commotion disturbs the greenery. Shredded bark and torn leaves spiral down from the canopy as a huge flapping bird tears into the foliage. Seconds later, it emerges with a struggling, cat-sized animal—a cuscus, ripped from its daytime hideaway among the epiphytes. With a few brutal blows of its hatchet bill, the bird finishes the job and takes flight, victim clutched in its talons.

The attacker is a Papuan Eagle, the most powerful predator on New Guinea. It is also known as the New Guinea Harpy Eagle, for its resemblance to South America's Harpy Eagle (p. 164), to which it was once thought related, and the Kapul Eagle, taking this name from the local term for the small arboreal marsupials known as kapul, on which it feeds.

Whatever the name, this is a formidable bird. Typical of large forest eagles in general build and appearance, with a crested head, long tail, large bill, massive talons, and broad, rounded wings, it is similar in size to the Crested Eagle (p. 206) of South America. In coloration, it is rather plain, with white underparts and a grayish-brown breast, head, and upperparts. The shortish crest may form a facial ruff that, as in owls, helps direct sound to the ears when it is searching for prey in the forest. The tail and underwings are barred and the legs unfeathered. Immatures are paler, with buff underparts. This eagle is the only member of genus *Harpyopsis* but is closely related to the Harpy Eagle and Crested Eagle, the

three genera forming a clade. The only eagles of equivalent size on New Guinea are the unrelated Gurney's Eagle (p. 156) and White-bellied Sea-eagle (p. 260). It is endemic to the island, found in both Papua and Irian Jaya (Indonesia), but is sparsely distributed, generally sticking to remote highlands, up to heights of 10,500 feet (3,200 m). It requires undisturbed tropical rain forest with a tall canopy.

The Papuan Eagle is thought to have a semi-nocturnal lifestyle, unusual among eagles, and is often detected by its resonant grunting call even after dark. It preys on phalangers, ringtail possums, forest wallabies, and other arboreal marsupials, as well as birds, reptiles, and even small pigs and New Guinea's "singing dogs" (dingo-like wild canines, descended from feral ancestors). As well as hunting in the canopy, where it may tear victims from tree cavities and epiphytes, it sometimes pursues prey on the ground in flapping bounds.

Much of what is known about the Papuan Eagle's breeding habits comes from observations of a single nest. These revealed that it breeds between April and August, building a big structure of sticks and epiphytes in the crown of a tall tree, and produces a single chick. The incubation and fledging periods are unknown but, like other large forest eagles, this species probably breeds less than annually due to the long dependency of the immature on its parents.

Papuan Eagles have lived more than thirty years in captivity. In the wild, however, this species is threatened by the ongoing loss of its forest habitat. It has also long been the target of hunters for its tail and flight feathers, still used in traditional ceremonies. Densities are naturally very low—studies in Crater Mountain Wildlife Management Area suggest each pair requires at least 58 square miles (150 km²). BirdLife International estimates an overall population in the 2,500 to 9,999 bracket and lists the species as Vulnerable. Conservationists require more data on the bird's territory size, especially in relation to prey abundance, and aim to promote the bird as a flagship species in ecotourism.

OPPOSITE Peering through the foliage into New Guinea's forest canopy reveals a rare glimpse of a Papuan Eagle.

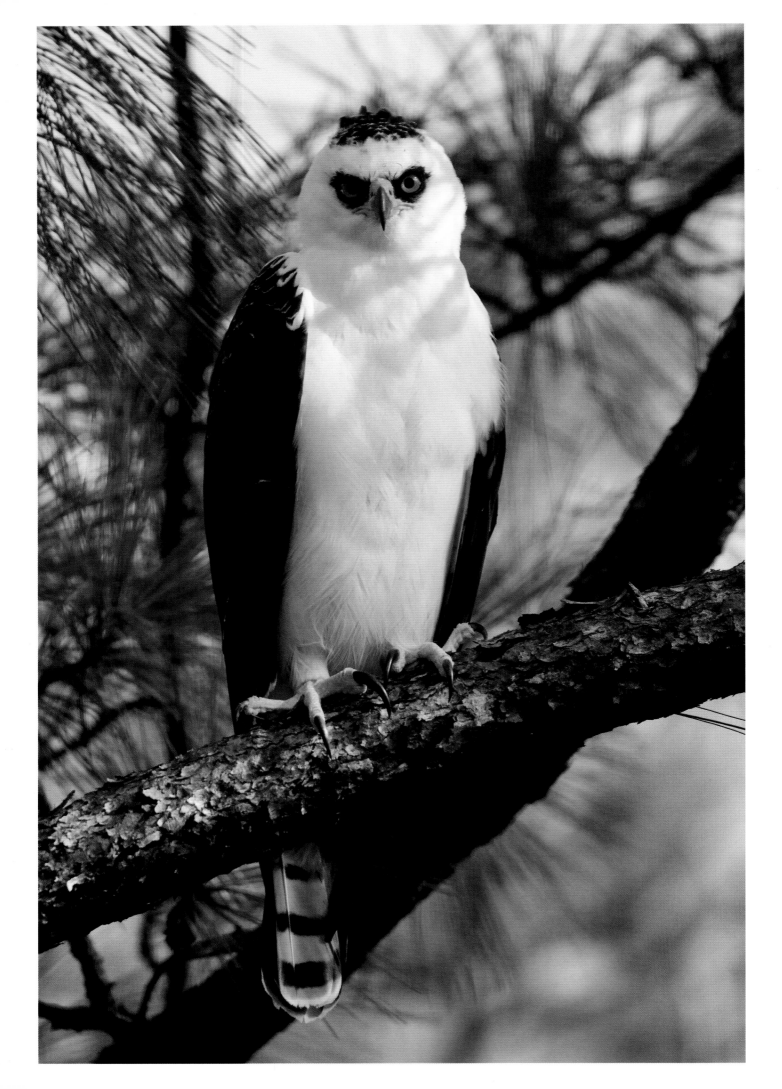

BLACK-AND-WHITE HAWK-EAGLE

SPIZAETUS MELANOLEUCUS

APPEARANCE
Small, lightly built; white head and underparts; black/sooty-brown upperparts, black crown patch and short bushy crest; black markings between the yellow eyes and cere create a panda-eye effect; in flight, shows black barring on broad white flight feathers and four black bars across tail. Immatures have a browner back, with pale edges to the upper wing coverts, and more resemble an immature Ornate Hawk-eagle.

SIZE
length 20–24 in. (50–60 cm)
weight 1.6–1.9 lb (750–850 g)
wingspan 3 ft 10 in. (117 cm)

DISTRIBUTION
Central America, from southern Mexico to Panama; South America, from Colombia to northern Argentina; absent from large areas, including El Salvador, much of Nicaragua, eastern Brazil, and the western Amazon Basin.

STATUS
Least Concern

SOMETIMES THE NAME SAYS IT ALL. The smart, two-tone plumage of the Black-and-white Hawk-eagle is unlike that of any other. Indeed, the only neotropical rain forest raptor decked out in similar livery is the black-faced hawk, which is only half its size.

This small, lightly built eagle is white below and black (or sooty-brown) above. A neat black crown sits on its white head, which bears a short bushy crest, and black markings between the yellow eyes and cere create a slight panda-eye effect. In flight, the white underside is marked with black barring on the flight feathers and four black bars across the tail. Immatures are browner above and resemble an immature Ornate Hawk-eagle (p. 178), a very close relative of this species.

Black-and-white Hawk-eagles range widely across the neotropics, from Oaxaca to Veracruz in southern Mexico, and south through Central America into northern South America, where their distribution extends down the Pacific slope of the Andes, around the Caribbean coast to the Guianas, and down Atlantic Brazil to northern Argentina. They are nowhere common, and are absent from much of El Salvador and Nicaragua, eastern Brazil, and the western Amazon Basin. The species has a fairly wide habitat tolerance but is essentially a bird of lowland tropical and subtropical forests.

The taxonomy of this eagle has undergone extensive revision. Today, it is classified as one of the four species of *Spizaetus* hawk-eagles, all of which were once grouped with the *Nisaetus* hawk-eagles. It had previously been classed as the single species in the genus *Spizaetus*, until research established its close affinity to the Ornate Hawk-eagle. To further complicate matters, its new scientific name *Spizaetus melanoleucus* was once used for the Black-chested Buzzard-eagle (now *Geranoaetus melanoleucus*). The Black-and-white Hawk-eagle is a fast, agile flier that soars above the canopy then swoops down to snatch prey. It often hunts along ridges and forest edges. Its diet comprises a variety of birds, as well as small mammals, reptiles, and toads.

The main breeding season appears to before the onset of the rains, which in Central America means March to June. It nests high in the canopy, usually building its stick nest near the top of a tall emergent tree—often on a ridge, from where it has a good view of the surroundings. Little is known about the breeding cycle but, inferring from other *Spizaetus* species, the female probably lays a single egg, which she incubates alone for forty to forty-eight days while the male provides food. Fledging may last sixty-five to ninety-five days and the youngster probably depends on its parents for several more months, meaning that a pair may breed only once every two to three years.

There is little conservation data. Once classified as Near Threatened, it is now considered Least Concern, as the population stands at an estimated 10,000 to 100,000, with a wide distribution and no significant evidence of decline.

OPPOSITE The Black-and-white Hawk-eagle's bold pied patterning is unlike that of any other eagle.

OVERLEAF A Black-and-white Hawk-eagle poses on a cecropia branch with a parrot it has captured.

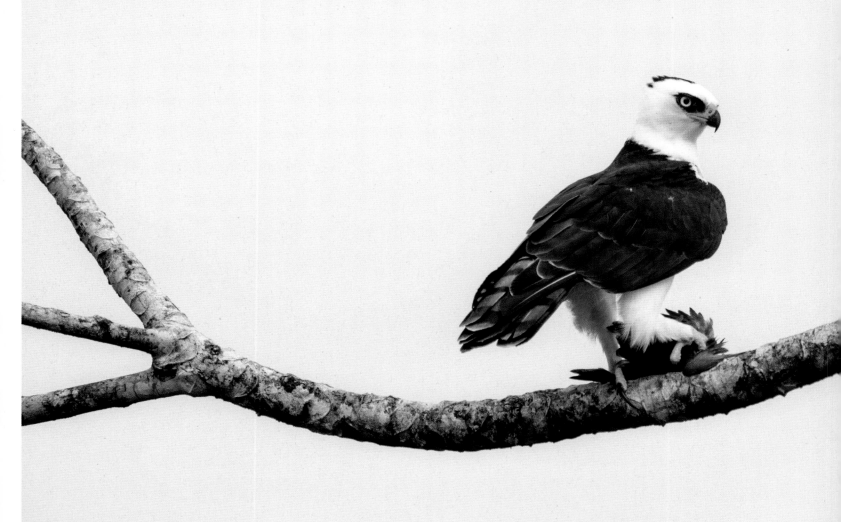

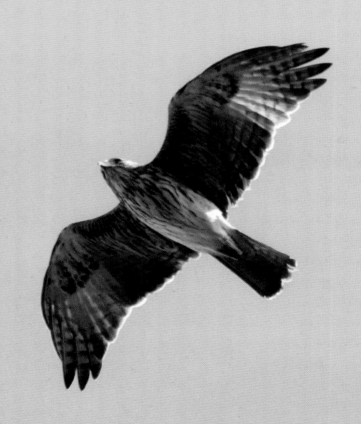

PYGMY EAGLE

HIERAAETUS WEISKEI

APPEARANCE
Small and compact, with thickly feathered legs; upperparts dark brown and underparts off-white with fine dark streaking on head and throat; differs from very similar Little Eagle in less pronounced (or absent) malar stripe, paler crown with more even streaking, more prominent breast streaking, no pale collar, and seven bars across the tail; in flight, shows square tail and pale markings across back and wing coverts.

SIZE
length 15–19 in. (38–48 cm)
weight 1 lb (483 g)
wingspan 3 ft 6 in.–4 ft 1 in. (112–126 cm)

DISTRIBUTION
New Guinea, Papua, and Irian Jaya (Indonesia); also Maluku archipelago.

STATUS
Least Concern

THIS TINY EAGLE WEIGHS NO MORE than a large pigeon, making it on average probably the smallest of the world's eagles. Once thought to be a New Guinea race of Australia's Little Eagle (p. 104), it achieved full species status in 2009 when taxonomists separated it from its Antipodean cousin on the basis of molecular evidence and plumage difference. Today, it is thought more closely related to the Booted Eagle (p. 122) of Africa and Eurasia—and, along with its two diminutive cousins, is probably the closest living relative of the extinct Haast's Eagle of New Zealand (p. 13), the largest eagle ever known.

Also known as the New Guinea Hawk-eagle, the Pygmy Eagle closely resembles the Little Eagle in both shape and plumage, but is even smaller. Like the Little Eagle, it is predominantly dark brown above and sandy below, but differs in some fine plumage details, including a less pronounced (or even absent) malar stripe, a more evenly streaked crown on a paler base, more prominent and extensive breast streaking, an absence of any pale collar, and seven (not six) bars across the tail. A dark morph also occurs. The only measurements available come from a male, and the females are thought to weigh up to twice as much.

The Pygmy Eagle is widespread across New Guinea, though is nowhere common, occurring on both the Papua and Irian Jaya (Indonesian) sides of the island, as well as across the Maluku archipelago, which lies to the west. It frequents tropical and subtropical forest, including riparian and montane forest, occurring from sea level up to 6,400 feet (1,950 m). It may also hunt over savanna and sometimes patrols along the forest edges.

There is little data on the biology of this species, which is presumed to be very similar in its lifestyle to the Little Eagle. Like the latter, it probably hunts both in flight and from a perch, snatching prey from the ground or among the branches. It is likely to feed on a variety of small mammals and small-to-medium-sized birds, and has been observed attacking a group of gray crows.

No more is known about this species' breeding cycle than its hunting behavior. One bird has been observed during March collecting sticks and moss, and nest construction is thought to be similar to that seen in the Little Eagle, with a smallish stick structure placed in a tree fork, but sited in more closed forest than the open terrain favored by its Australian cousin. Inferring from the Little Eagle, a female probably lays one to two eggs, with incubation lasting around thirty-seven days and the chicks fledging after eight weeks.

The Pygmy Eagle is listed by BirdLife International as Least Concern, due to its wide distribution. However, there are no reliable population figures, and the species is likely to be under threat in many areas from the ongoing deforestation that affects much of New Guinea.

OPPOSITE The Pygmy Eagle is a close relative of Australia's Little Eagle but has a more extensively streaked breast, visible here in flight.

BLACK EAGLE

ICTINAETUS MALAIENSIS

APPEARANCE
Medium to large; entirely sooty-black, with faint barring on tail, paler upper tail coverts and paler patches at base of primaries; yellow cere and legs; distinctive flight silhouette shows long wings with narrow base and long, splayed, primary "fingers," invariably held in a shallow "V"; when perched, shows fully feathered tarsi and wing tips that reach to or beyond tail tip; immatures paler, with buff head, underparts, and underwing coverts.

SIZE
length 27½–31½ in. (70–80 cm)
weight 2–2.6 lb (1–1.6 kg)
wingspan 5 ft 4 in.–5 ft 9 in. (164–178 cm)

DISTRIBUTION
Southern and southeast Asia: I. m. malaiensis from Myanmar to southern China, Taiwan, and Malay Peninsula; I. m. perniger from Nepal through Himalayan foothills; also in Eastern and Western Ghats, Aravalli range, and Sri Lanka.

STATUS
Least Concern

THE LEPCHA PEOPLE OF India's Darjeeling district know the Black Eagle as "the bird that never sits down." Indeed, this bird always seems airborne, using its long wings to float slowly over the canopy, with long, splayed primary "fingers" helping it to maneuver without stalling. And there is a good reason for this low-velocity flight: Black Eagles are specialist nest raiders. Once the prize is located, they use their long, relatively uncurved claws to extract the eggs and nestlings. Sometimes they will carry off an entire nest in order to devour its contents at leisure.

This medium to large Asiatic eagle lives up to its name, being entirely sooty-black in plumage, with the exception of some paler barring on the tail, paler upper tail coverts, and paler patches at the base of the primaries. The yellow cere and legs are striking. Its flight silhouette is distinctive, with its long wings pinched at the base and splayed at the primaries, held up in a telltale shallow "V." When perched, it reveals fully feathered tarsi and wing tips that reach, or even project slightly

beyond, the tail tip. The immature is paler, with a buff head, underparts, and underwing coverts.

The Black Eagle is the only member of its genus, and is not related to Verreaux's Eagle (p. 28) of Africa, which is often known by the same common name. There are two races: the nominate race, *I. m. malaiensis*, occurs in southeast Asia, from Myanmar to southern China, Taiwan, and the Malay Peninsula; the Indian race, *I. m. perniger*, occurs from Nepal west through the Himalayan foothills into Himachal Pradesh and Jammu and Kashmir; also reaching the Eastern and Western Ghats, the Aravalli Range in northwest India, and Sri Lanka. Across its range, this is a species of hill forests, absent from areas with less than 50 percent forest cover.

As well as eggs and nestlings, the Black Eagle takes a variety of other prey, including mammals such as rats, bats, and giant squirrels. It has even been known to capture young bonnet macaques, and monkeys of all species are quick to sound the alarm when this raptor's distinctive silhouette appears overhead. Pairs often forage together.

The breeding season varies between regions; in south India it lasts from November to January. A pair performs impressive courtship displays, involving undulating sky dances and steep dives with folded wings. Together, they build a platform nest about 3 to 4 feet (1–1.2 m) wide, typically in a tall tree overlooking a steep valley. The same site is often reused for many years. The female lays one to two eggs, which she incubates for thirty-five to forty days. Fledging takes sixty days, with the parents bringing fresh leaves daily to line the nest. With a population estimated as at least 10,000 individuals, BirdLife International lists this species as Least Concern. Nonetheless, widespread deforestation is likely to pose a serious threat to populations in many regions.

OPPOSITE The Black Eagle's long wings, visible when perched or in flight, enable it to glide slowly over the canopy in search of nests.

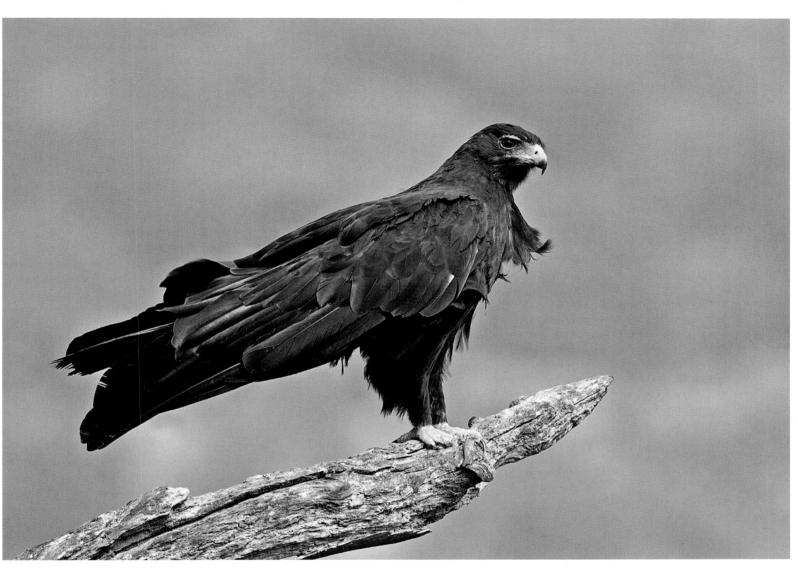
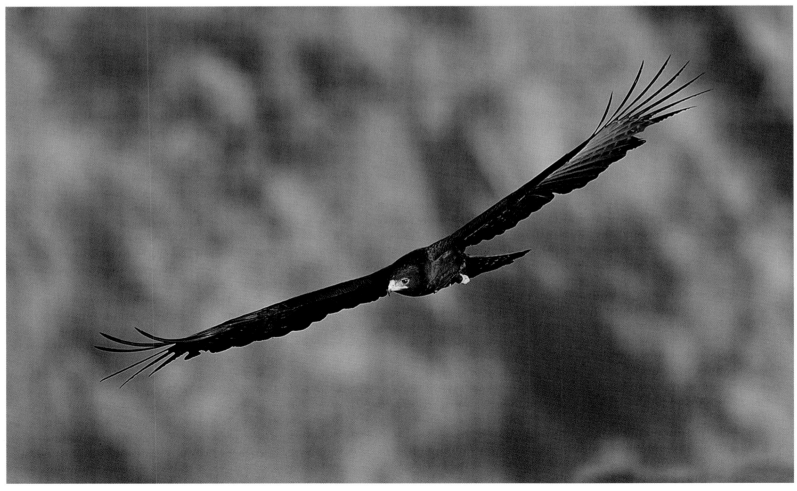

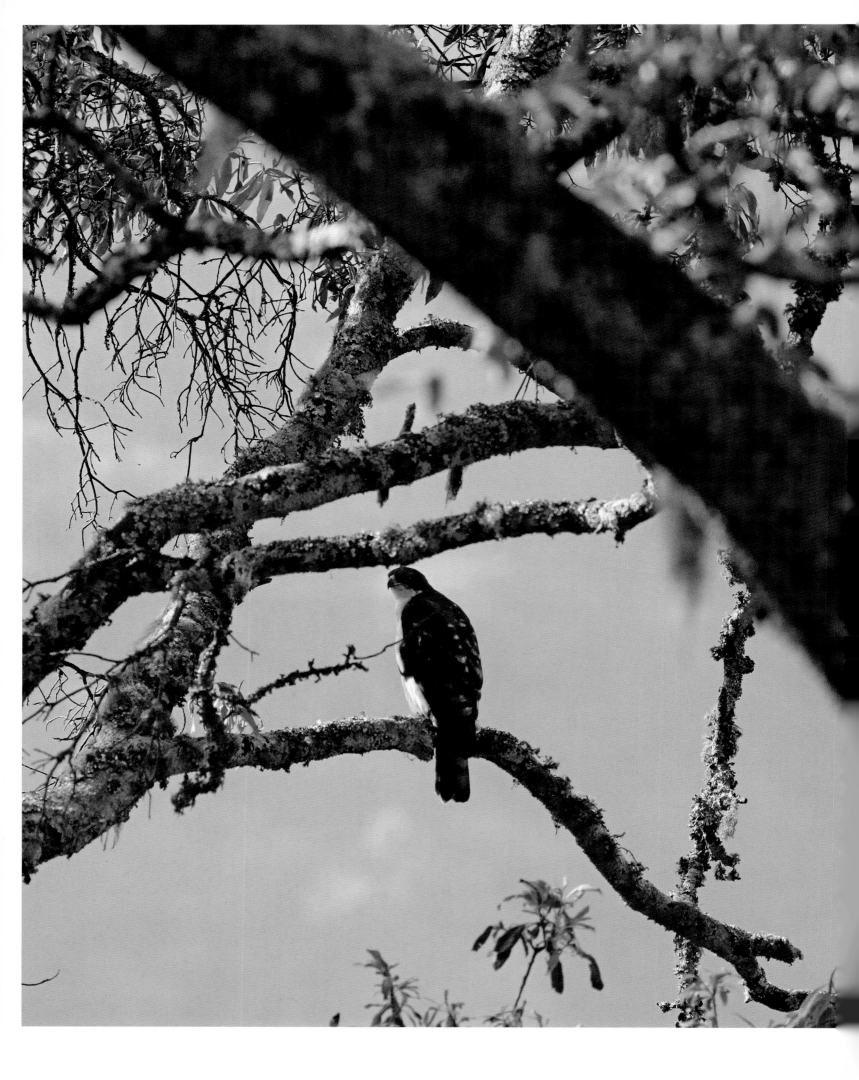

CASSIN'S HAWK-EAGLE

AQUILA AFRICANA

APPEARANCE
Small to medium-sized, slender; upperparts dark brown; underparts white, blotched black on flanks; tail barred; eyes yellow-brown; bill and cere yellowish; immatures have a brown head, dark-brown wings with white-tipped secondaries, rufous breast, and dense spotting on belly and flanks; in flight, adults show contrasting pattern of dark underwing coverts and pale flight feathers, with black trailing
edge, immatures' underwing coverts are pale.

SIZE
length 20–24 in. (50–61 cm)
weight 2–2.6 lb (0.9–1.2 kg)
wingspan 4 ft (120 cm)

DISTRIBUTION
West and Central Africa: from Sierra Leone east to Western Uganda, and south through the Congo Basin to northern Angola.

STATUS
Least Concern

THIS SELDOM-SEEN FOREST-DWELLING eagle resembles a smaller version of the African Hawk-eagle (p. 112) and the two are closely related. Unlike its larger, savanna-dwelling cousin, however, little is known about this raptor, which lives in some of Africa's most inaccessible forests.

Like the African Hawk-eagle, this species is dark brown above and white below, but its underparts are blotched with black on the flanks rather than, as in its savanna relative, streaked on the breast. Its eyes are yellow-brown and its bill and cere yellowish. Immatures have a brown head, dark-brown wings with white-tipped secondaries, a rufous breast, and dense spotting on the belly and flanks. In flight, the adult shows a contrasting pattern of dark underwing coverts and pale flight feathers with a black trailing edge, like that of the African Hawk-eagle; the immature's underwing coverts are pale.

Cassin's Hawk-eagle is restricted to the rain forest belt of West and Central Africa, occurring from Sierra Leone east to Western Uganda, and south through the Congo Basin to northern Angola. It prefers primary forest, ranging to altitudes of 5,500 feet (2,300 m).

This species gets its common name from U.S. ornithologist John Cassin (1813–69), who died of arsenic poisoning caused by the handling of preserved bird skins. Its taxonomy has an interesting history: originally assigned its own monotypic genus *Cassinaetus*, the species subsequently spent time in the genera *Hieraaetus* and *Spizaetus* before, following the latest research, being moved to the genus *Aquila*. The most recent proposal is to dispense with the "hawk" in its common name, in order to avoid confusion with the hawk-eagles of Asia (*Nisaetus*) and South America (*Spizaetus*), and change it to plain Cassin's Eagle.

Little is known about the ecology and breeding behavior of Cassin's Hawk-eagle. It is most often seen circling over the forest canopy or sailing along a forested ridge, sometimes betrayed by its shrill whistle, but may also perch for a long time in emergent trees near the forest edge. It is thought to still-hunt from a high perch, and probably targets a variety of small to medium-sized prey; the stomach contents of one collected specimen included the remains of birds and squirrels. From limited observations, it is known to build a large nest of sticks high in the canopy and line it with foliage. The female lays one to two eggs, from October to December in Ghana and Gabon, and in December in Uganda. Inferring from the African Hawk-eagle, incubation is likely to last forty-two to forty-four days, with fledging at seventy-three days. As with other *Aquila* species, siblicide is probably the norm, with only one chick surviving.

This species has a very large geographical range and is listed by BirdLife International as Least Concern, with an estimated population of 670 to 6,700 mature individuals. As the forests of West and Central Africa continue to shrink, however, it is likely to come under increasing pressure.

OPPOSITE Cassin's Hawk-eagle is one of the most secretive and little-known of Africa's eagles, keeping to dense forest.

RUFOUS-BELLIED HAWK-EAGLE

LOPHOTRIORCHIS KIENERII

APPEARANCE
Small, slim, and upright; upperparts blackish to dark gray; black hooded head with short bushy crest; white throat and white breast thinly streaked in black; chestnut belly; tail dark and barred; wings broad, with rufous coverts and pale, barred flight feathers; female larger than male, with blacker face; immatures much paler, with white underparts, white heads, and dark eye patches.

SIZE
length 18–24 in. (46–61 cm)
weight 1.6 lb (730 g)
wingspan 3 ft 5 in. –4 ft 7 in. (105–140 cm)

DISTRIBUTION
L. k. kienerii *occurs in India, Nepal, Bhutan, and Sri Lanka;*
L. k. formosus *in Myanmar, Thailand, Vietnam, Indonesia, the Malay Peninsula, and the Philippines.*

STATUS
Least Concern

AN EAGLE'S VELOCITY IS NOT easily measured, so no records have ever been posted for the speediest. But there are surely few species that could overtake a Rufous-bellied Hawk-eagle when it folds back its wings and plummets on its prey. It is fitting, then, that this small, agile species bears a passing resemblance to a peregrine falcon, the fastest known of all birds.

The Rufous-bellied Hawk-eagle is a small, lightweight eagle, with a characteristic upright stance. Its black-hooded head is topped with a short crest, and its white throat and streaked white breast contrast with the rich chestnut belly from which it gets its name. The upperparts are a sooty dark gray, the tail dark and barred, and the underside of the broad wings shows a contrast between dark rufous coverts and pale, barred flight feathers. Females are larger than males, with a blacker face, and immatures are much paler, with white underparts and a dark eye mask on an otherwise white face.

This species, also known as Chestnut-bellied Eagle and Rufous-bellied Eagle, has undergone several taxonomic revisions: originally described as *Astur kienerii*, it was subsequently assigned to both the *Hieraaetus* and *Aquila* genera, before finally acquiring its own monotypic genus, *Lophotriorchis*.

Ranging widely across southern and southeast Asia, the Rufous-bellied Hawk-eagle occurs in two distinct subspecies: *L. k. kienerii* is found in northern and northeast India, Nepal, Bhutan, Sri Lanka, and the Western Ghats of southern India; *L. k. formosus* is found farther east, in Myanmar, Thailand, Vietnam, Indonesia, the Malay Peninsula, and the Philippines. Across this entire range, it inhabits a variety of forested habitats and forest edges, to heights of up to 6,560 feet (2,000 m). Wherever it occurs, it is largely sedentary, although local movements have been observed in Malaysia.

This species is often spotted circling high over the forest canopy. It hunts a variety of birds, including pigeons, pheasants, and jungle fowl, sometimes descending on victims in a breakneck stoop to snatch them in midair, but also entering the canopy to capture prey among the branches or on the forest floor—where small mammals and reptiles may also be on the menu.

Breeding takes place during late winter on the Indian subcontinent, and is heralded with aerial displays that involve much stooping and quivering of wings. A pair chooses a tall, often bare, tree in which to build a large nest of sticks and twigs that measures some 3 feet 11 inches (1.2 m) across and 2 feet (60 cm) deep. The female lays a single egg, and both parents share in incubation and feeding the chick.

This species has a wide range and is listed by BirdLife International as Least Concern, with a population estimated to fall within the 1,000 to 10,000 mature individuals bracket. Severe deforestation and habitat destruction afflicts much of its range, however, and is likely to pose a threat in many areas.

OPPOSITE Like the peregrine falcon, which its face resembles, the Rufous-bellied Hawk-eagle often captures prey in fast aerial pursuit.

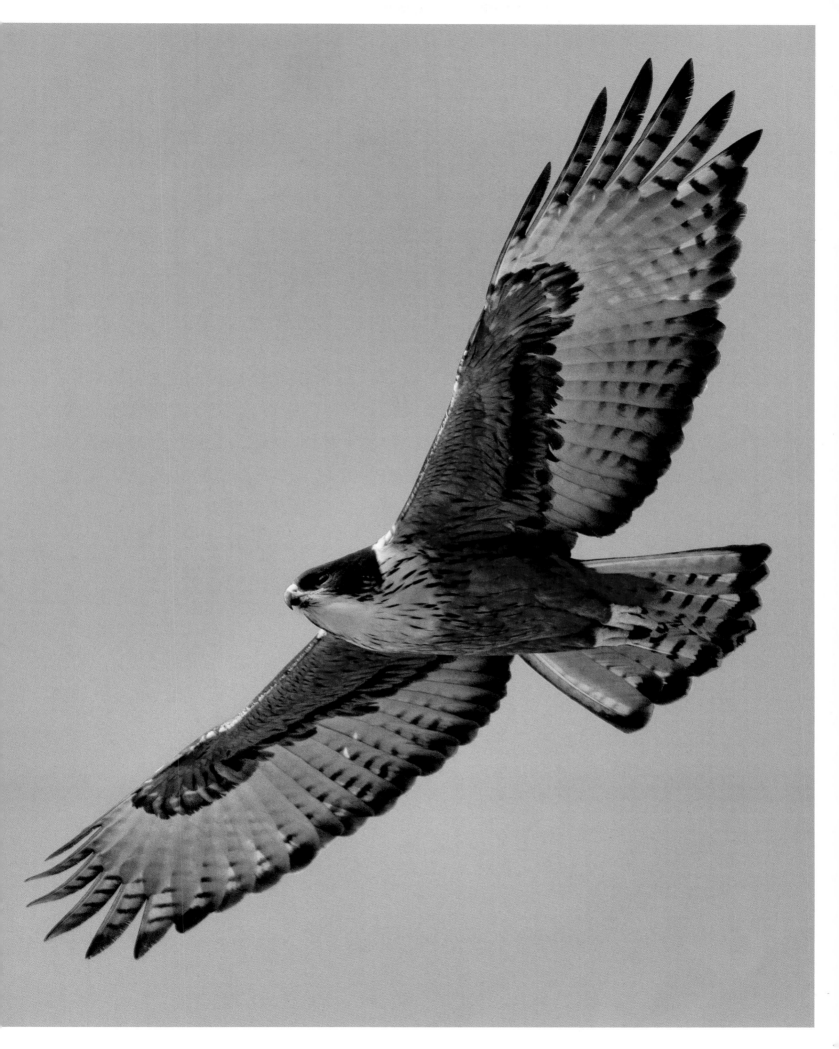

CONGO SERPENT-EAGLE

DRYOTRIORCHIS SPECTABILIS

APPEARANCE
Small; short rounded wings, elongated tail, and slight crest; large yellow eyes, and white throat with dark median stripe; upperparts chocolate brown, with rufous-brown collar; underparts white, irregularly blotched with black; tail brown with dark bars; underwings white, with spotted coverts and barred flight feathers; immatures paler, with whitish head, upperparts marked with dark spots that disappear with age, and whitish, lightly spotted underparts.

SIZE
*length 21–24 in. (54–60 cm)
weight no available data
wingspan 37–42 in. (94–106 cm)*

DISTRIBUTION
West and Central Africa; Sierra Leone in the west to Western Uganda in the east; south through the DRC and Gabon to northwest Angola.

STATUS
Least Concern

PROTECTIVE MIMICRY—THE PROCESS BY which harmless animals have evolved to resemble more dangerous ones for protection—is rare in the world of birds. This little-known eagle is, however, an exception. Though it feeds largely on reptiles and amphibians in the forest understory, and poses little threat to birds, its plumage bears an uncanny resemblance to that of the larger, bird-catching Cassin's Hawk-eagle (p. 220), which inhabits the same forests. This similarity allows it to go about its business free from the angry mobbing of small birds, which dare not risk confusing one with the other.

The Congo Serpent-eagle is a relatively small species, with short rounded wings, an elongated tail, and a slight crest on the back of its head. Its dark face shows large yellow eyes and a median stripe running down the white throat. The upperparts are dark chocolate brown, with a rufous-brown collar, and the white underparts are heavily and irregularly blotched with blackish spots and bars. The tail shows five to six dark bars, and the white underwings are spotted on the coverts and barred on the flight feathers. Immatures are paler, with a whitish head, a pale brown back marked with dark spots that disappear with age, and whitish underparts, lightly marked with black and reddish-brown spots.

This species ranges across the dense rain forests of tropical Africa, from Sierra Leone in the west to Western Uganda in the east, and south through the DRC and Gabon to Angola. Originally classified as a goshawk, which it resembles in shape, it was subsequently assigned a monotypic genus, *Dryotriorchis*. The most recent research suggests that it may be closely related to the *Circaetus* snake-eagles. Two subspecies are recognized: the nominate race *D. s. spectabilis* is found in western regions, and has more reddish-tinged and heavily blotched underparts than the eastern race, *D. s. batesi*.

The Congo Serpent-eagle is a denizen of dense lowland primary forest, generally below 3,000 feet (900 m), where it tends to stick to the understory and seldom appears above the canopy. It is a difficult bird to observe, although its distinctive calls—a cat-like miaow, and an extended nasal "cow-cow-cow"—often betray its presence. Its large eyes provide excellent vision in the gloomy light of the forest, where it drops from a perch to snatch up prey—typically toads or chameleons—which it dispatches in its sharp bill or talons. Individuals have occasionally been observed hunting along roads or clearings, and perching over rivers in search of water snakes.

Very little is known about the reproductive behavior of this eagle, which is known to breed June to November in DRC and October to December in Gabon. Its conservation status is similarly hard to assess. With a wide distribution and no evidence of decline, it is listed by BirdLife International as Least Concern, with an estimated population of more than 10,000 individuals. If deforestation continues at present rates, however, then it is likely to face threats. Curiously, despite its elusive nature, this eagle has a history of being kept as a pet.

OPPOSITE The secretive Congo Serpent-eagle tends to stick to the forest interior, hunting for reptiles and other small prey in the dark understory.

MADAGASCAR SERPENT-EAGLE

EUTRIORCHIS ASTUR

APPEARANCE
Small; long rounded tail, shortish rounded wings and short crest; upperparts earthy brown, with dark barring on back and wings and fine pale barring on nape; underparts white to pale gray, with wide irregular brown barring from belly to throat; talons large and powerful; eyes yellow; immatures paler brown with white mottling and white-tipped feathers.

SIZE
*length 22–26 in. (57–66 cm)
weight (estimated average): male 1.5 lb (700 g), female 1.9 lb (880 g)
wingspan 3 ft–3 ft 6 in. (90–110 cm)*

DISTRIBUTION
Madagascar; central highlands and northeast, from Zahamena in south to Marojejy in north; notably in Masoala National Park.

STATUS
Endangered

STUDIES OF MADAGASCAR's wildlife have produced many surprises over the years, not least the rediscovery of this raptor. After a last sighting in 1930, the Madagascar Serpent-eagle vanished for nearly half a century, presumed extinct. In 1977 and 1988, however, unconfirmed sightings raised new hopes. Finally, in 1993, a Peregrine Fund expedition to the Masoala Peninsula was able to confirm that the bird survived.

With its long, rounded tail, shortish wings, and brown, heavily barred plumage, this small, unusual eagle resembles a goshawk. Indeed, it is sometimes mistaken for Henst's goshawk, a similar-sized raptor also endemic to Madagascar. The upperparts are earthy brown, with darker barring on the back and wings and fine pale barring on the nape, while the underparts are white to pale gray with wide irregular brown barring from belly to throat. The talons are large and powerful, and the yellow eyes in the heavily barred face produce a cuckoo-like expression. Immatures are paler.

The Madagascar Serpent-eagle—also known as the Long-tailed Serpent-eagle—is the only member of the genus *Eutriorchis*. Unrelated to the *Spilornis* serpent-eagles of southern Asia, it is thought by some to have affinities with the *Gypaetinae* vultures. Highly endangered, it occurs in Madagascar's forested central highlands and northeast, from Zahamena in the south to Marojejy in the north, and notably in Masoala National Park. Its favored habitat is moist tropical lowland forest, and it rarely ventures beyond the forest edge.

This eagle is very hard to find, hence its long disappearance from the radar. Secretive and wary, it seldom flies above the canopy and is most often detected by its far-carrying, frog-like call: "wah wah wah wah." It hunts in trees and on the ground for chameleons, geckos, and frogs, gliding between perches below the canopy and often thrusting its feet into epiphytes or leaf litter in order to grab its prey. Snakes are seldom taken, despite the raptor's name, but bats and large insects may be.

Most studies of breeding come from the Masoala Peninsula, where five nests were located between 1997 and 2005, all built inside epiphytic ferns. Elsewhere, this bird is also known to build a stick nest in a tree fork. The clutch comprises one to two eggs, with incubation thought to last more than forty days and fledging another fifty-eight to sixty-two days. Productivity is likely to be low, with a pair producing just one offspring every two to three years.

The Madagascar Serpent-eagle is one of the world's rarest raptors. Since its confirmed rediscovery in 1993, scientists have located the bird in several areas where it was previously unknown, and it may occur farther south. The species faces numerous threats, however, including habitat destruction—through commercial logging, slash-and-burn farming, and mining—that has desecrated Madagascar's forests. Human persecution is a problem, with the bird mistakenly blamed for taking chickens—the real culprit being Henst's Goshawk. Today, BirdLife International lists this eagle as Endangered, with an estimated population of 250 to 999 individuals.

ABOVE This nest, on Madagascar's Masoala Peninsula, provided the first photographic evidence of breeding Madagascar Serpent-eagles, after the species was rediscovered in 1993.

RAPTORS OF THE RAIN FOREST

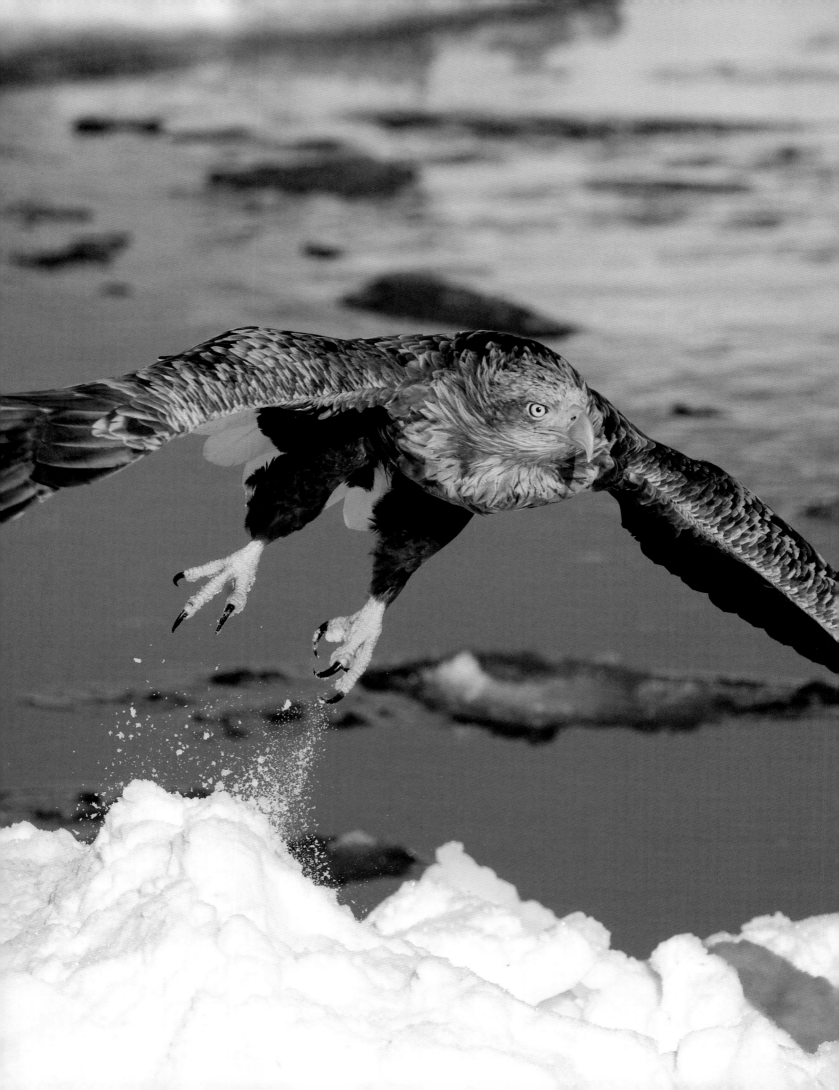

05 | WINGS OVER THE WATER

FOR THE TEN EAGLE SPECIES THAT MAKE UP this chapter, diet and habitat are inseparable. All of them are fish-eaters, so all must spend most of their lives close to water, whether inland, by the sea, or both. Among their special adaptations for fishing are deeply curved, fish-hook talons and spiny scales called spicules on the soles of their feet to provide extra grip on their slippery prey. All have also perfected the art of the shallow dive, swooping down on fish near the water's surface and, at the very last moment, flinging forward their talons to snatch the prize before flapping heavily skyward to avoid total immersion.

Perhaps because of this spectacular behavior, plus the birds' large size and bold markings, this group includes some of the best known of all eagles. There are two genera: the *Haliaeetus* sea-eagles and the smaller *Ichthyophaga* fish-eagles (confusingly, some of the former are also known as fish-eagles). The largest of the *Haliaeetus* species, and joint largest of all eagles, is the imposing Steller's Sea-eagle of the northwest Pacific, unmistakable with its piebald plumage and yellow hatchet of a bill. Only slightly smaller is the White-tailed Sea-eagle, which occurs right across northern Eurasia, from Iceland to Japan. The New World cousin of these two is the Bald Eagle of North America, celebrated as the emblem of the United States of America. It has a white (not bald) head and, like all *Haliaeetus* sea-eagles, a striking white tail.

These three species all supplement their fish diet with other aquatic prey, notably waterfowl such as ducks, auks, and gulls, which they capture from the water or from the birds' busy breeding colonies, showing impressive aerial agility for such massive predators. They may also take terrestrial prey, including mammals up to the size of deer fawns, and—fittingly, for birds whose square wings resemble those of vultures—are habitual scavengers, especially in winter, when they may feed on anything from dead fish to beached whales. Some species gather in large numbers where food is plentiful: Bald Eagles and Steller's Sea-eagles congregate along salmon spawning rivers, and the latter gather with White-tailed Eagles on the pack ice off Japan's Hokkaido island in one of the world's most impressive bird spectacles.

In Africa, the *Haliaeetus* group is represented by the African Fish-eagle—another spectacular bird, whose yodeling call, carrying far over the continent's waterways, is perhaps the best known of any raptor. In build and behavior, this species is very similar to its northern hemisphere relatives, capturing fish and other aquatic prey, and scavenging when the opportunity arises. It is also, in common with its cousins, a consummate pirate, stealing catches from herons, storks, and other fish-catchers that share its habitat. Its Asian cousin, the White-bellied Sea-eagle, ranges along tropical shorelines from India to Tasmania and is also well known for its noisy call.

The other members of the *Haliaeetus* group are Pallas's Sea-eagle, a species of the Central Asian lakes, now declining rapidly, Sanford's Sea-eagle, a Solomon Islands version of the White-bellied Sea-eagle, and the Madagascar Fish-eagle, a rare cousin to its African mainland namesake. The two *Ichthyophaga* species, the Gray-headed Fish-eagle and Lesser Fish-eagle, are both found in southern Asia. They are slightly smaller than sea-eagles, with dark tails, and are even more heavily reliant on a diet of fish.

Sea-eagles are as showy in their breeding behavior as they are in their hunting, performing spectacular tumbling courtship displays and calling loudly in duet. They also construct the biggest nests of all eagles—indeed, the Bald Eagle builds the largest stick nests of any bird in the world, its huge edifices weighing up to a tonne. Sadly, as well as facing such familiar threats as persecution and habitat loss, sea-eagles are especially vulnerable to water-borne pollution, and populations of several species plummeted during the second half of the twentieth century. Despite the harm we have caused to these birds, however, several enjoy a special status as national emblems.

OPPOSITE A White-tailed Eagle takes flight from the sea ice off the Japanese island of Hokkaido.

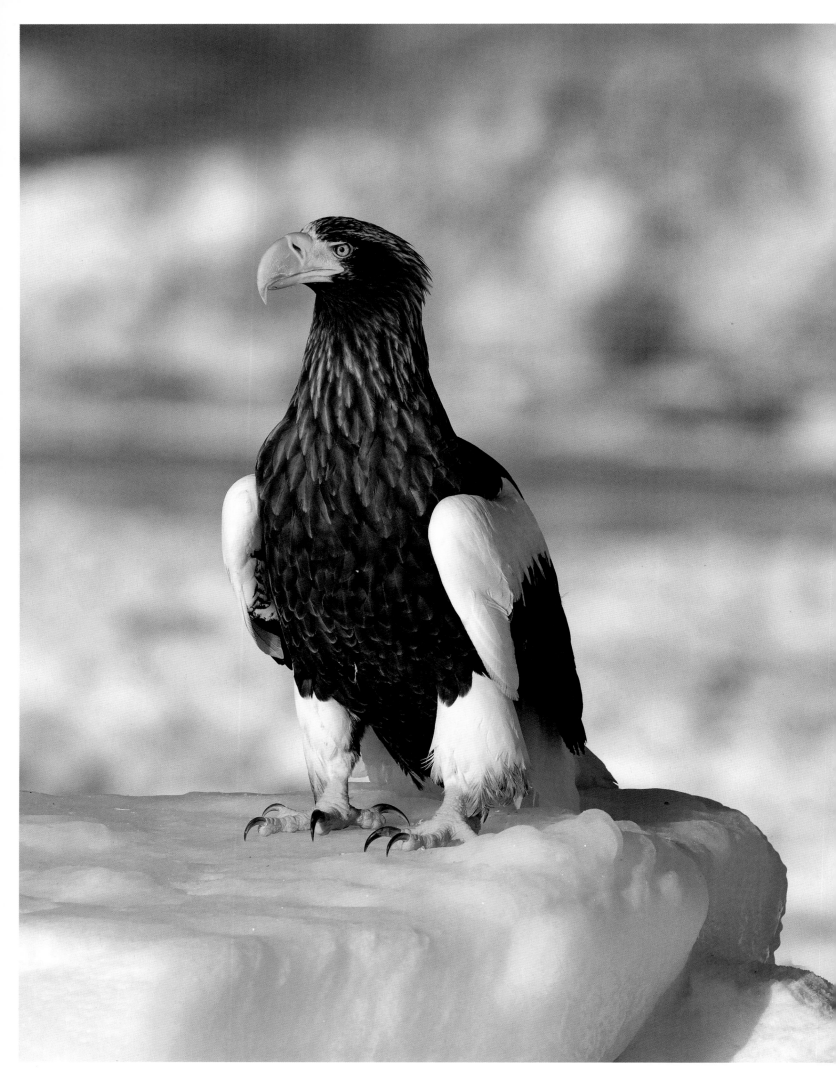

STELLER'S SEA-EAGLE

HALIAEETUS PELAGICUS

APPEARANCE

Huge (on average, the world's heaviest eagle); massive yellow bill; adult dark brown to black with strongly contrasting white on upperwing and underwing coverts, thighs, undertail coverts, and tail; flight silhouette shows long wings and diamond-shaped tail; feet bright yellow; immatures uniform dark-brown with paler brown streaking, blackish-brown bill, and dark terminal band to white tail; acquires full adult plumage in fifth year.

SIZE

length 33–41 in. (85–105 cm) weight female 15–20 lb (6.8–9 kg), male 11–13 lb (4.9–6 kg) wingspan 6 ft 5 in.–8 ft 1 in. (1.95–2.5 m)

DISTRIBUTION

Far eastern Russia and northwestern Pacific coast; breeds on Kamchatka Peninsula and surrounding coastal areas; also inland, along the lower Amur River; winters farther south, in Russia's Kuril Islands and Hokkaido, Japan.

STATUS

Vulnerable

FEW SIGHTS IN THE AVIAN world are more impressive than a Steller's Sea-eagle perched on the sea ice. With its yellow hatchet of a bill, piercing yellow-eyed glare, and formidable physique, this massive raptor—in its livery of snow-white and chocolate—lords it over a landscape of panoramic drama.

The sense of size is no illusion: this is, on average, the largest of the world's eagles, with females weighing in at an average 16.8 pounds (7.6 kg) and occasionally pushing 19.8 pounds (9 kg). This is 1.1 pounds (500 g) heavier than the average Harpy Eagle (p. 164) and 2.2 pounds (1 kg) more than the average Philippine Eagle (p. 170), its closest contenders. The White-tailed Sea-eagles (p. 238) with which it gathers on its wintering grounds seems diminished by comparison.

This eagle is not only the largest of the *Haliaeetus* sea-eagles but also the most striking. The piebald contrast of its snow-white wing coverts, thighs, and tail with its otherwise black to dark-brown plumage is visible from afar, and is set off by a huge yellow bill, the largest of any eagle. In flight, its square wings and long head produce the vulture-like silhouette characteristic of all sea-eagles. Its tail is diamond-shaped and, unlike that of the other species, has fourteen rather than twelve

rectrices. The average wingspan, at 7 feet 3 inches (2.2 m), is fractionally less than that of the White-tailed Eagle, although unverified records of up to 9 feet 2 inches (2.8 m) would, if true, make these the largest wings of any eagle. As in all sea-eagles, the yellow feet are armed with long, deeply curved claws and rough "spicule" scales beneath, both adaptations for gripping slippery fish.

Steller's Sea-eagle is found in far eastern Russia and the northwestern Pacific, and is named after pioneering German naturalist Georg Wilhelm Steller (1709–46), who accompanied Danish explorer Vitus Bering (1681–1741) on the Great Northern Expedition of 1733 to 1732. Molecular research has revealed that this species diverged from the same lineage that produced the Bald Eagle (p. 246) and White-tailed Eagle, and today the three are considered sister species. Some taxonomists have proposed splitting Steller's Sea-eagle into two subspecies: the nominate race *H. p. pelagicus* and another race confined to Korea, *H. p. niger*, which has no white except in the tail and has not been seen since 1968.

This species' breeding range encompasses the Kamchatka Peninsula and surrounding coastal areas, including the Sea of Okhotsk, the Bay of Penshina, and Sakhalin island. It also breeds inland, along the lower reaches of the Amur River. In winter, a large proportion of the population travels south, drifting with the sea ice from the Sea of Okhotsk out to Russia's southern Kuril Islands and some as far as Hokkaido, Japan. The latter sees numbers peaking during late February in the Nemuro Strait, where they gather beside White-tailed Eagles and smaller numbers of Golden Eagles (p. 22) in what must surely be the world's most spectacular assemblage of large raptors.

Like other *Haliaeetus* species, Steller's Sea-eagle feeds primarily on fish, scanning from a raised perch or while circling over the water, then swooping down to pluck its prey from the shallows with a perfectly timed lunge of its long legs and fish-hook talons. In rivers it favors salmon and trout,

OPPOSITE Steller's Sea-eagle is the largest eagle in the world, on average, and strikes an imposing figure.

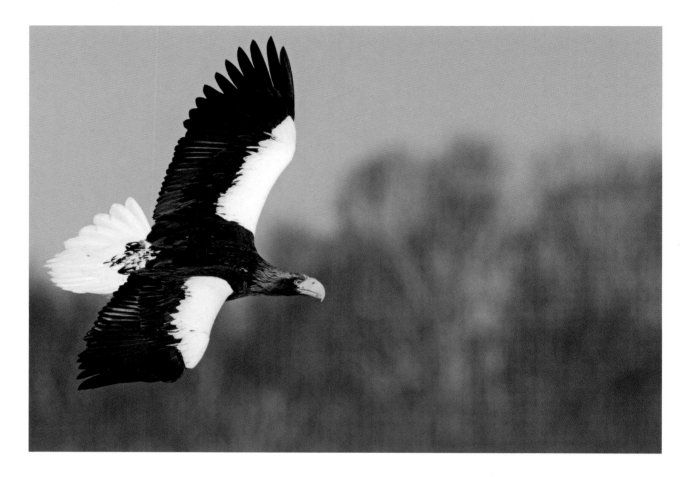

and regularly takes fish weighing 13 to 15 pounds (6–7 kg). Large numbers congregate on salmon spawning rivers in late summer, with peak counts of 700 reported in Kamchatka. On Hokkaido island, in winter, the main prey is Pacific cod, which peak during February in the Nemuro Strait, their numbers boosted by a commercial fishery.

Fish are not the only item on the menu. This versatile predator takes a wide range of water birds, from ducks and geese to gulls, herons, cranes, and cormorants. Inland, it also takes terrestrial birds, such as grouse, ravens, and owls, as well as various mammals, from hares and voles to Arctic foxes and domestic dogs. It will even carry off seal pups: claims of victims weighing 20 pounds (9.1 kg) would, if true, represent the greatest load-carrying known in any bird. Like other sea-eagles, this species is not above scavenging: many wintering birds in Japan subsist on Sika deer carcasses. It will also steal food from other eagles and subordinates of its own species.

Steller's Sea-eagle breeds beside the coast or alongside large rivers with mature trees. Ceremonies begin for the breeding pair by late February with a soaring courtship display flight over the breeding area, accompanied by loud cries. The bulky stick nest is constructed atop a rocky outcrop or large tree, and measures some 4 feet 11 inches (1.5 m) deep by 8 feet

(2.5 m) wide. A pair maintains several nests within its territory, generally built around 3,000 feet (900 m) apart. The pair mates on the nest, after which the female lays one to three greenish-white eggs, slightly larger than those of a Harpy Eagle and probably the biggest on average of any eagle. The chicks hatch after an incubation of thirty-nine to forty-five days. Usually only one survives to adulthood, although as many as three have been recorded. They fledge after seventy days, in late August or early September. Egg predation and nest collapses ensure that only 45 to 67 percent of eggs are successfully reared to adulthood. After fledging, youngsters take five years to acquire full adult plumage.

An adult Steller's Sea-eagle has no natural enemies, although arboreal predators such as sable, ermine, and even brown bear may raid an unattended nest for eggs or small nestlings. Of greater concern are the threats posed by people, which include habitat loss, industrial pollution, over-fishing, and even direct persecution. Heavy flooding along Russian rivers, attributed to climate change, has caused widespread nest failure, with birds unable to fish for their broods. Today, BirdLife International lists the species as Vulnerable, with a world population estimated at fewer than 5,000 individuals and thought to be in decline.

ABOVE In flight, the white markings and diamond-shaped tail of the Steller's Sea-eagle are visible from afar.

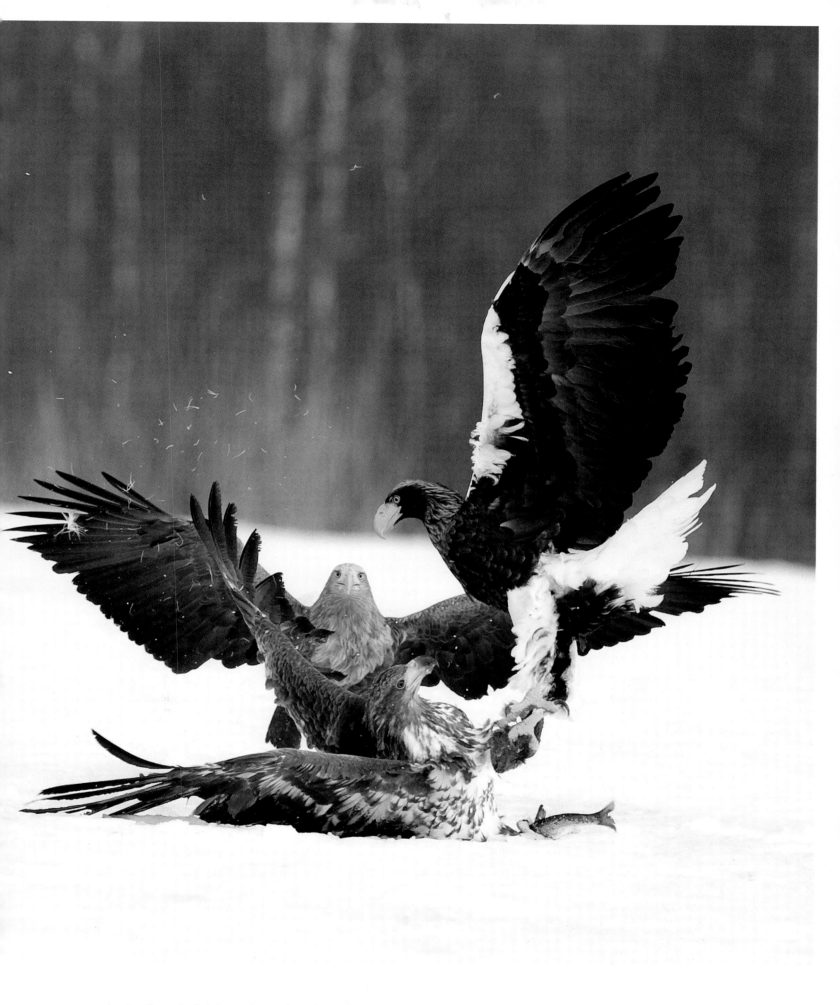

ABOVE Feathers fly, as a Steller's Sea-eagle grapples with two White-tailed Sea-eagles for possession of a fish.

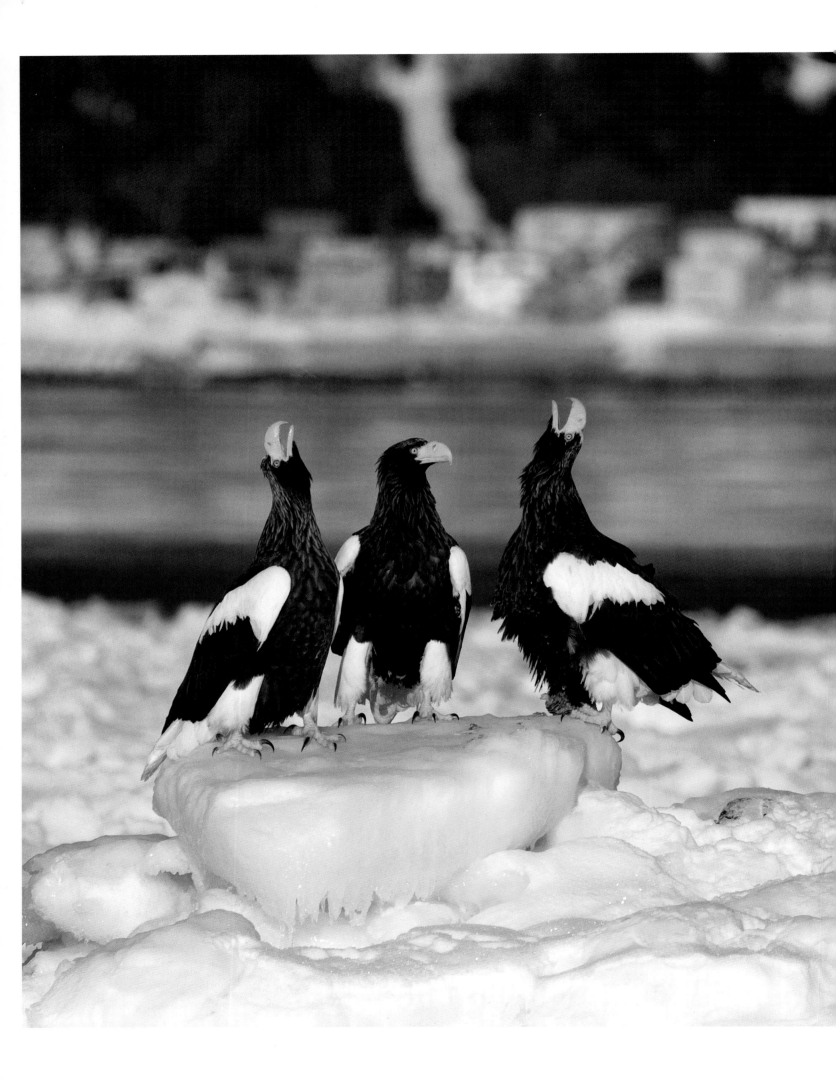

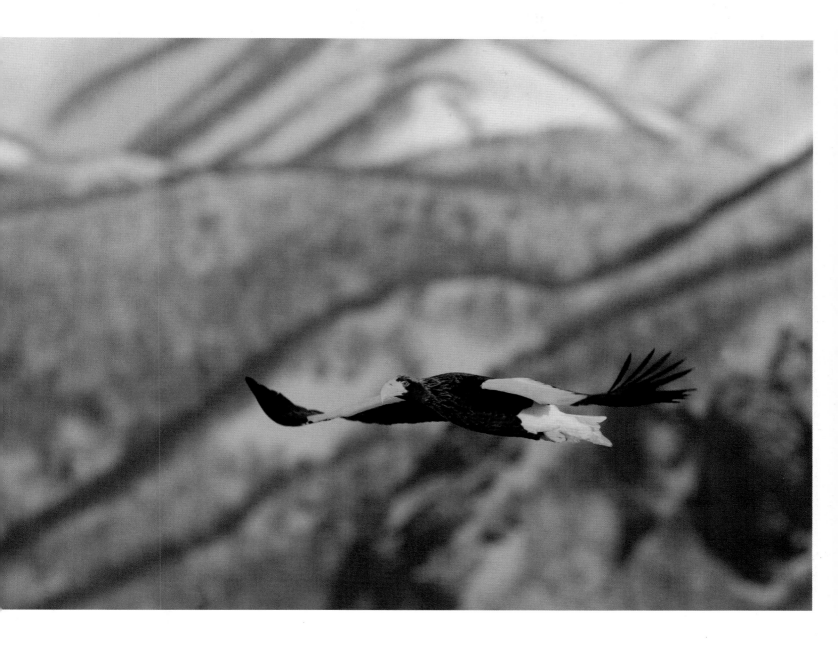

OPPOSITE Two adult Steller's Sea-eagles raise their heads to utter their deep cackling call, while a third looks on.

ABOVE An adult Steller's Sea-eagle glides in against the snowy backdrop of the Japanese island of Hokkaido.

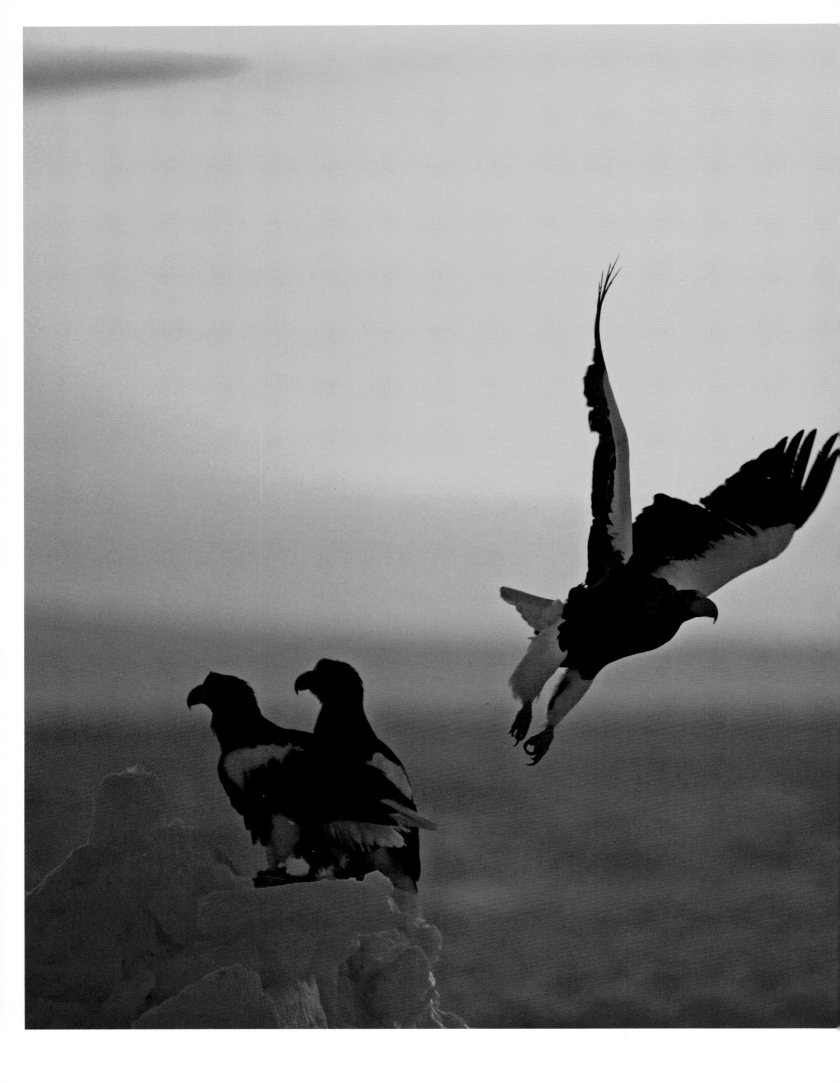

LEFT Every winter, Steller's Sea-eagles congregate on the sea ice off the Japanese island of Hokkaido.

WHITE-TAILED SEA-EAGLE

HALIAEETUS ALBICILLA

APPEARANCE
Very large; massive yellow bill; adult mottled brown with paler head and white tail; very long, square wings, long head and neck, and short tail create distinctive flight silhouette; feet yellow; immatures uniform dark-brown with paler brown streaking, blackish-brown bill, and dark terminal band to white tail; acquires full adult plumage in fifth year.

SIZE
length 26–37 in. (66–94 cm) weight female 8.8–15.2 lb (4–6.9 kg); male 6.8–11.9 lb (3.1–4.5 kg) wingspan 5 ft 10 in.–8 ft (1.78–2.45 m)

DISTRIBUTION
Northern Europe and Asia, from Greenland in the west to Siberia and Japan in the east: significant populations in Norway and Russia; isolated populations in Greenland, Iceland, and the Balkans; reintroduced to United Kingdom and Ireland; northernmost populations migrate south in winter, some as far as the Arabian Gulf and South China Sea.

STATUS
Least Concern

PEOPLE AND WHITE-TAILED SEA-EAGLES have a long history. This bird's bones have been found entombed in 6,000-year-old burial mounds on Scotland's Orkney Islands, suggesting that prehistoric people considered the species sacred. It was once known as Erne, a name derived from the Old English *earne*, meaning "eagle." Some archaeologists even believe that the ancient Orcadians left out their corpses for the eagles to consume—rather as Tibetans once did with vultures for their Buddhist "sky burials." More recently, the bird has featured in the coats of arms of Poland and Serbia.

This massive eagle is the biggest in Europe and, on average, the fourth biggest worldwide. Its median wingspan, at 7 feet 2 inches (2.2 m), is the largest of any eagle—although both Steller's Sea-eagle (p. 230) and the Philippine Eagle (p. 170) have higher recorded spans. In the United Kingdom, where the only raptor of comparable size is the Golden Eagle (p. 22), it is the bird's shape that identifies it: often described as looking like a "flying barn door," it appears more vulture-like than its elegant cousin, its massive square wings held flatter while gliding. The flight silhouette also shows a head and neck that project farther, and a shorter wedge-shaped tail. These features—the square wings, long neck, and short, broad tail—are all typical of the *Haliaeetus* genus of sea-eagles, and taxonomists now believe the White-tailed Sea-eagle to be most closely related to North America's Bald Eagle (p. 246). A closer look reveals other typical features: a massive yellow bill; bright yellow, unfeathered legs; a pale head that becomes almost creamy with age; and, of course, the conspicuous white tail. When perched, the brown plumage looks slightly unkempt, the upperparts scalloped with pale feather edges. Immatures are darker, with a dark bill and a dark terminal band to the white tail, which becomes whiter.

White-tailed Sea-eagles range across northern Europe and Asia, from Greenland in the west to Siberia and Japan in the east. Norway holds the largest European population, with up to 11,000 pairs. Isolated populations also occur in Greenland, Iceland, and the Balkans. It is a largely sedentary species, with only the northernmost populations—such as those from northern Scandinavia and Siberia—migrating south in winter, some as far as the Arabian Gulf and South China Sea. Individuals from Siberia occasionally reach Alaska.

In the United Kingdom, this species has an interesting history. Persecuted to extinction by 1916, it was reintroduced during the 1970s to the Isle of Mull and has since reestablished itself around the coast and islands of northern Scotland. A separate population has recently been reintroduced to Ireland. Individuals that turn up elsewhere in the United Kingdom, however, tend to be wanderers from mainland Europe.

Wherever in the world the White-tailed Sea-eagle occurs, it is—as the name "sea-eagle" suggests—often near the coast. However, it may also find suitable habitat inland, around wetlands and water bodies, and may settle around lowland lakes in winter. Its key requirements are large and open expanses of wetland, coast, or river valley, with nearby undisturbed cliffs or open stands of large, mature trees for nesting.

Fish are a key food item, caught feet-first after a diving descent, legs flung out ahead at the last second to snatch the prize from the surface. Both marine and freshwater species

OPPOSITE A White-tailed Sea-eagle plucks a fish deftly from the water's surface then gains height with a heavy downbeat of its huge wings.

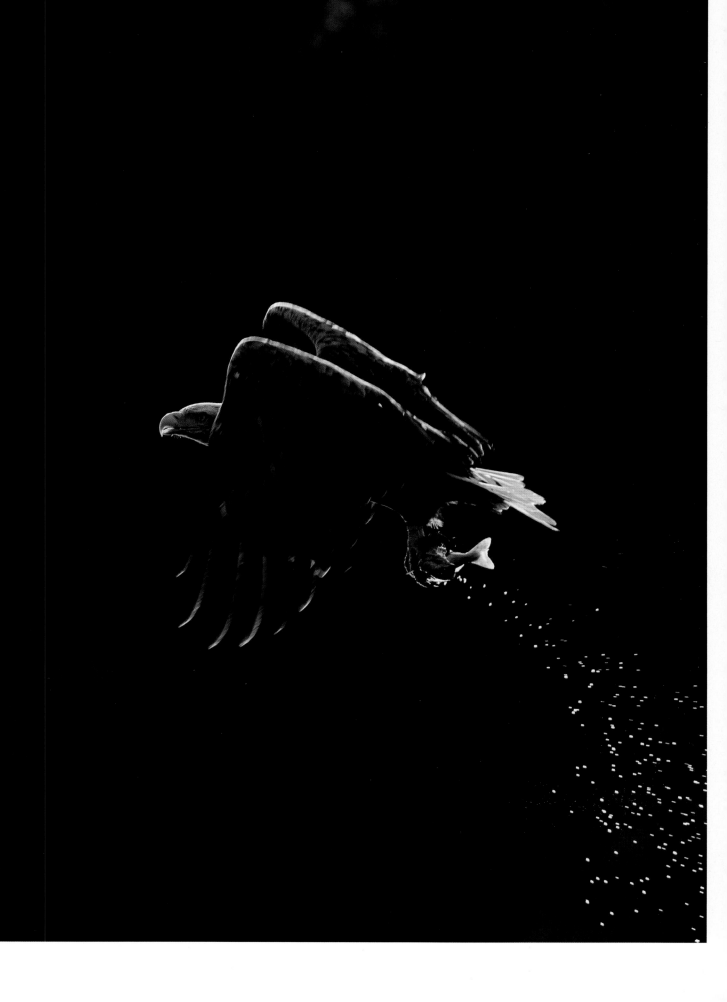

are taken. Water birds are also important prey in many areas, including seabirds such as fulmars taken at their breeding colonies and waterfowl seized from lakes. With diving species, such as auks, the eagle may make repeated passes, the bird diving to escape but eventually tiring and allowing the raptor to capture it at the surface.

Not all prey is aquatic. A wide variety of terrestrial species make the menu, including game birds and mammals up to the size of deer fawns. Like other sea-eagles, this resourceful raptor will pirate food from other hunters. In winter, it turns increasingly to carrion, including the remains of birds, deer, and fish. In some regions, the eagles congregate on carcasses— sometimes alongside other eagles such as, on the Japanese island of Hokkaido, the even larger Steller's Sea-eagle (p. 230).

White-tailed Sea-eagles occupy territories of 11.5 to 27 square miles (30–70 km²). They pair for life, renewing their bond with a spectacular aerial courtship display, in which both birds lock talons midair and cartwheel toward the ground. Like other *Haliaeetus* eagles, they also call in duet—a fast, high, yelping bark. The massive stick nest is built in the crown of a tall tree or on a sea cliff. It is reused and built up every year, sometimes becoming so big that the tree collapses under its weight. A female produces one to three eggs, laid two to five days apart in spring. The parents take turns at incubation, and the eggs hatch after thirty-eight days. The first hatchling is generally larger than its siblings, but siblicide is rare. The young can feed themselves at five to six weeks and fledge at eleven to twelve weeks. They will hang around the nest, dependent on their parents, for up to ten more weeks.

Young White-tailed Sea-eagles are vulnerable in their early years, and must rely largely on scavenging as their hunting skills develop. If they can get through their first winter, their survival chances increase. They fear very few natural predators, and may reach the age of twenty-five or more. Their greatest threats come from humans, notably poisoning from pesticides and other environmental pollutants that work their way up the food chain. Direct persecution from those who consider the raptors a threat to their livestock remains a problem, as does, increasingly, collision with obstacles such as wind turbines.

White-tailed Sea-eagle populations plummeted during the nineteenth and twentieth centuries but have been recovering since the 1980s, thanks to conservation and reintroduction programs. Today, this species is listed as Least Concern by the IUCN, with an estimated 20,300 to 39,600 mature individuals worldwide. In Europe, the breeding population is estimated at 9,000 to 12,300 breeding pairs, of which the expanding U.K. population accounts for around 100. Since 2006, the bird has also naturally re-established itself in the Netherlands. The trend is encouraging, but as long as the threats persist, conservationists remain vigilant.

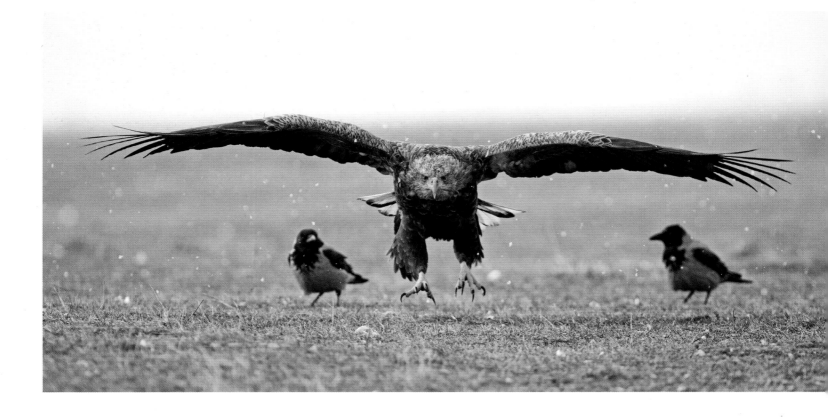

ABOVE A White-tailed Sea-eagle dwarfs two hooded crows. Smaller scavengers will often gather around the giant raptor at a carcass to feed on any leftovers.

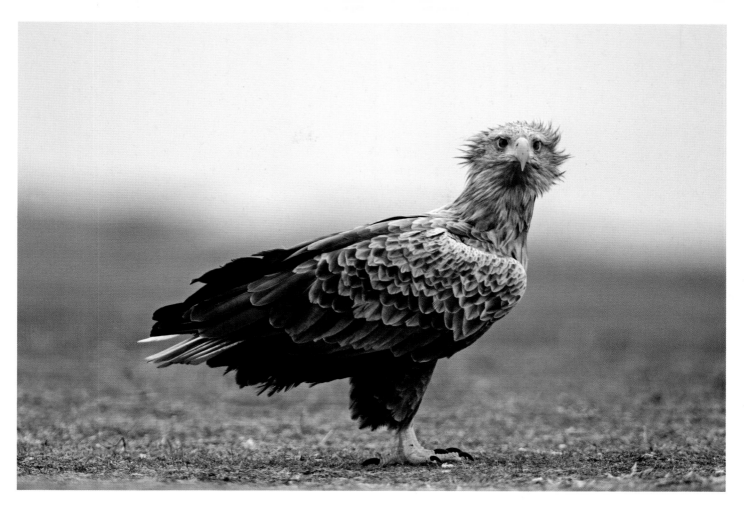

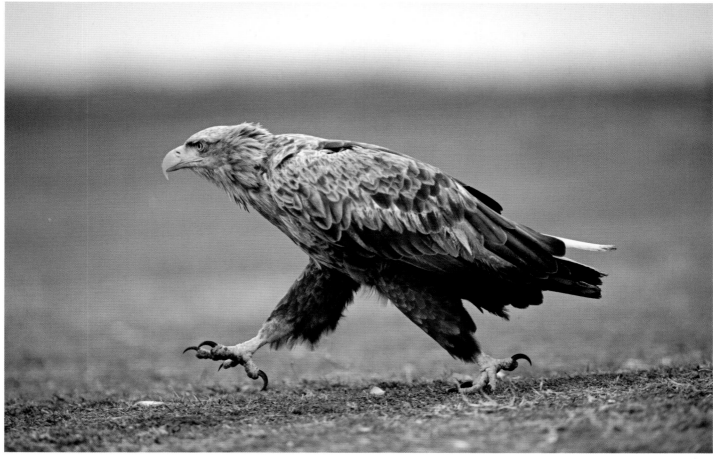

ABOVE White-tailed Sea-eagles gather during winter in Hungary's Hortobágy National Park. On the ground, these magnificent birds can appear surprisingly scruffy and awkward.

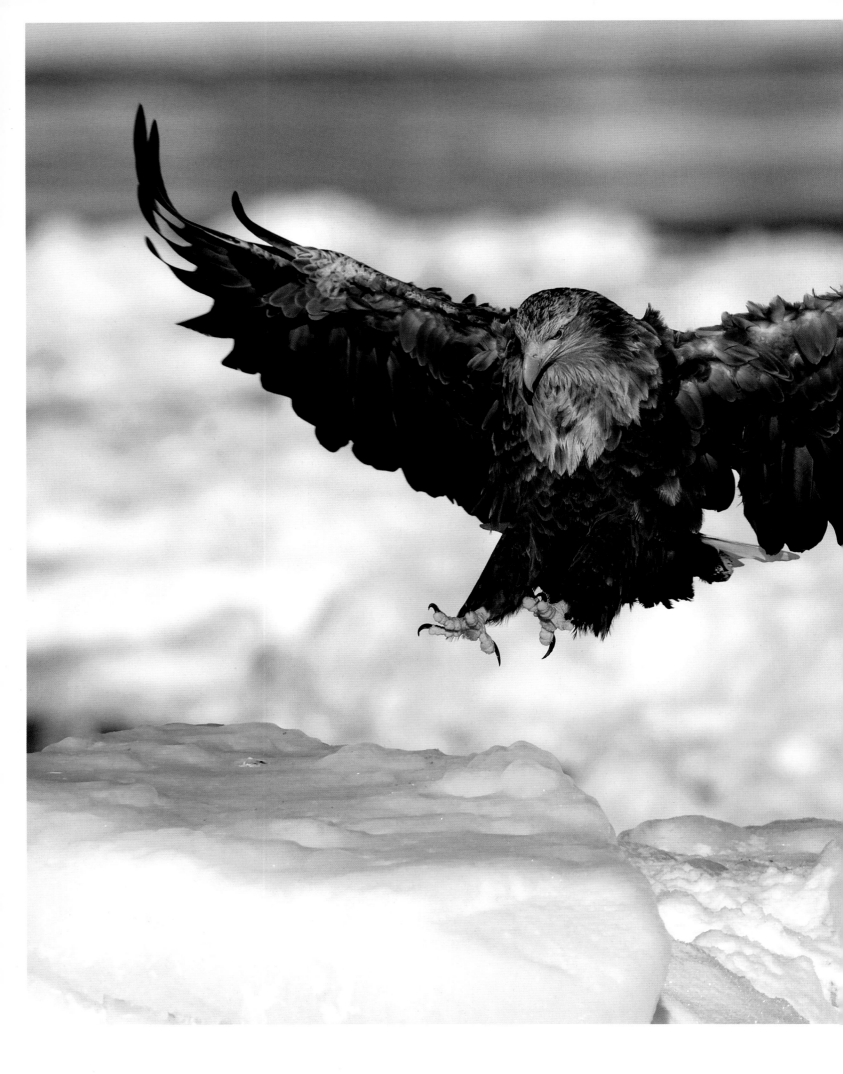

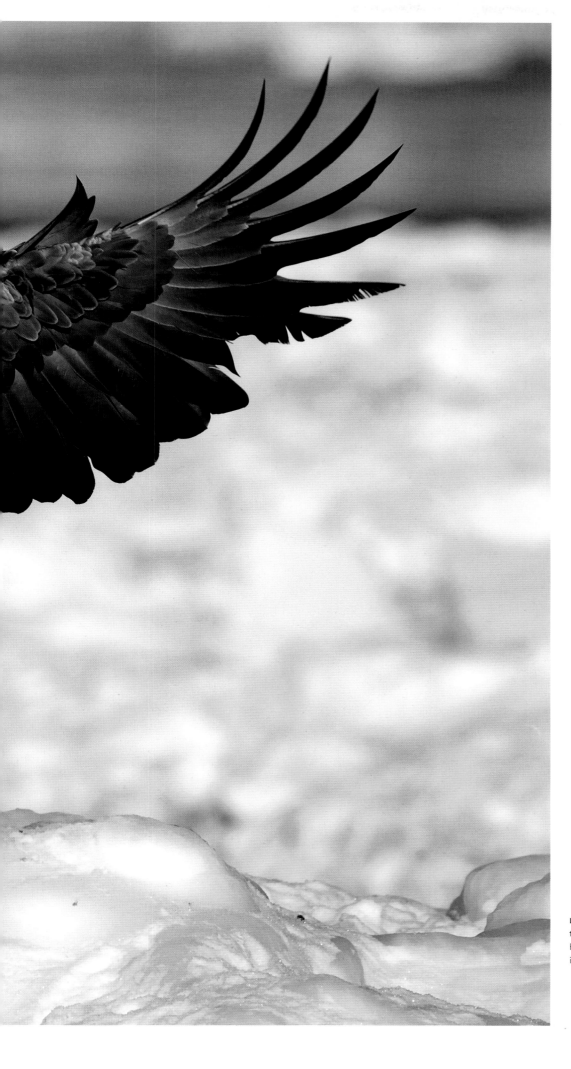

LEFT A White-tailed Sea-eagle lands on the sea ice off the Japanese island of Hokkaido. The wingspan of this species is, on average, the largest of any eagle.

WINGS OVER THE WATER

RIGHT A fishing White-tailed Sea-eagle strikes the water in a blur of speed, power, and timing.

BALD EAGLE

HALIAEETUS LEUCOCEPHALUS

APPEARANCE
Very large; dark brown body and wings; pure white head, neck, and tail; massive yellow bill; yellow feet and iris, unfeathered legs; broad, straight-edged wings; wedge-shaped tail; immatures brown with scruffy white streaking, reaching full adult plumage by year four or five.

SIZE
length 28–40 in. (70–102 cm) weight 6.6–13.9 lb (3–6.3 kg); female on average 25 percent larger than male wingspan 5 ft 11 in.–7 ft 6 in. (1.8–2.3 m)

DISTRIBUTION
North America; breeds in every mainland U.S. state, Alaska, every Canadian province and Baja peninsula (northern Mexico); northern populations migrate south in winter.

STATUS
Least Concern

"BALD" SEEMS A RATHER IGNOMINIOUS EPITHET for this impressive eagle. Its head is fully feathered, but in a pure white that, together with its white tail and dark brown body, produces the "piebald" appearance that explains the name. The Bald Eagle is one of the world's best-known birds. Ever since 1782, when Congress incorporated the eagle's image into the Great Seal of the United States, it has been emblematic of that nation. Long before, it was also revered in Native American cultures, seen as a spiritual intermediary between humans and the gods. Despite this, the 1950s saw the bird heading toward extinction. Its subsequent reversal of fortune has been a conservation success story.

The Bald Eagle is fractionally larger than the Golden Eagle (p. 22) and is regarded as the largest North American eagle. The average size of the species increases the farther north you travel, with the largest being from Alaska, where females may exceptionally weigh 17 pounds (7.5 kg) and span 8 feet (2.4 m) across the wings. Adults are dark brown with a pure white head and tail and bright yellow feet and bill. It has the typical *Haliaeetus* profile, with a massive bill, unfeathered legs, sharply curved talons, and broad, straight-edged wings held flat in flight. Its wedge-shaped tail is slightly longer than that of a White-tailed Eagle, which gives it a slightly greater average length. Immatures are brown all over with scruffy white streaking, reaching full adult plumage by their fifth year.

The Bald Eagle's scientific name *leucocephalus* derives from the ancient Greek *leuco*, meaning "white," and *cephalos*, meaning "head." The species forms a species pair with the White-tailed Sea-eagle (p. 238), the two having diverged from other *Haliaeetus* sea-eagles and adapted to fill the same ecological niche on either side of the Atlantic. Taxonomists recognize two subspecies: the nominate race *H. l. leucocephalus* is found in the southern United States and Baja; the larger race, *H. l. washingtoniensis*, occurs in the northern United States, Canada, and Alaska.

At the Bald Eagle's lowest ebb, its breeding range shrank to a handful of scattered populations in Alaska, the Aleutians, north and east Canada, and Florida. Today, there are an estimated 70,000 Bald Eagles and the species occurs across North America, breeding in every contiguous U.S. state, Alaska, every Canadian province, and Mexico's Baja Peninsula. Southern populations are largely resident. Northern ones are more migratory, moving south when water freezes over and sometimes forming aggregations hundreds strong along salmon spawning rivers. There are even two records of wanderers crossing the Atlantic to Ireland. Across its range, this is a bird of wetlands both inland and along the coast, preferring large bodies of open water with abundant food and nearby old-growth trees for nesting.

The Bald Eagle is primarily a fish-eater. Key species vary: in the Pacific Northwest, spawning trout and salmon dominate the menu; in Florida, catfish are the favorite. A typical catch weighs 2.2 to 6.6 pounds (1–3 kg) and is plucked from the water in a shallow feet-first dive, using fish-hook claws and sharp "spicule" scales beneath the toes to secure it. Water birds also make the menu and, in some areas, such as Yellowstone, are as important as fish. They include grebes, ducks, coots, and gulls, and sometimes such larger species as common loon, sandhill crane and Canada goose. The eagle will capture swimming birds at the surface but also grabs birds in flight with impressive agility. The diet also includes a variety of

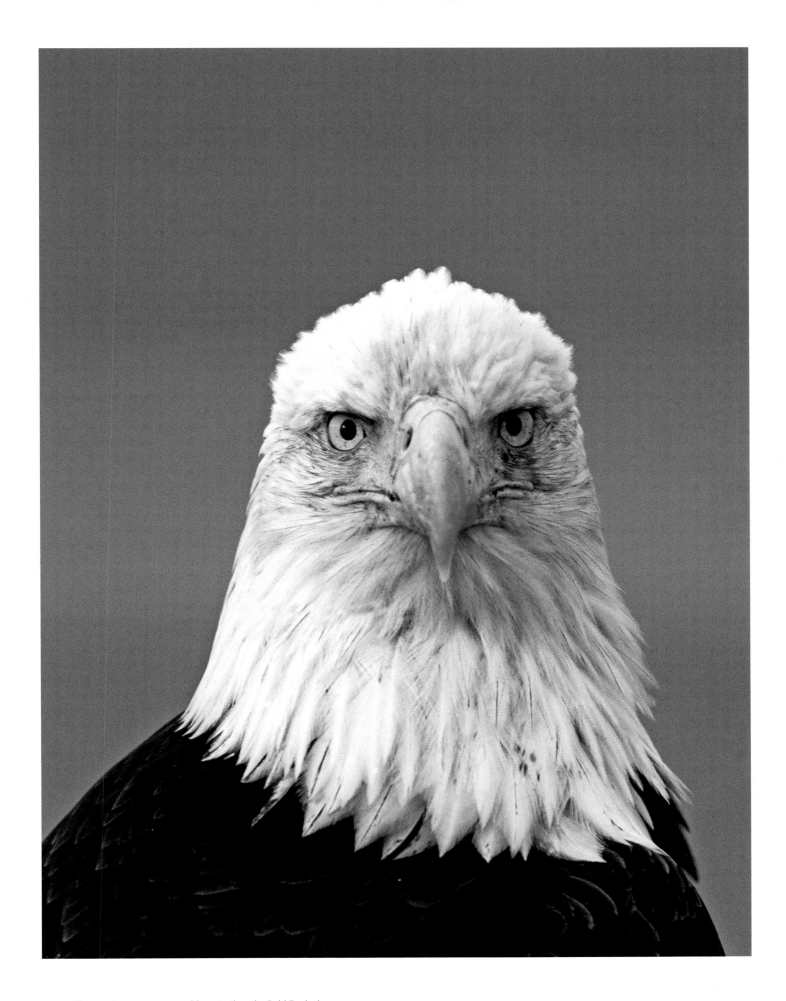

ABOVE Few creatures are more emblematic than the Bald Eagle, known worldwide as the national bird of the United States.

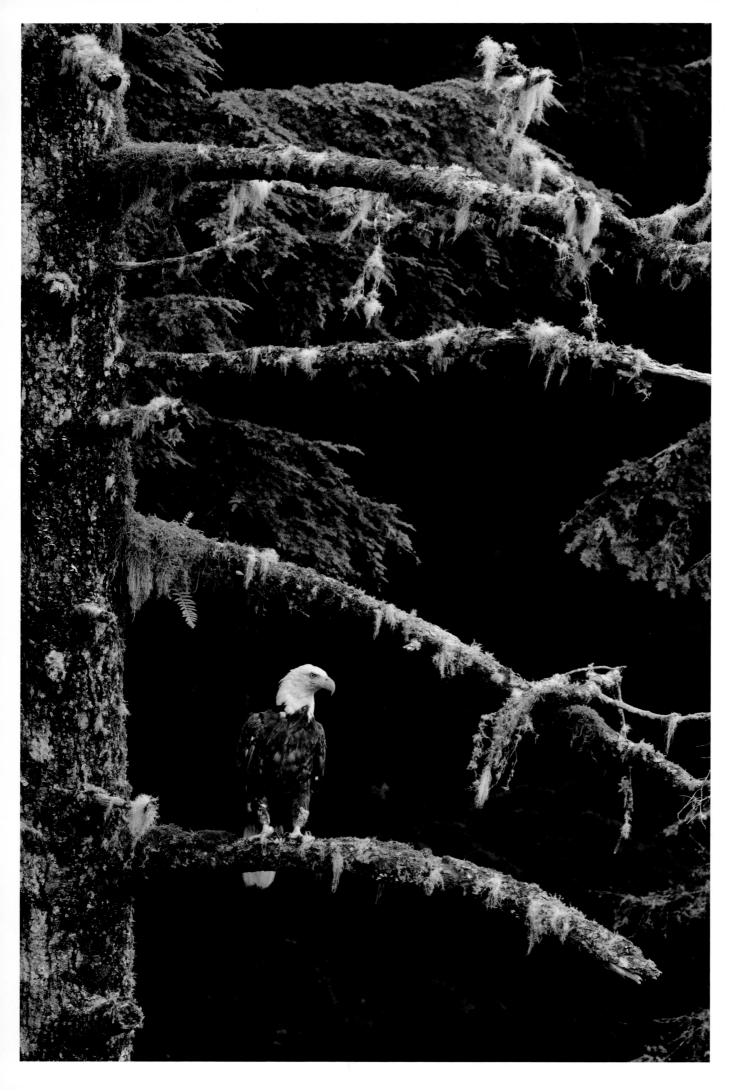

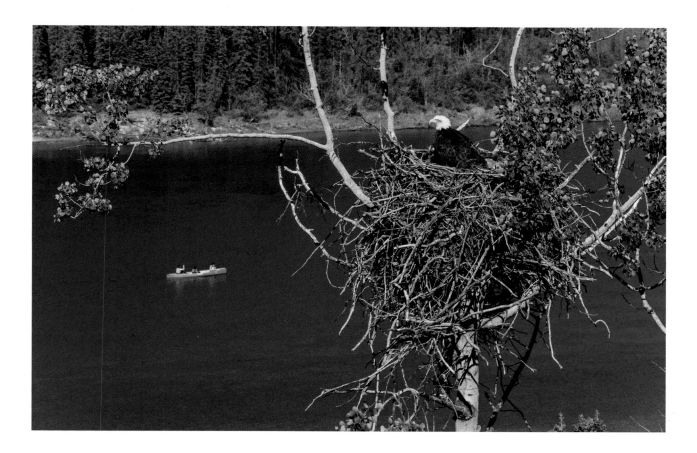

mammals, from rabbits and ground squirrels to deer fawns. At the coast, stillborn seal pups, crayfish, and octopus have been recorded as prey. Farmers sometimes accuse this eagle of attacking lambs, but such claims are seldom verified. It does, however, take plentiful carrion—especially in winter, when it scavenges from carcasses up to the size of beached whales. It is also a kleptoparasite, stealing food from other predators.

The Bald Eagle breeding cycle starts with a dramatic aerial courtship display, in which male and female swoop, cartwheel, lock talons, and freefall. Each pair defends a waterside territory of some 0.6 to 1.2 miles (1–2 km), within which they build their nest—usually high in a tall, mature tree, although they may be sited lower if surrounded by water. The nest is the largest stick construction of any bird. The largest recorded measured 9 feet 6 inches (2.9 m) wide by 20 feet (6 m) deep and was estimated to weigh more than 2 tons (1,814 kg). Nests seldom last more than five years, as the ever-expanding structure generally breaks the tree or collapses in a storm.

The female lays her clutch of one to three eggs (typically two) as early as late February, often with snow still on the ground. Incubation lasts for thirty-four to thirty-six days, with both male and female taking turns. Siblicide is rare, though in the early days, when the size difference is greatest, the smaller chick may perish. The eaglets gain up to 60 ounces (170 g) a

day, the fastest growth rate of any North American bird. They fledge after eight to fourteen weeks, in June or early July, but stay around the nest for another six to eight weeks before dispersing.

Adult Bald Eagles have no regular predators and may live more than twenty years in the wild (thirty-eight has been recorded). Nestlings are at more risk, with predators including hawks, owls, and raccoons known to snatch them—although adults protect their nest fiercely and have been known to knock a black bear from a tree. The main threats are human. The bird's rapid decline during the twentieth century came down to two major factors. First, excessive hunting: in Alaska alone, bounty hunters killed more than 100,000 eagles between 1917 and 1952. Second, pollution: in particular from the insecticide DDT, which worked its way up the food chain to cause egg-thinning and widespread breeding failure. By the 1950s, the bird had plummeted from an estimated eighteenth-century population of 300,000 to 500,000 to only 412 pairs across the forty-eight contiguous states of the United States. Thankfully, conservation prevailed. In 1967, the species was declared Endangered and in 1972, DDT was banned. Recovery has been dramatic, with a 779 percent increase in forty years. In 1995, the eagle's conservation status was downgraded from Endangered to Threatened, and in 2007 it was removed from both lists in the lower forty-eight states of the United States.

OPPOSITE A Bald Eagle finds a lookout in the towering temperate rainforest of Vancouver Island, British Columbia.

ABOVE A Bald Eagle at its nest above the Yukon River, Canada. This species makes the largest known stick nest of any bird. WINGS OVER THE WATER

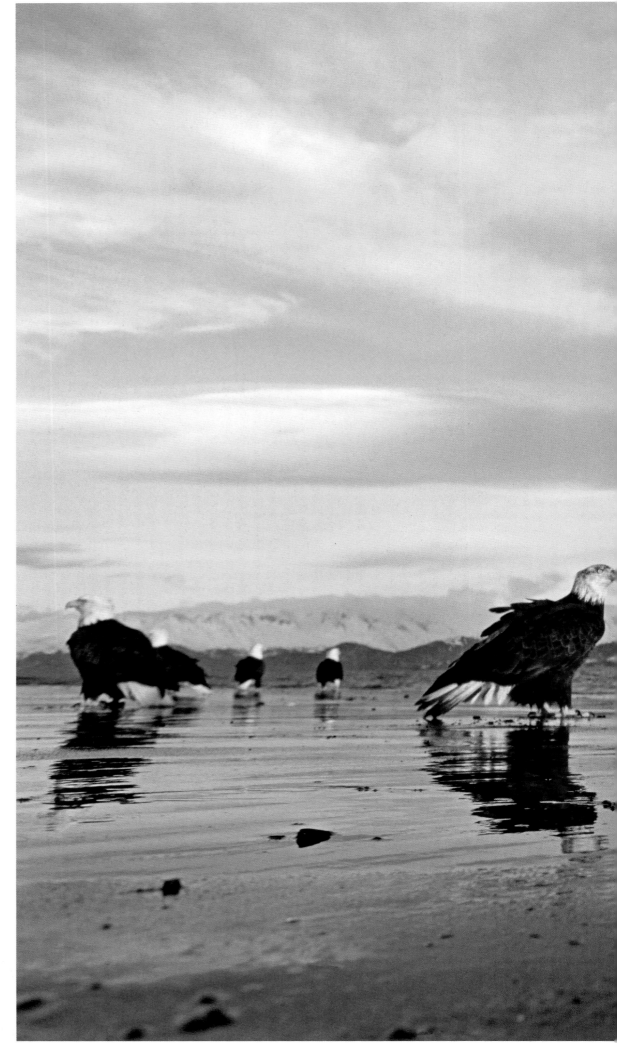

RIGHT Bald Eagles gather on a beach in Alaska, where they await handouts from a local fisheries plant.

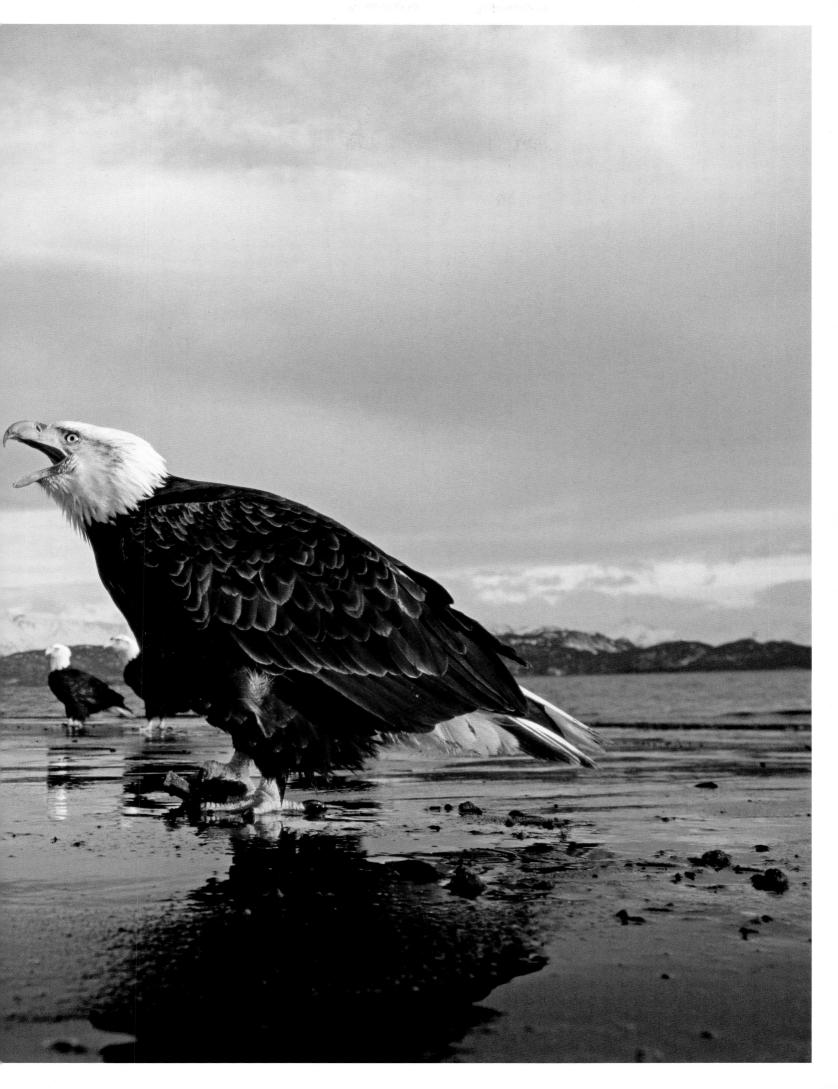

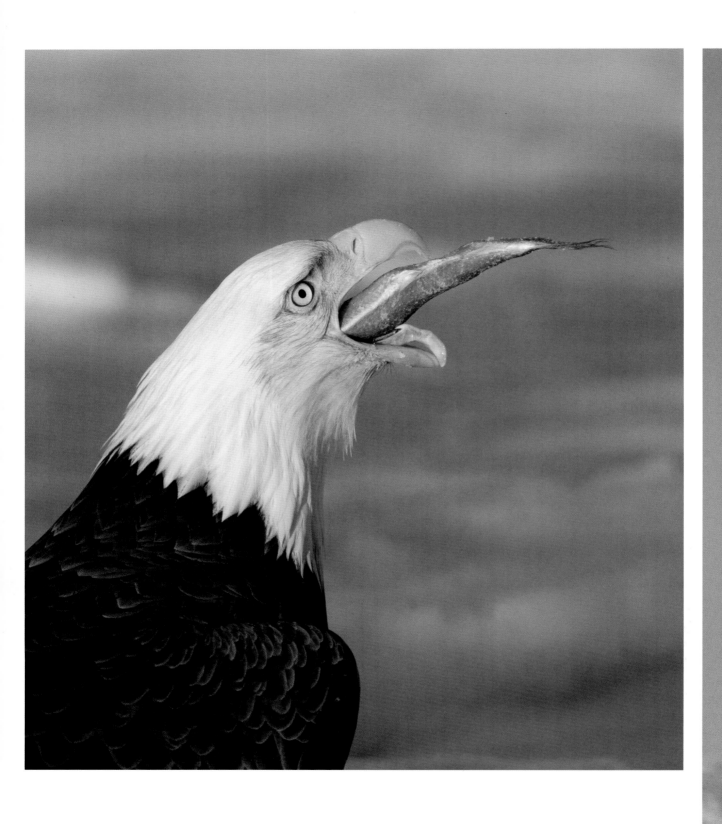

ABOVE A Bald Eagle generally tears larger fish into pieces to ingest but may swallow smaller fish whole.
RIGHT The white head and white tail of an adult Bald Eagle distinguish it from any other large U.S. raptor.

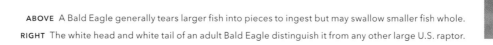

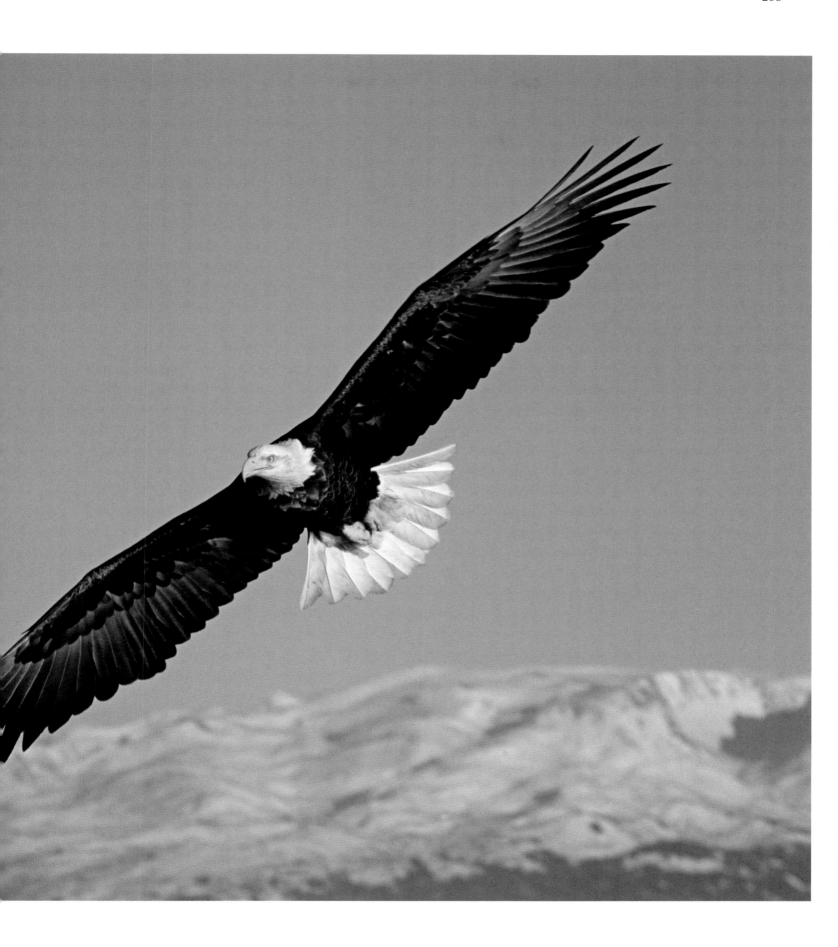

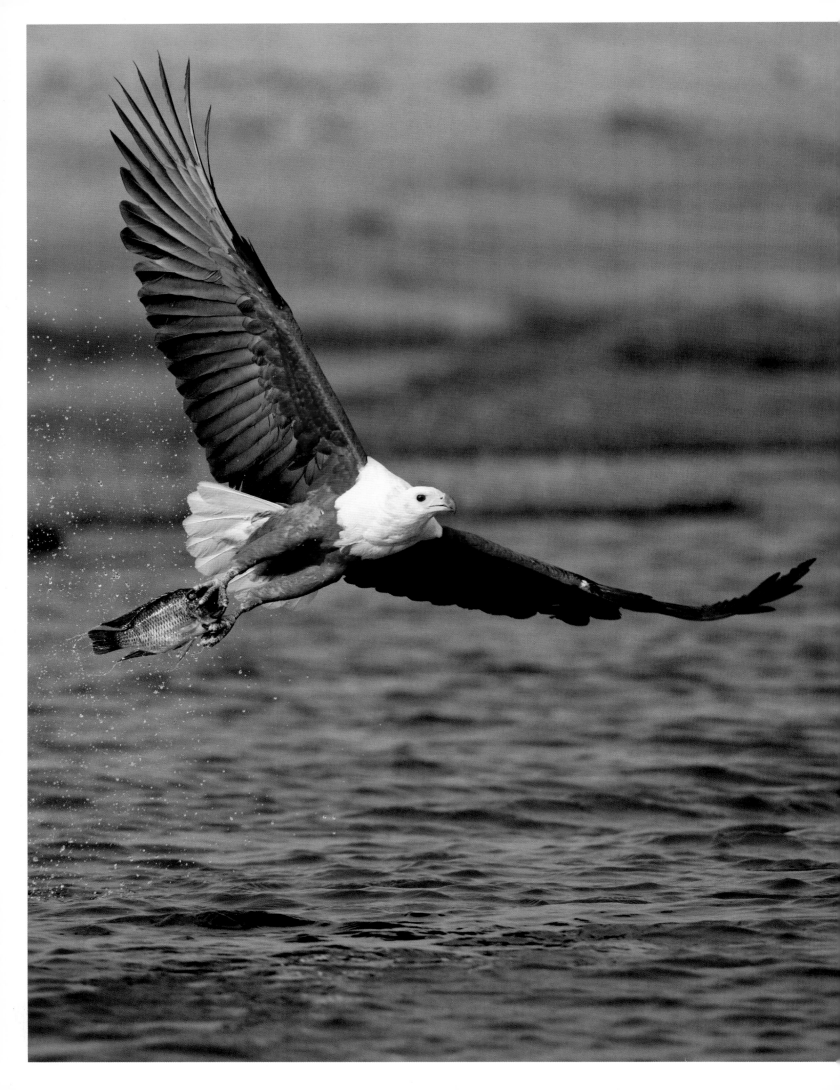

AFRICAN FISH-EAGLE

HALIAEETUS VOCIFER

APPEARANCE
Large; head, neck, breast, and tail snow-white; belly and wing coverts chestnut; wings black; feet yellow, with deeply curved talons; bill yellow with black tip; cere and naked face yellow; eyes dark brown; immatures scruffy brown, mottled, and streaked with white; in flight, appears broad-winged and short-tailed.

SIZE
length 25–29½ in. (63–75 cm)

weight female 7.1–7.9 lb (3.2–3.6 kg); male 4.4–5.5 lb (2–2.5 kg) wingspan 5 ft 8 in.–6 ft 9 in. (1.75–2.1 m)

DISTRIBUTION
Sub-Saharan Africa; from Senegal east to Sudan, and south to South Africa's Cape; absent only from the most arid areas of eastern and southwestern Africa.

STATUS
Least Concern

"THE SOUND OF AFRICA." There can be few birds whose voice is more evocative of an entire continent than the African Fish-eagle. This raptor's high, yelping call—a gull-like "weee-ah, kluu, kluu, kluu"—rings out from Lake Victoria to the banks of the Zambezi River, evoking a sense of wilderness.

With such a strident call—plus striking plumage and a spectacular fishing technique—it is little wonder that this raptor is deeply embedded in African culture. The mysterious Zimbabwe bird statues, discovered in the ancient ruins from which the country took its name, are thought be representations of this species, and today it is the national bird of Zimbabwe, Namibia, Zambia, Malawi, and South Sudan.

An adult African Fish-eagle is unmistakable in its handsome livery of snow-white head, breast, and tail, rich chestnut belly and shoulders, and coal-black wings. It has yellow feet, with deeply curved talons, a black-tipped yellow bill, and a yellow cere that extends into a naked yellow face. The immature is scruffier, its brown plumage mottled and streaked with white. In flight, this eagle has the typical broad-winged, short-tailed silhouette of all *Haliaeetus* sea-eagles.

The African Fish-eagle ranges widely across sub-Saharan Africa, from Senegal east to Sudan in the north, then south across the entire continent to South Africa's Cape. It occurs in numerous habitats, from tropical rain forest to savanna, provided there are large water bodies that are well stocked with fish. It is absent only from the most arid areas of eastern and southwestern Africa, where such water bodies are absent. Notable concentrations occur along East Africa's Rift Valley lakes, on large rivers such as the Zambezi and in wetlands such as Botswana's Okavango Delta.

In Africa, this species is known simply as "Fish-eagle." "African Sea-eagle" would be better, however, as it belongs to the *Haliaeetus* sea-eagle group rather than the true fish-eagles of the genus *Ichthyophaga*. Its closest relative is the Madagascar Fish-eagle (p. 268). It received its scientific species name *vocifer* from French naturalist François Levaillant (1753–1824), who described it as "the vociferous one."

African Fish-eagles are invariably seen in pairs, sometimes soaring high on a thermal but often perched high in a waterside tree, from where they can see any fish near the surface. Their diet comprises a higher proportion of fish than any other *Haliaeetus* species: up to 90 percent, according to some studies. Typically, they still-hunt from a perch, scanning the water for movement then descending in a long glide before throwing both legs forward to pluck their catch from the water. Despite the resulting explosion of spray, they seldom enter more than leg-deep—unlike an osprey, which immerses itself completely. As in all *Haliaeetus* sea-eagles, rough scales on the underside of the feet, called spicules, add traction to the grip of the talons. Catch secured, usually in one foot, they then fly back to the tree to feed at leisure. Choice of fish varies by region, with catfish and lungfish preferred in many areas. Anything up to about 4 pounds (1.8 kg) may be lifted from the water. Above that, and the eagle is unable to take off and may have to drag its catch across the surface to the shore. In the dry season, when shrinking pools leave fish floundering in the shallows, the raptor may fish from the shore, simply wading in to grab its catch and flap back out again.

This opportunism extends to other prey. In the soda lakes of East Africa, the eagles specialize in targeting flamingos,

OPPOSITE An African Fish-eagle takes flight with a bream, plucked from the surface of Botswana's Chobe River.

swooping through their panicked ranks to seize a gangly victim. Along Zambia's Luangwa River, they target nesting colonies of southern carmine bee-eaters. Aquatic reptiles such as small terrapins, baby crocodiles, and monitor lizards are also sometimes taken, as are, occasionally, mammals such as hyraxes and young monkeys. This species is also a skilled kleptoparasite, patiently watching other fishers, such as the goliath heron and saddle-billed stork then stealing their catch.

However it gets its food, the African Fish-eagle is an extremely efficient predator. Studies show that an experienced individual in a region of abundant food may need to spend no more than ten minutes per day actively hunting, even though not all its attempted strikes are successful.

Breeding generally takes place during the dry season, when water levels are low and fish easier to catch. This means May to October in southern Africa and June to September in eastern coastal regions. A pair of African Fish-eagles mate for life. Courtship includes impressive aerial acrobatics, swooping, tumbling, and talon-grappling. This is when the birds are at their noisiest, pairs duetting with a yodeling call.

A pair maintains two or more large stick nests, each placed in the fork of a large tree near water. Nests are reused from one season to the next, growing larger with the addition of new nesting material, which includes reeds, papyrus heads, and the nests of weaver birds. In areas with abundant food, pairs may be more tolerant of one another than is often the case with large raptors, often nesting just a few hundred yards apart. The female lays one to three eggs, with incubation—for which she is largely responsible—lasting forty-two to forty-five days. Siblicide is uncommon, with two young often reared successfully. Youngsters fledge at sixty-five to seventy-five days and remain dependent on their parents for another three months. If they survive their first year, they may live up to twenty-four years.

With an estimated population of 300,000, the African Fish-eagle is listed by BirdLife International as Least Concern. The species has been a beneficiary of dam-building projects across Africa. However, its survival is dependent on healthy wetlands. In this respect, it acts as an environmental indicator: the disappearance of African Fish-eagles from an area is often evidence of contaminated waterways. And without that clarion call, the river seems eerily silent.

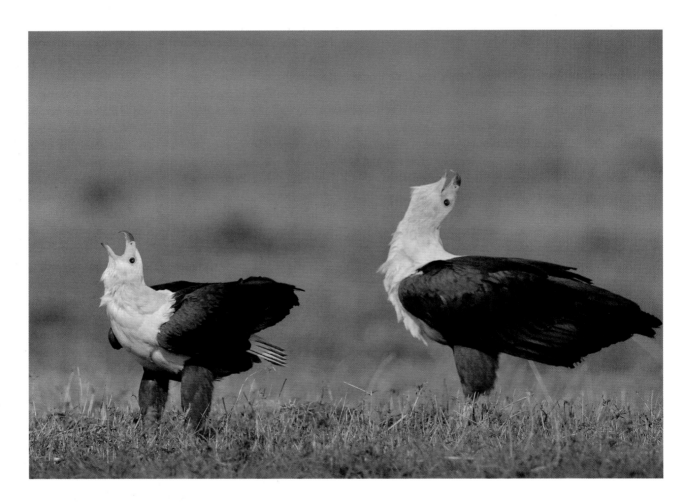

ABOVE African Fish-eagles often utter their famous calls in duet, throwing their heads right back over their shoulders.

OPPOSITE An African Fish-eagle harasses a marabou stork, attempting to steal its catch.

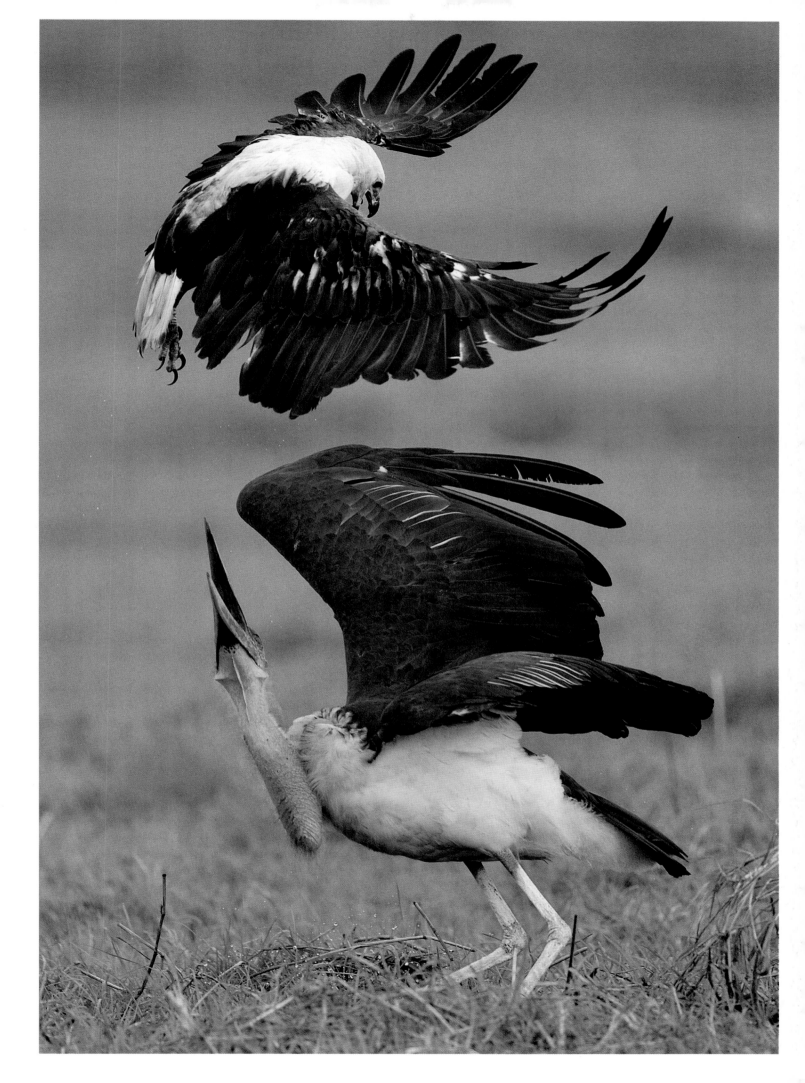

RIGHT Two African Fish-eagles on Botswana's Chobe River flinch at the aerial bombardment of a long-toed lapwing. Other water birds often harass this raptor, which poses a threat to their young.

WINGS OVER THE WATER

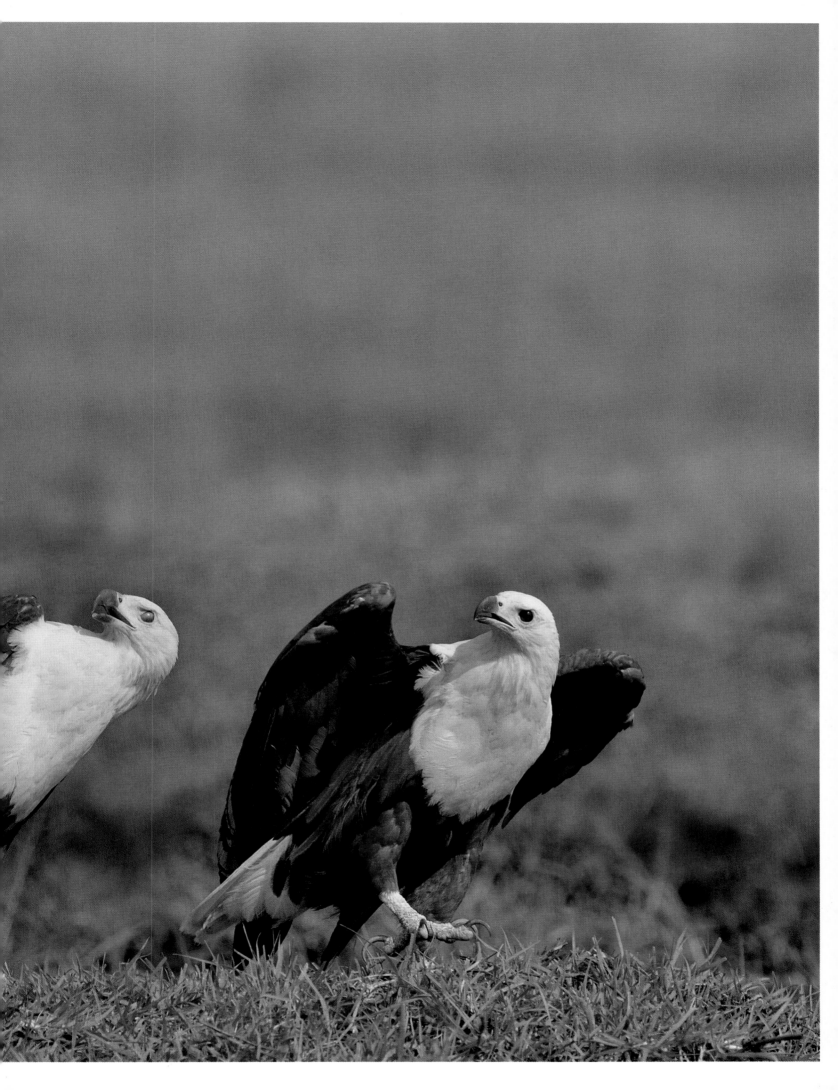

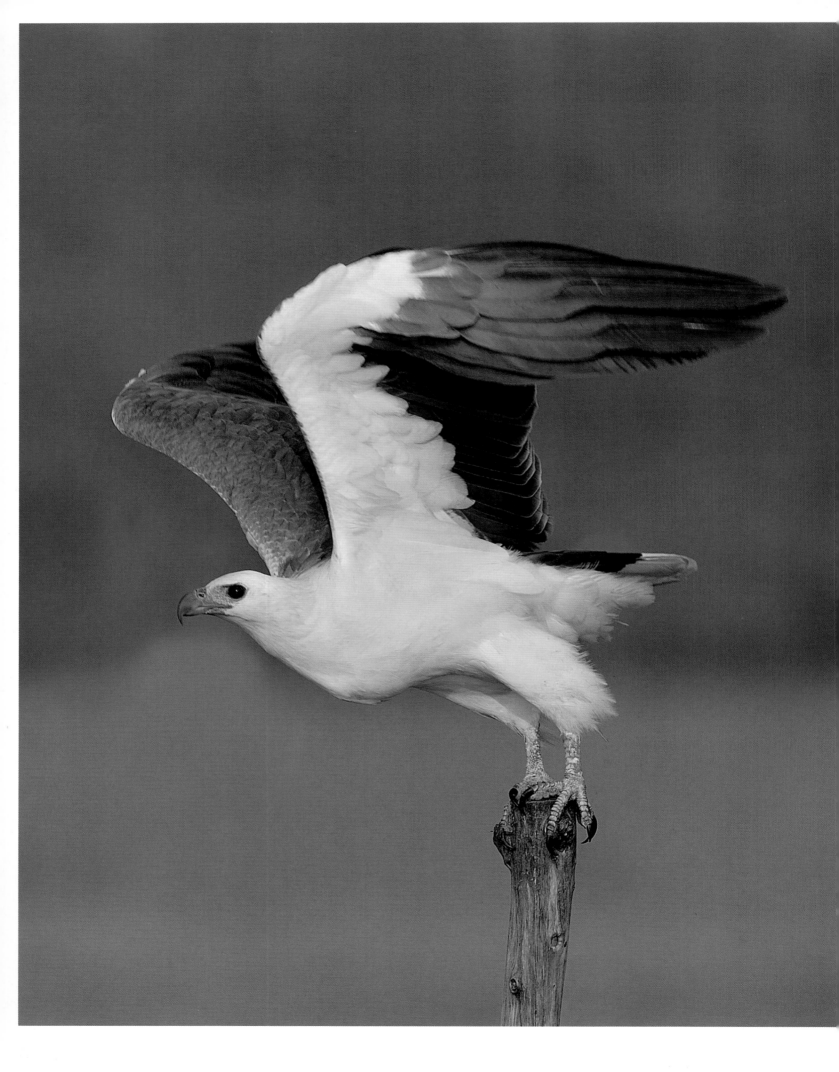

WHITE-BELLIED SEA-EAGLE

HALIAEETUS LEUCOGASTER

APPEARANCE

Large, with unfeathered legs, broad wings, and short, wedge-shaped tail; head, underparts, and tail white; back slate-gray; flight feathers black; cere and bill dark blue-gray, eyes dark and legs yellow or gray; soars with wings in a shallow "V"; immatures brown with creamy-white streaking.

SIZE

length female 31–35 in. (80–90 cm);

male 26–31 in. (66–80 cm) weight female 5.5–9.9 lb (2.5–4.5 kg), male 4–6.6 lb (1.8–3 kg) wingspan 5 ft 9 in.–7 ft 3 in. (1.7–2.2 m).

DISTRIBUTION

South Asia; southeast Asia, including Malay Peninsula, the Philippines, Hong Kong, and Indonesia; Australasia.

STATUS

Least Concern

THIS RAPTOR HAS LONG BEEN celebrated in the cultures of the different peoples who share its wide range. In Malay folklore, it is *burung hamba siput*, the "slave of the shellfish," its goose-like honking thought to warn shellfish of the turning tide. In Australia's Northern Territory, the Mak Mak people take their name from the bird. Even in modern-day Singapore, the bird is featured on the $10,000 note.

The White-bellied Sea-eagle is a large species with the typical sea-eagle profile: unfeathered legs, broad wings, and short, wedge-shaped tail. It is the whitest *Haliaeetus* species, being pure white on the head, underparts, and tail, with a slate-gray back and black flight feathers. The cere and bill are dark blue-gray and the legs yellow or gray. When soaring, it holds its wings in a stiff, shallow "V." Immatures are brown with creamy white streaking.

This eagle ranges widely around much of tropical Asia and Australasia. It occurs on numerous small Indian Ocean and Pacific Islands, though in the Northern Solomon Islands is replaced by Sanford's Sea-eagle (p. 266). Stragglers have even made it to New Zealand. It is chiefly a species of coasts and major waterways, including estuaries, lakes, billabongs, and mangroves. The White-bellied Sea-eagle first came to the attention of western science in 1781, noted off western Java by ornithologist John Latham (1740–1837) on Captain James

Cook's last voyage, but was not described until 1788. Molecular research has revealed that it forms a super-species with Sanford's Sea-eagle, the latter differing by virtue of its dark head. The two species may have diverged as recently as 150,000 years ago.

Like all sea-eagles, this is a highly opportunistic predator. Fish make up at least half its diet, typically snatched from the surface. It also captures marine reptiles, such as turtles and sea snakes, water birds, from coots to cormorants, and a few mammals—notably flying foxes, grabbed in flight or from their hanging roosts. It shares the general *Haliaeetus* talent for piracy, stealing catches from smaller raptors. Among its more enterprising feeding techniques are following dolphins to catch prey they have flushed, and dropping crabs from a height in order to break into their shells.

Some White-bellied Sea-eagles are nomadic. Others form life-long pairs and may occupy the same territory for many years. Breeding is heralded with loud honking duets and spectacular, talon-grappling display flights, the pair following each other across the sky. The large stick nest is built in a tall tree or electrical tower, and lined with grass and seaweed. Some pairs may also build on sea cliffs and, on remote islands, on the ground. The female lays two eggs, which she incubates for around six weeks. It is unusual for both young to survive. Fledging takes seventy to eighty days, after which the youngster may remain in its parents' territory for six months or more, before dispersing. If it survives its first year, it may live for another thirty.

With a population estimated at 10,000 to 100,000 individuals, BirdLife International lists this species as Least Concern. In parts of Australia, the creation of dams and the introduction of the common carp has allowed it to increase its range. However, in other areas—including Thailand and southeastern Australia—it has declined, generally due to human disturbance at its nest and the loss of suitable nesting trees. Other threats include military exercises, pesticide pollution, and collision with power lines.

OPPOSITE A White-bellied Sea-eagle takes flight, revealing plumage whiter than in any other *Haliaeetus* species.

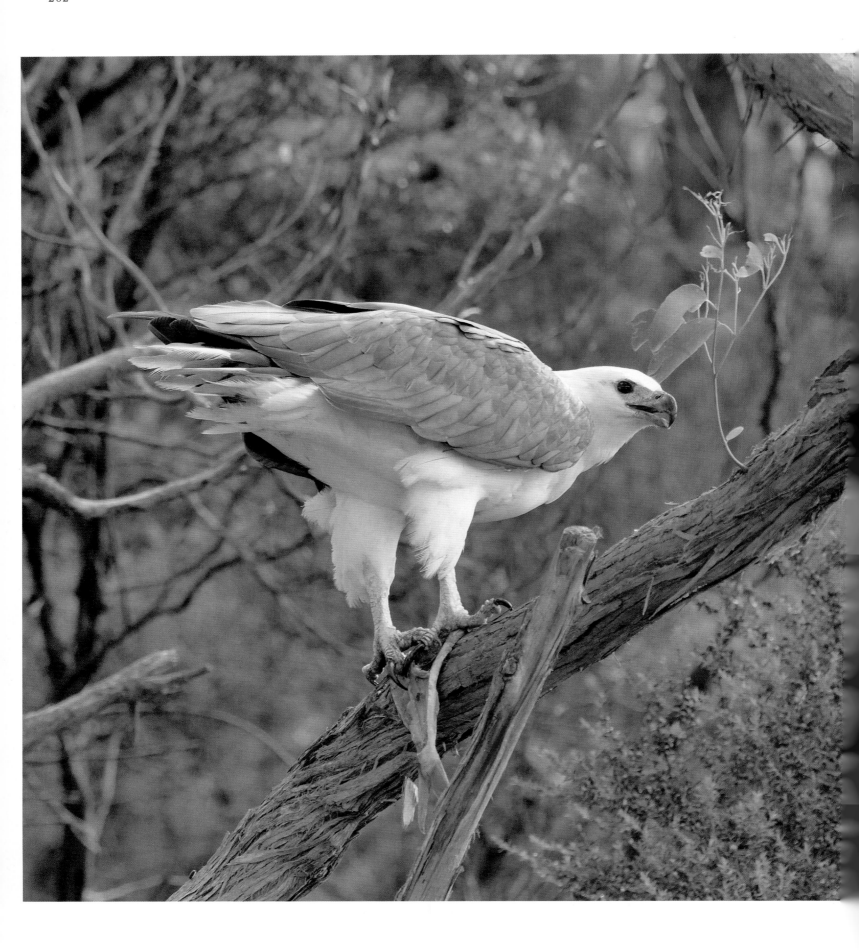

WINGS OVER THE WATER

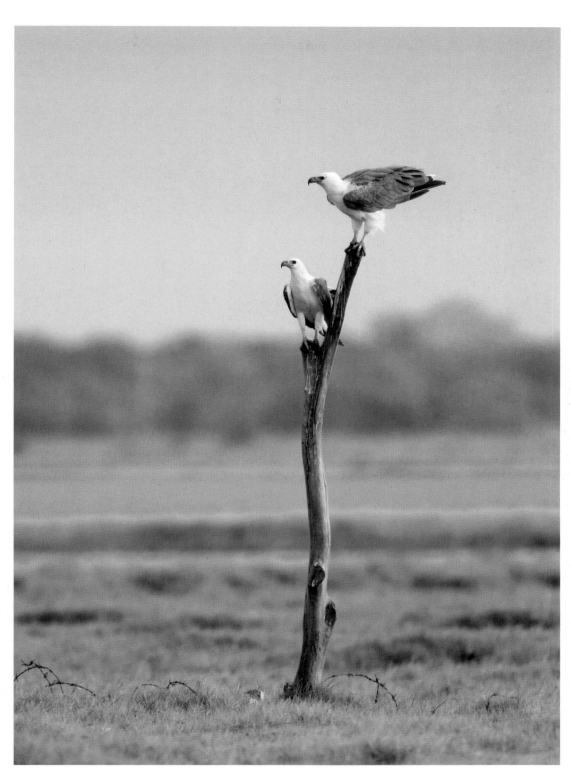

LEFT A White-bellied Sea-eagle perches on a favorite waterside spot with a fish it has captured and already half consumed.

ABOVE Like all *Haliaeetus* sea-eagles, pairs of this species often stick close together.

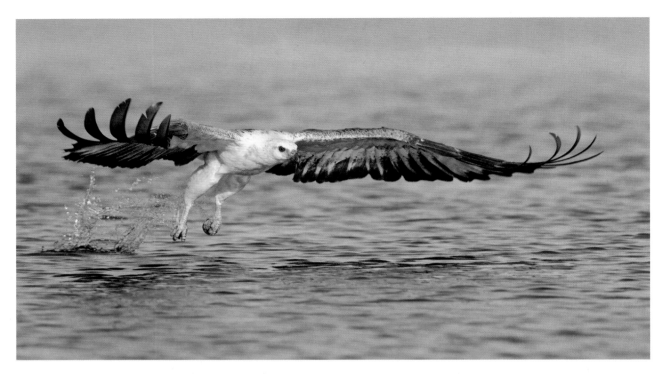

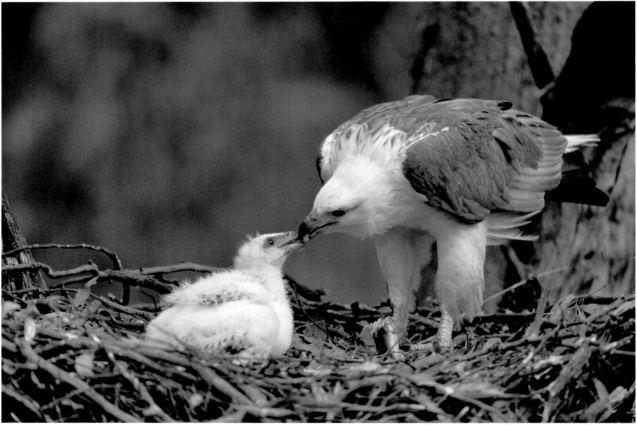

TOP Missed! Not every strike is successful. The mottled plumage of this White-bellied Sea-eagle reveals that it is a young and thus inexperienced bird.

ABOVE A White-bellied Sea-eagle shows great delicacy in delivering food to its single chick.

OPPOSITE A White-bellied Sea-eagle perches at a favorite fishing lookout, revealing the impressive length of its sharply curved talons.

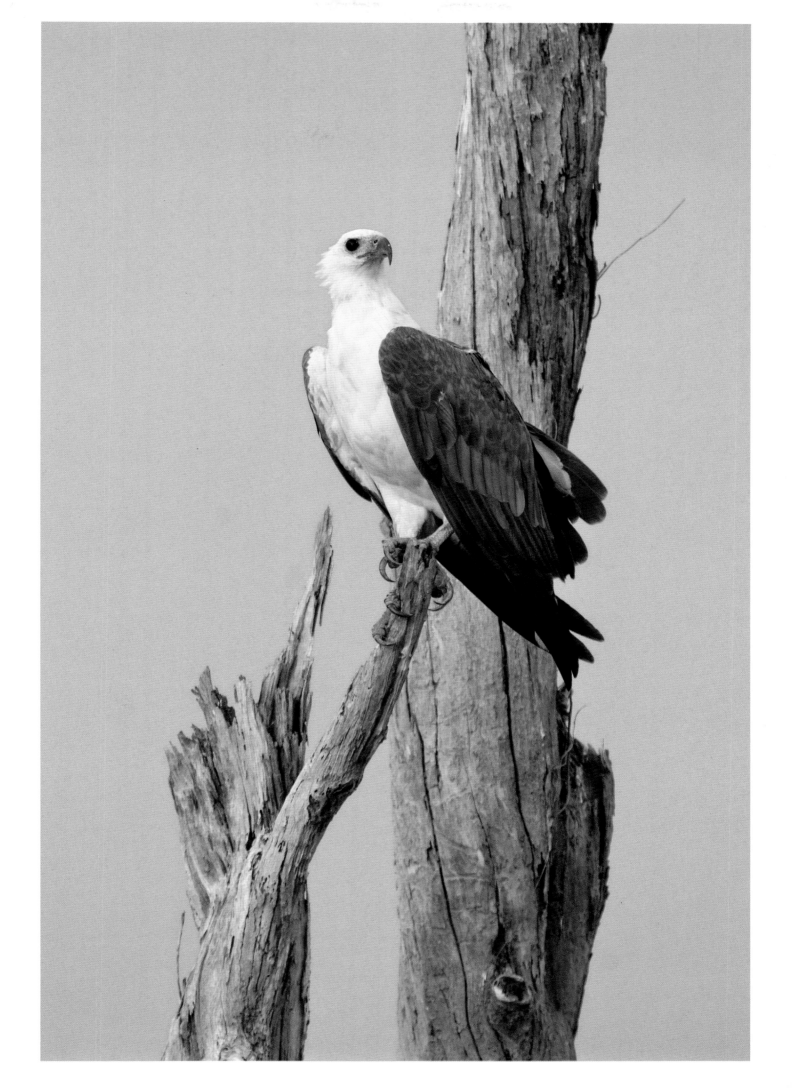

SANFORD'S SEA-EAGLE

HALIAEETUS SANFORDI

APPEARANCE
Medium-large, with long neck, shortish, wedge-shaped tail, and broad wings; unfeathered tarsi and long, curved talons; head creamy to pale brown; underparts rusty brown; back dark grayish-brown; tail all dark; eyes brown, cere gray, and bill gray with black tip; immatures have browner head and pale-edged upperparts.

SIZE
length 28–35 in. (70–90 cm)
weight 15–20 lb (1.1–2.7 kg)
wingspan 5 ft 5 in.–6 ft (1.7–1.8 m)

DISTRIBUTION
The Solomon Islands, on all principal islands except Rennell; also Bougainville and Buka islands, Papua New Guinea.

STATUS
Vulnerable

IN THE BLUE WATERS OF THE South Pacific, one eagle has claimed a kingdom of its own. Sanford's Sea-eagle is the only large raptor on the Solomon Islands and, apart from the saltwater crocodile, is the archipelago's biggest predator. It was not until 1935, however, that U.S. scientist Ernst Mayr (1904–2005) recognized the bird as a species in its own right. Mayr named the bird after Leonard C. Sanford (1868–1950), amateur ornithologist and trustee for the American Museum of Natural History. Today, it is also called Solomon Eagle, and is commemorated on the nation's postage stamps.

Sanford's Sea-eagle is a relatively small *Haliaeetus* sea-eagle, though hefty nonetheless. It shares the group's characteristic profile of short, wedge-shaped tail, broad wings, unfeathered legs, and long, curved talons. Closely related to the White-bellied Sea-eagle (p. 260), it differs in having a creamy to pale-brown rather than white head, rusty-brown underparts, and a browner back. It is the only sea-eagle with a completely dark tail. The eyes are brown and the cere and bill gray. Immatures have a browner head and pale-edged upperparts.

This species occurs on the principal Solomon Islands, with the highest numbers recorded on the New Georgia group. It would be considered endemic were it not for the fact that a small population also occurs on the neighboring islands of Bougainville and Buka, part of Papua New Guinea. It frequents coastal forests, mangroves, and tidal flats, but also wanders upriver to the rain forest interior.

Molecular studies show that Sanford's Sea-eagle is closely related to the White-bellied Sea-eagle, differing genetically by only 0.3 percent. The lineages are thought to have diverged less than one million years ago. The two form a "species pair," in which, like other *Haliaeetus* species pairs (Bald Eagle/White-tailed Eagle; African Fish-eagle/Madagascar Fish-eagle), one's head is white and the other's pale brown.

Sanford's Sea-eagle forages for dead fish, crabs, sea snakes, and other prey along the shoreline. It also captures pigeons from the forest canopy, and hunts arboreal mammals. In settled areas, it is known to capture chickens and domestic cats, and to scavenge dead feral dogs. Like all sea-eagles, it is an accomplished pirate and often steals fish from ospreys.

Little is known about this eagle's breeding cycle. A pair displays together in synchronized rocking flight, legs dangling and wings held up in a "V," and duets with loud honking calls. They build a large stick nest in a tall tree. Clutch size, incubation, and fledging times probably mirror that of the White-bellied Sea-eagle.

This species has a limited range, and with a declining population estimated at 250 to 999 individuals is listed by BirdLife International as Vulnerable. Its main threats come from habitat degradation, both from logging and pollution in coastal areas. Shooting—for food, sport, and in retribution for occasional attacks on poultry—is a concern, as is capture for the illegal pet trade. More research is needed to establish a clearer picture of the species' conservation status.

OPPOSITE A pair of Sanford's Sea-eagles tend to their nest in the Solomon Islands.

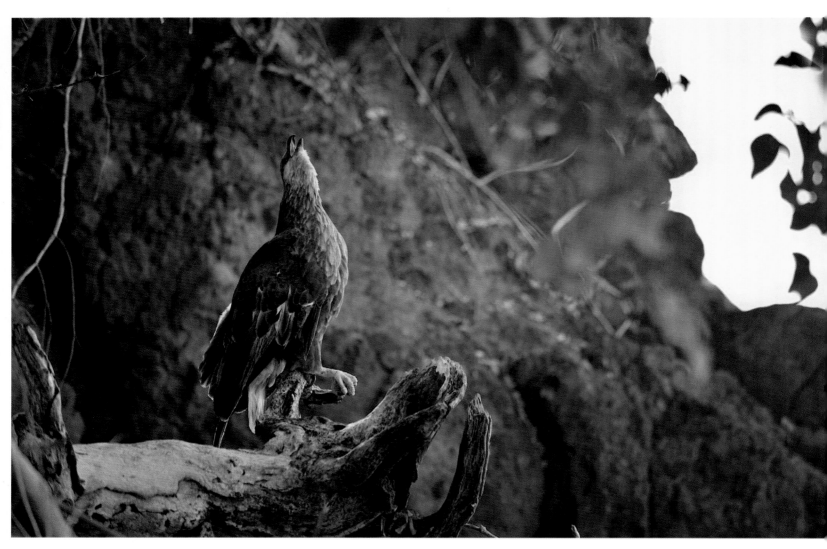
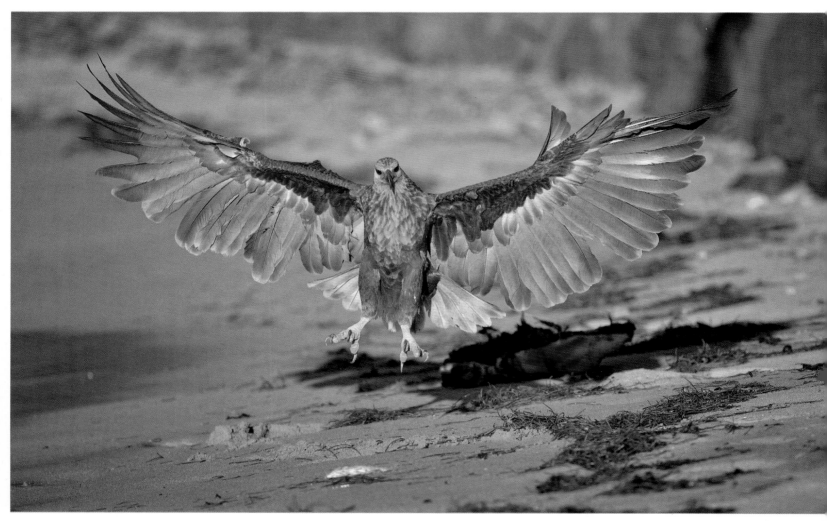

MADAGASCAR FISH-EAGLE

HALIAEETUS VOCIFEROIDES

APPEARANCE
Medium-large; broad wings, unfeathered tarsi, and long, curved talons; head pale brown with whitish cheeks and throat and dark cap; body and wings reddish brown, with darker flight feathers; tail white, short, and wedge-shaped; bill blackish with paler base; eyes dark and legs pale gray; immatures streaked on head, with dark tail and paler fringes to flight feathers.

SIZE
length 23½–26 in. (60–66 cm)
weight female 6.2–7.7 lb (2.8–3.5 kg); male 4.9–5.7 lb (2.2–2.6 kg)
wingspan 5 ft 5 in.–5 ft 11 in. (1.65–1.80 m)

DISTRIBUTION
Madagascar; northwest coastal strip, from Morombe to Diego Suarez.

STATUS
Critically Endangered

THE MADAGASCAR FISH-EAGLE IS THE largest raptor in Madagascar, and one of the rarest birds in the world, with a breeding population of little more than 100 pairs.

This eagle is a sister species of the African Fish-eagle (p. 254) and is similarly known for its high ringing call. In common with other *Haliaeetus* species pairs, it is slightly smaller than its close relative, with a pale brown and cream rather than fully white head. Its body and wings are reddish brown, darker on the flight feathers, and its conspicuous white tail is short and wedge-shaped. The blackish bill has a paler base, the eyes are dark, and the legs pale gray. Immatures are streaked on the head, with a dark tail and paler fringes to the flight feathers.

The Madagascar Fish-eagle is endemic to Madagascar, where it is confined to a western coastal strip. Today, the population is concentrated in three main regions: the Antsalova region west of Bemaraha Nature Reserve; the Tsiribihina River; and the coast from Mahajamba Bay to the island of Nosy Hara. Prime habitat encompasses estuaries and other large water bodies with surrounding forest, including dry deciduous forest and mangroves.

This eagle is a specialist fish catcher, swooping down feet-first to pluck its prey from the surface. Other prey includes crabs, turtles, and, occasionally, other birds. The breeding season is May to October. A pair builds a stick nest in the fork of a tree or on rocky island crags. The female lays two eggs, which she incubates for thirty-seven to forty-three days. Only one chick generally survives, the other succumbing to bullying or starvation. It fledges after about eighty days. This eagle is unusual in practicing polyandry: one female mates with several males, which all assist in nesting. However, one-third of breeding attempts fail to produce an egg.

Numbers plummeted during the twentieth century, down to forty pairs. Recent research has resulted in a figure of around 120 breeding pairs, or 360 individuals. BirdLife International lists the species as Critically Endangered. Its threats are a familiar combination of habitat loss and persecution. The former includes deforestation (notably the felling of potential nesting trees) and the conversion of wetlands to rice paddies. The latter includes hunting driven by a superstition that the bird's foot carries healing powers: eagles have been captured and left with one foot chopped off to die of stress or starvation—although there is at least one example of an individual that survived such a gruesome event and bred successfully. Entanglement in fishing nets and competition with people for fish are also problems. Conservation measures center on protecting key sites, notably the Manambolomaty complex in the Antsalova region. In 1996, the Peregrine Fund initiated a targeted conservation program in order to further studies of this species and to help local people share their natural resources sustainably with the birds. The release of individuals rescued from siblicide in the nest and raised in captivity has boosted the wild population, and further captive breeding is under consideration.

OPPOSITE ABOVE A Madagascar Fish-eagle throws back its head to utter its high ringing call.

OPPOSITE BELOW The Madagascar Fish-eagle often feeds along the shoreline, swooping down to collect dead fish and other items left by the tide.

GRAY-HEADED FISH-EAGLE

ICHTHYOPHAGA ICHTHYAETUS

APPEARANCE
Medium-large and stocky; long neck with proportionally small head and small bill; legs relatively short, with unfeathered tarsi and long, recurved talons; tail white with broad dark band across tip; upperparts dark brown; thighs and belly white, breast brown; head gray with pale yellow eye; immatures paler and streakier with brown head and dark eyes.

SIZE
length 24–29½ in. (61–75 cm)
weight female 5–5.9 lb (2.3–2.7 kg), male 3.5 lb (1.6 kg)
wingspan 5 ft–5 ft 10 in. (1.6–1.7 m)

DISTRIBUTION
South and southeast Asia; from India and Sri Lanka to western Indonesia and the Philippines.

STATUS
Near Threatened

IT'S A STRANGE NOISE FOR a raptor: first, a subdued chuckling and gurgling, then an owl-like hooting followed by a nasal, goose-like honking, and finally a high-pitched scream. But this is the call of the Gray-headed Fish-eagle, expert fish-catcher of Asia's tropical waterways.

This medium-large eagle belongs to the *Ichthyophaga* genus of fish-eagles, slightly smaller than the *Haliaeetus* sea-eagles with which it was once grouped. Like its sister species, the Lesser Fish-eagle (p. 276), it has a long neck with a small head and a sharply hooked bill. The legs are relatively short, with unfeathered tarsi and very long, recurved talons. Its most striking plumage feature is a white tail, which—unlike that of any adult *Haliaeetus* eagle, except Pallas's Fish-eagle (p. 272)—has a broad dark band across the tip. Otherwise, it has dark brown upperparts, a white belly and thighs, a brown breast, and the gray head for which it is named. The eyes are a pale yellow. Immatures are paler and streakier with a brown head and darker eye, the head becoming gray as they mature.

The Gray-headed Fish-eagle ranges from India and Sri Lanka across southeast Asia into western Indonesia and the Philippines. Wherever it occurs, it frequents wetland habitats surrounded by lowland forest, from slow-moving rivers to lakes, reservoirs, marshes, estuaries, and lagoons. In Sri Lanka, it has acquired the local name tank eagle from its fondness for artificial irrigation reservoirs, known locally as tanks.

This eagle is generally seen perched upright on bare branches over water. In comparison with *Haliaeetus* sea-eagles, it spends little time soaring and no aerial displays have been described. A specialist fish-catcher, it dives down from its perch to snatch its prey from the shallows or quarters the water in slow flight, searching for dead fish floating at the surface. Fish too heavy to lift may be dragged to the shore and consumed there. Other prey includes aquatic reptiles such as water snakes, terrestrial birds, and the odd small mammal.

November to May is the breeding season, with some regional variations: in India, it prefers November to January; in Sri Lanka, December to March. A pair chooses a tall tree close to water and away from humans, in which they build a nest of sticks measuring up to 4 feet 10 inches (1.5 m) across and 6 feet 6 inches (2 m) deep. A female lays two to four eggs, typically two, and both parents share parental duties. Incubation lasts forty-five to fifty days, with the youngsters fledging seventy days after.

The Gray-headed Fish-eagle is in decline. The official population estimate is 10,000 to 100,000 individuals, with the true figure likely to be toward the lower end. BirdLife International lists the species as Near Threatened. Threats include habitat loss and degradation through deforestation, pollution, and over-fishing, as well as human disturbance. The construction of dams on the Mekong River is likely to affect the breeding population on Cambodia's Tonlé Sap lake, which has been the subject of a monitoring program since 2006. More monitoring is needed, as well as increased forest protection and an awareness campaign for local communities.

OPPOSITE A Gray-headed Fish-eagle sits out a rain shower; rain makes fish harder to see beneath the surface.

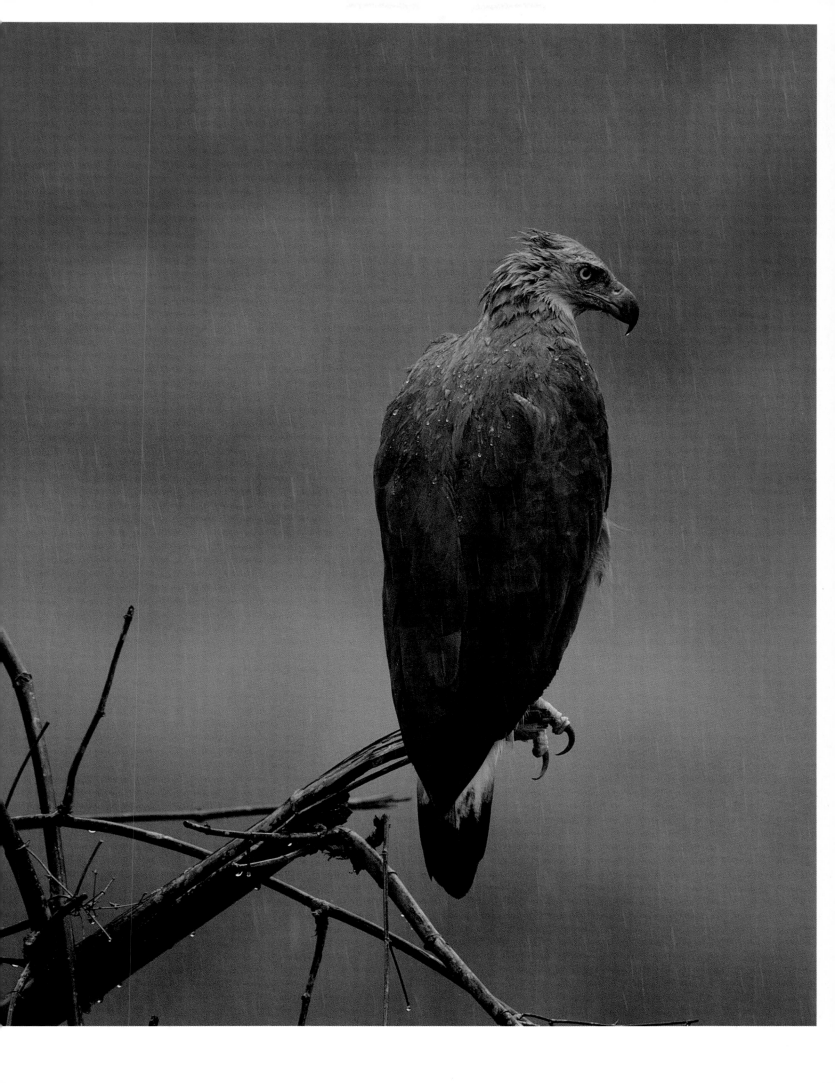

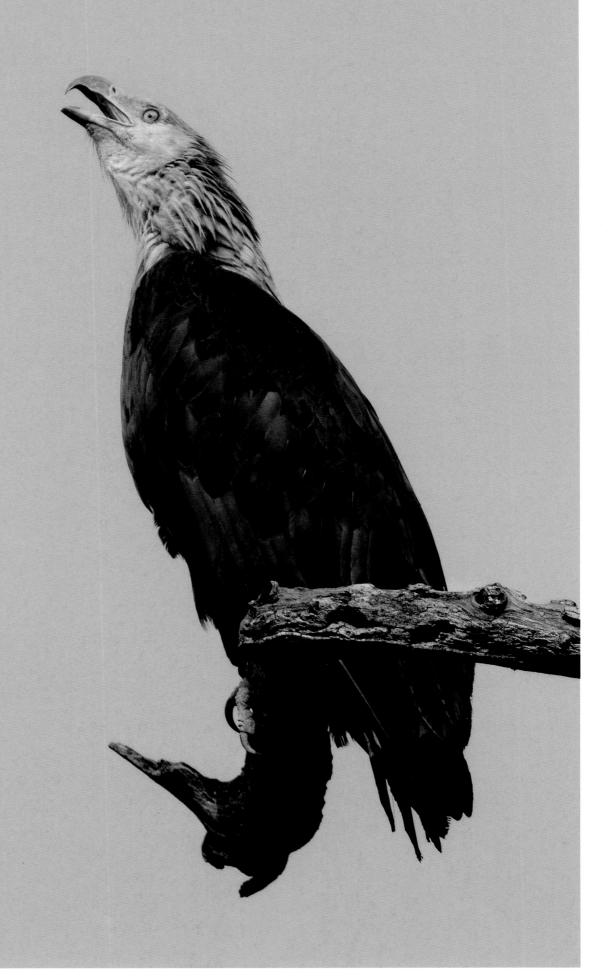

PALLAS'S FISH-EAGLE

HALIAEETUS LEUCORYPHUS

APPEARANCE
Large and bulky, with long neck and short tail; unfeathered tarsi; long dark talons and powerful dark bill; upperparts dark brown and underparts brown; head cream to pale brown; tail white with broad, black terminal band; in flight, long, broad wings show pale line along the coverts and pale flash in the primaries; immatures streaky brown, with darker head and tail.

SIZE
length 30–33 in. (76–84 cm)
weight 4.4–8.1 lb (2–3.7 kg)
wingspan 5 ft 10 in.–7 ft (1.8–2.12 m)

DISTRIBUTION
Breeds in northern India, Bangladesh, Myanmar, and Bhutan; visits Central Asia; partially migratory; some non-breeding birds travel farther north and south.

STATUS
Endangered

WHEN PRUSSIAN ZOOLOGIST Peter Simon Pallas (1741–1811) made his expeditions to southern and central Russia, this big eagle would have been a common sight beside the rivers and lakes of the vast interior. It subsequently became one of numerous species to take its name from the adventurer. Today, it has vanished from much of its former range.

Pallas's Fish-eagle belongs to the *Haliaeetus* group of sea-eagles. It shares the group's bulky profile, with a powerful bill, long talons, and unfeathered tarsi. Unlike the others, however, its white tail has a broad, black band across the tip, which explains its alternative name of Band-tailed Fish-eagle. This feature gives it a passing resemblance to other *Ichthyophaga* fish-eagles, but it is a larger bird, with entirely brown underparts, darker brown upperparts, and a cream to pale brown head and neck, more reminiscent of an immature Madagascar Fish-eagle (p. 268). In flight, its long, broad wings show a pale line along the coverts and a pale flash in the primaries. Immatures are streakier brown, with a darker head and tail.

This species once bred in a broad band across the steppes of Central Asia, from Kazakhstan through southern Russia to Mongolia and southern China, but the latest surveys suggest it now only frequents these regions as a non-breeding visitor. Today, the breeding population is probably confined to northern India, Bangladesh, Myanmar and, marginally, Bhutan. It is a partially migratory species, though little is known about its movements. Some non-breeding populations travel north of the Himalayas while others head southwest toward the Persian Gulf. Across its breeding range, it inhabits wetlands, including lakes and large rivers, from the lowlands up to altitudes of more than 13,100 feet (4,000 m).

Pallas's Fish-eagle is a versatile and opportunistic predator. Primarily a fish-eater, it also takes water birds up to the size of geese. Frogs, turtles, and other aquatic reptiles also make the menu, and it will harass and steal prey from other birds.

The breeding season starts in early November toward the south of its range and from early March farther north. Pairs are monogamous, and the two birds work together to build a large stick nest, usually near the highest point of a waterside stand of tall trees, and line it with hay, rushes, leaves, and other soft materials. The female lays one to three eggs. Incubation lasts forty to forty-five days, with the last egg usually failing to survive. Both parents work together to provide for their brood.

Pallas's Fish-eagle declined dramatically during the twentieth century and now appears to have lost most of its Central Asian breeding range. Today, with a population estimated at fewer than 2,500 individuals, BirdLife International lists the bird as Endangered. Its habitat faces numerous threats, from the draining of wetlands and felling of nesting trees to over-fishing and, in India, the spread of the invasive water hyacinth, which chokes lakes and waterways. Only a concerted conservation effort will ensure that the bird is not consigned to history.

OPPOSITE Pallas's Fish-eagle marks the start of the breeding season with its persistent guttural call, typically given from a bare branch over the water.

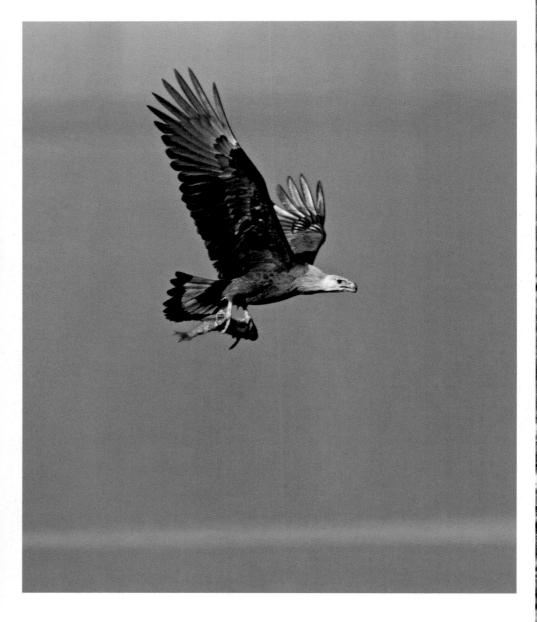

ABOVE A powerful bird, Pallas's Fish-eagle is known to capture fish weighing up to 13 pounds (6 kg), as heavy as itself.

RIGHT Pallas's Fish-eagle is largely an inland species, typically hunting around the shoreline of large lakes.

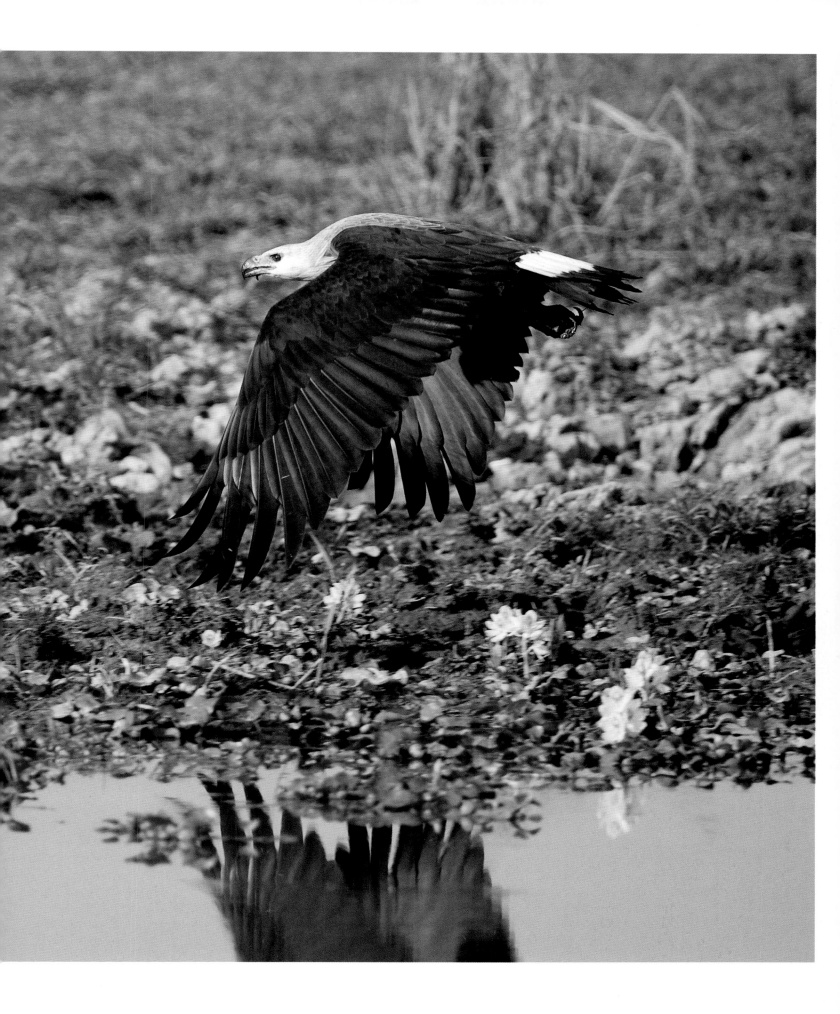

WINGS OVER THE WATER

LESSER FISH-EAGLE

ICHTHYOPHAGA HUMILIS

APPEARANCE
Small-medium; stocky, with short tail, unfeathered tarsi, long neck, small head, and smallish, sharply hooked bill; upperparts dark brown; head and neck brownish-gray; breast brown and belly and thighs white; darkish tail, with pale base and indistinct darker terminal band; immatures similar in color but streakier.

SIZE
length 20–26 in. (51–68 cm)

weight 1.7 lb (785 g)
wingspan 3 ft 11 in. – 5 ft 5 in. (1.2–1.7 m)

DISTRIBUTION
South and southeast Asia; Indian subcontinent, both in the Himalayan foothills and Karnataka in the south; east to Nepal, Myanmar, and China; south through the Malay Peninsula to Indonesia, including Thailand, Laos, Cambodia, and Vietnam.

STATUS
Near Threatened

THIS SPECIES IS THE SMALLEST OF THE specialist fish-catching eagles. It is one of two species in the *Ichthyophaga* genus, alongside the slightly larger Gray-headed Fish-eagle (p. 270), which it closely resembles. Both were formerly grouped with the *Haliaeetus* sea-eagles, and share a similar fish-eating lifestyle. But both are a little smaller and even more dependent on fish as a diet—a fact reflected in the extreme curvature of their long talons, which more resemble those of an osprey than any other eagle.

The Lesser Fish-eagle is small to medium in size, with a short-tailed, stocky build, and unfeathered tarsi. It has a long neck with a proportionally small head and a small, though sharply hooked, bill. Its coloration is similar to that of the Gray-headed Fish-eagle, with dark brown upperparts, a brown breast, and a white belly and thighs. The head is browner, however, contrasting less with the back and breast, and the tail is darker, with a less distinct terminal band. Immatures are similar in color but streakier.

This species shares much of its range with the Gray-headed Fish-eagle, which means the two similar-looking birds

are sometimes mistaken for one another. It has a scattered distribution in the Indian Subcontinent, found primarily in the Himalayan foothills but also in an isolated population in Karnataka in the south. From India, it ranges east, through Nepal, Myanmar, and southern China, down through the Malay Peninsula to Indonesia, with scattered populations in Thailand, Laos, Cambodia, and Vietnam. Two subspecies are recognized: the nominate race *I. h. humilis* is native to the Malay Peninsula, Sumatra, Borneo, and Sulawesi; the more northeasterly race *I. h. plumbeus* is native to India, Nepal, and Myanmar.

Across its range, this eagle inhabits the forested margins of lakes, rivers, and wetlands, and is often found around hill streams and fast-running water. Though usually occurring at altitudes of below 3,300 feet (1,000 m), it has been recorded at more than 7,870 feet (2,400 m) in Nepal. It tends to move on rotation between favorite hunting spots, from trees overhanging the water to rocks and logs in mid-stream, flying out to snatch fish from near the surface.

Like the Gray-headed Eagle, this is a highly vocal species, whose loud cackling calls sound from a distance like a querulous child. Pairs become particularly vocal during the breeding season, which is March to August in India and Nepal and November to April in most other places. Little is known about the breeding cycle. A female lays two to four eggs in a nest of sticks, up to 3 feet 2 inches (1 m) across and 4 feet 10 inches (1.5 m) deep and lined with green leaves. Incubation and fledging rates are unknown but likely to be similar to those of its sister species. Habitat loss and disturbance remain threats for this species, which is uncommon and declining across much of its range. BirdLife International lists it as Near Threatened, with a population estimated at 10,000 to 50,000 mature individuals.

OPPOSITE The Lesser Fish-eagle is similar in build to the larger *Haliaeetus* Sea-eagles, but has a smaller bill. The Lesser Fish-eagle often fishes from low-level perches in the middle of rivers.

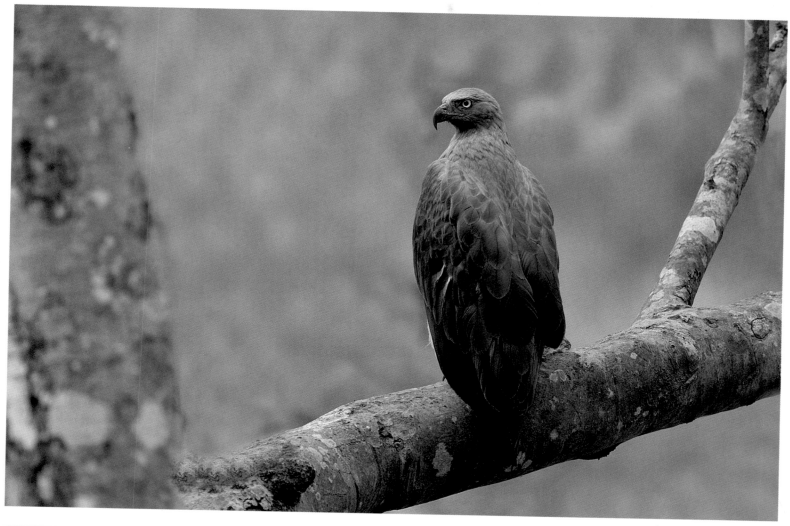
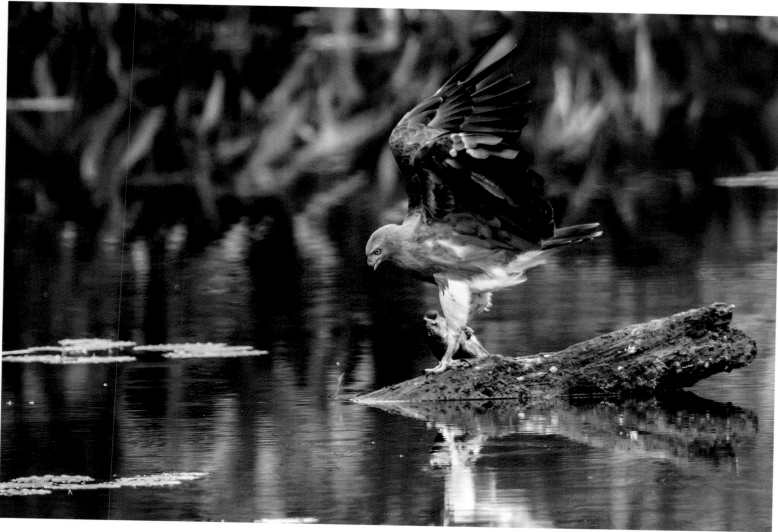

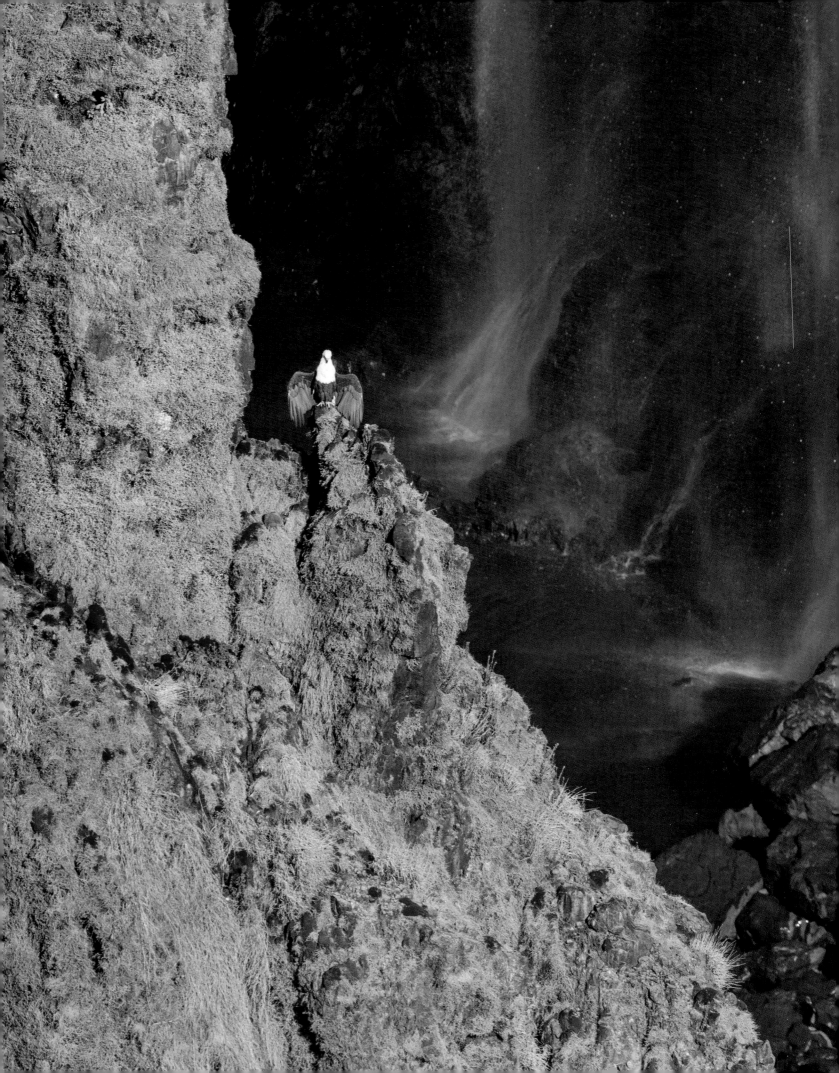

GLOSSARY

Afforestation
The planting of trees in order to create a forest (the opposite of deforestation). Often done for commercial purposes but sometimes also in order to regenerate a native habitat for conservation or environmental benefit.

Bioaccumulation
The chemical process by which substances, including toxins, are absorbed at a low level of a food chain and pass up as a residue through each link in the chain, with the potential to harm animals at the top of that food chain—such as eagles.

Biome
A broad ecological region, such as tundra, desert, or tropical rain forest. Each comprises a suite of habitats, all with their own communities of plants and animals with shared characteristics that reflect the prevailing climate and soil type. A biome may be found in different biogeographical realms, with the species composition differing from one to the next.

Cere
A fleshy covering at the base of a bird's upper mandible, through which the nostrils open. Especially pronounced in birds of prey, and often brightly colored—typically in yellow or red.

Cerrado
Large tropical region of wooded grassland covering some 20 percent of Brazil, located between the Amazon rain forest to the north and Pantanal wetlands to the south. Home to a rich biodiversity, it is one of the most threatened and over-exploited regions in South America.

Color morph
Distinct color variant within a species. The Tawny Eagle, for example, comes in dark brown and pale brown color morphs. The term does not apply to color difference between the male and female of a species (sexual dimorphism, see Diomorphic) or between adult and young. Neither does it correlate with differences between subspecies, to which greater genetic distinctions apply.

Conspecific
Of animals or plants: belonging to the same species. The Golden Eagle of Eurasia, for example, is conspecific with the Golden Eagle of North America.

Coverts
Small feathers above and below a bird's wings and tail that cover and protect the base of the longer flight feathers. Coverts are arranged in layers: on the upper wing, for example, the greater coverts are overlaid by the median coverts, which, in turn, are overlaid by the lesser coverts.

Dimorphic
Occurring in two distinct forms. Eagles are sexually dimorphic in that females are larger than males—although, unlike in many birds, the sexes of most eagles differ very little in plumage.

Emergent
Of or denoting a plant that is taller than the surrounding vegetation—typically of a forest tree that projects above the rest of the forest canopy. Many rain forest eagles nest in emergents, from where they are able to scan for prey in the surrounding canopy.

Epiphyte
Plant that grows harmlessly on another plant, such as a tree, and derives moisture and nutrients from the air and rain, and sometimes from debris accumulating around it. Epiphytes include, in temperate regions, mosses and liverworts, and in the tropics, ferns and orchids. They differ from parasites in that they use other plants for physical support without any detrimental impact on the host.

Facial disk
Concave arrangement of feathers on the face of certain birds, most notably owls but also in certain diurnal birds of prey, including the Harpy Eagle. It surrounds the eyes and serves to collect and direct sound waves toward the ears. The feathers can be adjusted to alter the focal length of the disk, enabling the bird to focus at different distances.

Family
Taxonomic level above genus and below order. The eagles belong in a single family, the Accipitridae, alongside hawks, kites, buzzards, harriers, and Old World vultures. This is one of four families that make up the order Accipitriformes, which encompasses all diurnal birds of prey.

Fingers
Birdwatcher's term for the tapered primary wing feathers of eagles and other birds that are visible separately when the wings are spread in soaring flight—resembling the fingers of a spread hand.

Genus (plural: genera)
Taxonomic level above species and below family, and forming the first part of a binomial species name. The Accipitridae comprises some sixty-eight genera, of which nineteen are composed of eagles. The genus *Haliaeetus* comprises the sea-eagles, thus, Steller's Sea-eagle is *Haliaeetus pelagicus*.

Hand
Birdwatcher's term for the outermost section of a bird's wing, extending from the carpal joint (wrist) to the tips of the primary feathers. A hand may be spread or closed, depending on the manner of flight.

Kleptoparasitism
Feeding technique in which an animal takes prey or other food from another animal that has caught, collected, or otherwise prepared it. Also used to describe the theft of nest material or other objects from one animal by another. A number of eagle species, notably the *Haliaeetus* sea-eagles, are habitual kleptoparasites.

Myxomatosis
A highly infectious and usually fatal viral disease of rabbits that was encouraged in some places as a control measure—notably during the 1950s, when in the United Kingdom the rabbit population fell by 99 percent. Rabbit populations quickly recover when the disease is eradicated, but eagles and other predators that subsist on rabbits may be severely affected.

Nominate
The first-named race of a species, in which the scientific name is the same as the species name. Thus, *Aquila chrysaetos chrysaetos* is the nominate race of the Golden Eagle, *Aquila chrysaetos*, which also occurs in five other races across the northern hemisphere.

Order
Taxonomic level above family and below class. Thus, the Accipitriformes order, to which eagles belong, comprises four families and is one among some twenty-eight orders in the class Aves (birds).

Pants (U.K.: Trousers)
Birdwatcher's term for the loose baggy feathers that hang from a bird's belly and cover the tibia—the highest visible part of the leg (sometimes, confusingly, called the thigh). Pants are a conspicuous feature of many eagle species, notably those in the *Aquila* genus.

Pliocene Epoch
Geological time period roughly 5.3 million to 2.6 years ago. It followed the Miocene Epoch and was followed by the Pleistocene Epoch.

Polyandry
Pattern of mating among animals, in which a female has more than one male mate. The opposite—in which a male has more than one female mate—is more common, known as polygyny.

Scapulars
Tract of small feathers covering a bird's shoulders, often forming a distinct line or groove where they overlay the folded wing.

Siblicide
The deliberate killing of one sibling by another, generally a younger by an older sibling. In some animal species, including many eagles, this has evolved as a deliberate breeding strategy: a pair produces a second chick as insurance against the possibility of a first egg or hatchling failing to survive, with siblicide ensuing if the first egg hatches healthily.

Species pair
Two very closely related and similar species that have evolved into separate, genetically distinct species through geographical separation—for example, the Bald Eagle and White-tailed Sea-eagle. A group of such closely related species may be called a "superspecies." The taxonomic distinctions involved are often a matter of debate.

Tarsus (plural: tarsi)
The lower leg of a bird, extending from the ankle joint to the base of the toes. In most perching birds, this is the only part of the leg generally visible. Some eagles (the "booted" eagles) have feathered tarsi; others, such as sea-eagles and snake-eagles, do not.

Taxonomy
The science of classification. Taxonomists trace the evolutionary heritage of each organism, determining which can be classified as species, which species make up a genus, which genera form a family, and so on.

Terminal band
A colored band, typically in black or white, that some birds have across the end of the tail. It is often an important aid to identification. Above the terminal band is often a sub-terminal band.

FURTHER INFORMATION

BIBLIOGRAPHY AND FURTHER READING

A wide range of published sources, both in print and online, have helped provide the factual material in this book. The following list includes sources that have been an important reference for the author, and also recommends reading for those who wish to explore further. The internet offers a wealth of resources about eagles, including where to see them, how to identify them, and how to become involved in their conservation.

Cramp, Stanley and Simmons, K. E. L. (editors),
The Birds of the Western Palearctic, Vol. 2: Hawks to Bustards
(Oxford University Press, reprint of first edition, 1979)
Second volume of landmark nine-volume ornithological handbook to the region's birds. An exhaustive repository of information, with extensive data on all aspects of the biology of each species, although now overtaken in some cases by more recent developments in taxonomy and distribution.

Debus, Stephen, *Australasian Eagles and Eagle-Like Birds*
(CSIRO Publishing, 2017)
An illustrated record of all the eagles and eagle-like hawks in Australasia, including Australia's three eagle species, plus four additional endemic species in Melanesia. It places the Australasian species in their regional and global context, reviews their population status and threats, provides new information on their ecology, and suggests ways in which to secure their future. A valuable resource for raptor biologists, birdwatchers, and raptor rehabilitators.

Dunne, Pete, *Birds of Prey: Hawks, Eagles, Falcons, and Vultures of North America* (Houghton Mifflin, 2017)
A lively and personal account of North America's birds of prey, including the continent's two eagle species, from a leading U.S. ornithologist and natural history writer. Intertwines history from the early ornithologists with current knowledge, and is illustrated with excellent color images that span both behavior and identification.

Ferguson-Lees, James and Christie, David A., *Raptors of the World: A Field Guide* (Helm Field Guides, 2005)
The definitive guide to this popular group of birds, revised for the original handbook to create a more lightweight field reference covering the world's 340 raptor species, including all its eagles. Updated taxonomy and color distribution maps for each species.

Forsman, Dick, *Flight Identification of Raptors of Europe, North Africa and the Middle East*
(Bloomsbury Natural History, second edition, 2016)
The ultimate flight identification guide to raptors of the Western Palearctic, with detailed information on all eagle species in all plumages, ages, and races. Accompanied by a full range

of photographs. Invaluable for birdwatchers to the region, especially those trying to separate the tricky "brown" eagles.

Love, John A., *A Saga of Sea Eagles* (Whittles Publishing, 2013)
Entertaining and evocative account of the reintroduction of White-tailed Sea-eagles to Scotland, by a key figure in the project since the 1960s. More a memoir than a scientific report, with absorbing insights into the wild places these birds once inhabited and the legends they have spawned.

Tarboton, W. R. and Pickford, Peter, *Southern African Birds of Prey*
(Struik Publishers, third revised edition, 1994)
A beautiful collection of photographs spanning one of the world's richest regions for eagles, with informative text by one of Africa's leading ornithologists.

Tingay, Ruth E. and Katzner, Todd E., *The Eagle Watchers*
(Comstock, 2010)
Lively collection of stories by twenty-nine eagle researchers sharing field experiences and personal narratives that don't feature in their scientific publications. Covers twenty-four species on six continents, from well known to obscure and endangered. Features fine color photographs, information on raptor conservation, a global list of all eagle species with ranges and conservation status, and a color map of all sites visited. Royalties are donated to two leading nonprofit organizations for raptor conservation.

Tomkies, Mike, *Golden Eagle Years* (Jonathan Cape, second revised edition, 1994)
Highly readable account from the 1970s of one man's studies of Golden Eagles in the Scottish Highlands. The author, a former Coldstream Guardsman, offers a fascinating insight into the rigors of studying and photographing this elusive bird in remote places and challenging conditions long before the age of satellite telemetry—and of relations with local landowners.

Watson, Jeff, *The Golden Eagle* (T & AD Poyser, second edition, 2010)
Definitive monograph that first appeared in 1997 and compiled everything known about the Golden Eagle. The author, who died before this revision, was one of the world's foremost experts on Golden Eagles. This edition is expanded and updated with much new fascinating information on social interactions and conservation.

www.eagledirectory.org
Online directory dedicated to providing accurate information about all eagle species around the world. With links to images, video, and audio. Browse by taxonomy, alphabetical order, or region.

www.globalraptors.org
Global raptor information network maintained by the Peregrine

ACKNOWLEDGMENTS

Fund, and designed to provide information on all diurnal raptors and to facilitate communication between raptor researchers and organizations interested in their conservation. A dynamic database, continually updated with conservation and research information.

youtube.com
An excellent resource for video clips of eagle species in action, including some dramatic amateur footage of hunting behavior (plus, inevitably, some rubbish).

CONSERVATION ORGANIZATIONS

Audubon Society (www.audubon.org)
North America's leading conservation organization, with more than 450 chapters across the United States. Promotes the protection of eagles, among other wildlife, with publications, wildlife preserves, and citizen science projects.

BirdLife International (www.birdlife.org)
Global partnership of conservation organizations that works to conserve birds (including eagles), their habitats, and global biodiversity.

Hawk and Owl Trust (hawkandowl.org)
National U.K. charity founded in 1969, dedicated to conserving owls, eagles, and other birds of prey in the wild, and increasing knowledge and understanding of these birds. Creates and manages nesting, roosting, and feeding habitats; carries out practical research; and welcomes visitors to wildlife preserves, education centers, and outreach projects.

IUCN (www.iucn.org)
The International Union for Conservation of Nature. International Nongovernmental organization founded in 1948 that gathers data in order to monitor the conservation status of all plant and animal species on Earth. The IUCN Red List assigns each species a conservation category, ranging from Least Concern to Critically Endangered.

Peregrine Fund (www.peregrinefund.org)
Nonprofit organization founded in 1970 when the peregrine falcon was nearly extinct in North America. Has since extended its work to many raptors around the world, researching little-known species, conserving habitat, educating the public, and building communities' capacity for conservation. Numerous endangered eagles, such as the Madagascar Fish-eagle, have been the subject of dedicated projects.

RSPB (www.rspb.org.uk)
The United Kingdom's largest nature conservation charity. Lobbies for conservation, encourages citizen science, and manages nature preserves around the United Kingdom to save birds—including eagles.

Author (Mike Unwin)
I would like to thank all those whose hard work and encouragement lie behind this book. It was a pleasure once again working with the team at Quarto. I am grateful to Ruth Patrick and Hannah Phillips for getting the project under way, to Carol King for her editorial expertise (and immense patience), and to Isabel Eeles for her lovely layouts—especially when working with some of the very scant imagery available for the most rarely photographed species.

It was, as ever, both a privilege and a laugh working with David Tipling, whose stunning pictures not only reflect his dedication in pursuing these elusive birds but also reveal the eye of a true artist. Having stood long hours with David beneath a Harpy Eagle nest in a Panama rain forest, waiting in vain for the female to return, I know just how much patience—and sweat—goes into his work. It was also an education seeing him curate the best of the images from elsewhere, accepting no compromise over studio shot and digital composite in order to find those pictures where the true spirit of the wild bird has been captured with integrity.

I am grateful to all those naturalists and conservationists whose dedication to eagles has brought us a deeper understanding of these magical but much-maligned birds. Without them, there would be far fewer eagles to photograph. Also to the friends who have enhanced my enjoyment of eagles in many parts of the world, not least Elspeth Macdonald and Roddy Paul at their home in Scotland's wild Wester Ross. And, finally, I would like to thank my own family: my parents, who encouraged my love of nature from the earliest days; and my wife Kathy and daughter Florence, with whom I have shared many memorable wildlife moments—not least with eagles.

Photographer (David Tipling)
My encounters photographing eagles have always been deeply memorable. Whether waiting for days in a hide in a Finnish winter for Golden Eagles to come to feed or watching a majestic Philippine Harpy Eagle soaring over rain forest.

Many species are confined to some of the remotest corners of our planet, adding to the challenge. Advancement in camera technology has encouraged a huge army of birders to carry a camera when out in the field. It is to those people I am most indebted for supplying their images for this book. With their help it has been possible to illustrate here in a single volume every species. Tracking down the people who have taken high-quality images has often been challenging. I am particularly grateful to Tim Loseby for helping to find some of the more elusive photographers and photographs from the Orient and putting me in touch with some world-class bird photographers in India.

For my part, photographing some species has required a lot of help. In Finland, Jari Peltomäki introduced me nearly two decades ago to photographing Golden Eagles during midwinter close to the Arctic Circle. We have shared many adventures in pursuit of eagles not just in Finland and Norway but in India and Japan too. The late Jean Keene also known as the Eagle Lady lived on Alaska's Homer Spit. A fomer rodeo trick rider, with flaming red hair, Jean was on each of my three visits to the spit to photograph Bald Eagles very hospitable. I am indebted to Carlos Bethancourt and Raúl Arias of the Canopy Family in Panama. Carlos is both a good friend and a first-class guide and birder who made it possible for both myself and Mike Unwin to both see and photograph a Harpy Eagle in the wild.

Choosing this final selection of images has been a team effort. It has been a great pleasure to work once more with Mike Unwin who had a huge input into this process. Thanks also to Isabel Eeles for her eye-catching design and patience with us when we sometimes wanted things changed and then changed again, and to Carol King for her guidance keeping us all on track.

INDEX

PICTURE CREDITS

Every effort has been made to trace all copyright owners but if any have been inadvertently overlooked, the publishers would be pleased to make the necessary arrangements at the first opportunity. (Key: **t** = top; **b** = bottom; **l** = left; **r** = right)